Jazz

HERMAN LEONARD

BLOOMSBURY

New York Berlin London Sydney

Published by Bloomsbury USA, New York

All papers used by Bloomsbury USA are natural, recyclable products made from wood grown in well-managed forests. The manufacturing processes conform to the environmental regulations of the country of origin.

LIBRARY OF CONGRESS CATALOGING-IN-PUBLICATION DATA HAS BEEN APPLIED FOR.

ISBN: 978-1-60819-333-2

First U.S. Edition 2010

10 9 8 7 6 5 4 3 2 1

Design and layout: www.carrstudio.co.uk
Printed in China

Contents

This book is dedicted to all the

wonderful musicians within these pages,

who let me in and turned me on.

Foreword

WYNTON MARSALIS

Herman Leonard's photographic archive is extremely important for the history of jazz. The depth and clarity of his work has defined the look and feel of our music for more than half a century.

Herman's style is elegant, clear and spontaneous, so when people think of jazz, many of his images come to mind: the great Dexter Gordon photograph, Charlie Parker in a jam session, young Miles playing for himself backstage – and countless others.

My father and the musicians in New Orleans have always loved Herman and his pictures. He was comfortable with black people, and you can see it in his photographs. He feels like someone from New Orleans – bohemian, living in the moment, with a real youthful vigor and zest, relaxed but with a special intensity. It's the feeling of jazz, seemingly effortless, but endlessly inventive - and Herman always gives you that feeling.

New Orleans, February 2010

Herman Leonard:
In His Own Words

REGGIE NADELSON

Late one night in 1949, Charlie Parker, Miles Davis, and the rest of the quintet had just finished their last set at the Royal Roost club on 47th and Broadway in New York. With them that night, as on many others, was Herman Leonard, a young photographer. They liked the unassuming white kid, a skinny handsome young guy with a pencil moustache, who seemed able to catch the music itself in the pictures he made, with a couple of small spotlights and his trusty Speed Graphic camera.

'It was my project to make a visual diary of what I heard,' says Herman Leonard. 'To make people see the way the music sounded. I wanted to do with light what artists do with a line sketch: show the whole character. I had two lights; it was all I could afford.'

At eighty-seven, he has a dazzling memory. Never pompous, he doesn't use photographer's lingo, always more interested in the musicians themselves than technical language or the verbiage of high art. His own words, the anecdotes he tells – insightful, funny, profound – are as evocative as his pictures.

'I used to tell cats that Herman Leonard did with his camera what we did with our instruments,' says Quincy Jones. 'Looking back across his career, I'm even more

certain of the comparison: Herman's camera tells the truth, and makes it swing. Musicians loved to see him around. No surprise; he made us look good.'

Over the years, Herman Leonard took photographs of musicians, the bands and soloists and singers in New York clubs like the Roost and Birdland. Bebop was being born and Leonard found a way to capture the look.

'In those days, everybody smoked,' says Tony Bennett, a friend of Leonard's for fifty years. 'It was wild that Herman actually put smoke in all of his photographs.' 'He's a painter with his camera,' Bennett adds. 'Look at the ray of light on Duke Ellington that shows his spirituality; look at how he put Art Tatum's hands, the greatest pianist ever, who was blind, in the foreground; Chet Baker, handsome as Montgomery Clift; Count Basie playing baseball in Central Park. Herman's photos made a documentary of that era.'

The photographs are often so immediate that they're like frames from a movie. In one, Ella Fitzgerald sings to an audience at a club. First, you see the audience, and then you realize that at the table in front are Duke Ellington and Benny Goodman. Look carefully at the photograph of Erroll Garner, and from the background emerge those wannabe

hip young guys, suits and skinny ties, who frequented the jazz clubs of the 1940s and 1950s. At Brasserie Lipp in Paris in 1958, you see Johnny Hodges seated in a booth watching coolly while a French waiter, standing, attentive, serves him, pouring a glass of wine. Hodges is black; the waiter is white. Many of Herman Leonard's photographs tell a complicated story; sometimes you have to look two or three or ten times to see it all.

With their rich blacks, whites and silvers, the sense of images both fleeting and permanent, the pictures look beautiful and astonishing, the way the music was then, and still is; they look, as the great critic Whitney Balliett famously said of jazz itself, 'Like the sound of surprise.'

Herman Leonard caught the musicians in performance, but also at ease, or at home, or backstage, as if a friend had dropped by: Louis Armstrong with a sandwich and a bottle of champagne, or Duke Ellington and Billy Strayhorn sharing a cigarette by the piano. Herman's images seem imbued with the friendship and collaboration that is the essence of jazz.

The special quality of the photographs is in the iconic beauty of the pictures, the way Leonard made up the language of jazz photography, the fact that when people think jazz, as often as not, they see his pictures. There's something else, something indefinable that is revealed in the photographs: Herman really knew his subjects; they were his friends, they gave him access. The photographs – Billie Holiday just released from jail, Frank Sinatra, melancholy in a recording session – show an intimacy and trust and a kind of love for the man on the other side of the camera who always told the truth.

Herman was – and is – in love with his subjects and the musicians knew it. They felt it. They let him in not just because he took wonderful pictures and evolved as a master printmaker, a genius at exquisite detail, of light and shade, but because you couldn't make these pictures unless you were Herman. They are, in that sense, an act of being Herman Leonard.

I got to know Herman Leonard in New Orleans and then LA half a decade ago. Almost everybody there, and most jazz buffs, too, thought of him simply as Herman, the way you might think of Duke or Dizzy; a singular talent requiring only a first name. I've had his photographs on my walls for a long time: Miles Davis backstage at Birdland; Dexter Gordon; Ella Fitzgerald, Ray Brown's arms around her, her expression so sweet, so filled with love for her husband, with such a sense that he loves her back. This is Ella, the woman who sings the great standards – 'I've Got a Crush on You', 'Someone To Watch Over me' – the way only she can, the way that made George Gershwin say he felt he had never really heard his music until he heard Ella Fitzgerald sing.

Herman Leonard's photographs have given generations of jazz lovers a way in, as if we'd been there in New York at the Roost or Birdland or later in Paris or San Francisco. I look at them, and I can feel Herman there, the Herman who tells a great joke, and is also deeply humane, a great artist, a profoundly good man. A *mensch*.

Herman Leonard was born in 1923 in Allentown, Pennsylvania, a blue collar industrial city of less than 100,000 in the Lehigh Valley, about sixty miles north of Philadelphia. Herman's father Joseph arrived from Romania in 1907, his mother Rose followed a year or two later, both from the Iaşi, near the Black Sea, about 300 miles from Bucharest. Herman's father arrived with nothing; he started a business making women's corsets, and prospered.

'He came with the proverbial five dollars in his pocket,' Herman says of his father. 'He got a job on a sewing machine in a factory, he started a business, making ladies' corsets, custom-made corsets, business boomed, and so he made a bit of money.'

A secular Jewish family, parents from the old country, kids – Herman, Francesca, Ira – born in America, the Leonards, who spoke English at home, only spoke Yiddish when they didn't want the kids to know something.

Unusually for the times, the family took vacations in Europe, sailing on the big liners, sightseeing in Paris. Herman's mother, a woman with a deep social conscience who always reminded him about the starving kids in India if he didn't finish his dinner, also took him to Argentina and to Palestine. The experiences gave him an early view of another world, a taste for travel, for those things unknown in provincial Allentown, where, as he points out, there was only one trolley car.

When he was about twelve, his brother Ira provided him with a gift that would change everything.

'He gave me a Box Brownie which were these little wooden plastic covered cameras with one little lever and you had to look through a viewfinder. My brother helped me develop my first roll of film in the basement where we had a little darkroom,' Herman recalls. 'The image came up and it was like magic.'

A shy kid, he realized photography made him popular, most of all with the girls. It was around this time that he also heard the music that would change his life. Like most people at that time, Herman listened avidly to the radio.

'When I heard jazz, it was a whole new thing, like eating candy for the first time,' he says. 'I remember when Nat King Cole came on the radio with 'Straighten Up and Fly Right', and it made my feet move. And I really liked the improvisational part of it; nothing was too orchestrated. So I became enthralled with the jazz thing.'

Ohio University in Athens, Georgia, was one of the few colleges which gave degrees in photography and Herman was soon made head of photography for the school year book, with an office and a staff. He took pictures at basketball games, and dances, but what interested him were the portraits of the professors he took. He honed his early skills at portraiture, with ways of seeing people and ways to make them comfortable in front of his camera.

In 1942, he interrupted his education to enlist, hoping to be an officer which, he admits now was 'an ego thing'. He wanted to wear the uniform, he says, grinning, 'to impress the ladies'.

He told the military he was a photographer, but in the admission test, he failed a question about the ingredients of Kodak D-72 Print Developer. 'I used to buy the can and on it there were instructions, dissolve in hot water. And then I'd process the film. They said, "You can't be a photographer. You're going to be a medic."'

Herman has the most enormous capacity for enjoyment, for sucking the juiciest bits out of his experiences. He was trained as a medic to evacuate people from Arctic conditions and then sent to Burma. Like many men of his generation, Herman makes light of the danger and recounts his war as experience rather than horror.

He found time to take a few pictures. On moonless nights, he went into his tent and swished the negatives around in developer he had poured into his helmet.

Herman Leonard knew exactly what he wanted to do when the war was over. He returned to Ohio to finish his degree, a young man in a hurry and somehow, even at twenty, he had a specific direction. He drove himself to Ottawa and knocked on Yousuf Karsh's door. The great portrait photographer told Herman he already had an assistant but invited him in for lunch. Herman charmed Solange Karsh, Yousuf's wife, and Karsh offered to take him on, without pay – Herman's father agreed to help out. For a year, he worked with Karsh, learning many of the techniques he employed throughout his career.

In 1947, Herman went to New York. He found a little studio and apartment at 220 Sullivan Street, a couple of blocks from Washington Square. The young Herman Leonard shot corporate photographs and the occasional portrait to make a living, but it was jazz, the music 'that made my feet move', that had great allure. He couldn't afford the New York clubs, so he offered their owners pictures for their publicity posters if they'd let him into rehearsal.

The time was absolutely ripe when he arrived, as Bebop moved to the clubs in midtown Manhattan. In the mid 1940s, a radical new kind of jazz had arrived in New York City. Led by its originators Charlie Parker and

Dizzy Gillespie, the new music dazzled and bewildered its audiences.

Bebop filtered into the clubs on 52nd Street – Onyx Club, Three Deuces, the Famous Door. But it was at the Royal Roost that Herman Leonard took many of his great photographs, including his most famous, the great picture of Dexter Gordon, smoke seeming to curl up in great plumes from his saxophone.

Charming, full of both *joie de vivre* and drive, Leonard was invited into the clubs and the lives of the musicians. Somehow, in his gut, he understood that jazz and photography were perfect for one another, both expressions of modern life, both somehow best defined in a world of black and white and silver, a New York nighttime world of light and shadow, skyscraper and tarmac, of neon and gleaming instruments.

This was New York in its prime, the post-war city that was becoming the centre of the world, where artists, writers, musicians, dancers, actors were mixing it up, both high-life and low, bohemian and grand, in Greenwich Village and Harlem and on 52nd street. The soundtrack for all of it was modern jazz. It was also a wild time, which took its toll on some of the artists who had become Herman's friends.

The majority of Herman Leonard's great jazz photos were taken in the 1940s and 1950s, but he photographed some of the musicians over a lifetime. There are pictures of Dizzy Gillespie, a young man kidding around with his band, and pictures of the venerable master on the set of Sesame Street. Herman photographed Miles Davis from 1947 until Miles's death in 1991. Nobody got that much of Miles; most people hardly got anything at all.

By 1950, Herman had accumulated enough photographs that friends suggested he take them to the Museum of Modern Art; that perhaps they would do a show. The chief of the photography department at the time was Edward Steichen.

'I made an appointment, I made these big prints, thinking they'd be very impressed, and I went up there.

Steichen looked at them and he said, "The work is very nice, technically beautiful but I don't hear the music."'

Herman eventually settled in Europe, living first in Paris, and then for most of the 1970s in Ibiza. He was a working photographer, but the jazz photographs from the 1940s and 1950s remained, for the most part, under his big bad bed, banished if not completely forgotten. Rock and roll had, to a large extent, drowned out jazz.

Then, in 1986, Herman found himself in the middle of a divorce, in London, with two kids, and broke. A tiny gallery off the then funky Portobello Road put up an exhibition of Herman Leonard's jazz photos. The *Sunday Times* ran an eight-page spread. The BBC transmitted a half-hour documentary.

Ten thousand people came to the exhibition and he sold 250 prints. People who had known his jazz photographs all their lives – from album covers, newspapers or posters outside jazz clubs – realized Herman Leonard was the man who had taken them. Finally, he had the recognition he'd craved for so long. With it came a new artistic life and, as he travelled back to the United States more often, a new life in the city he loved most of all.

In 1991, Herman's work was shown in New Orleans. It was love at first sight and he settled there, among people he could party with and places where he could listen to good music. It was, he says, like coming home.

He had come home. The city where jazz was born became the city where the greatest of jazz photographers settled and thrived. He set up a studio in his Lakeview house. He produced exquisite handmade prints of the jazz greats, and took pictures of younger musicians in New Orleans: Slim Gaillard, Ellis Marsalis, Kermit Ruffins, James Andrews, Doc Cheatham, Victor Goines, Nicholas Payton. He shot street scenes and club scenes and Mardi Gras.

'Maybe it was the ease of life there,' says Herman. 'I've never in my life felt more comfortable in my own skin than I did in New Orleans. This city was an amalgam of

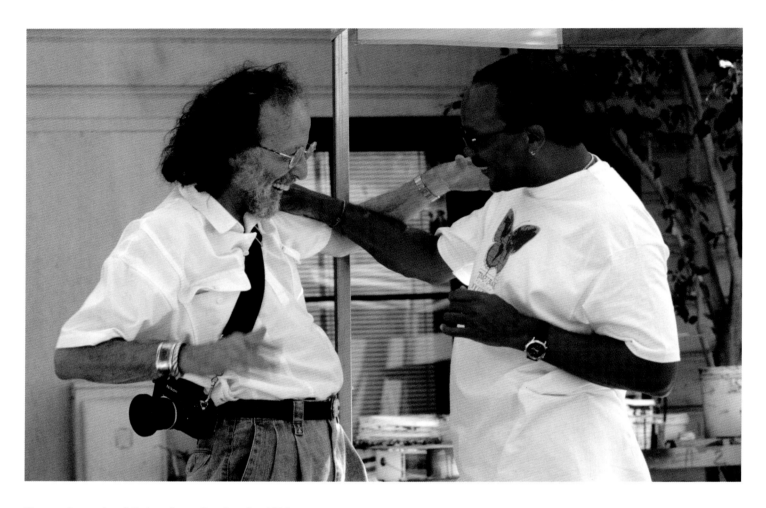

Herman Leonard and Quincy Jones, Los Angeles, 1990

200 years, a gumbo of cultures which produced the only uniquely American art form, which is jazz.'

Katrina hit in 2005. 'It was as if a big hand came down and just smacked everything,' Herman says. His house was flooded, his family evacuated, he lost as many as 6000 prints, as well as his carefully logged exposure records. The prints would have been Herman Leonard's legacy, enough for thirty years of sales.

Having lost everything, Herman picked himself up and started again, moving on to Los Angeles, and starting over again at the age of eighty-two. He opened a new studio.

He received a life-time Lucie award for his work, and opened a definitive exhibition of his work at Jazz at the Lincoln Center in New York last year.

He works most days, producing new prints, as well as a stunning portfolio of the jazz greats. He keeps in touch with pals like Quincy Jones and Tony Bennett.

I remember a night with Herman we spent at Snug Harbor, a New Orleans club, listening to Ellis Marsalis. In his seventies, Marsalis bounds on to the stage to join his trio. He and Herman Leonard exchange a little comradely banter.

The exchange dramatizes Leonard's visceral feeling for jazz, and for the people who make it. It also underlines how jazz musicians regard him – as one of their own. The Marsalis trio rolls out a succession of witty and original readings of jazz classics, and Leonard circles the bandstand with his digital camera, moving and swaying with the music so that he seems almost to be a fourth member of the band.

Back in his seat, he is utterly absorbed in the music, head bowed, eyes shut, smiling and nodding with the beat. Herman Leonard is in his element.

'How do you get your energy, baby?' Herman calls out to his friend Ellis.

Before sailing into another exhilarating tune, Marsalis yells back, 'From you, baby.'

As I sit down to write this in the winter of 2010, just as I'm heading out to LA for Herman's eighty-seventh birthday, I learn that he isn't well. A jaunty phone call from Herman himself announces this. 'Hi babe, hi kid,' he says and tells me the news. I feel lousy.

And then I think: if something happens to Herman, I have him around me, on my walls, speaking through the musicians, through Ella's shy smile, and Tony Bennett's youthful ebullience and the smoke curling out of Dexter Gordon's sax, and the thrilling celebratory look of Louis Armstrong and Duke Ellington.

On the same wall I also keep a picture of Herman and his pal Dizzy Gillespie, a photo taken by Quincy Jones.

And there's this: if something happens, as one day it inevitably must, I'll recall what Tony Bennett said when he heard Frank Sinatra had died: 'I don't have to believe that.'

Lester Young's hat, New York, 1948

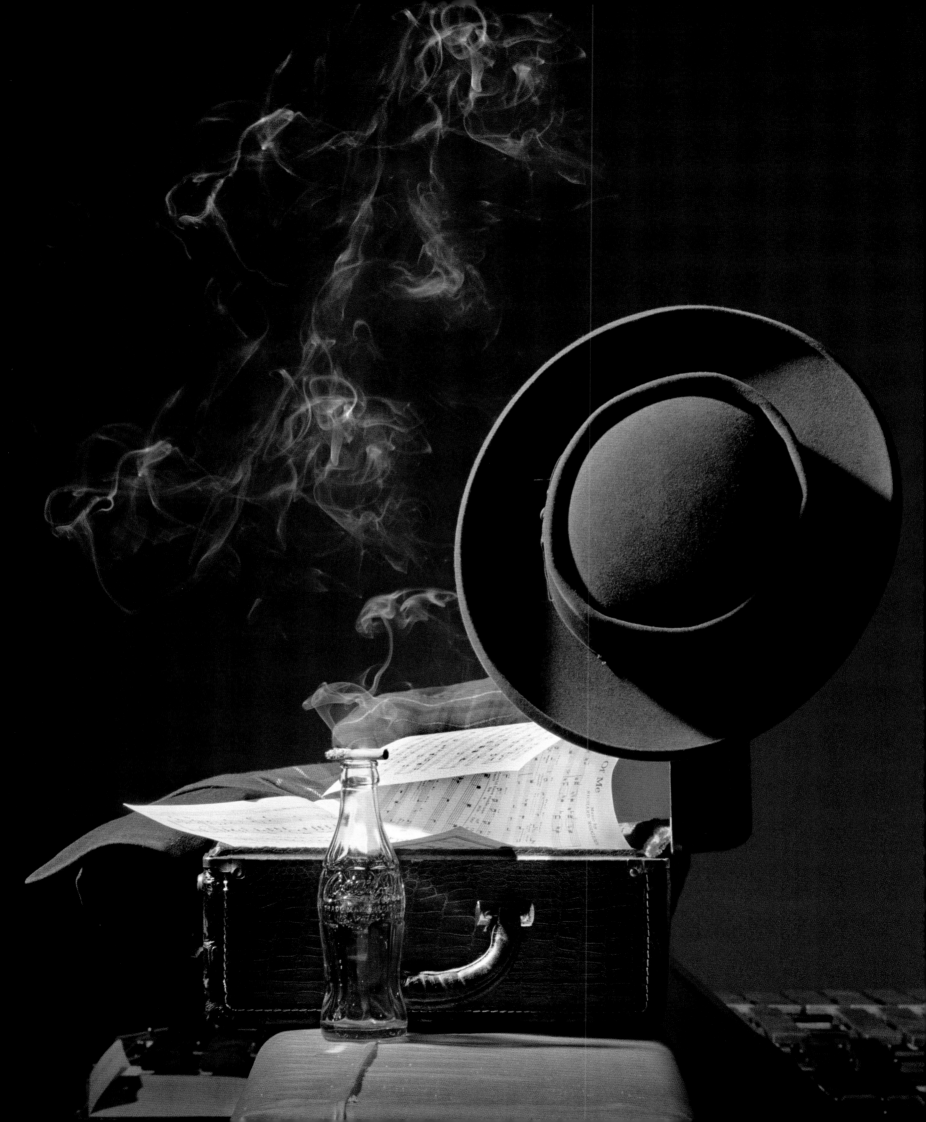

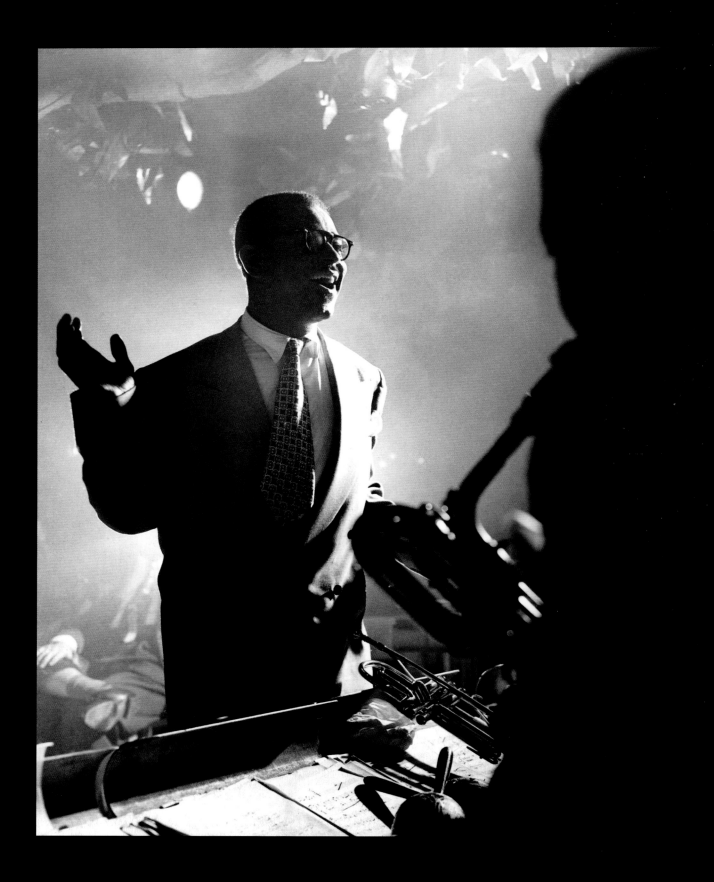

Both: Dizzy Gillespie, New York, 1948

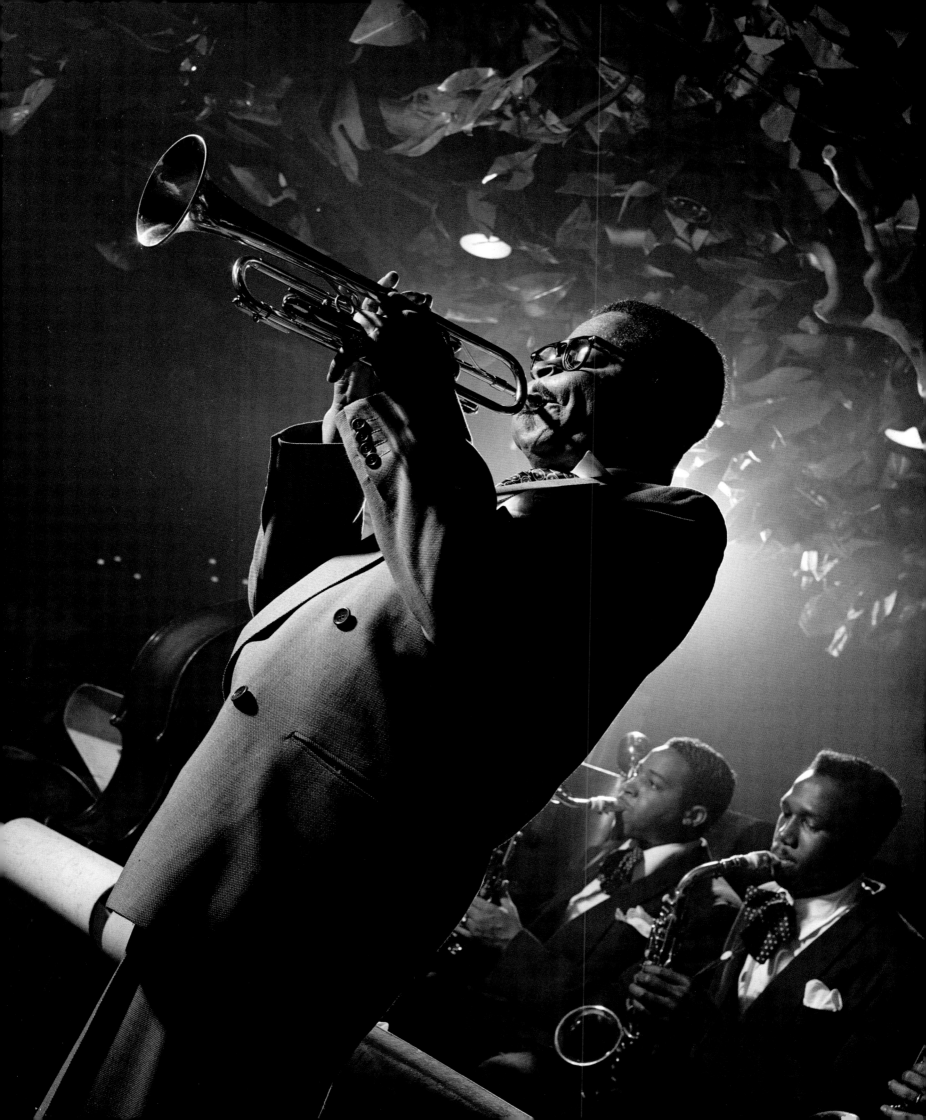

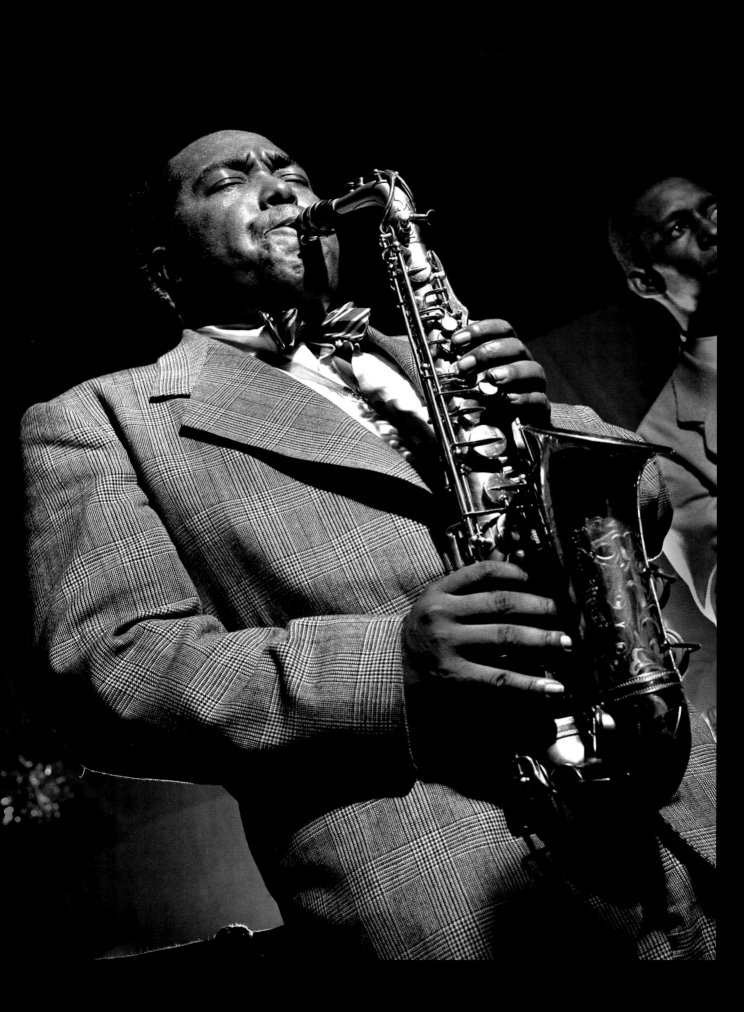

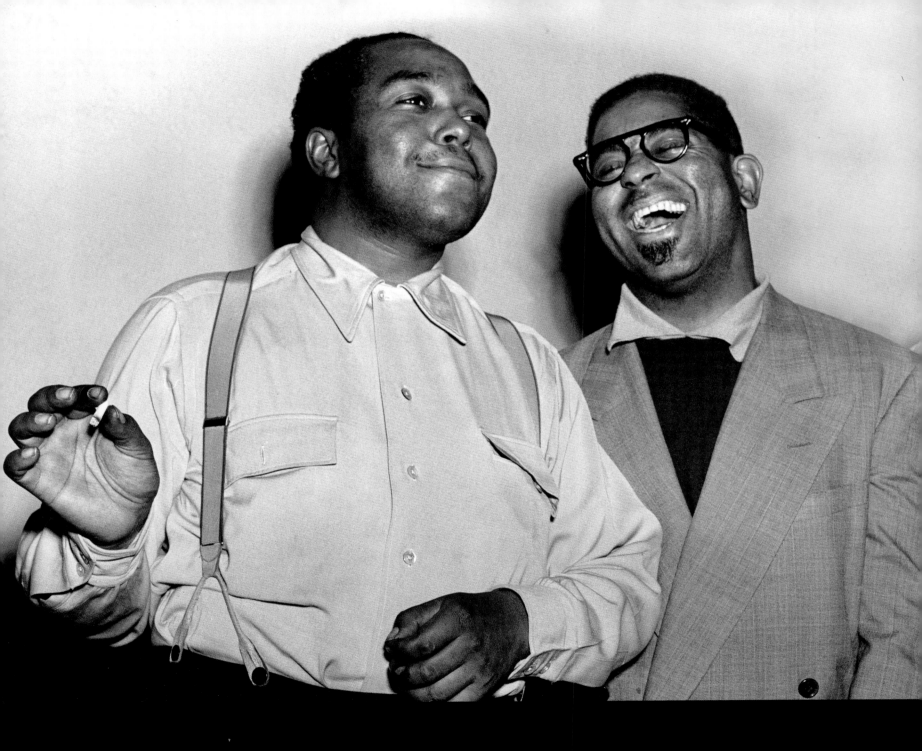

Above: Charlie 'Bird' Parker and Dizzy Gillespie,
New York, 1949

Overleaf: Charlie 'Bird' Parker and The Metronome
All-Stars, New York, 1949, *left to right:* Billy Bauer,

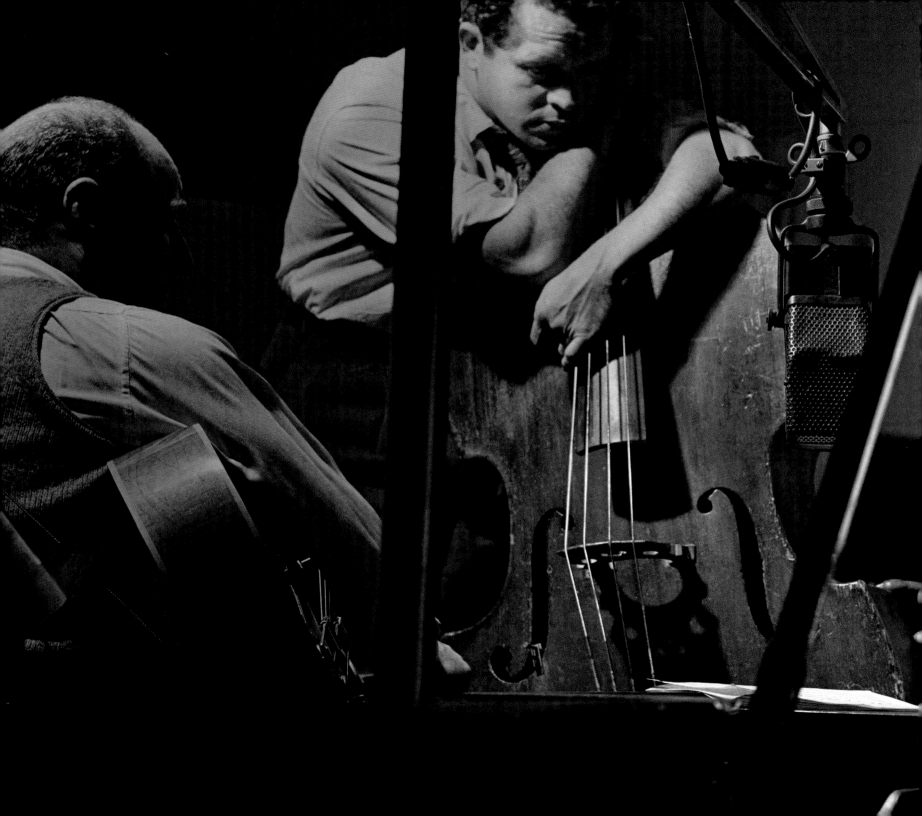

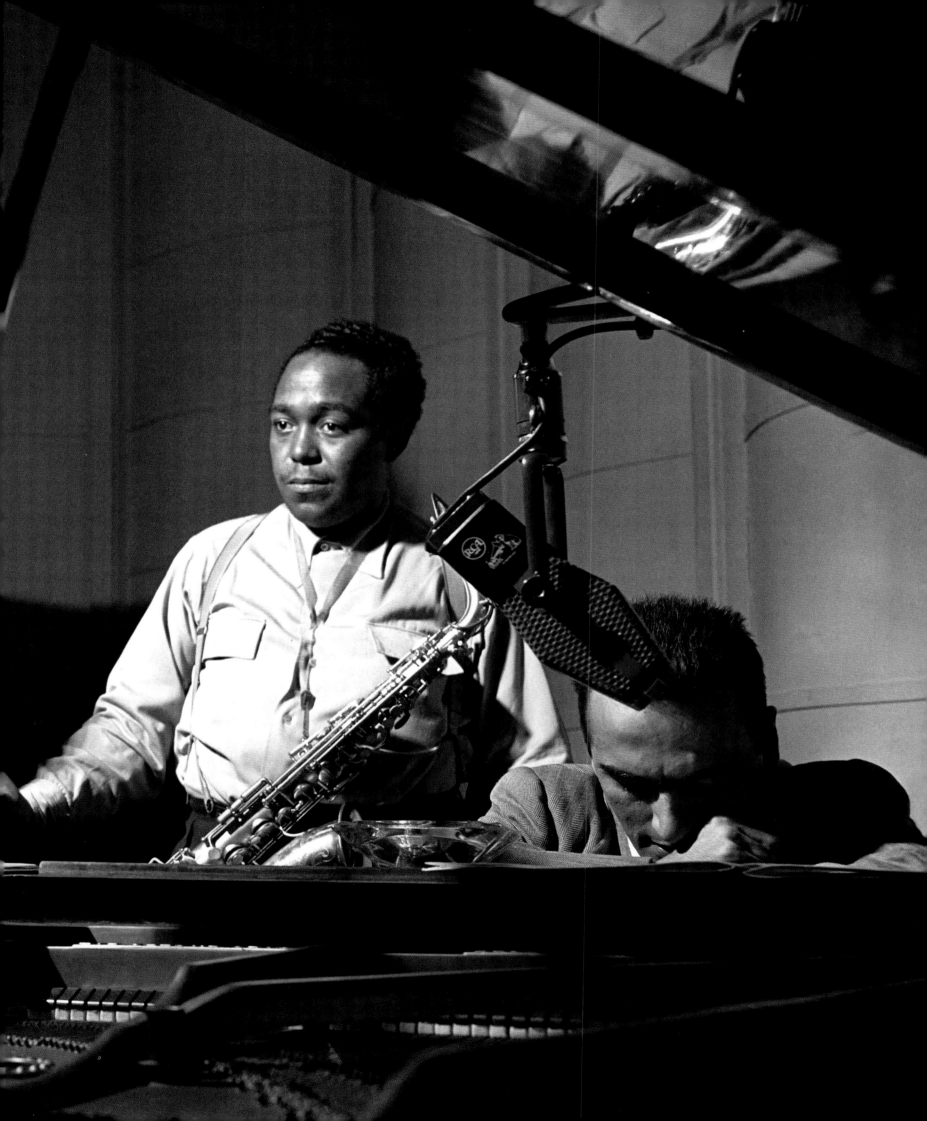

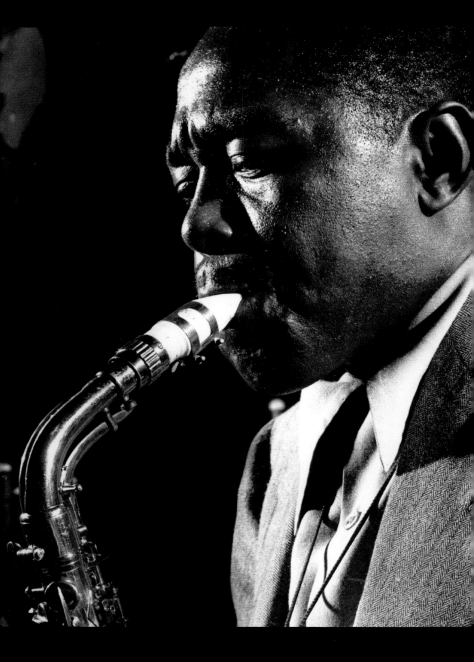

Charlie 'Bird' Parker, New York, 1948

Opposite: Charlie 'Bird' Parker and The Metronome All-Stars, New York, 1949, *clockwise from left*: Billy Bauer, Eddie Safranski, Charlie Parker, Lennie Tristano

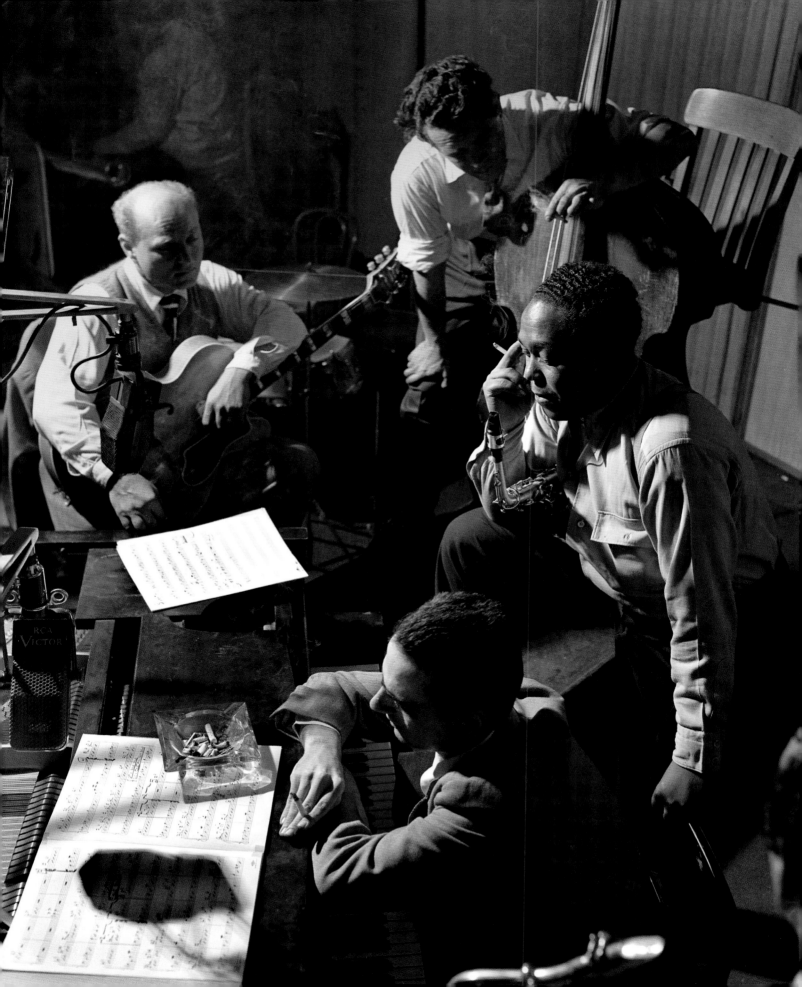

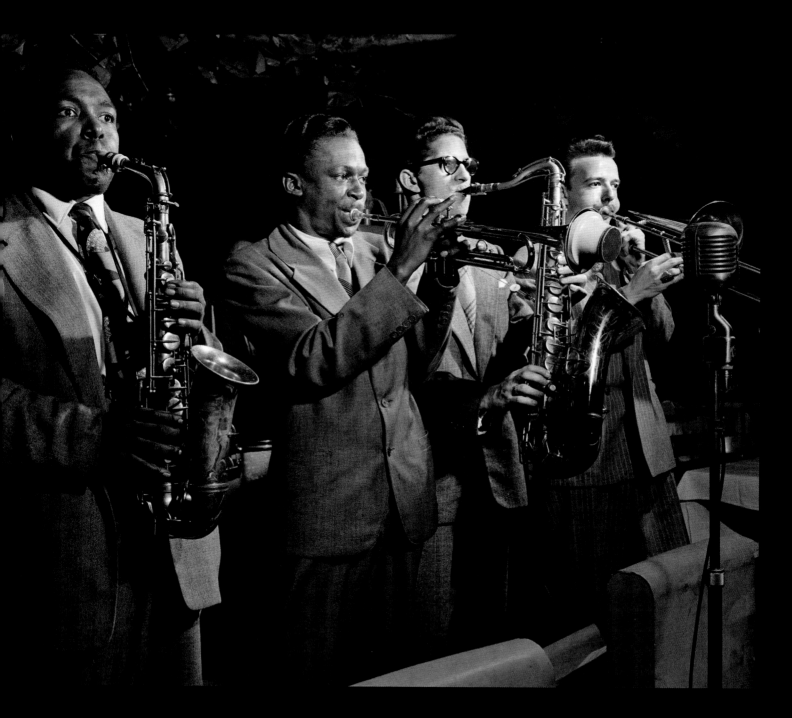

From left to right: Charlie 'Bird' Parker, Miles Davis,
Allen Eager and Kai Winding, New York, 1948

Opposite: Miles Davis, Birdland, New York, 1949

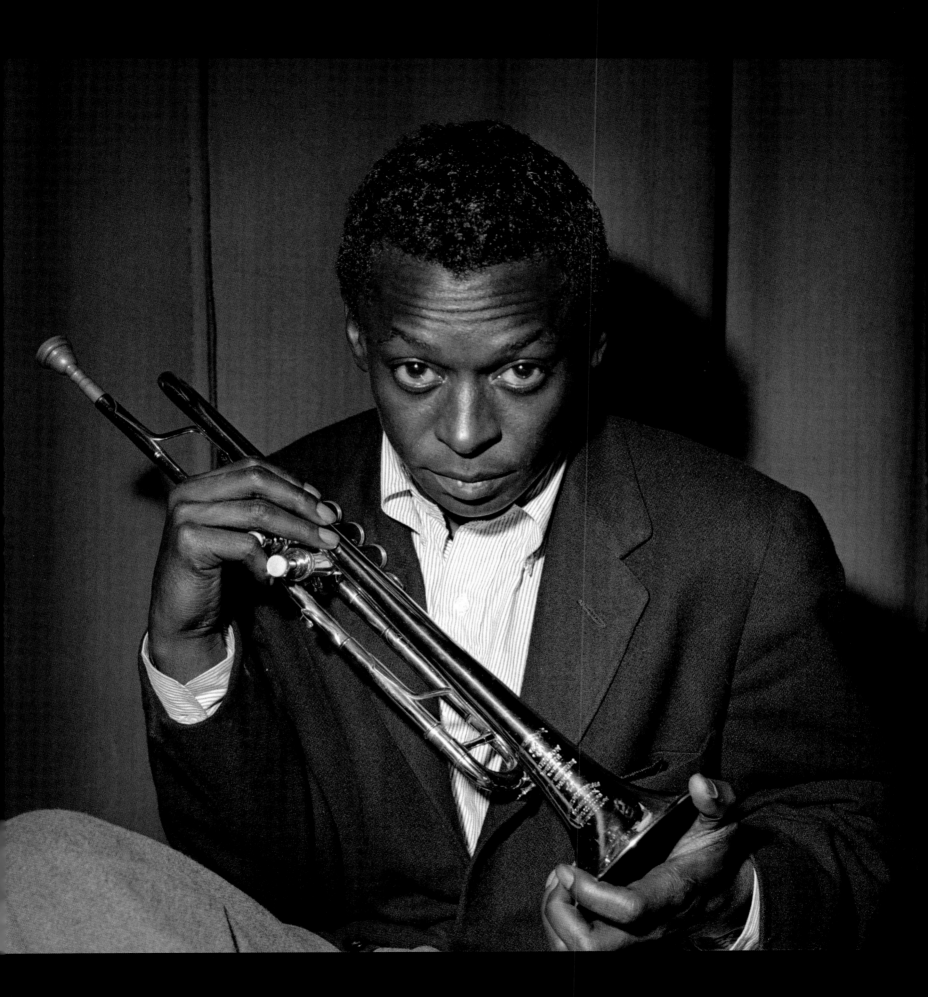

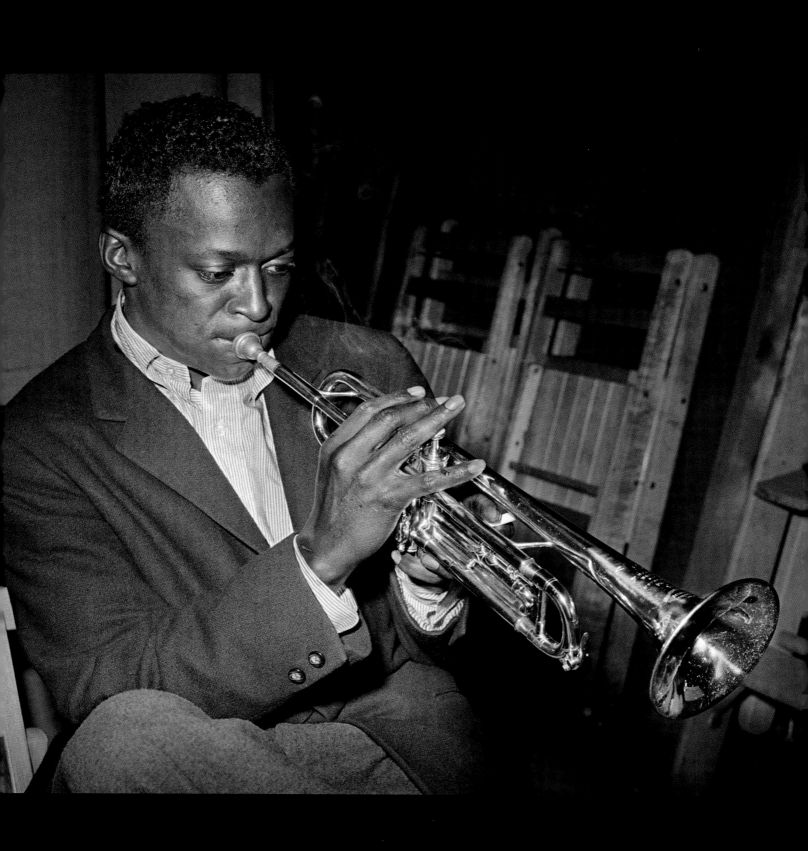

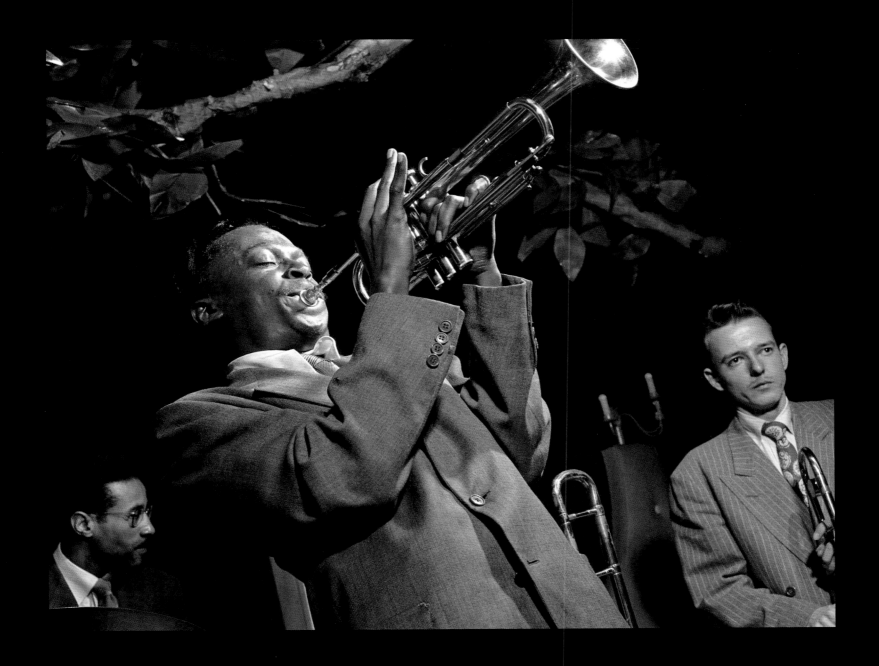

Opposite: Miles Davis, Birdland, New York, 1949

Miles Davis, the Royal Roost, New York, 1948

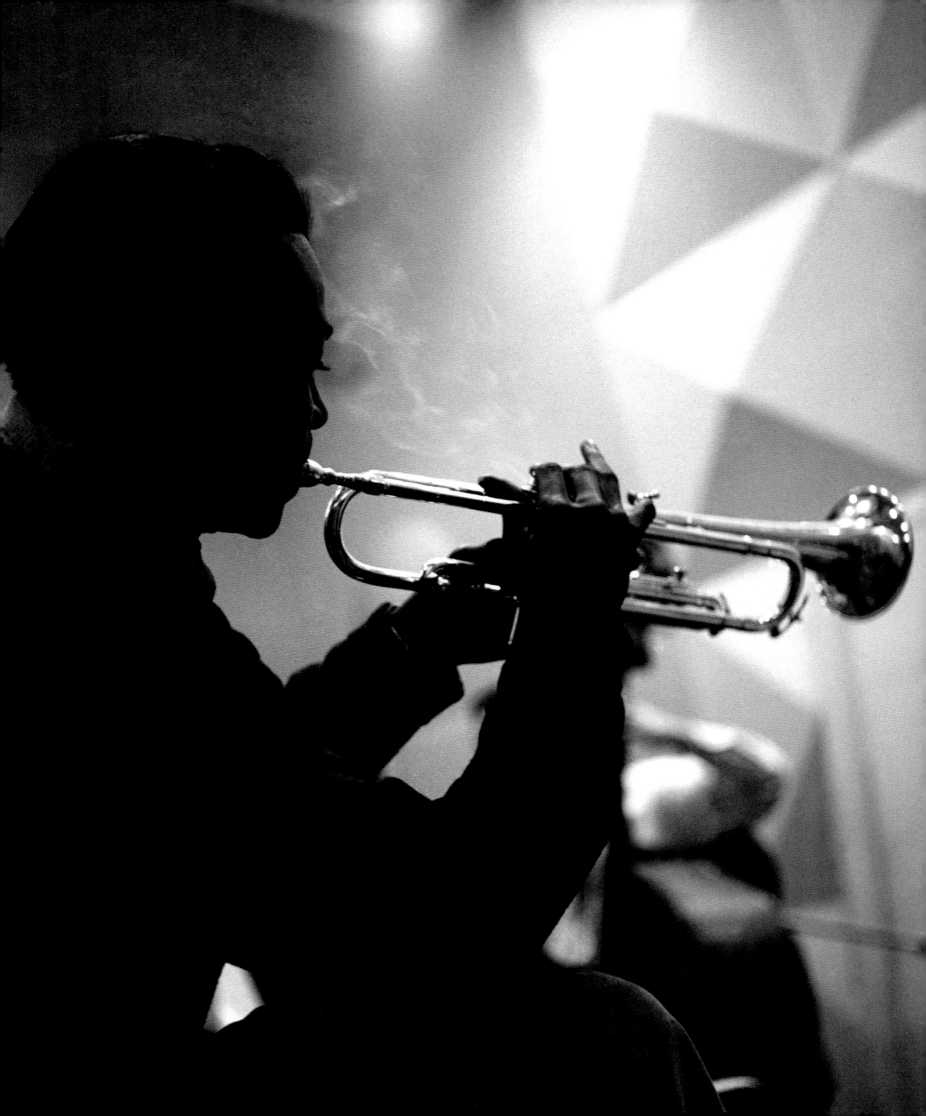

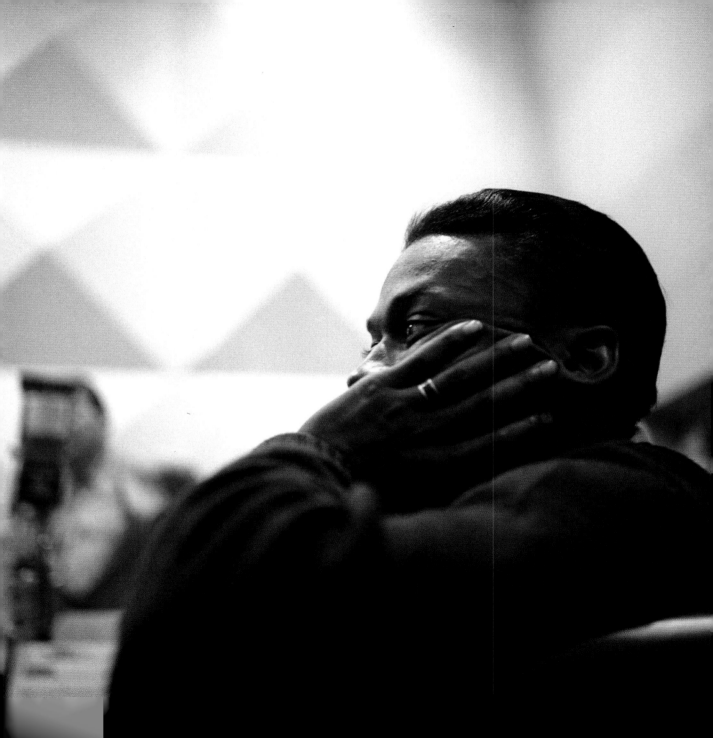

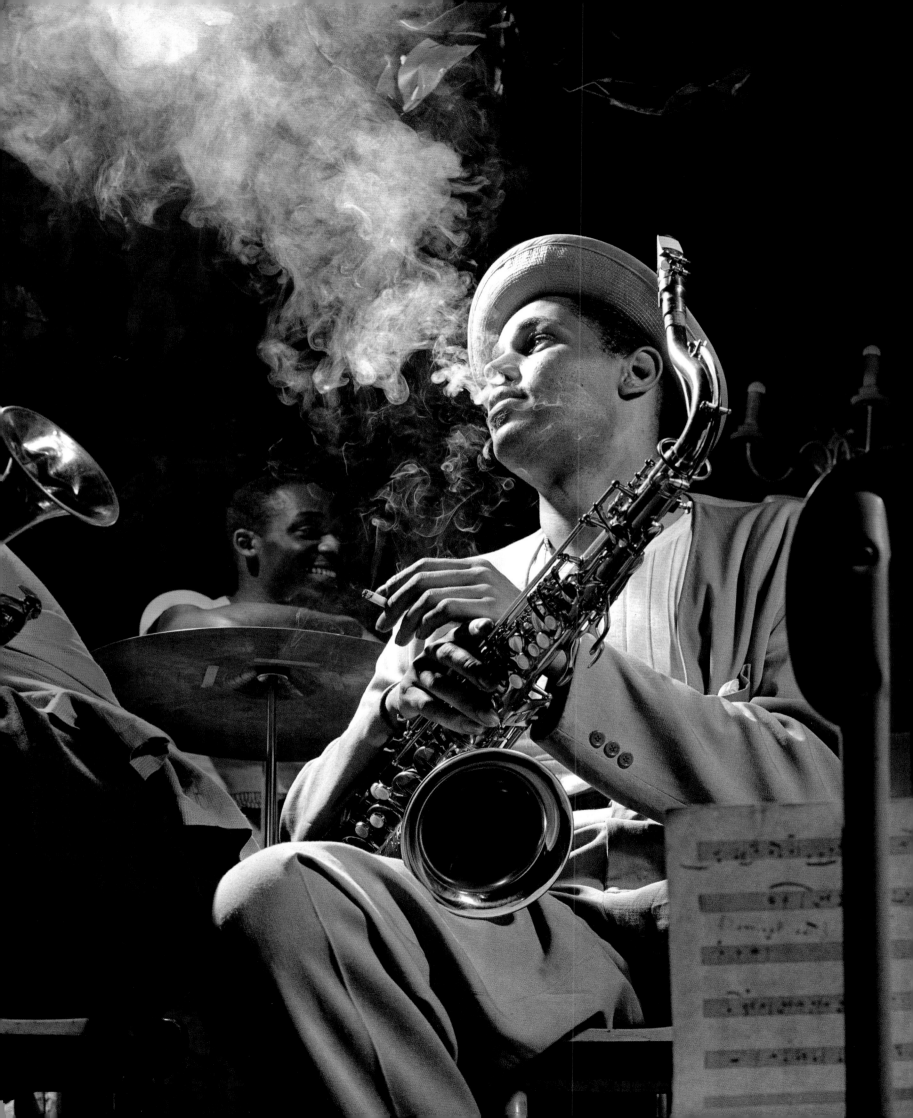

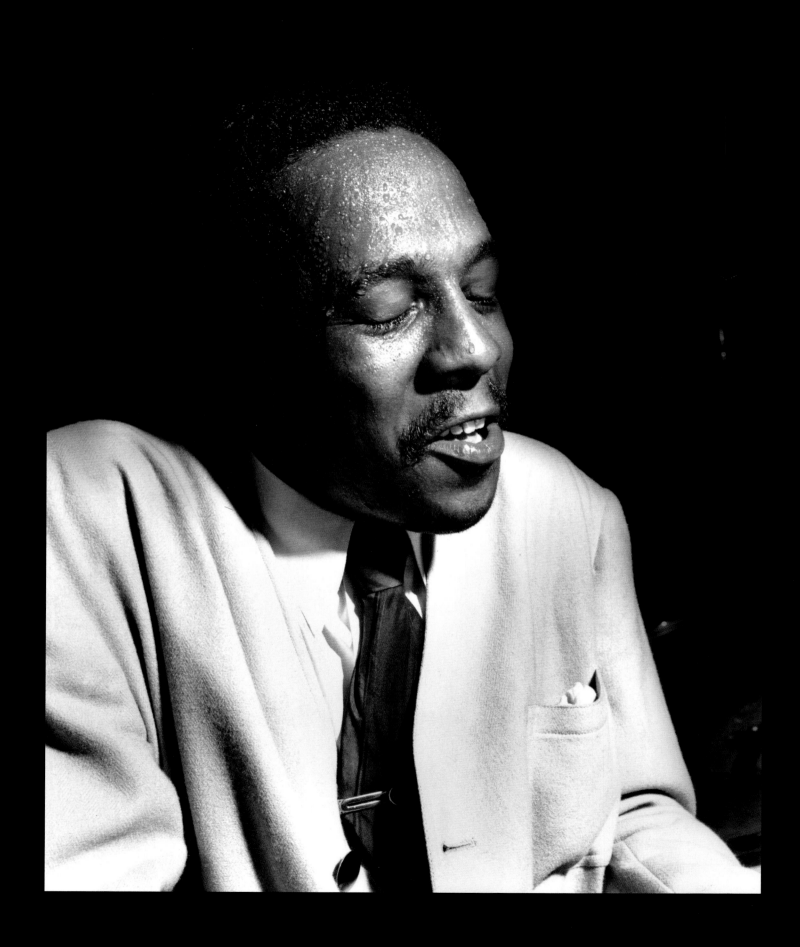

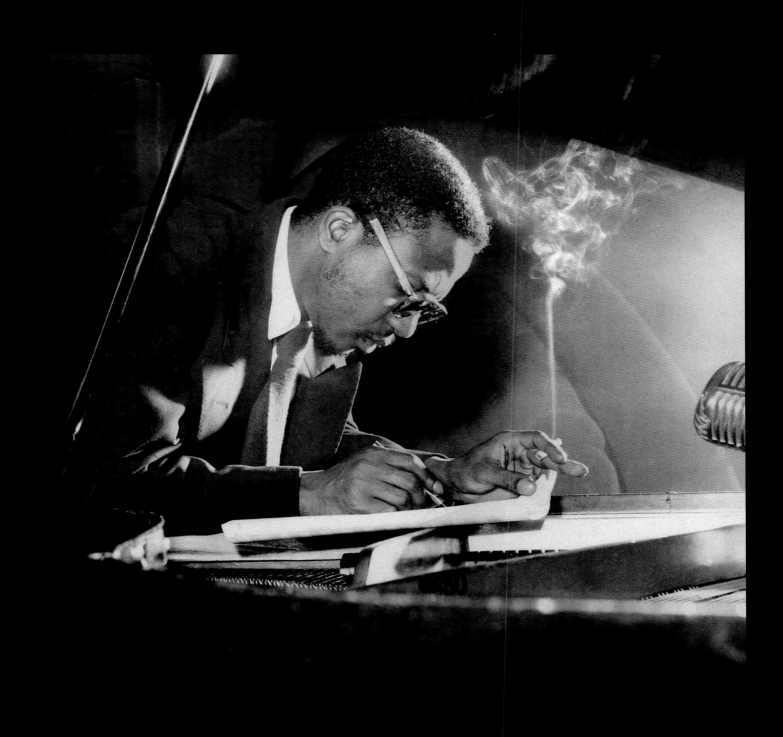

Thelonious Monk, Minton's Playhouse, New York, 1949

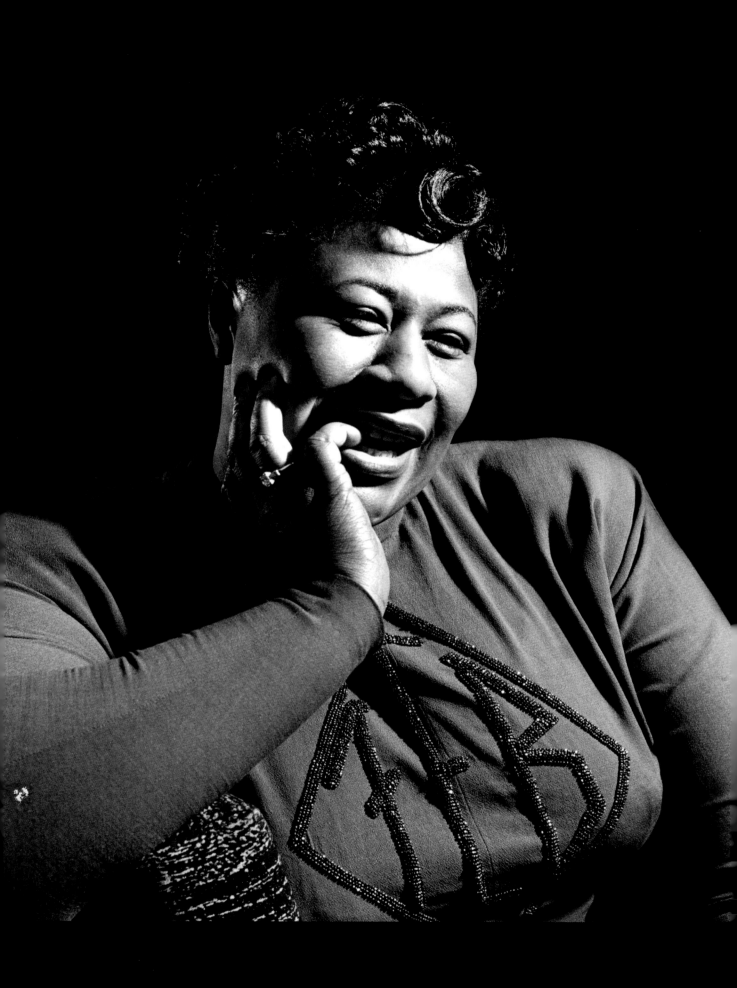

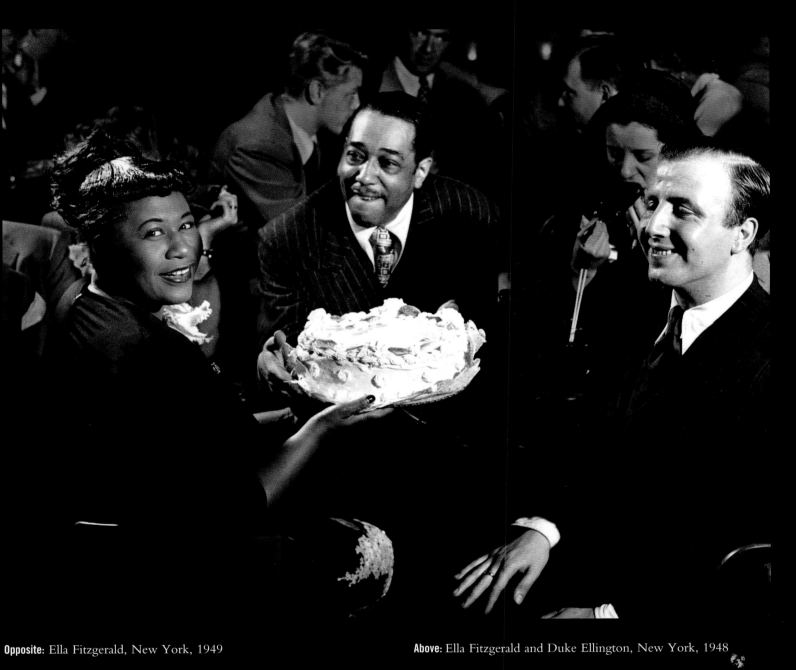

Opposite: Ella Fitzgerald, New York, 1949

Above: Ella Fitzgerald and Duke Ellington, New York, 1948

Overleaf: Ella Fitzgerald, Duke Ellington and Benny Goodman, New York, 1948

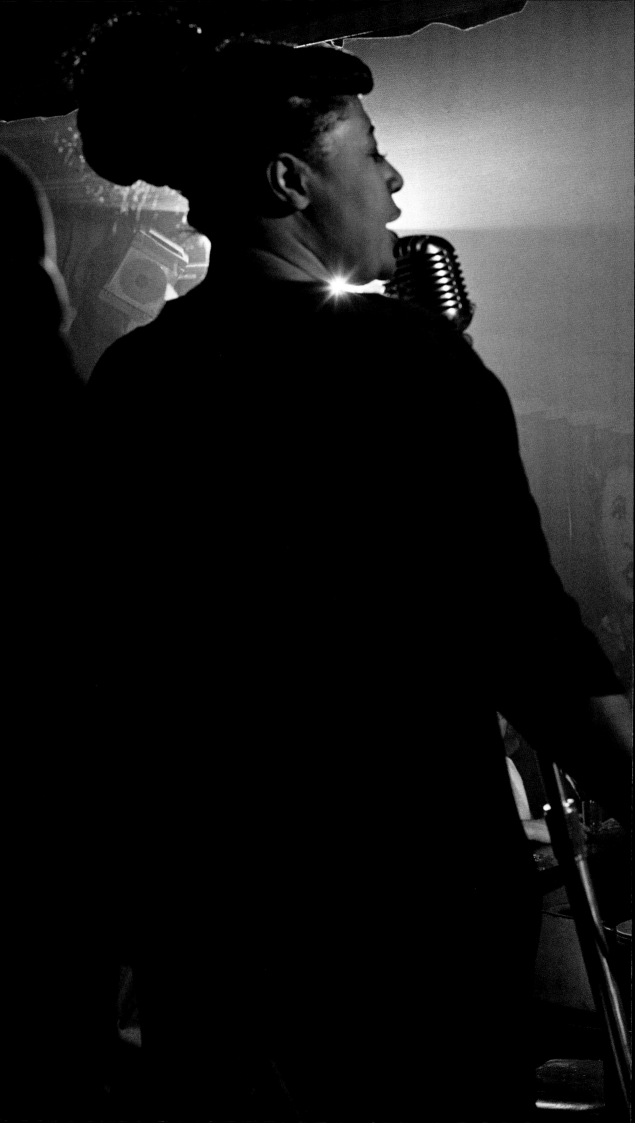

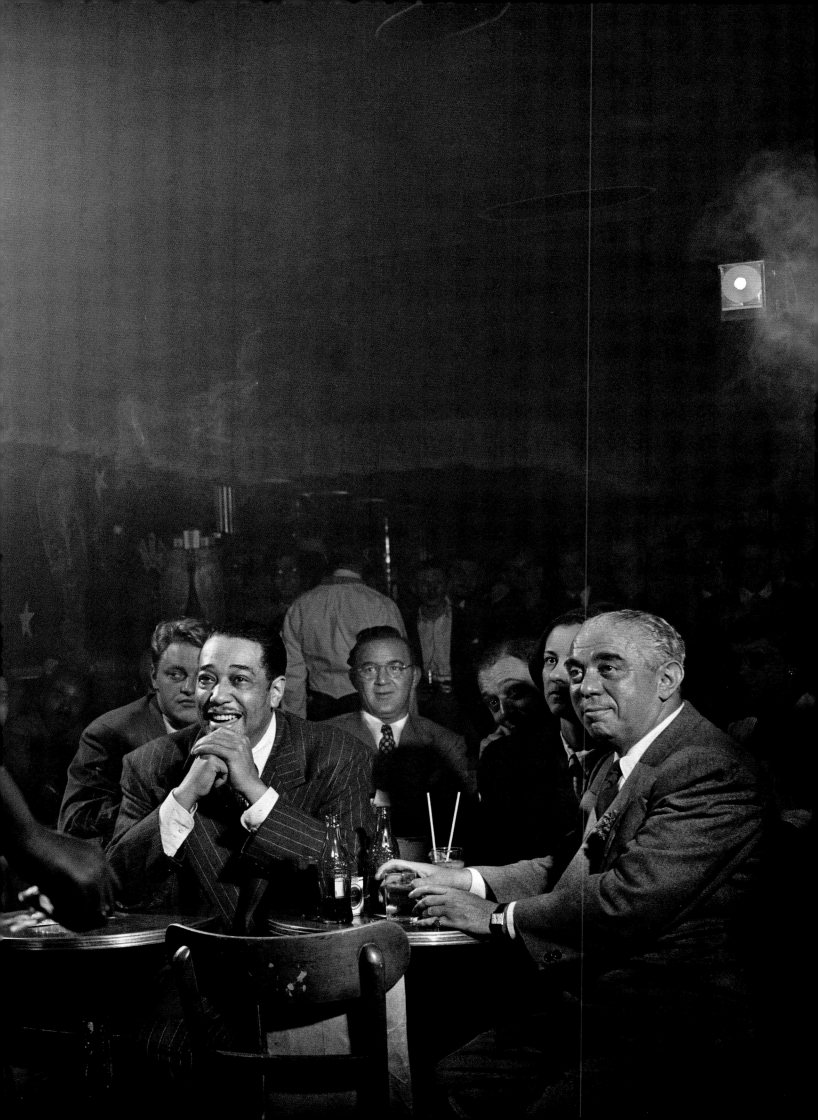

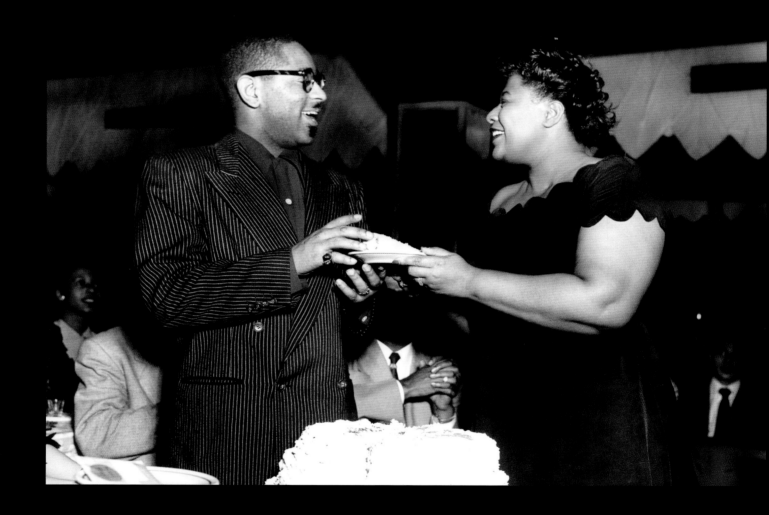

Ella Fitzgerald and Dizzy Gillespie New York, 1949

Opposite: Ella Fitzgerald, New York, 1949

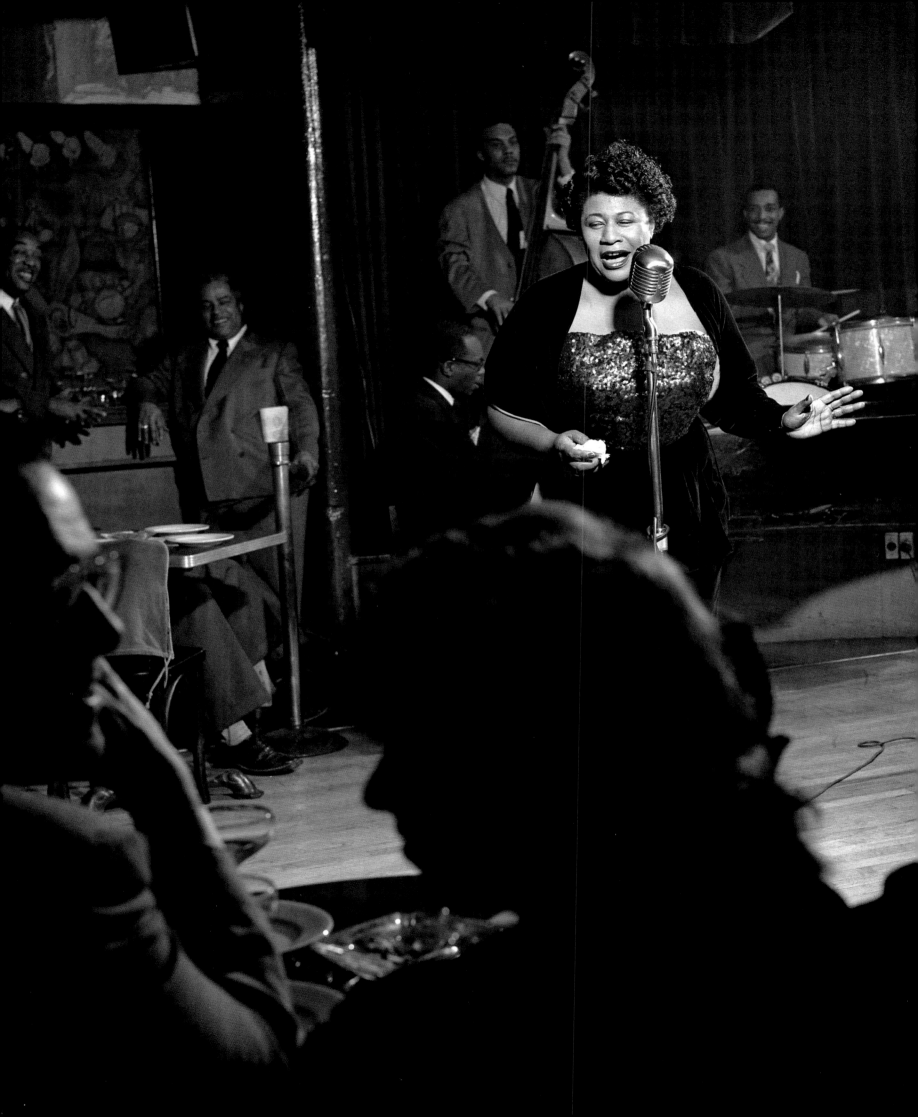

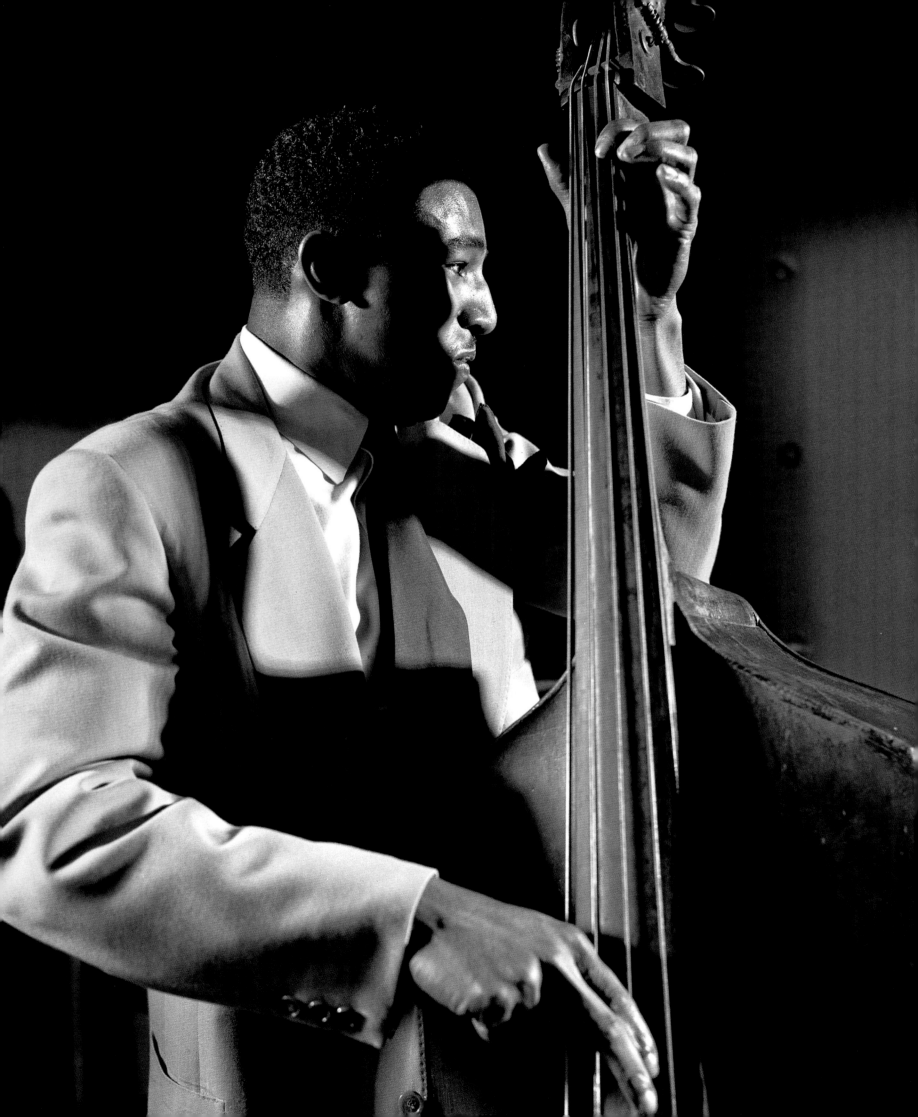

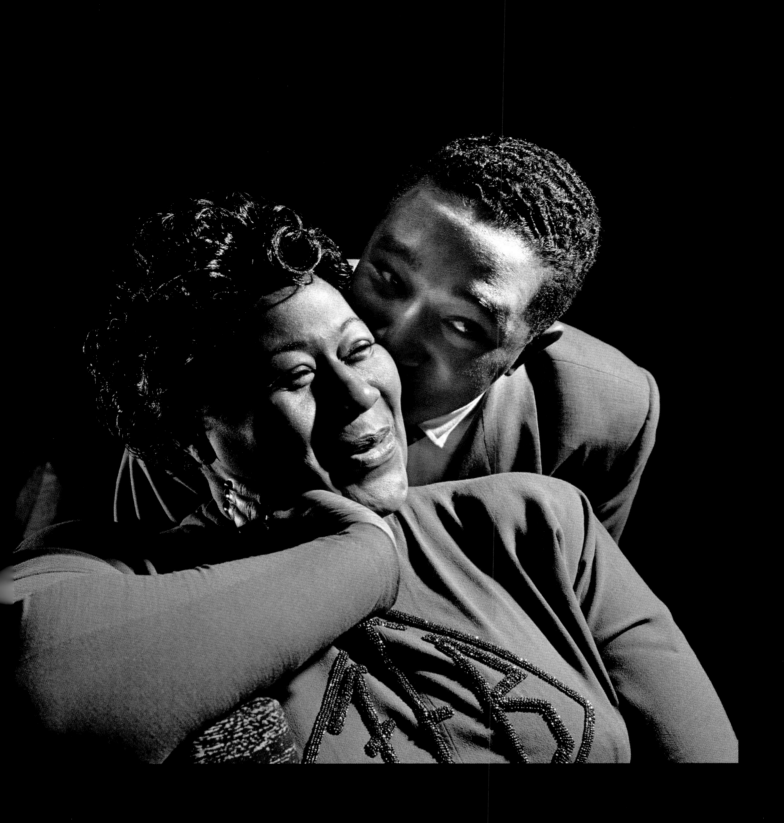

Opposite: Ray Brown, New York, 1948

Ella Fitzgerald and Ray Brown, New York, 1949

Billie Holiday, New York, 1949

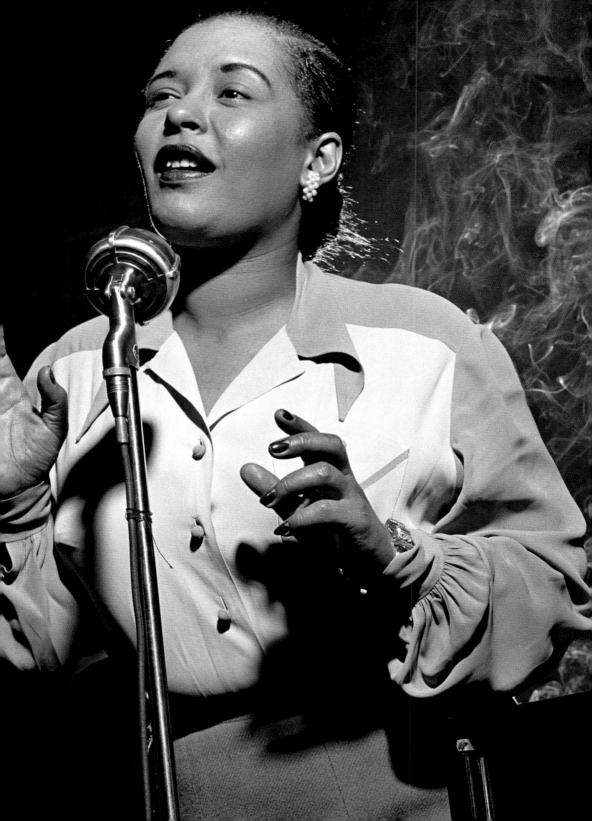

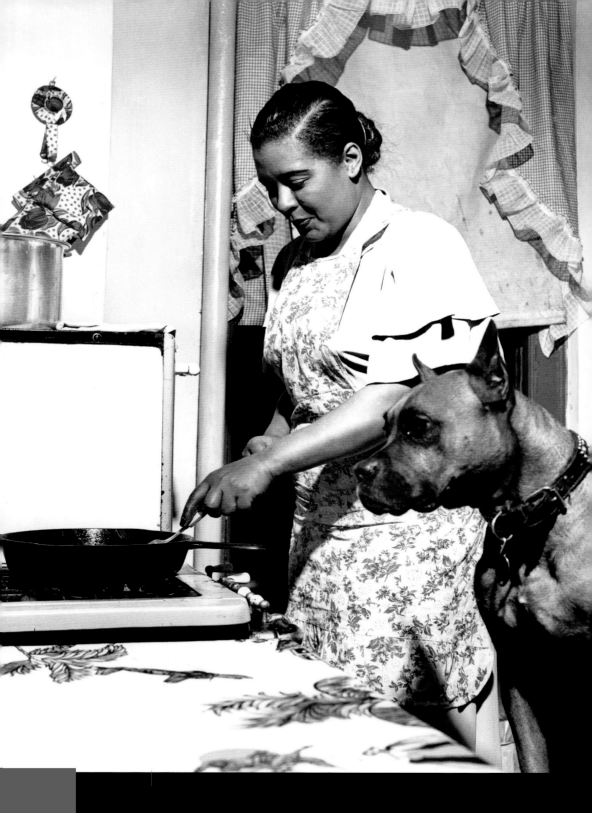

and Mister N

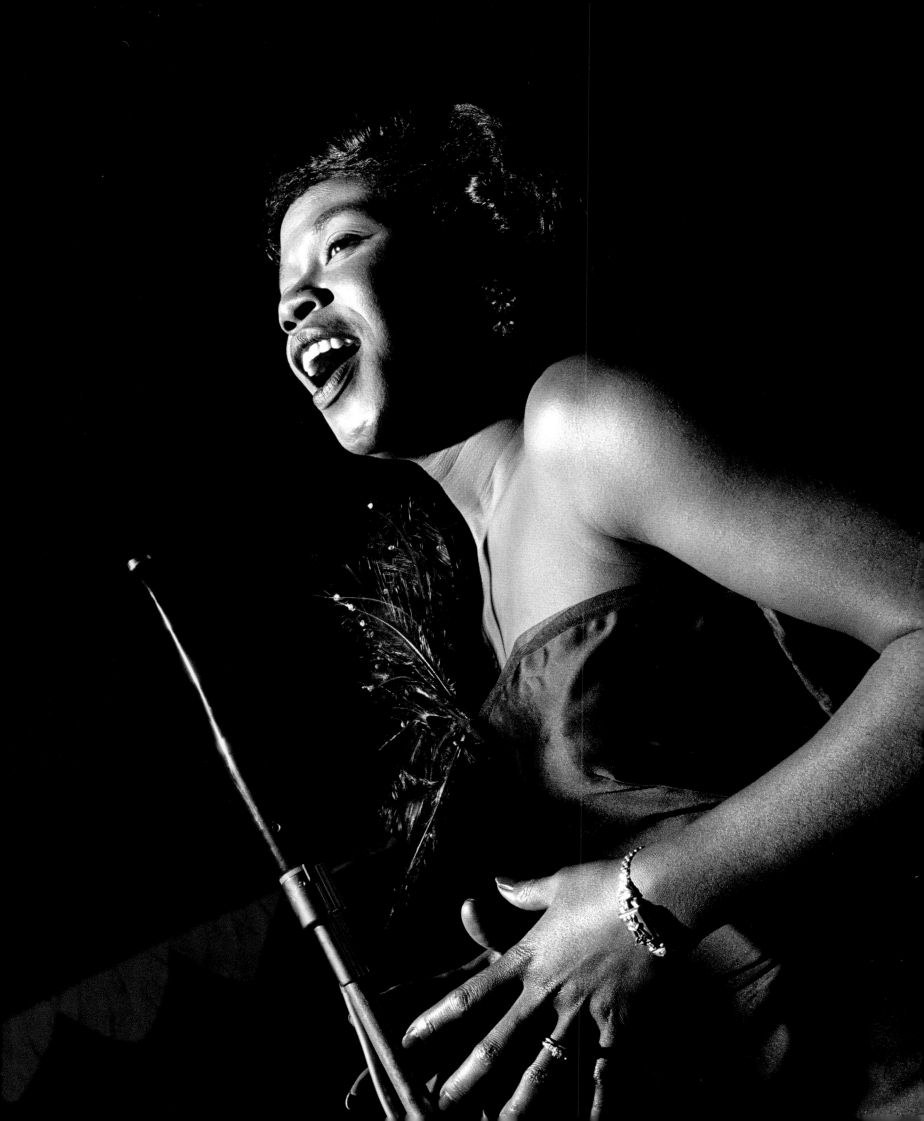

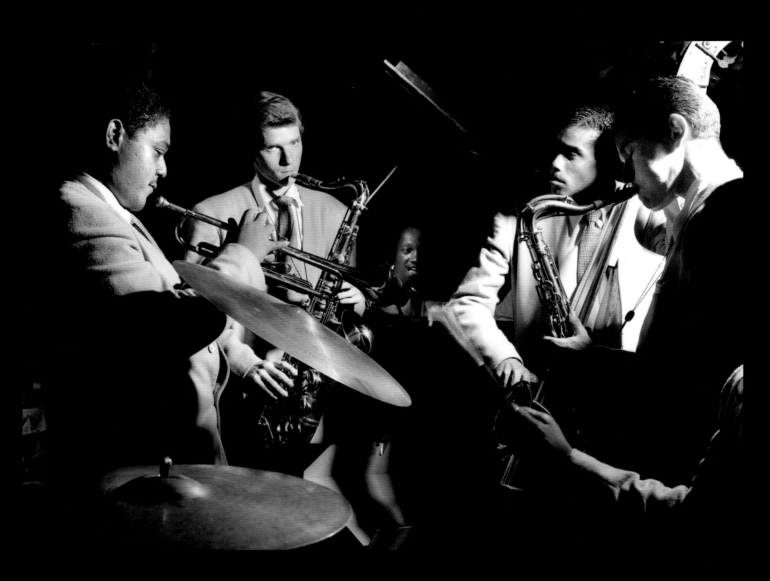

Fats Navarro, Jimmy Ford, Tadd Dameron
and group, the Royal Roost, New York, 1948

Opposite and overleaf: Fats Navarro, the Royal Roost, 1948

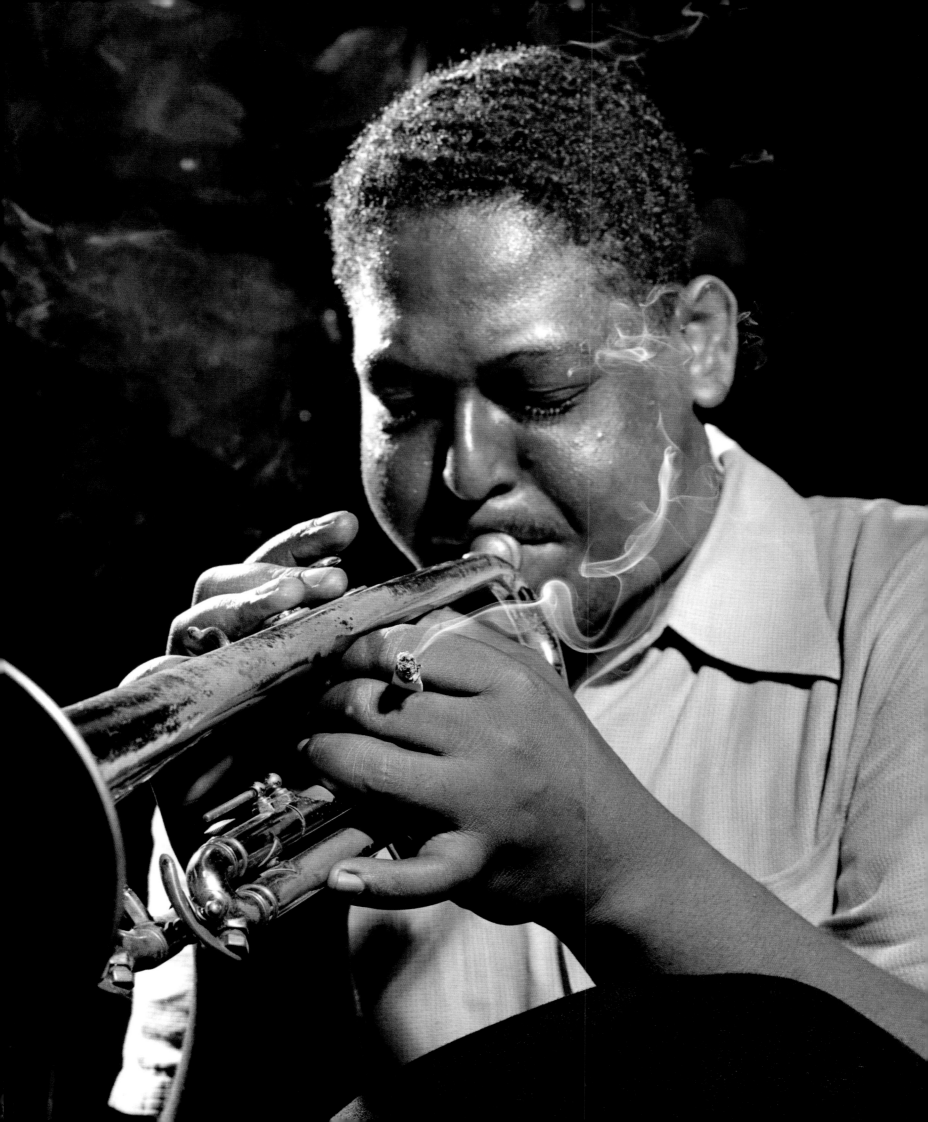

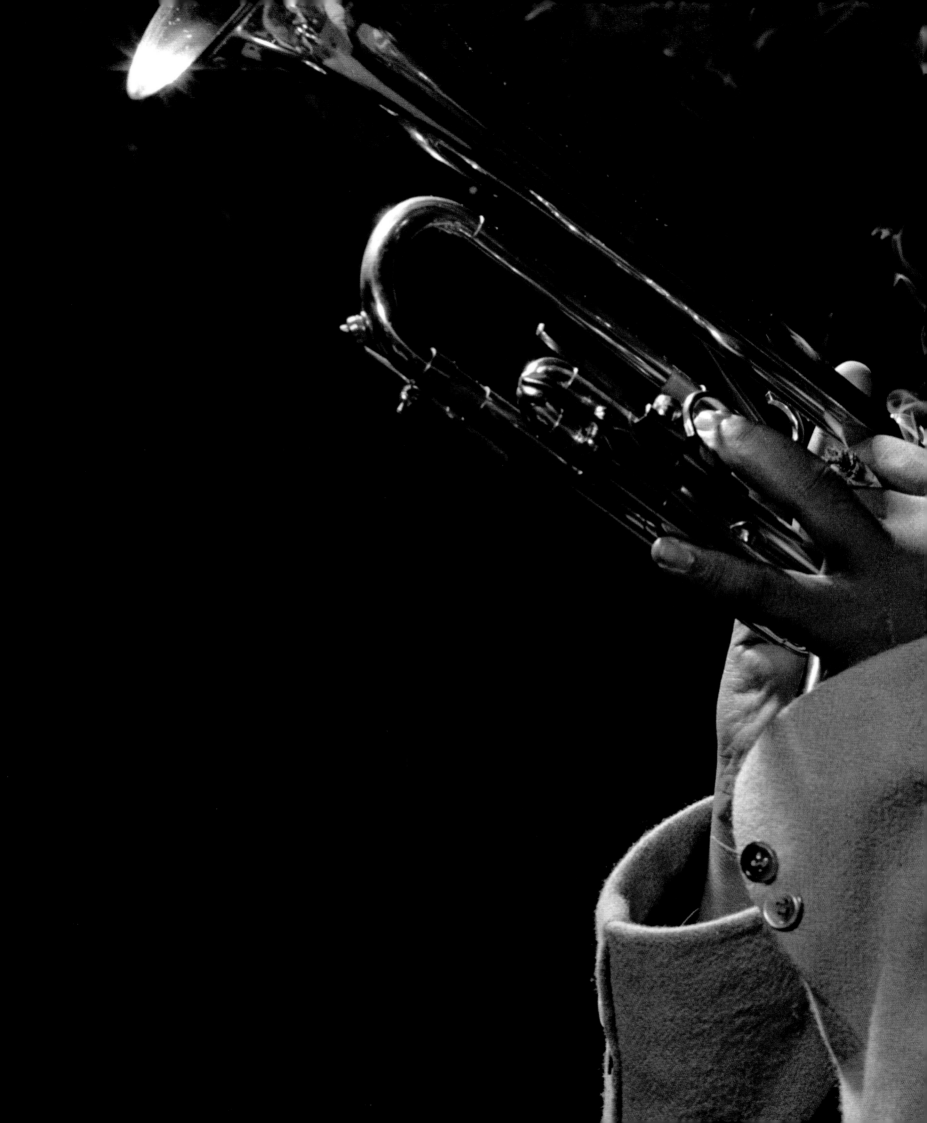

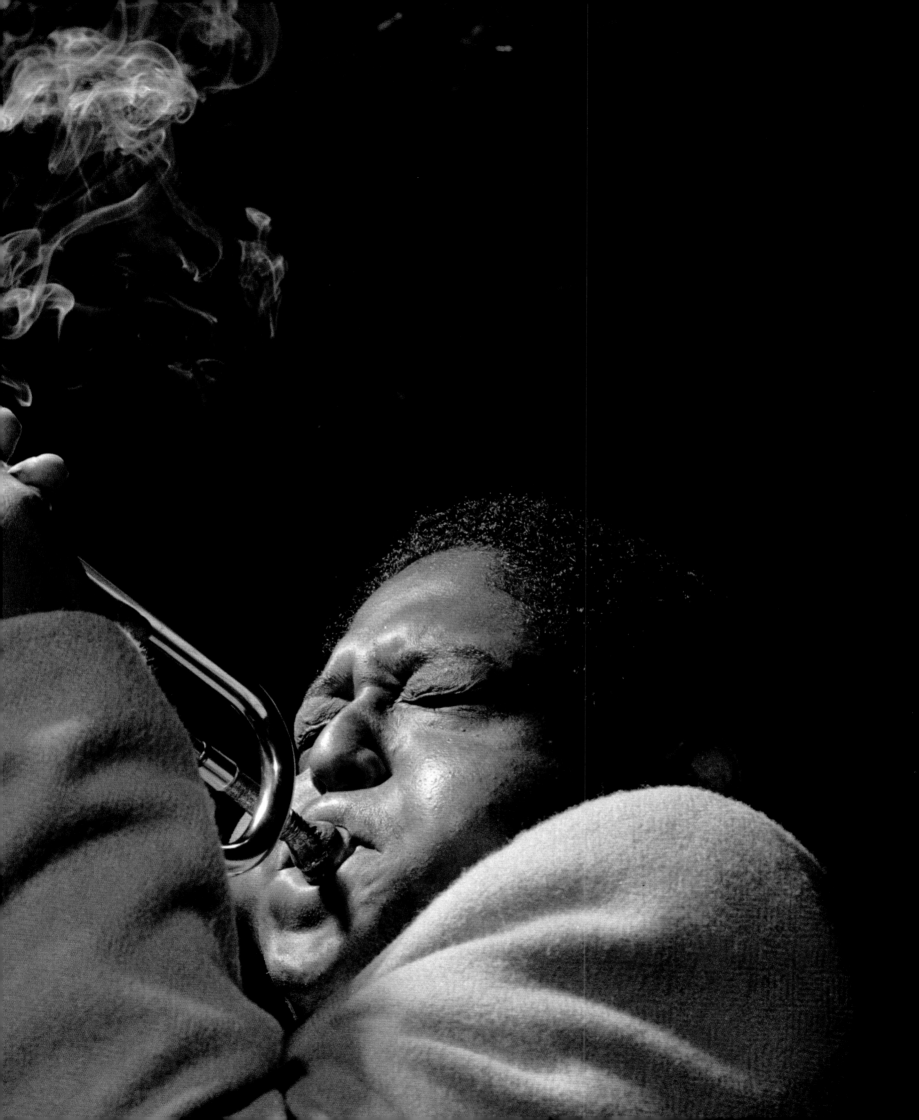

Kenny Clarke, New York, 1948

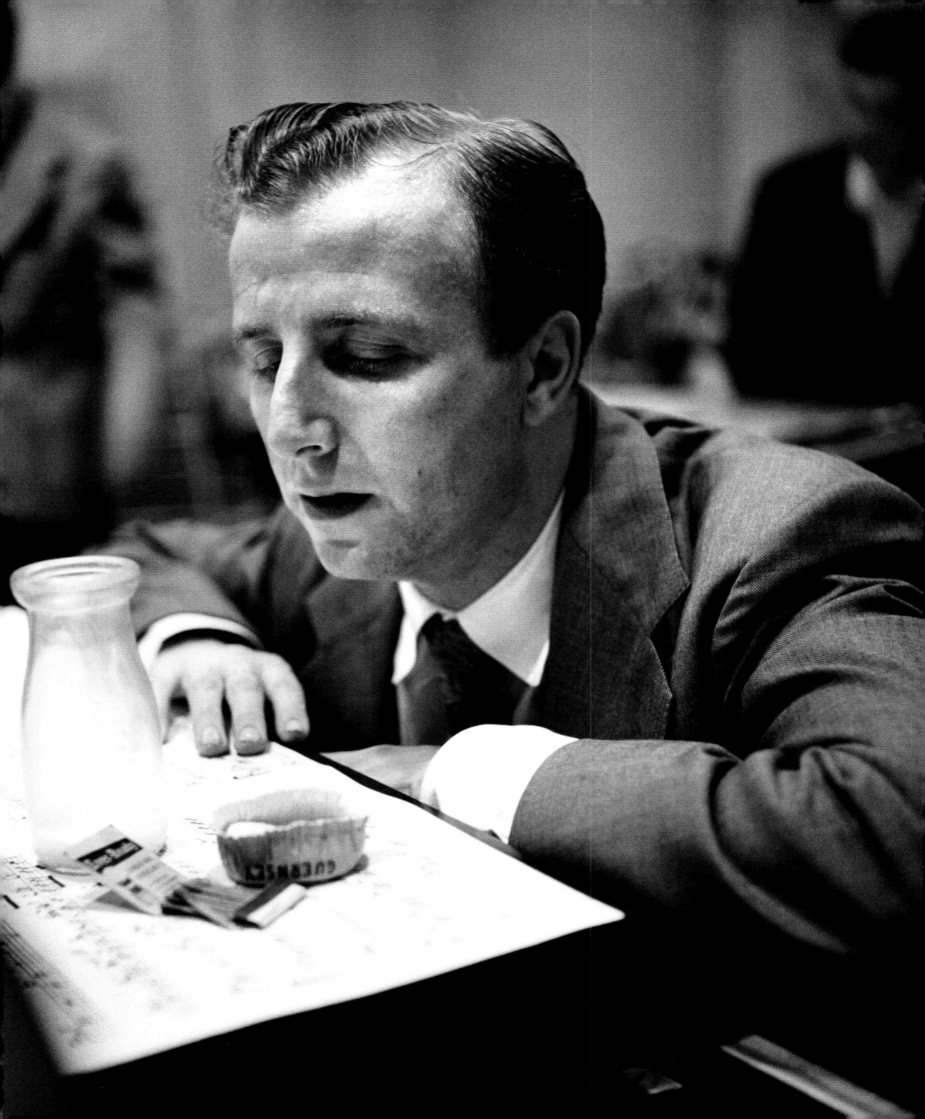

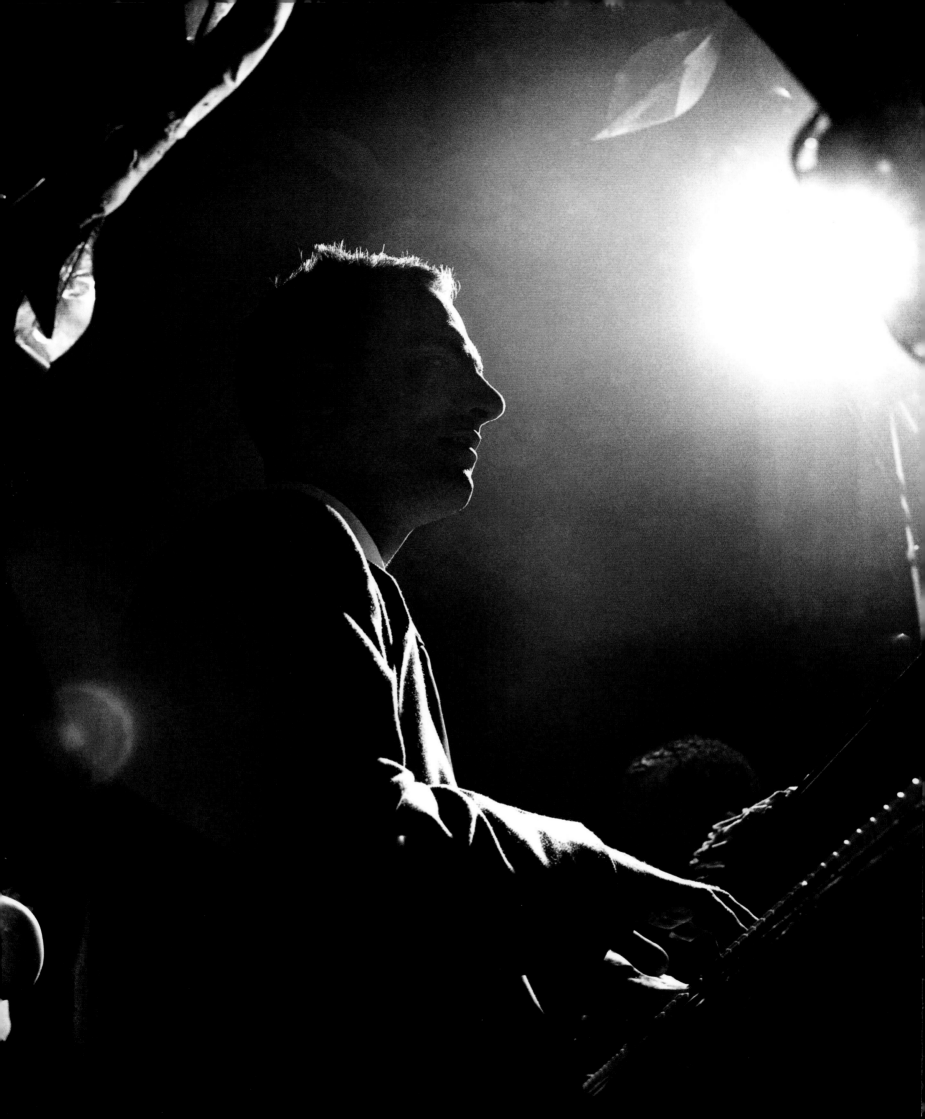

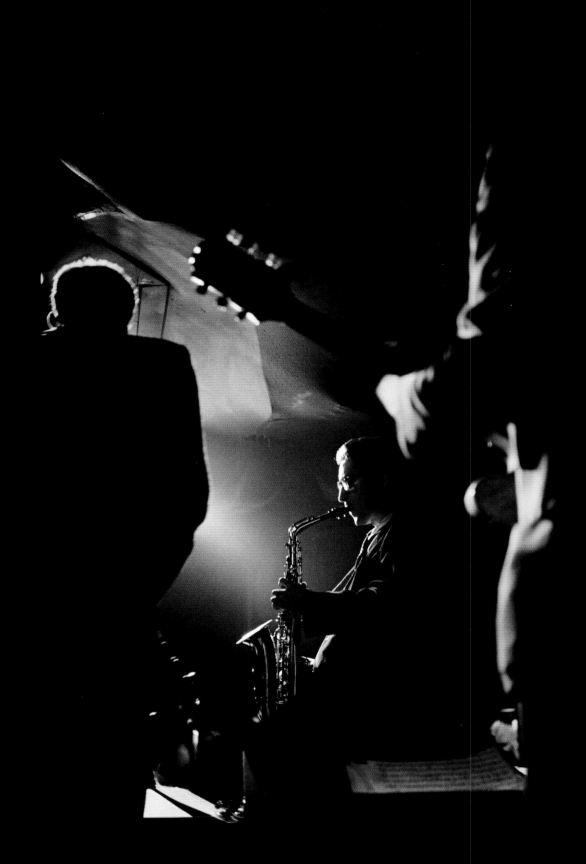

Opposite: Lennie Tristano, New York, 1949 Lee Konitz, New York, 1949

Lennie Tristano and Lee Konitz,
New York, 1949

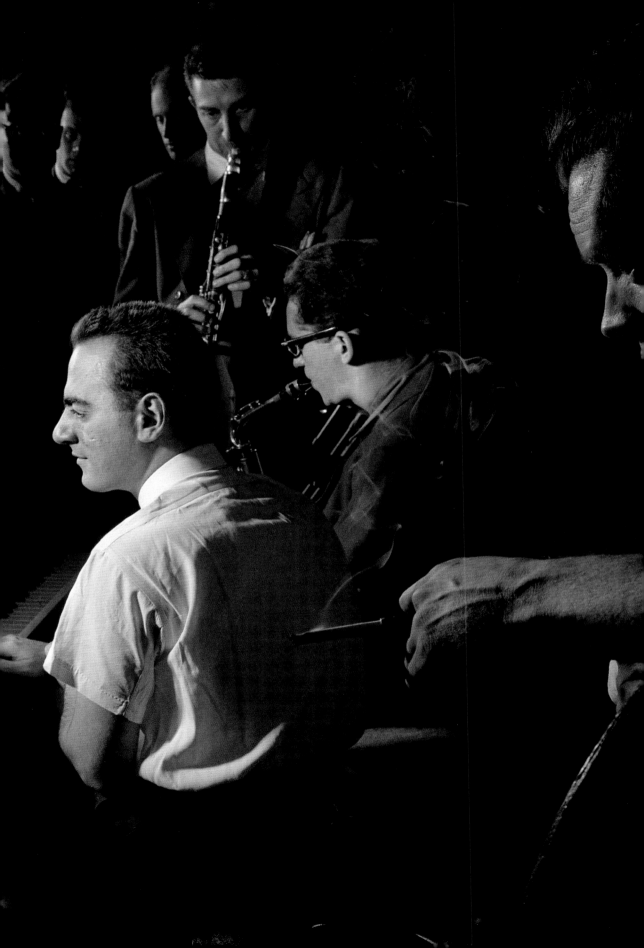

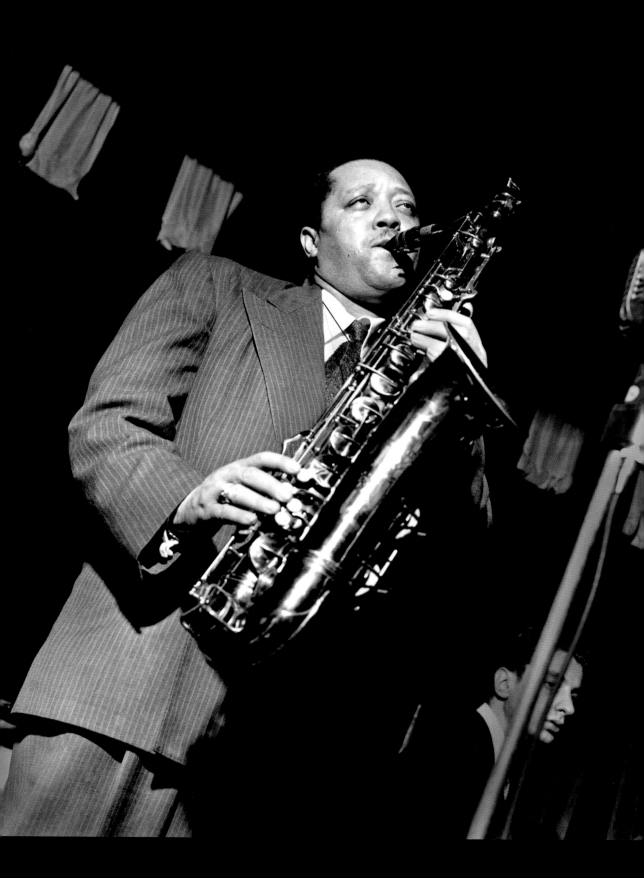

ath: Lester Young, New York, 1948

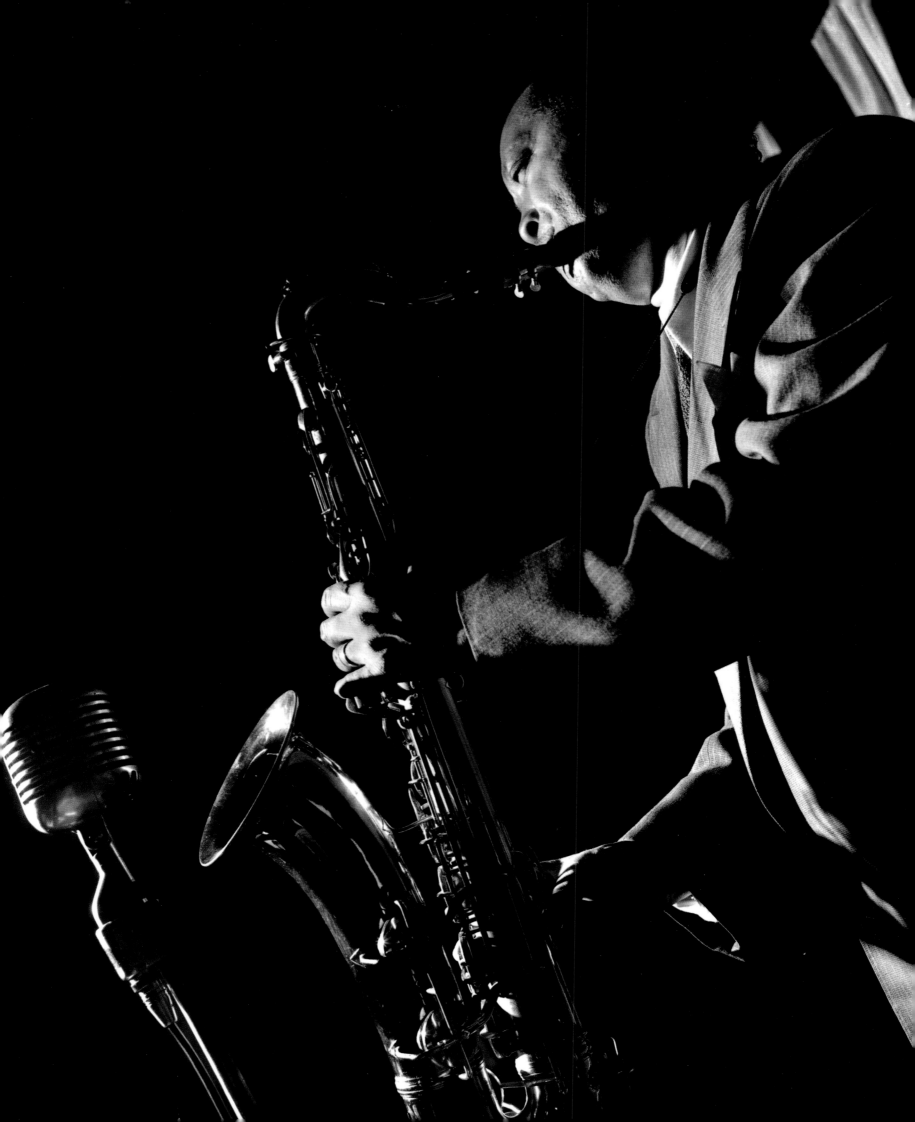

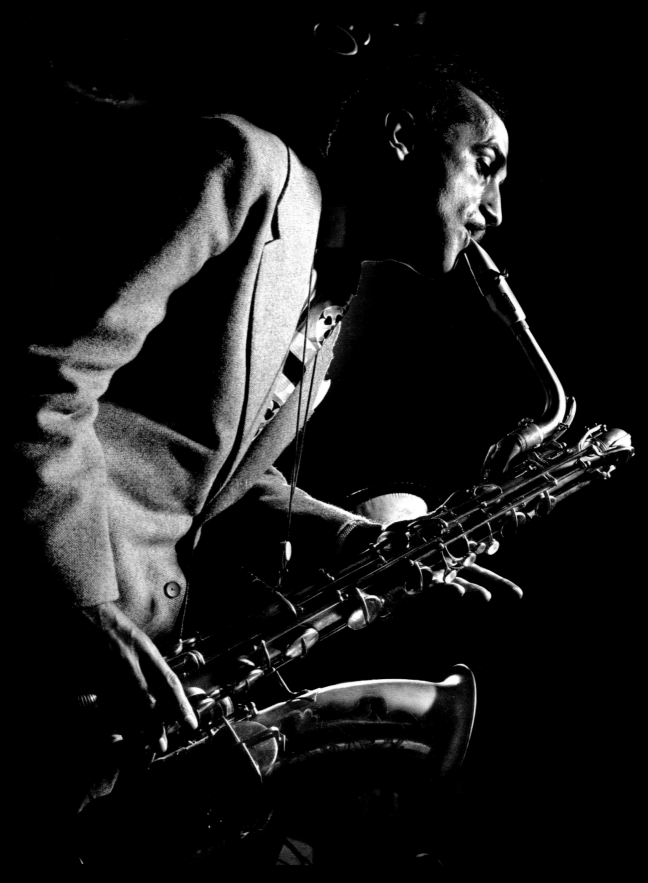

Charlie Ventura, New York, 1948 **Opposite:** Lucky Thompson, New York, 1948

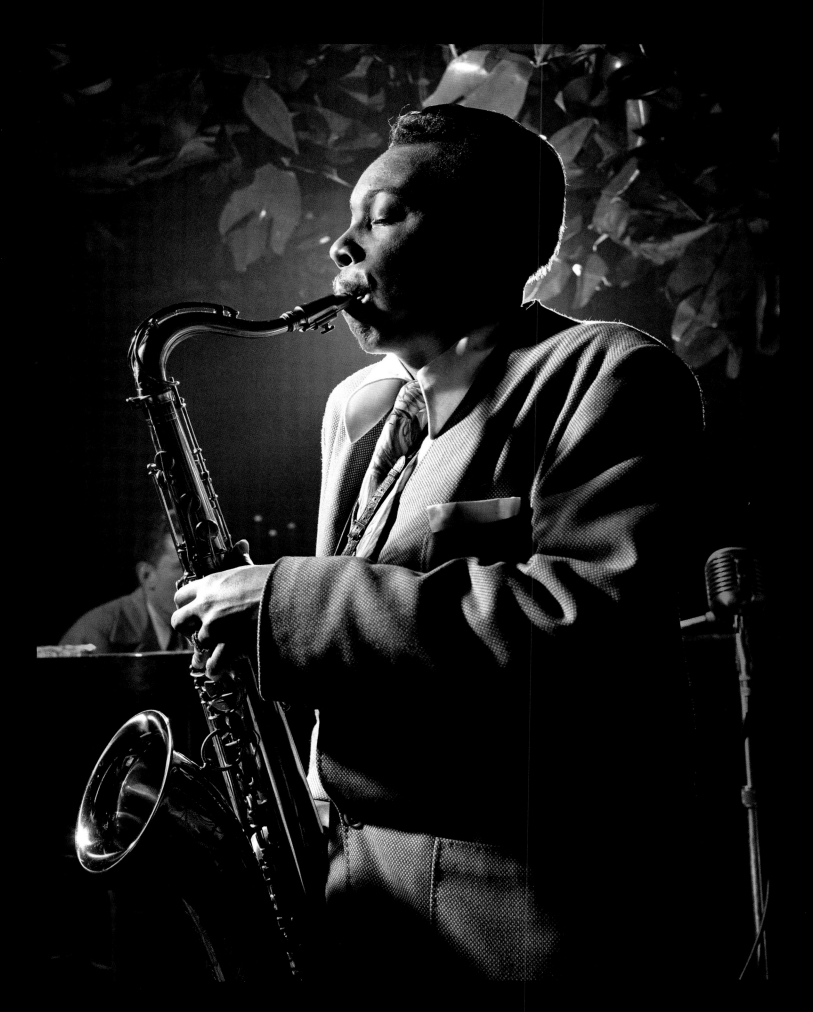

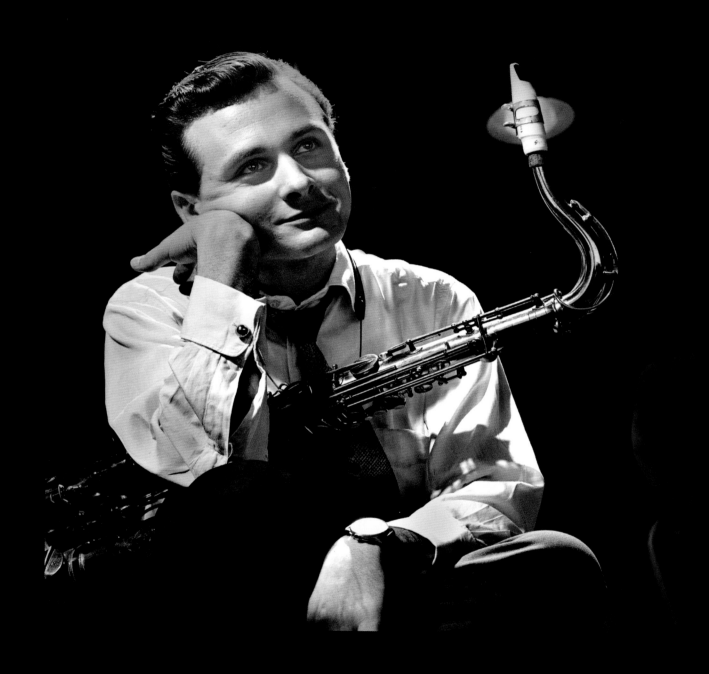

Both: Stan Getz, New York, 1949

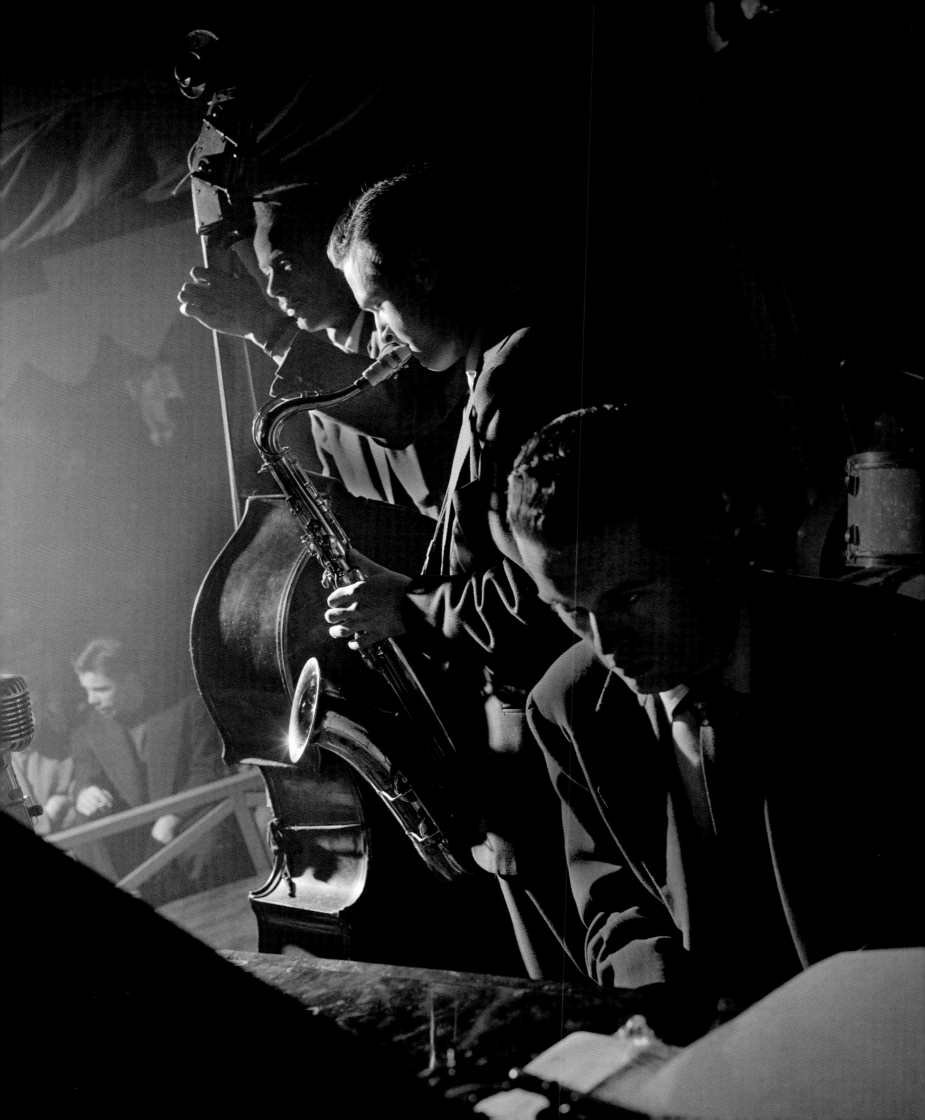

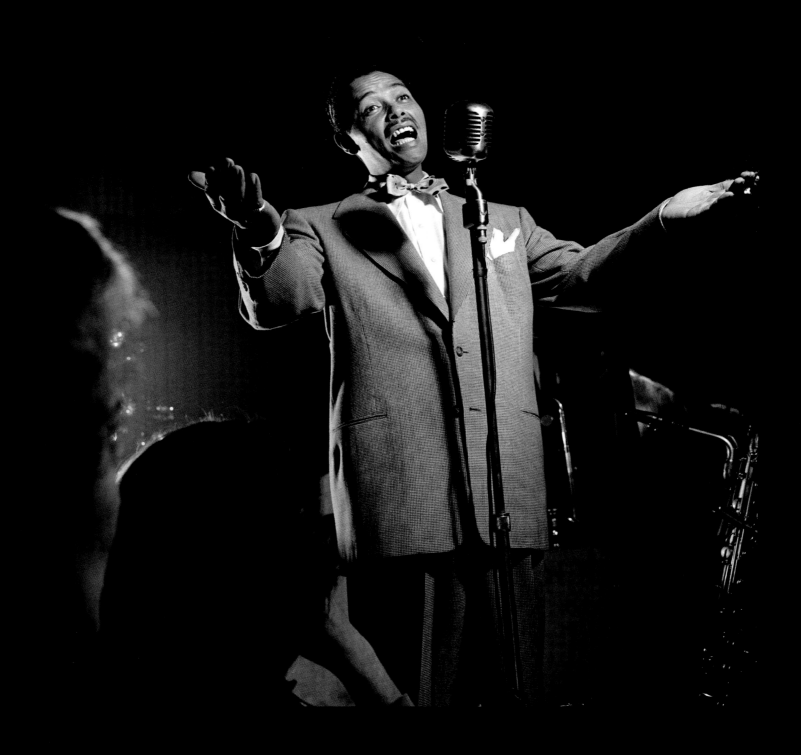

Both: Billy Eckstine, the Royal Roost, New York, 1948

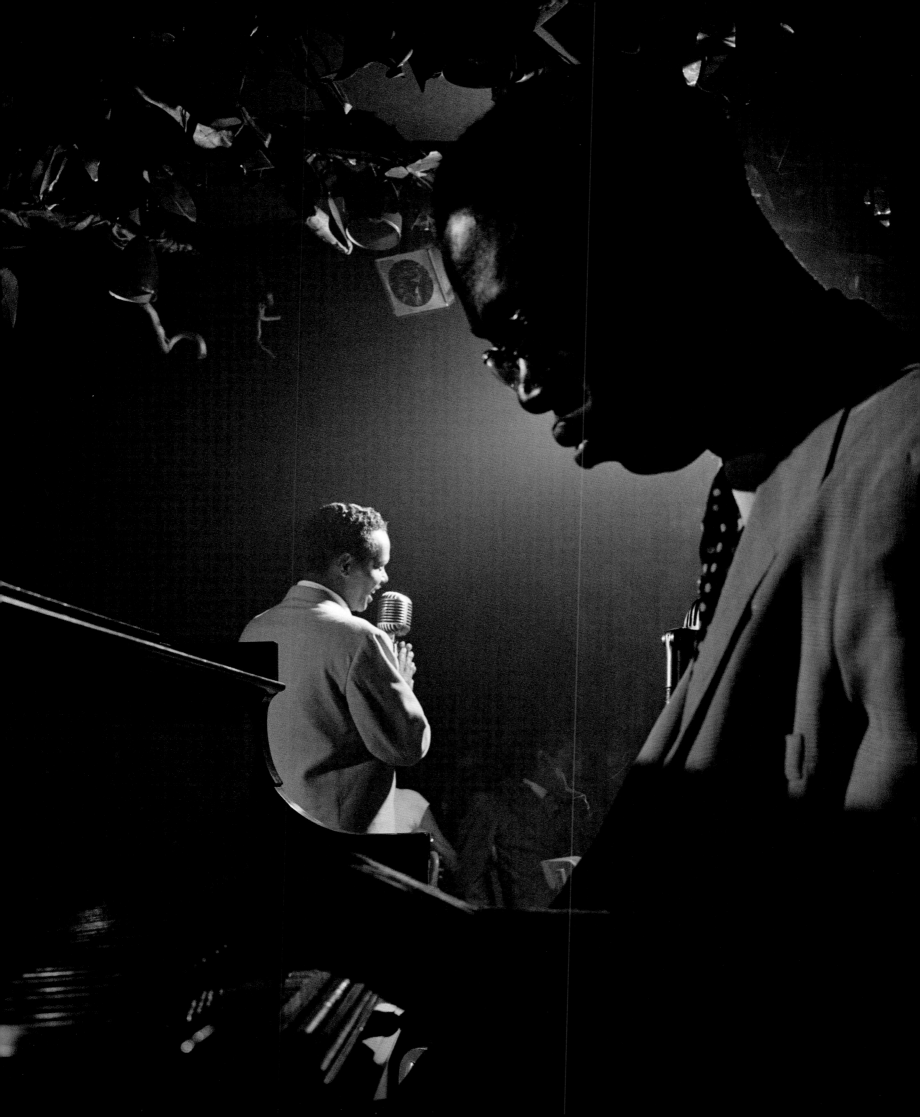

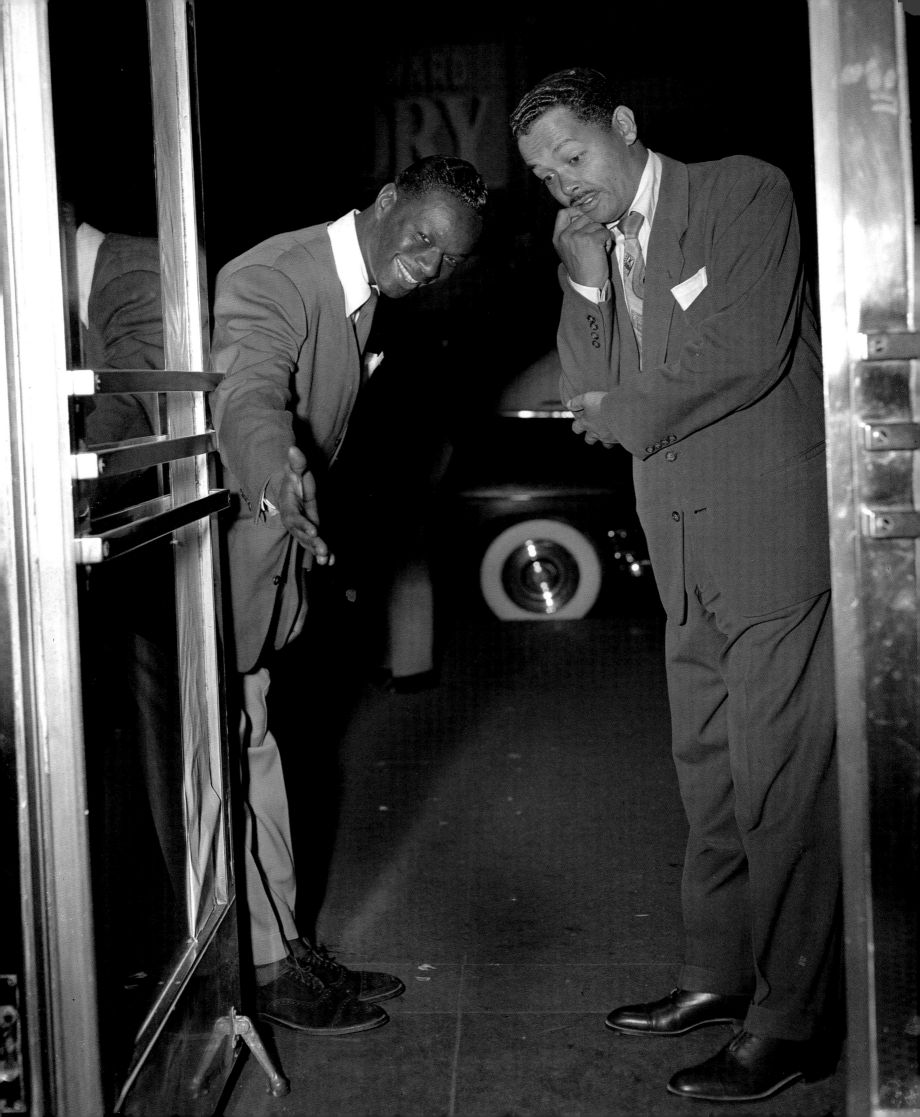

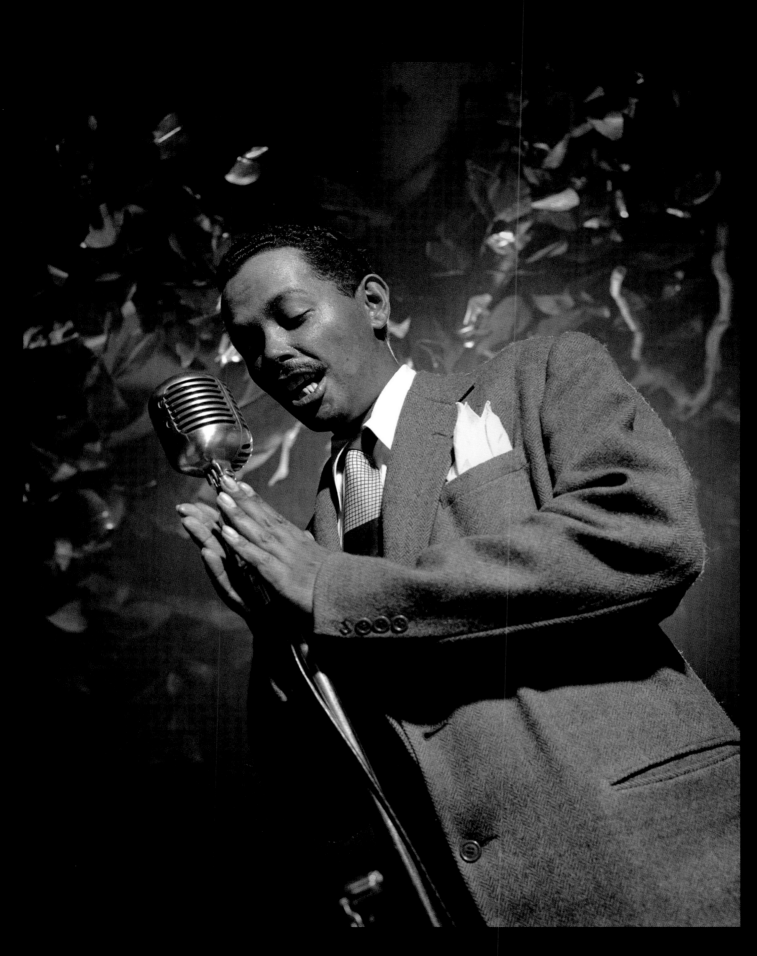

Opposite: Billy Eckstine and Nat King Cole,
the Royal Roost, New York, 1948

Billy Eckstine, the Royal Roost,
New York, 1948

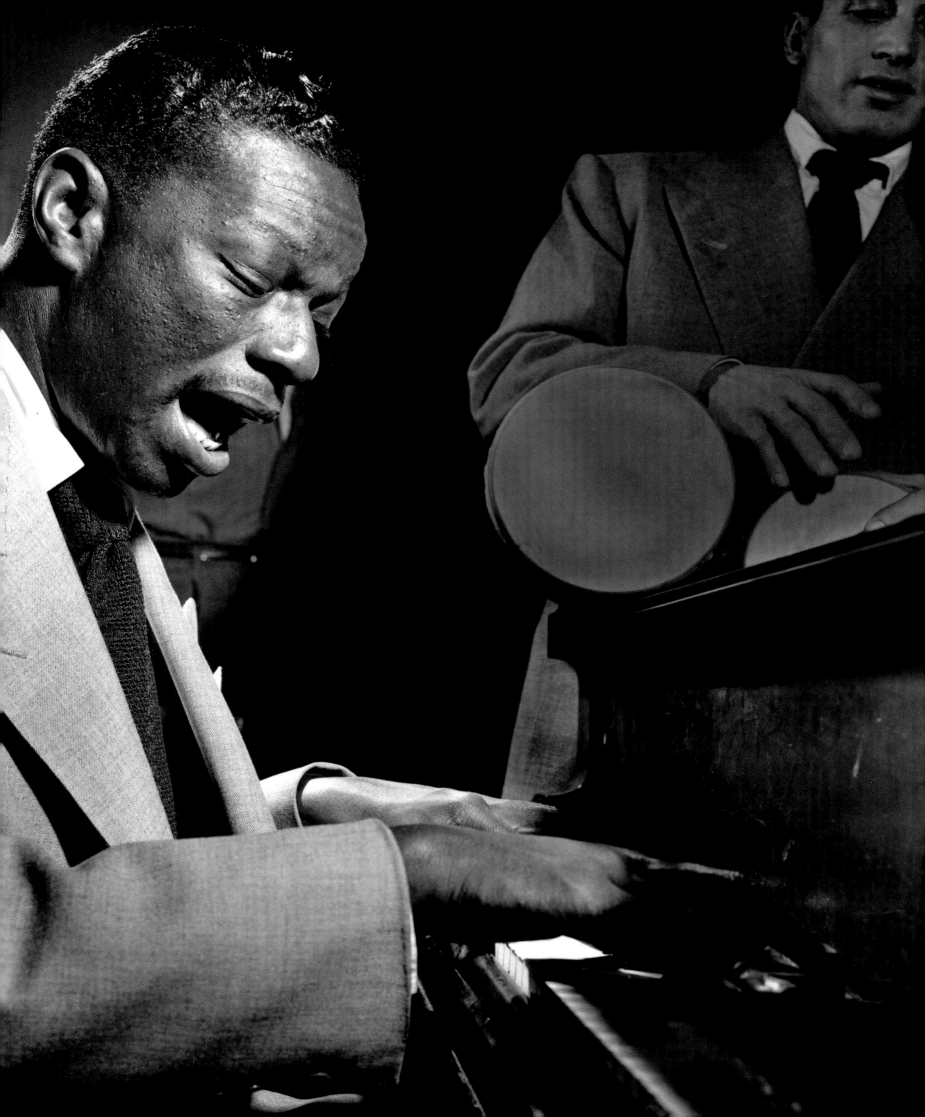

Nat King Cole, New York, 1949

Overleaf: *Clockwise*, Tadd Dameron, Curly Russell,
Jimmy Ford, Allen Eager and Fats Navarro,
the Royal Roost, New York, 1949

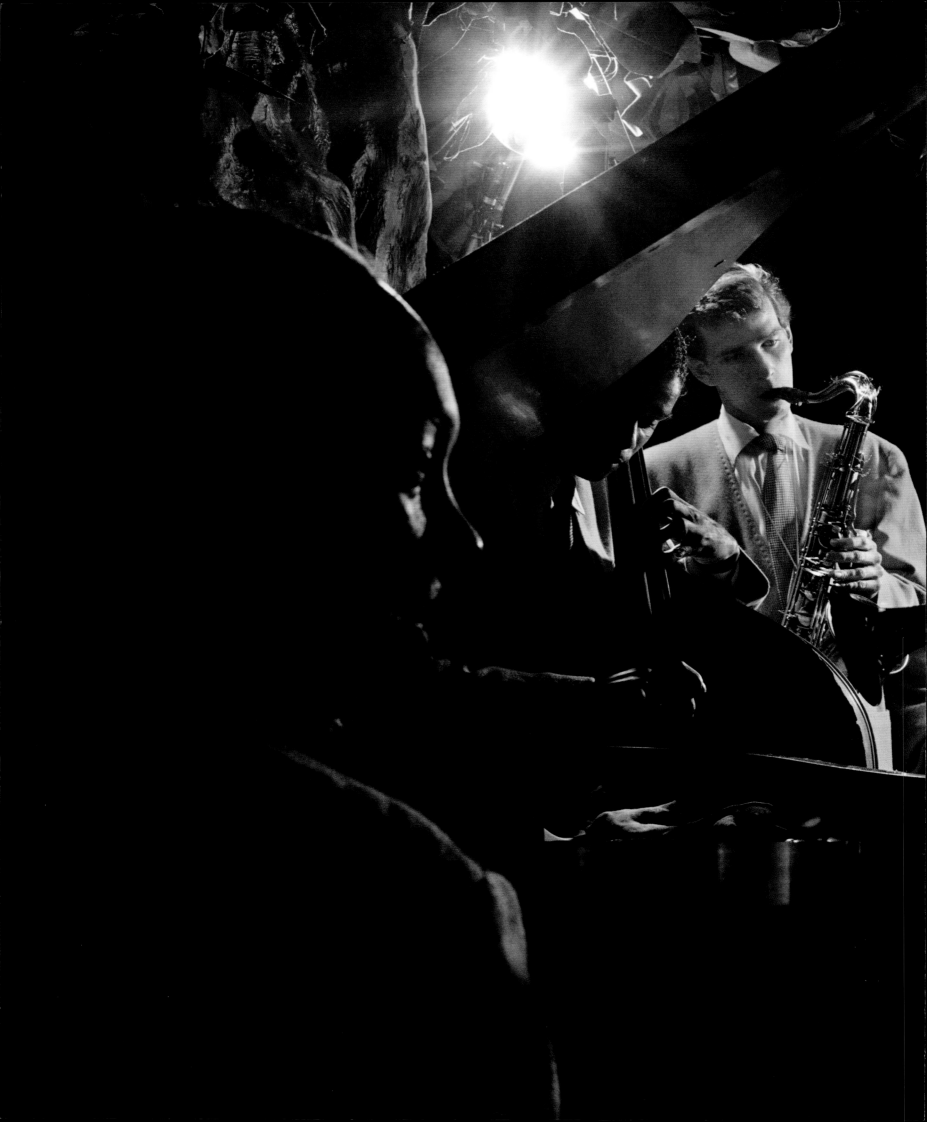

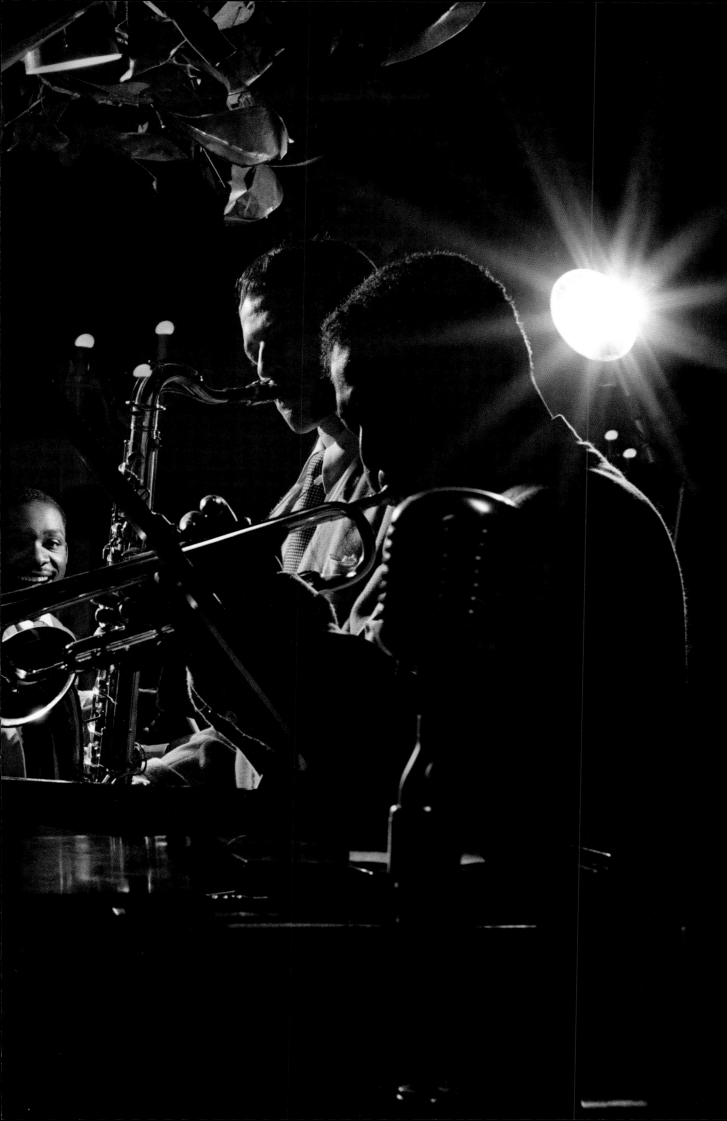

Tadd Dameron, New York, 1948

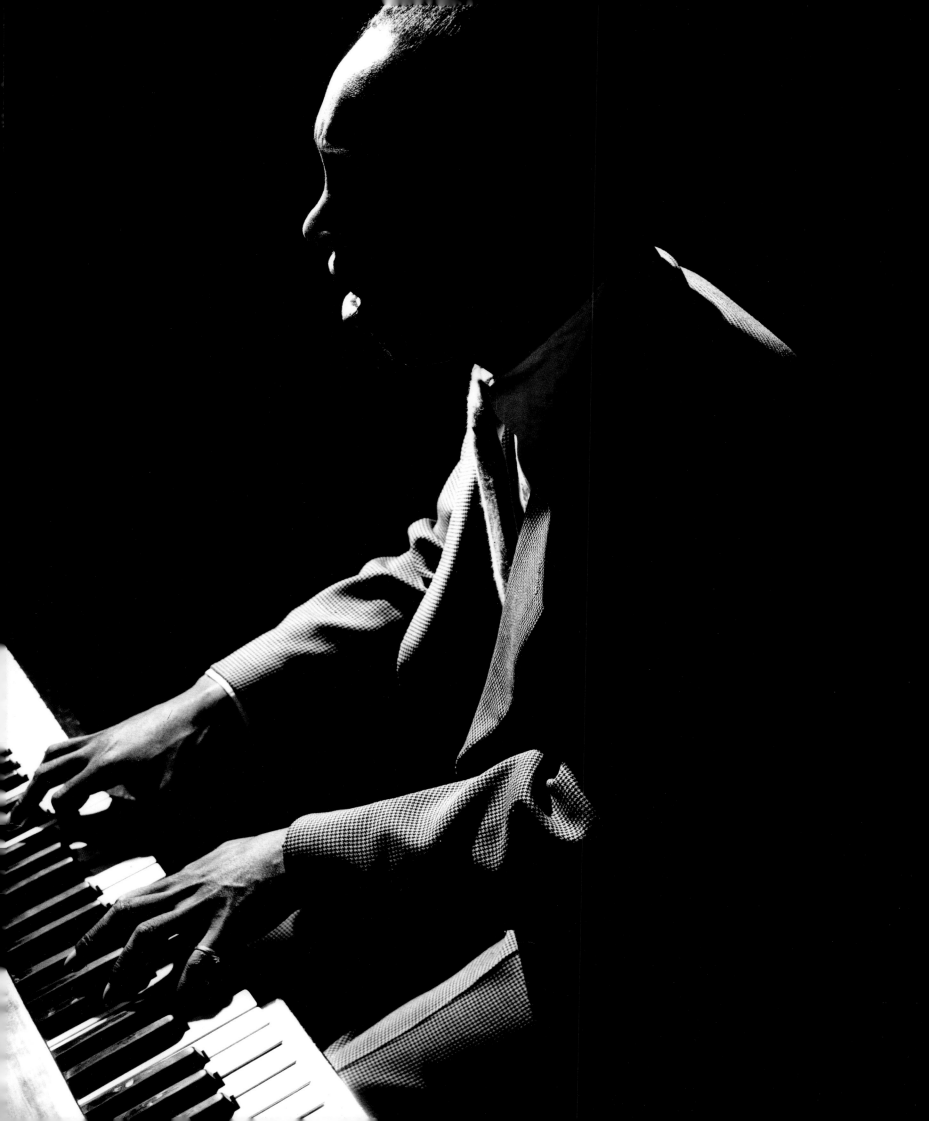

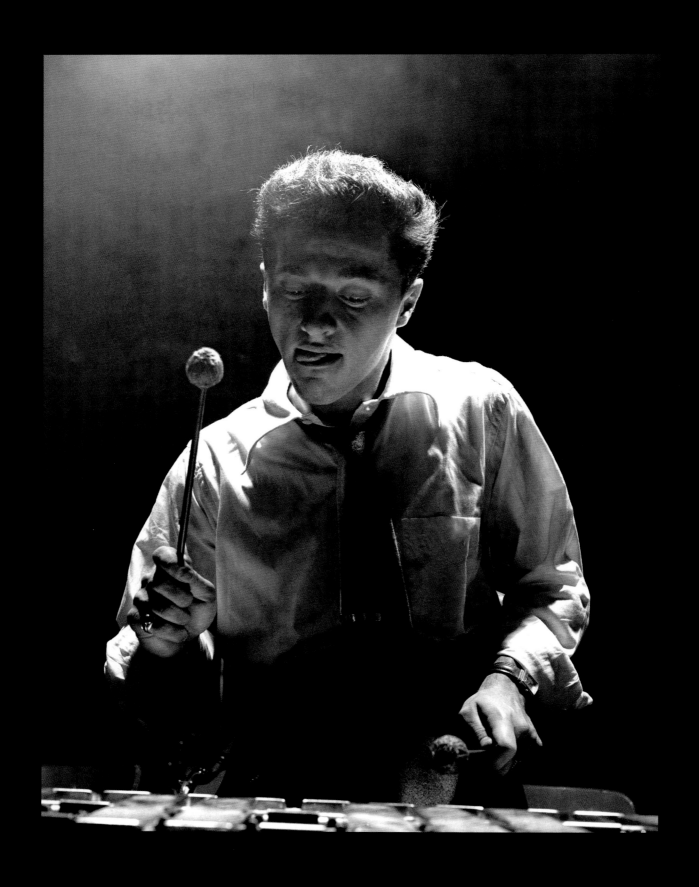

Both: Terry Gibbs, the Royal Roost, New York, 1948

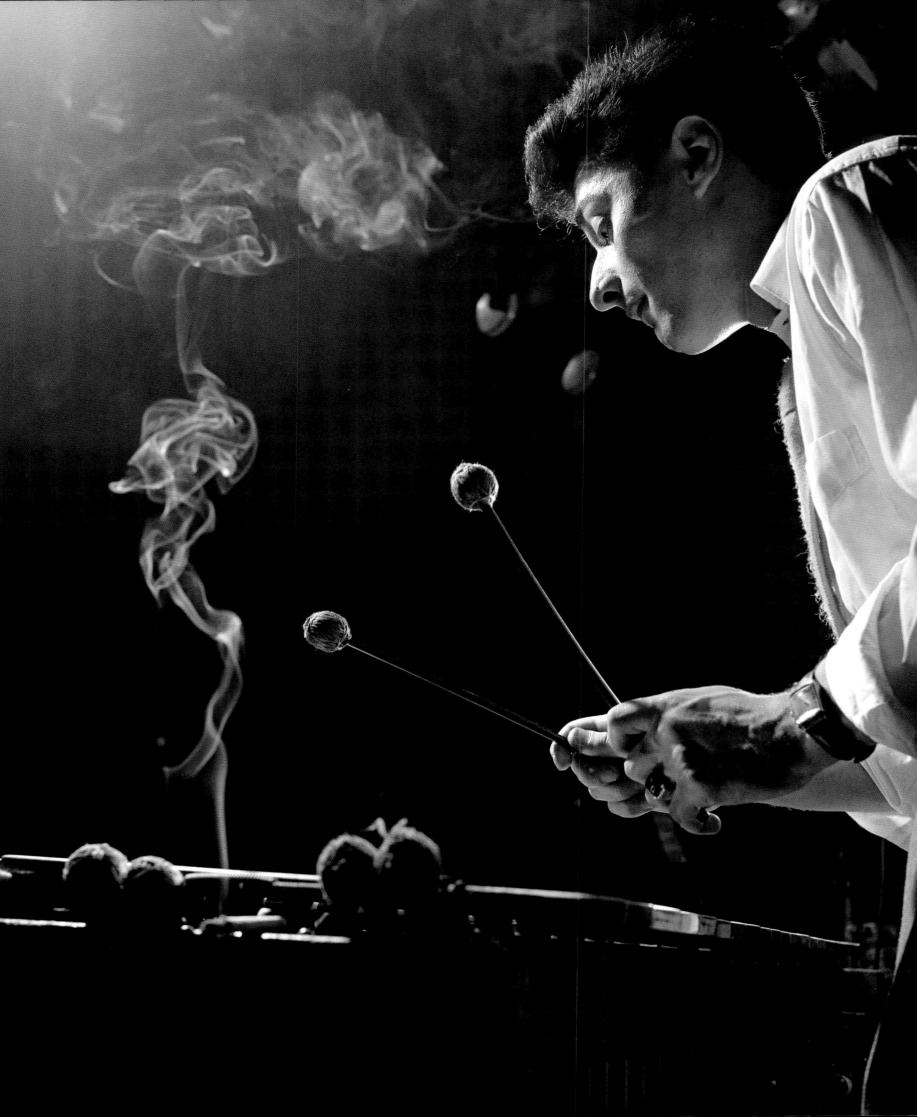

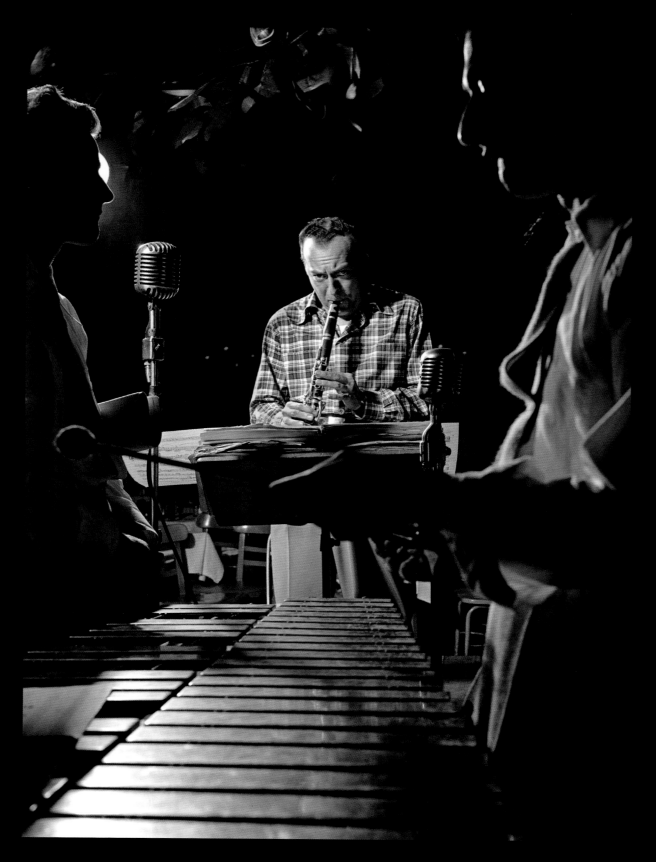

Woody Herman, the Royal Roost,
New York, 1948.

Opposite: The brass section of Woody
Herman's band, *top left to right*, Stan Getz,
Al Cohen, Herbie Stewart, Zoot Simms, and
Serge Chaloff, the Royal Roost, New York, 1948

Overleaf: Woody Herman, New York, 1949

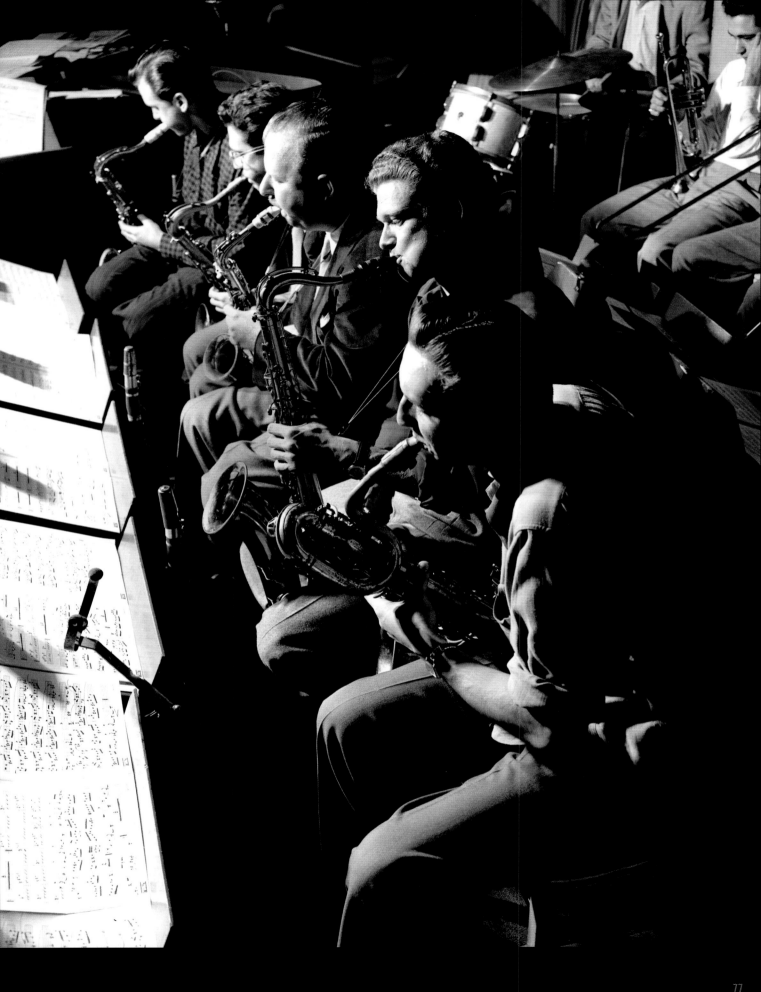

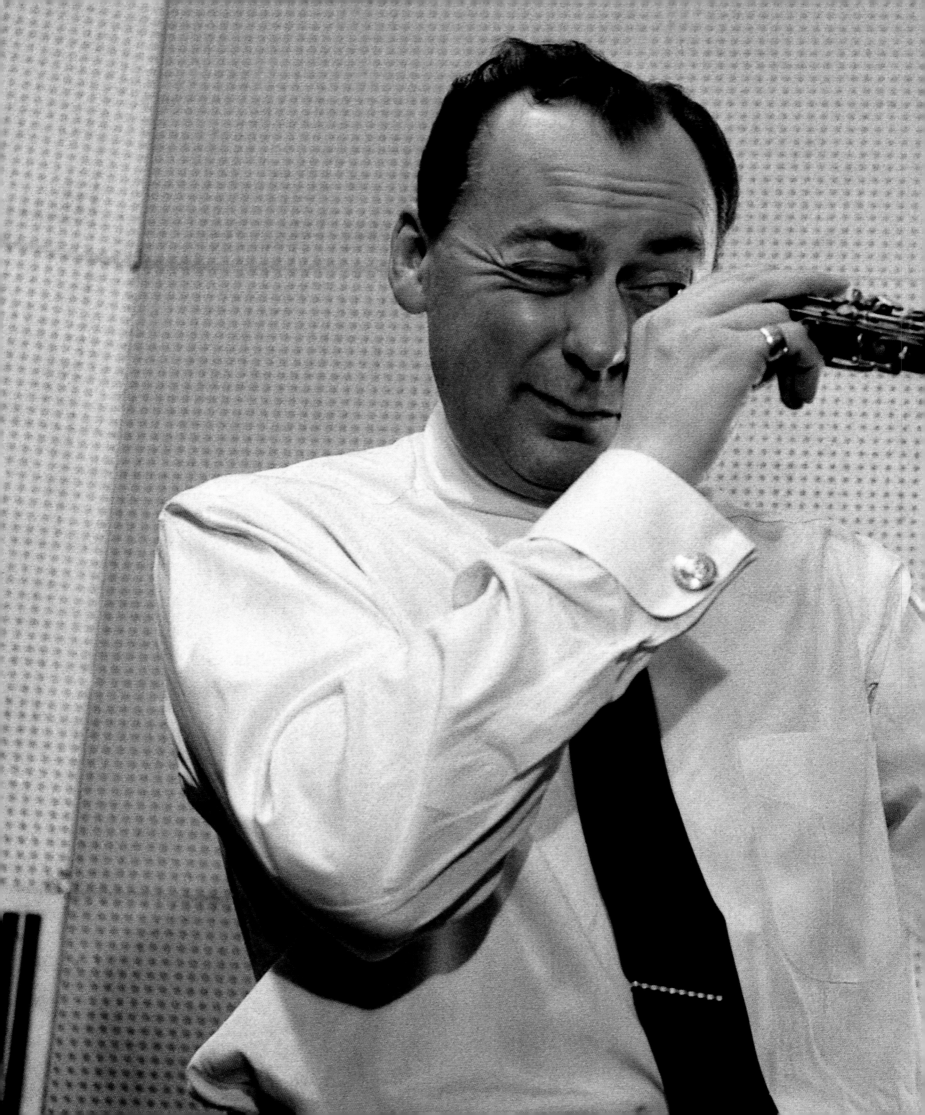

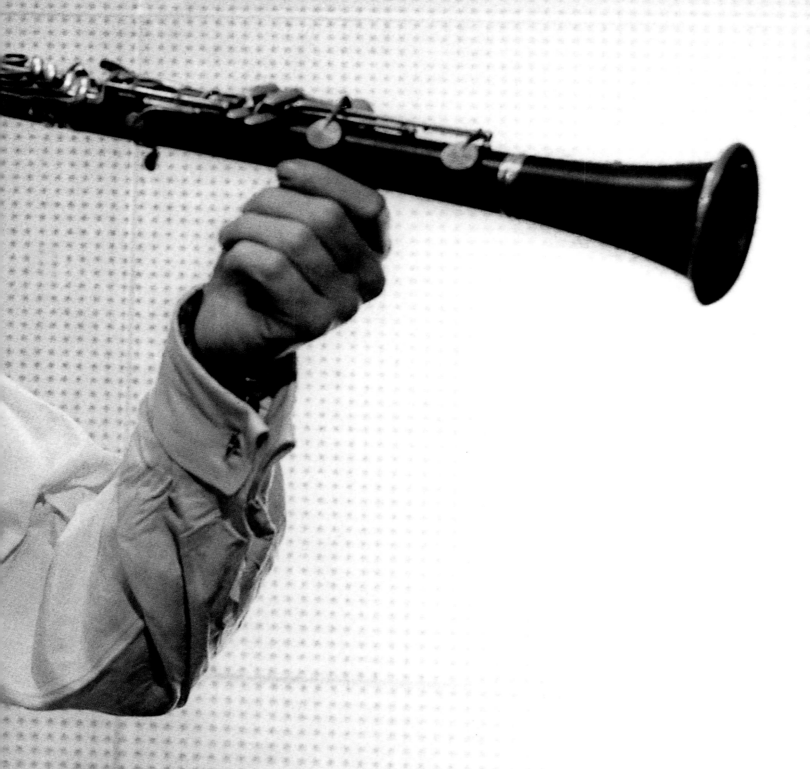

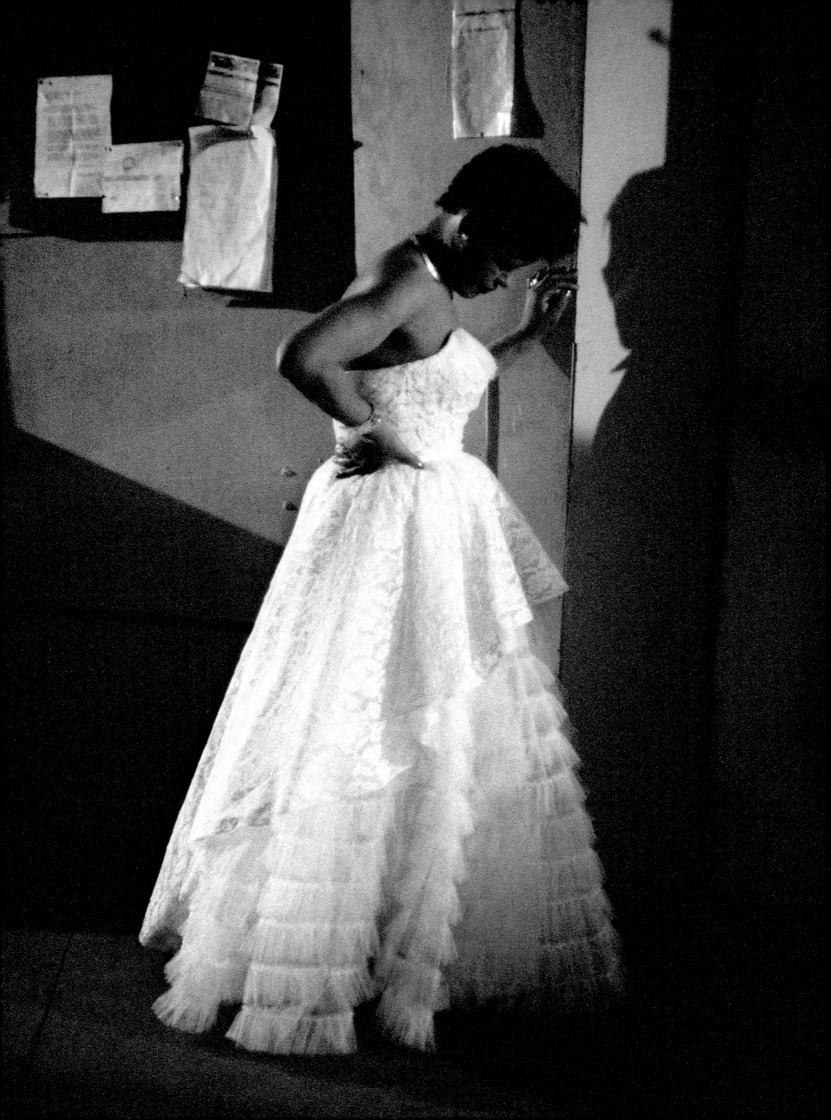

Billie Holiday, Hollywood Bowl, Los Angeles, 1953

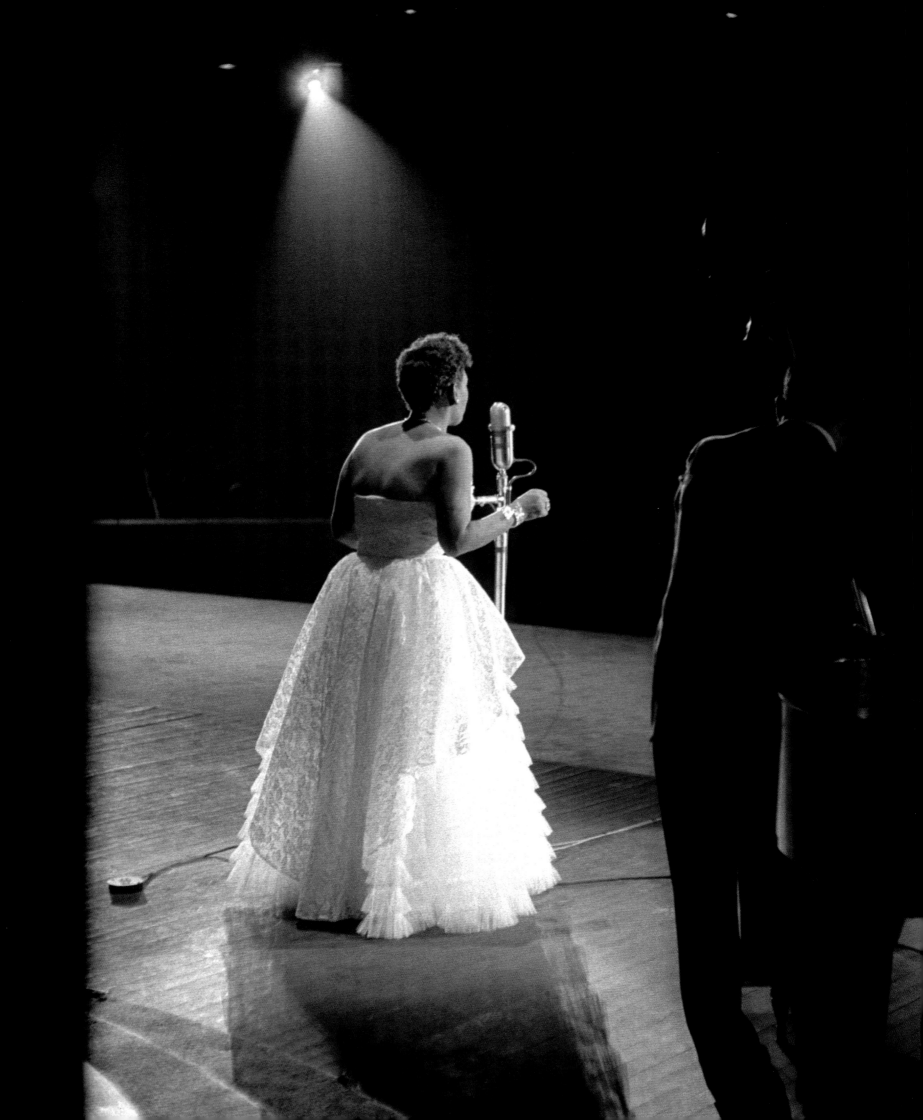

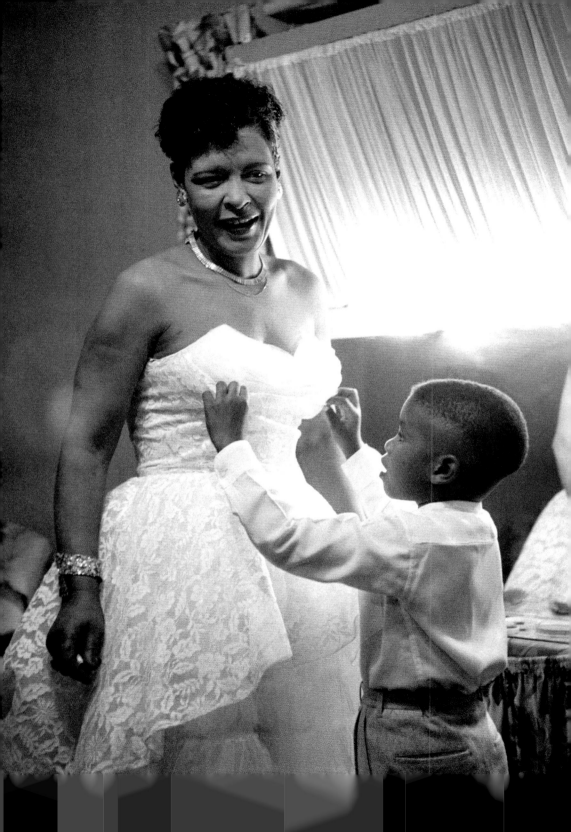

Buddy Rich, New York, 1954

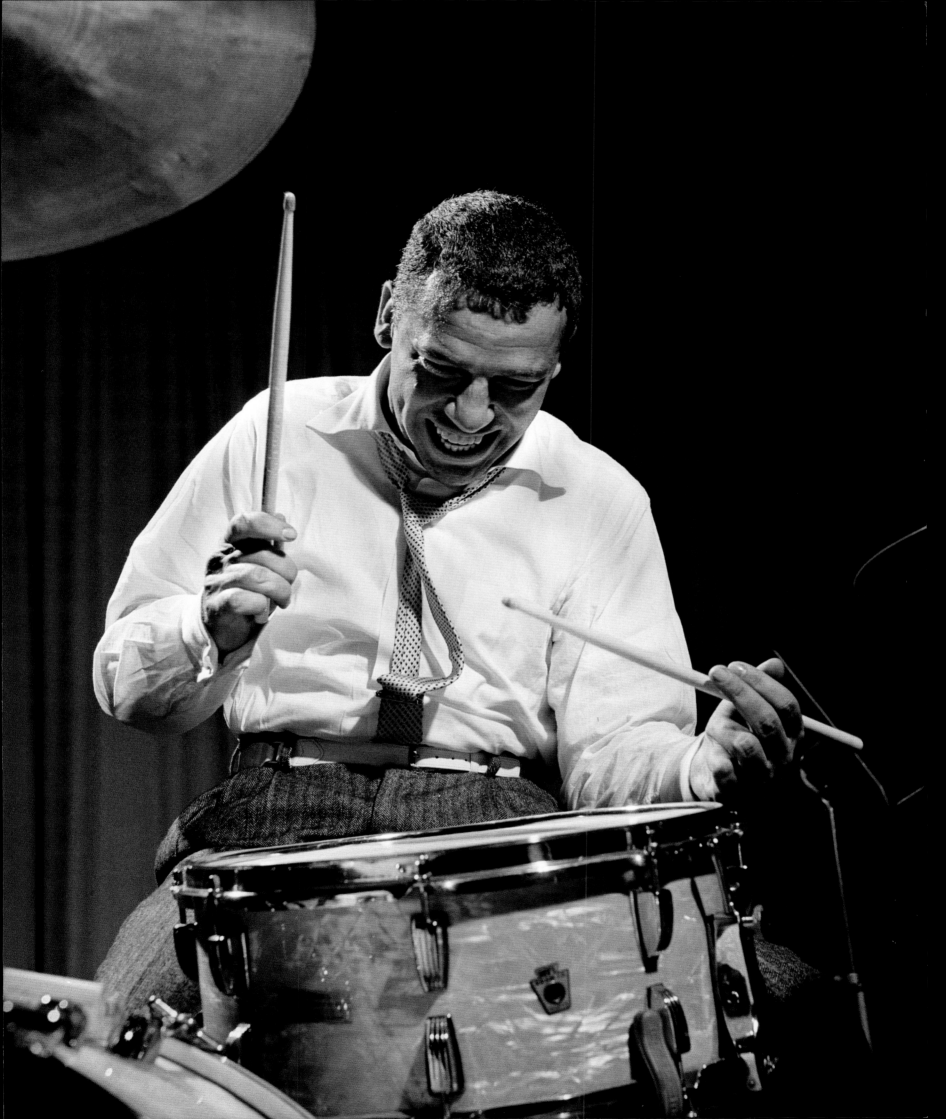

Art Blakey, Paris, 1958

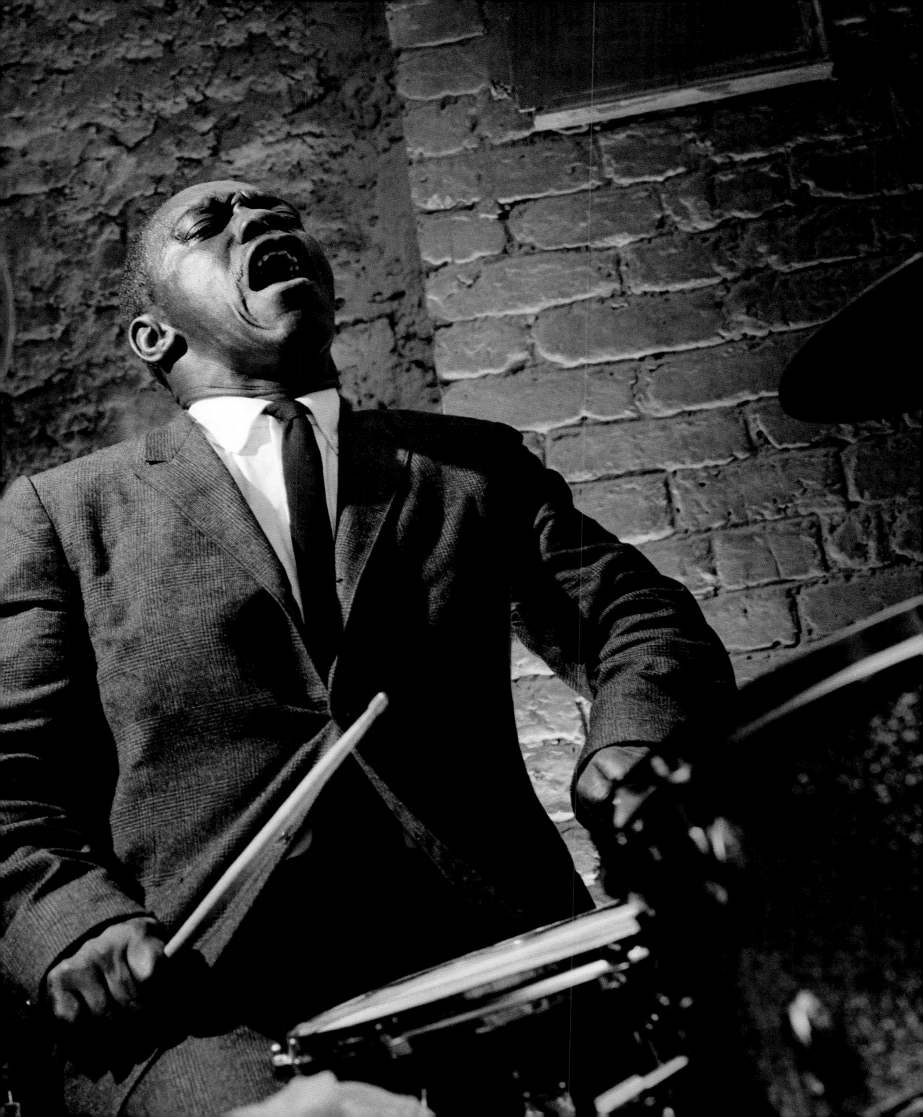

Max Roach, New York, 1954

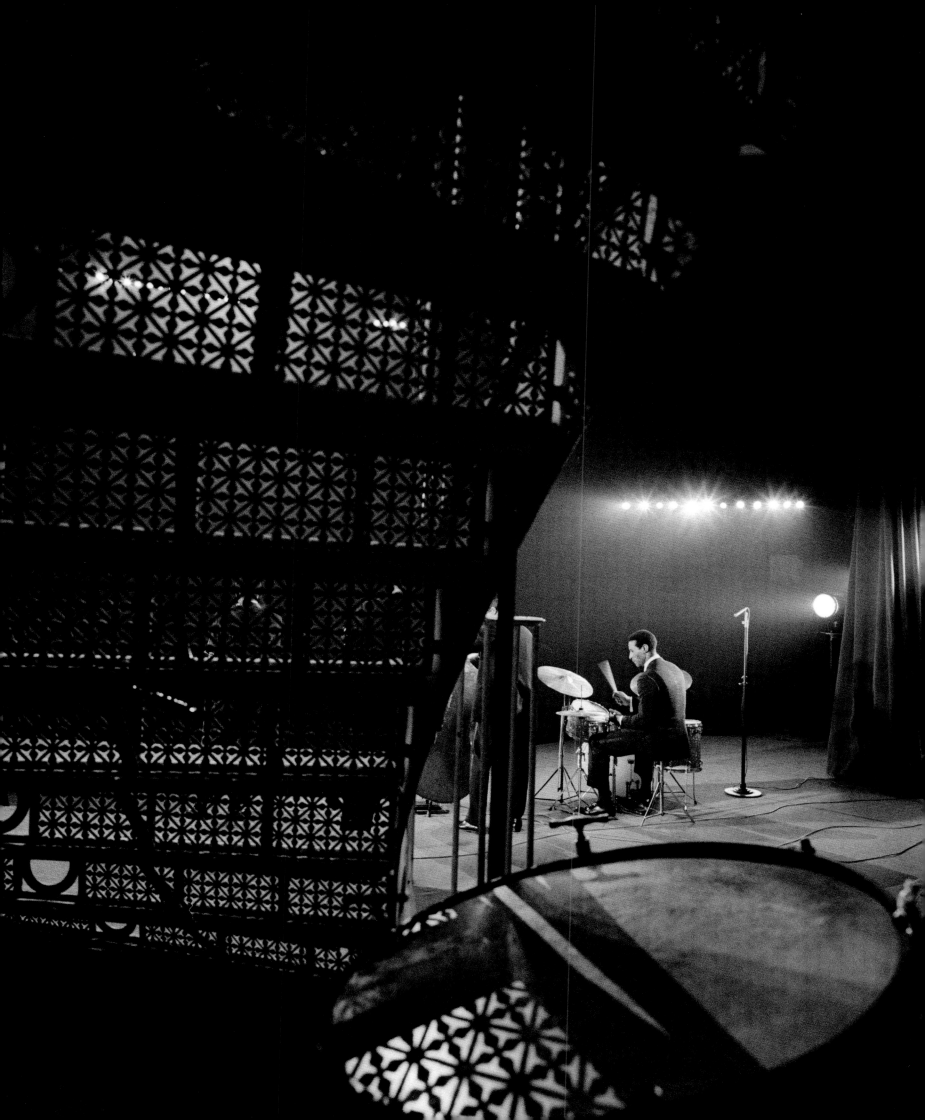

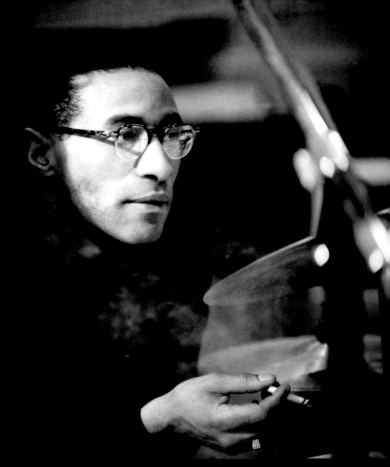

Max Roach, New York, 1954

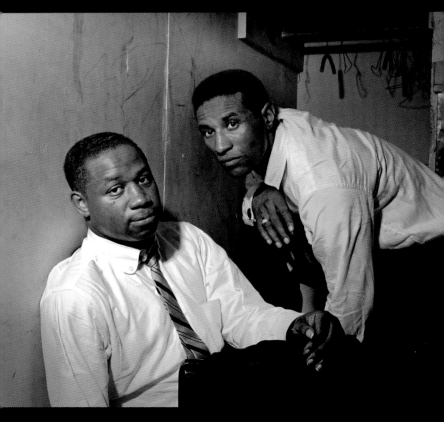

Clifford Brown and Max Roach, New York, 1954

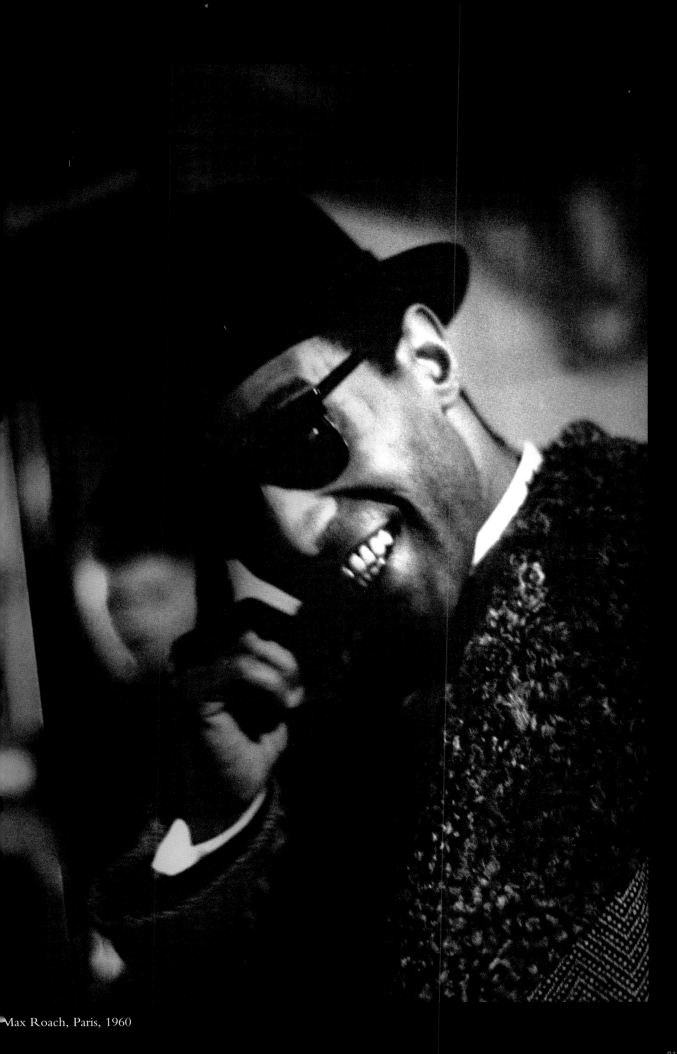

Max Roach, Paris, 1960

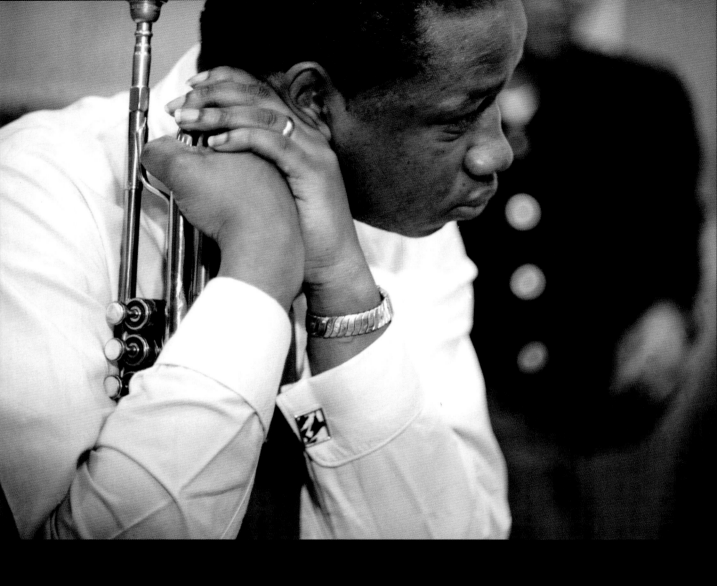

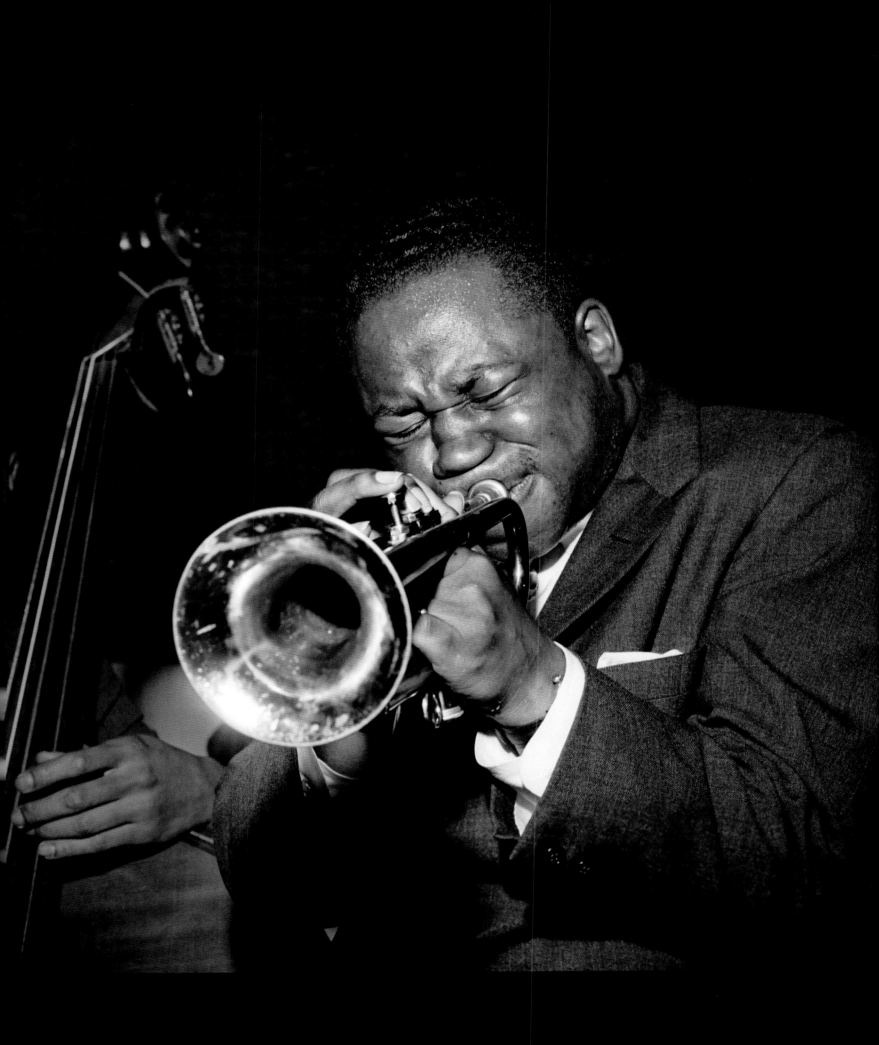

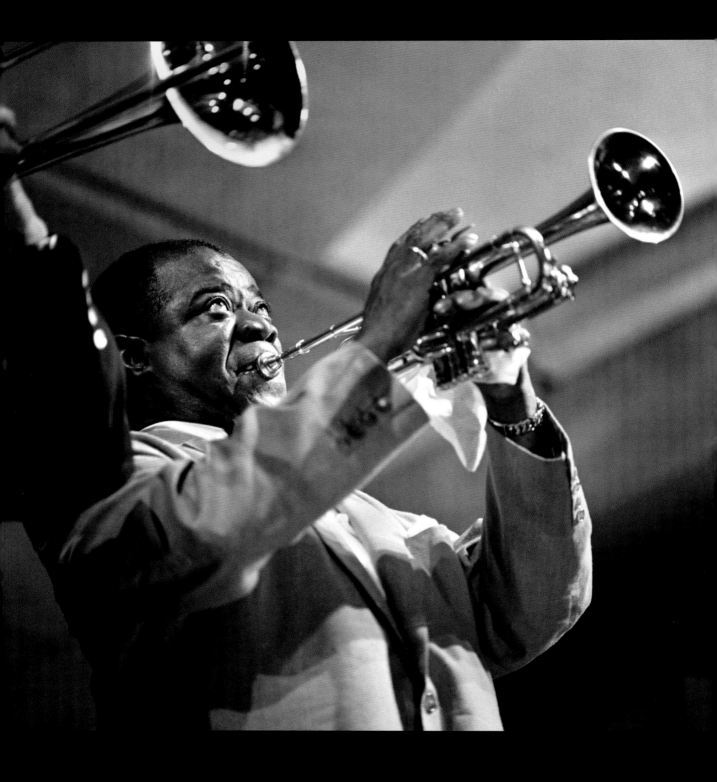

Louis Armstrong, Newport Jazz Festival, 1955

Opposite: Louis Armstrong, New York, 1950

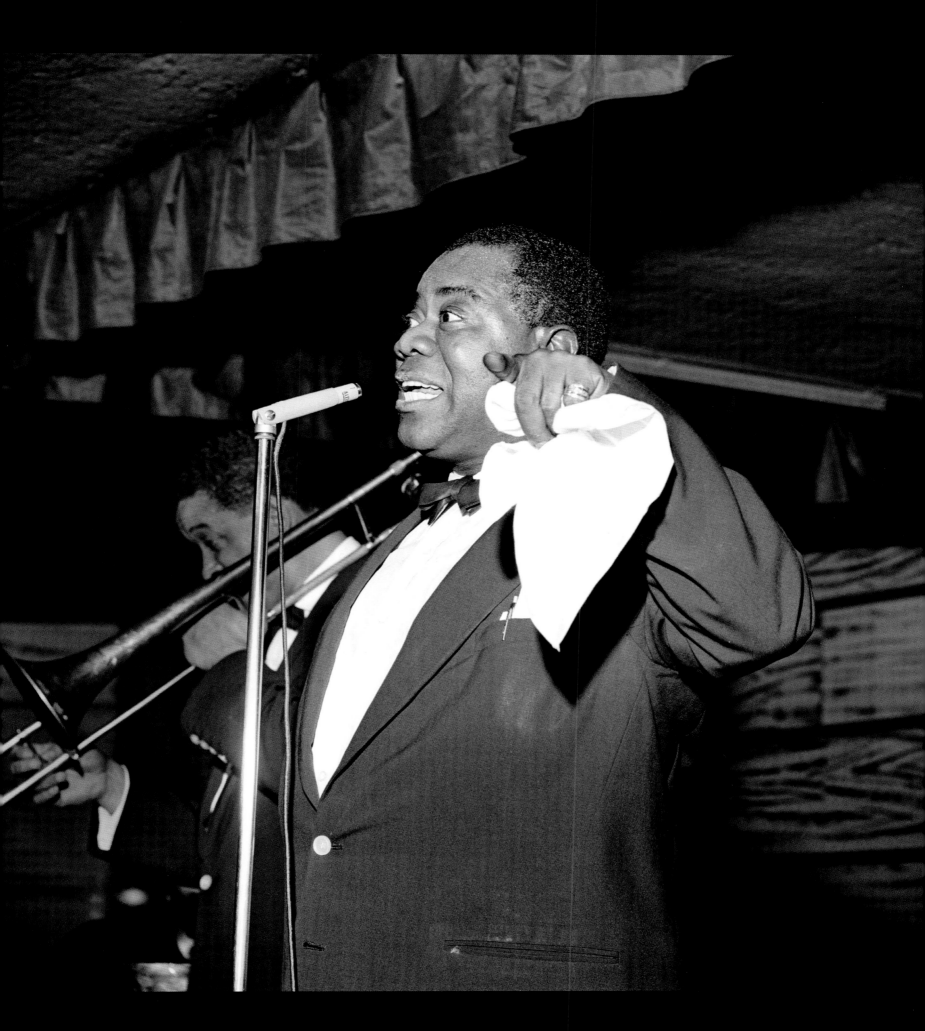

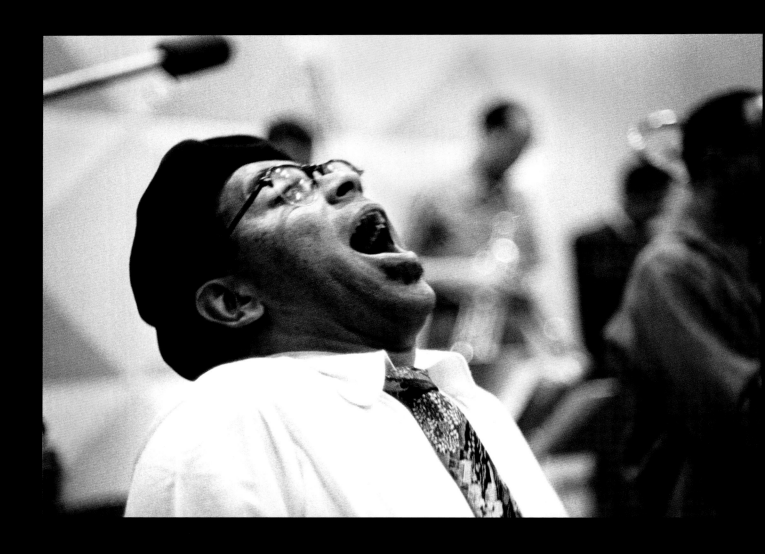

Dizzy Gillespie, New York, 1952 **Opposite:** Dizzy Gillespie, New York, 1955

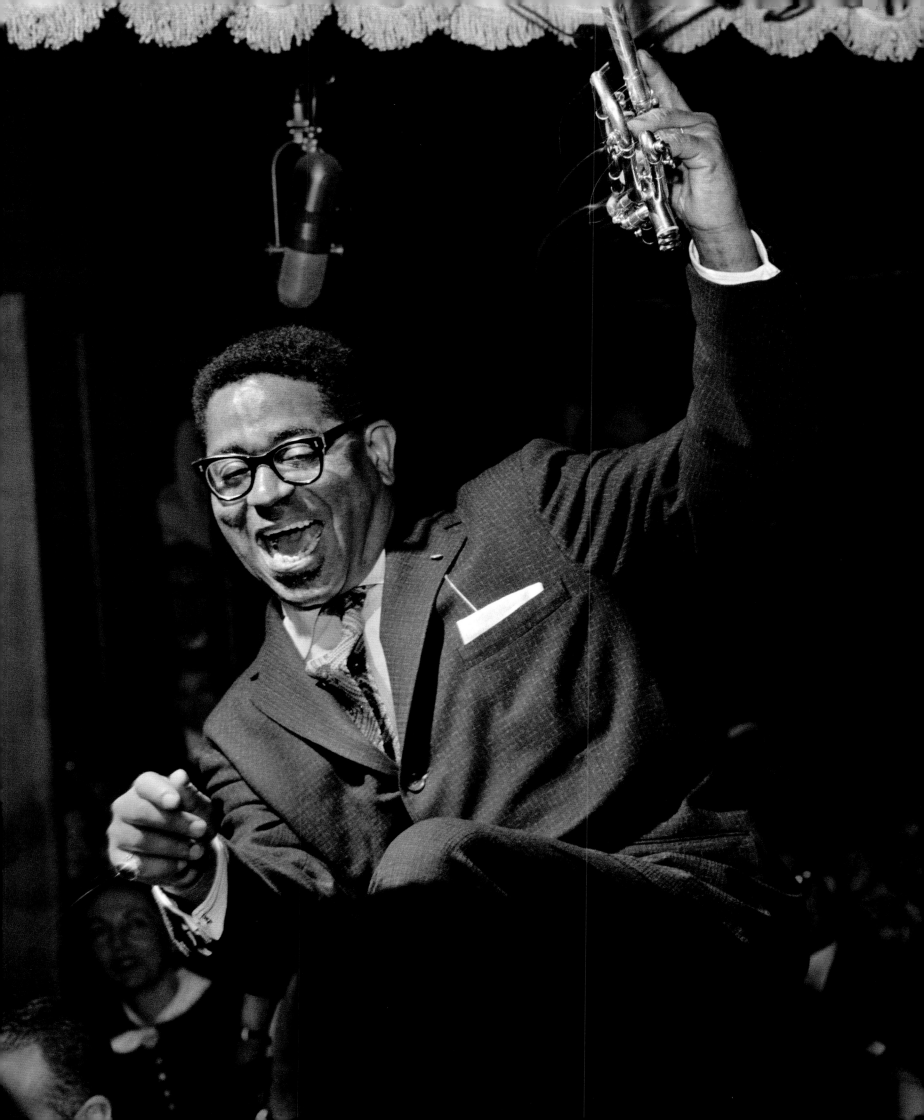

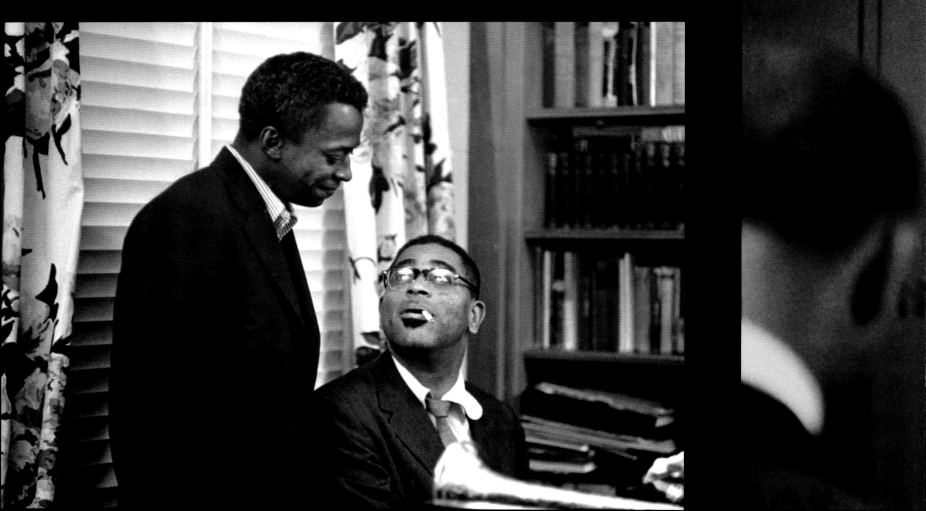

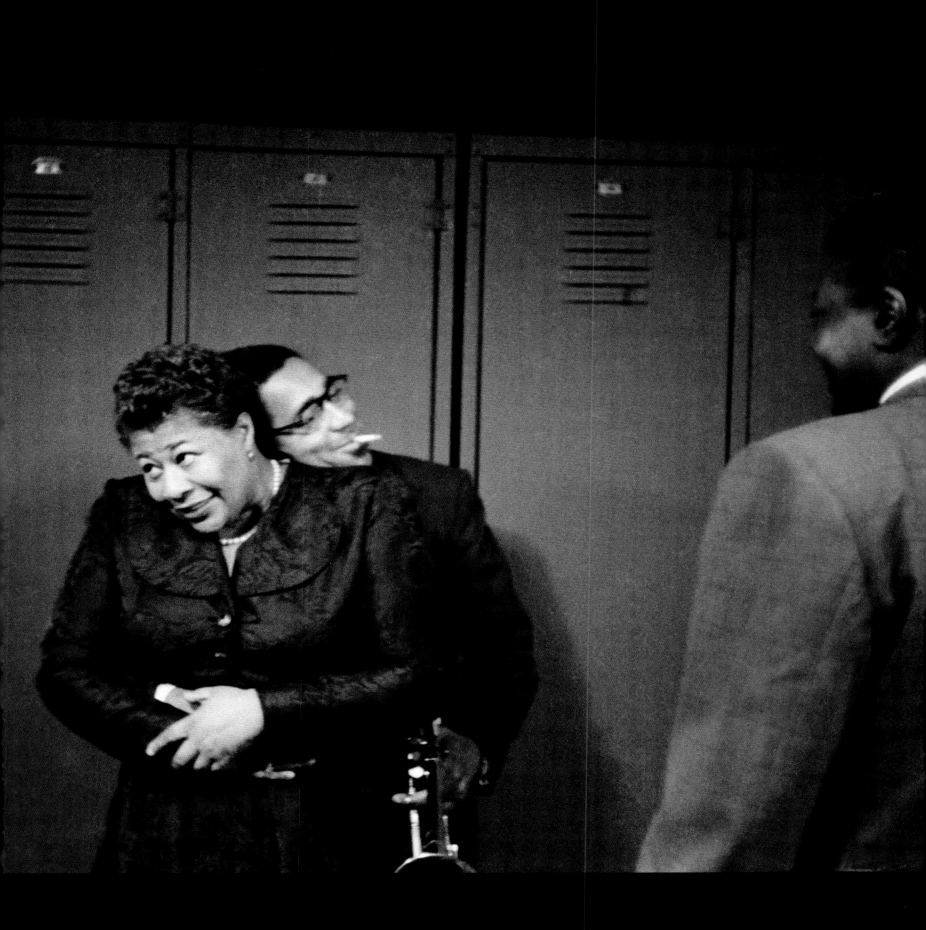

Ella Fitzgerald and Dizzy Gillespie, New York, 1950

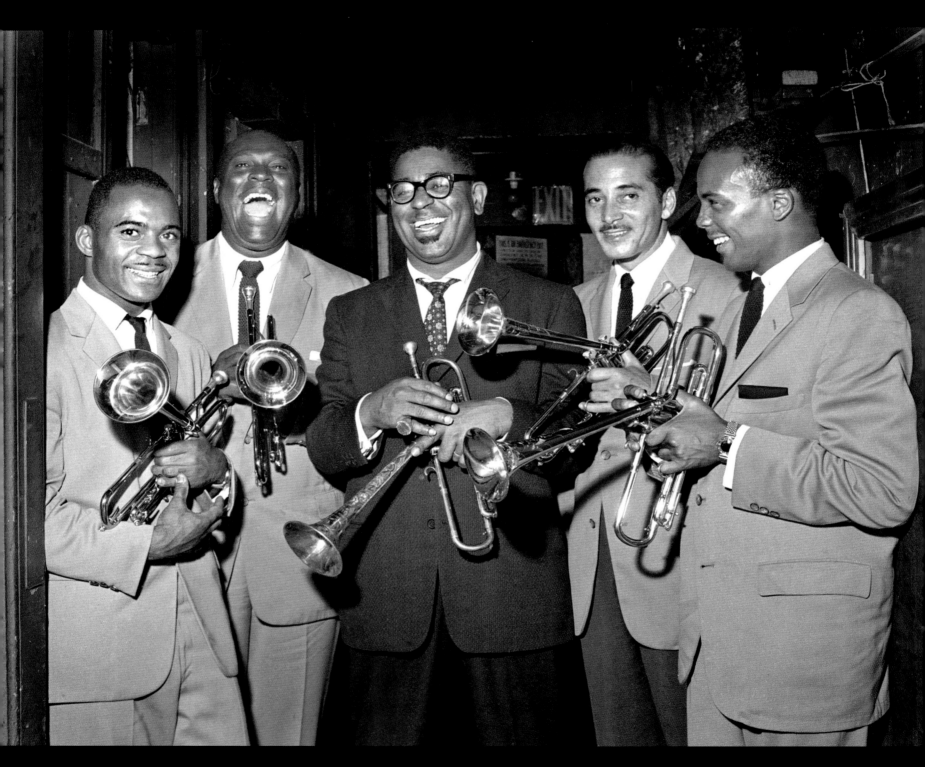

Joe Gordon, E V Perry, Dizzy Gillespie, Carl Warwick and Quincy Jones, New York, 1955

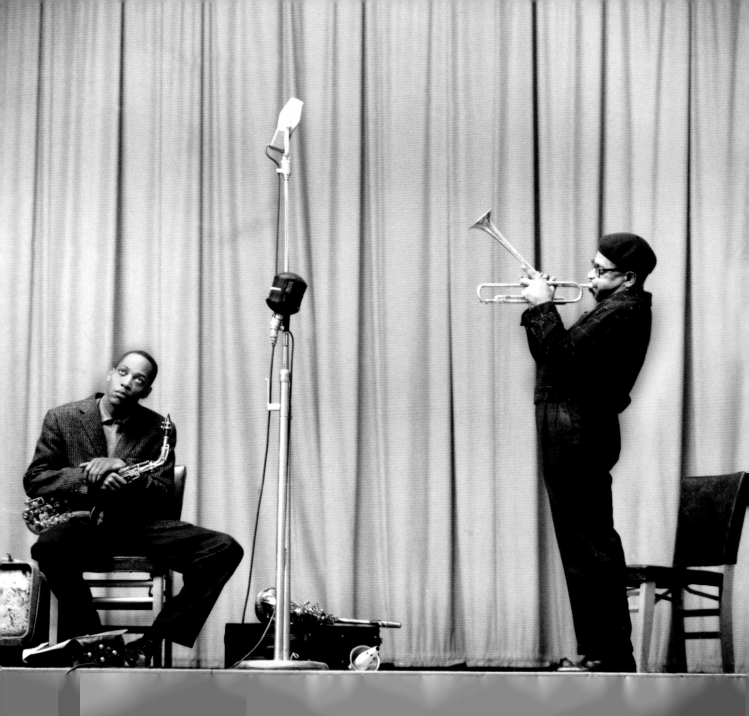

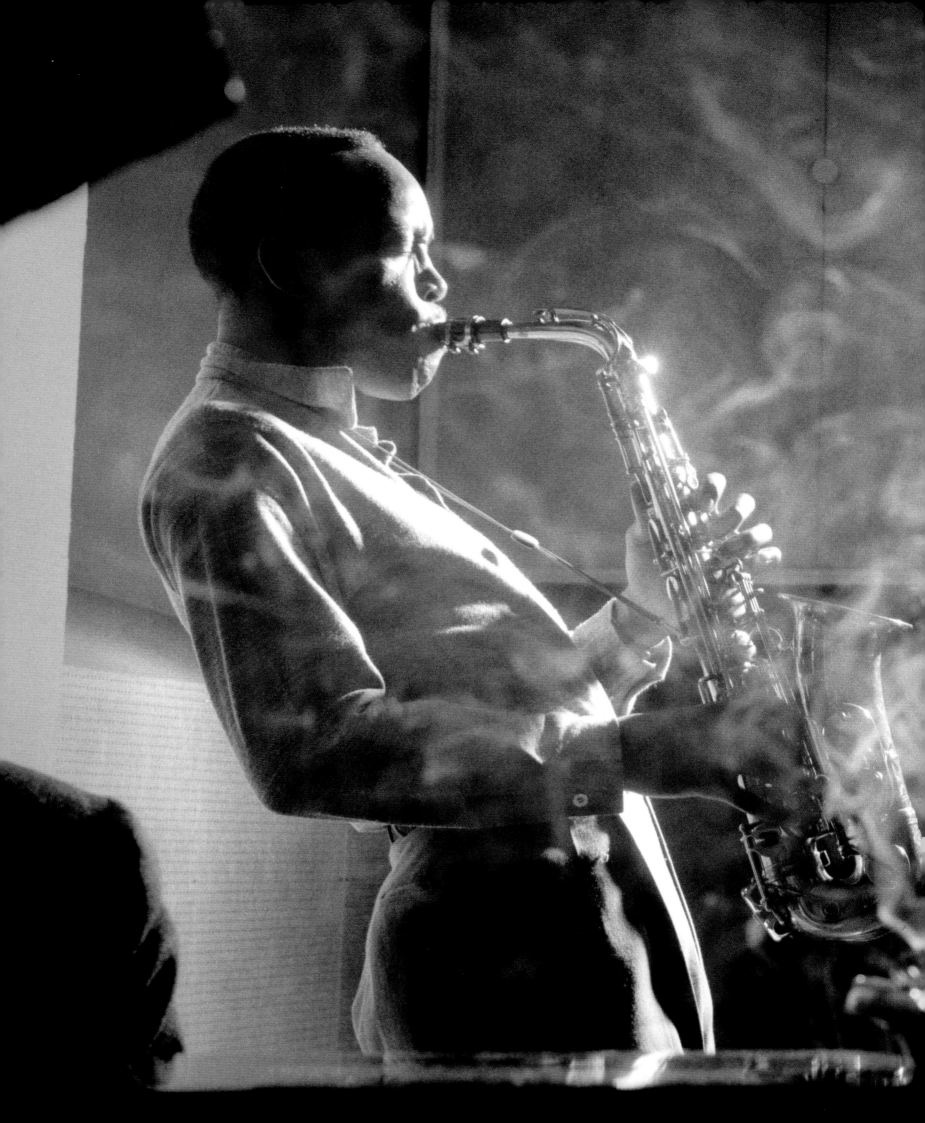

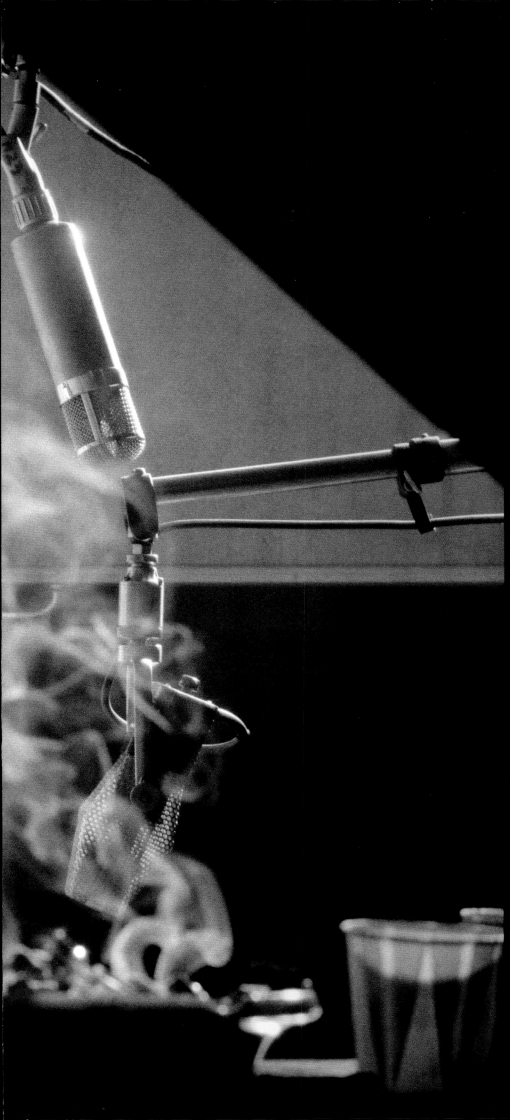

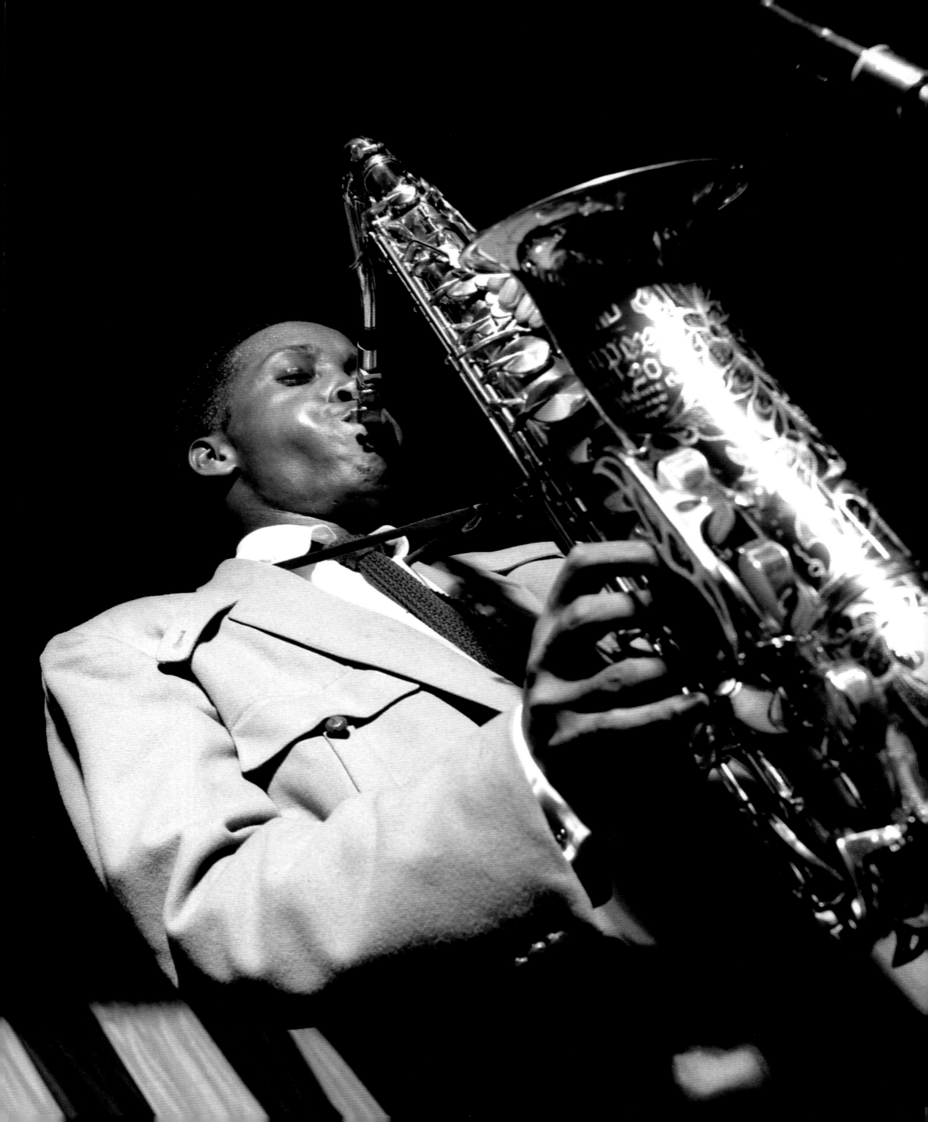

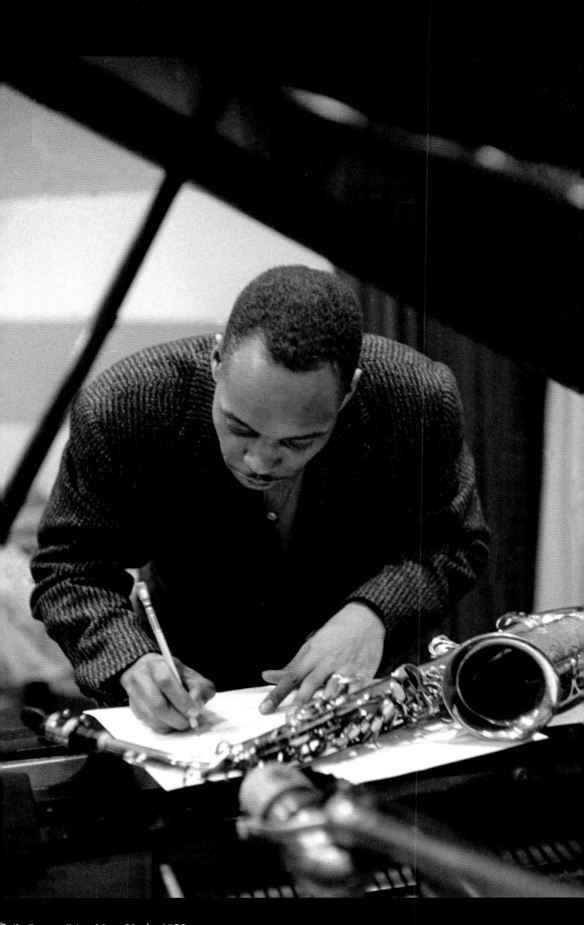

Both: Sonny Stitt, New York, 1953.

James Moody, New York, 1951

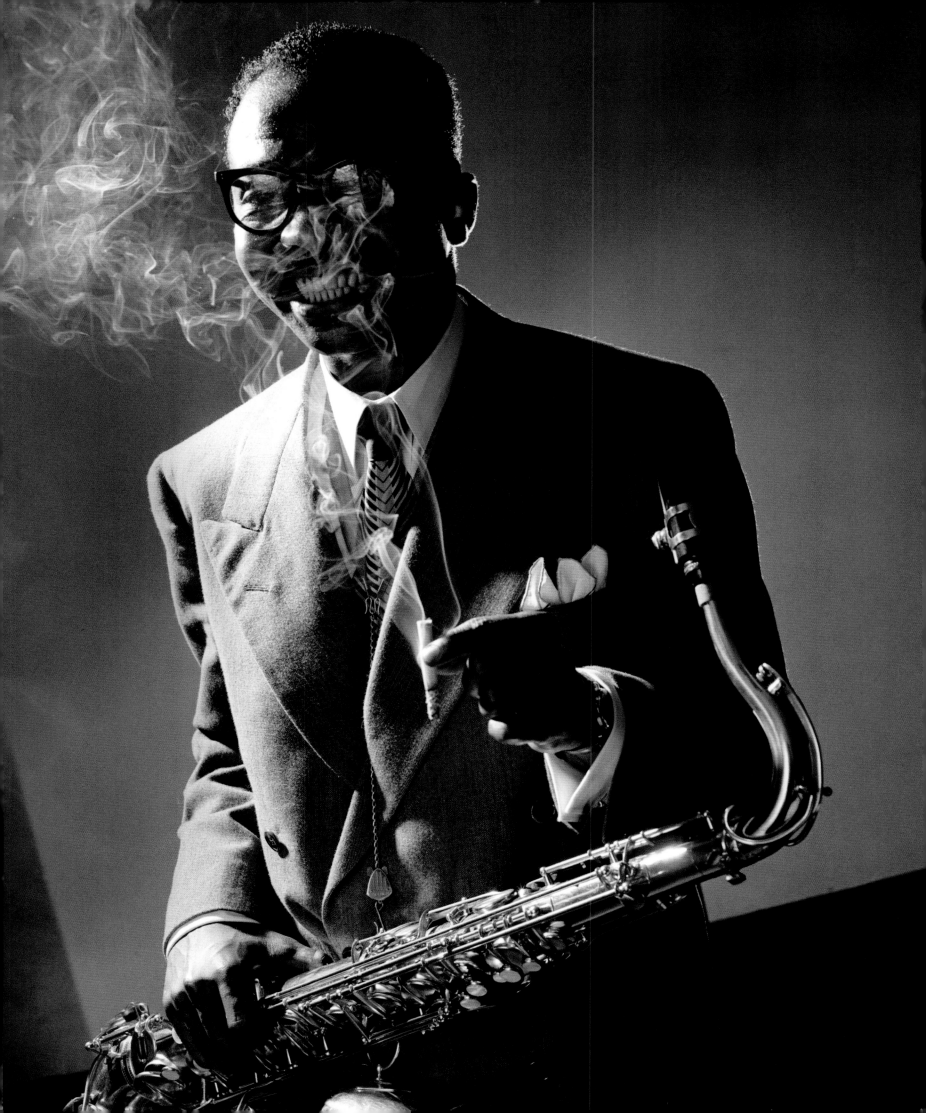

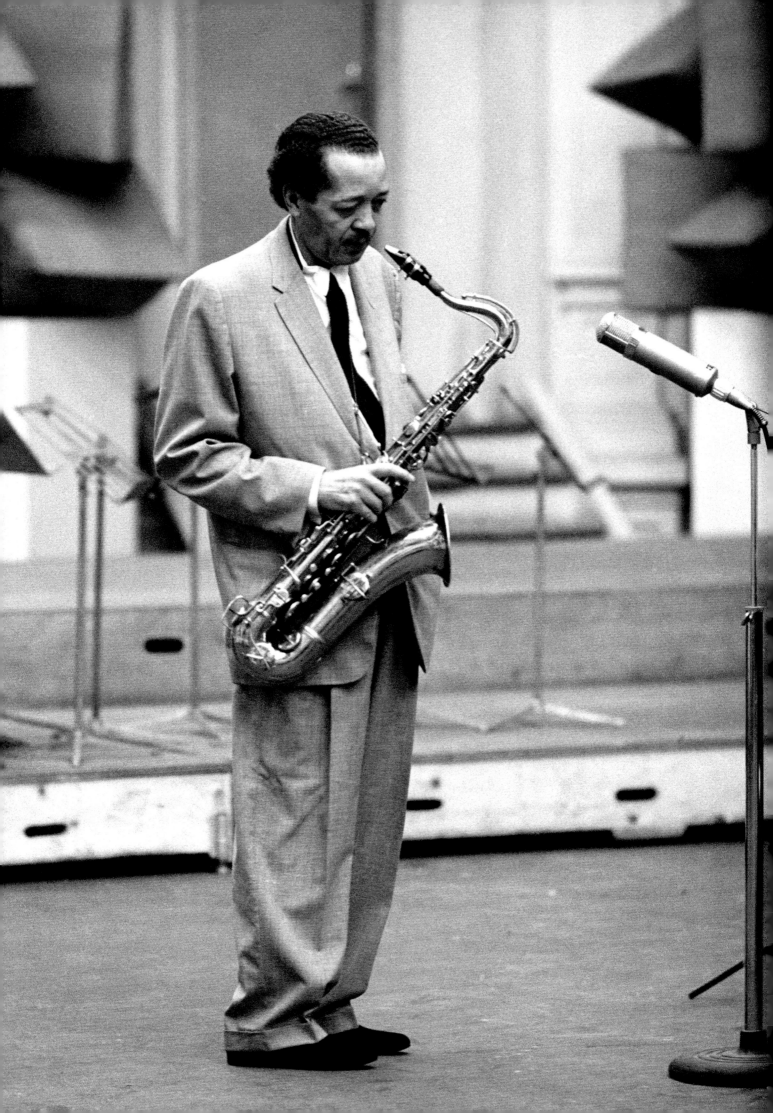

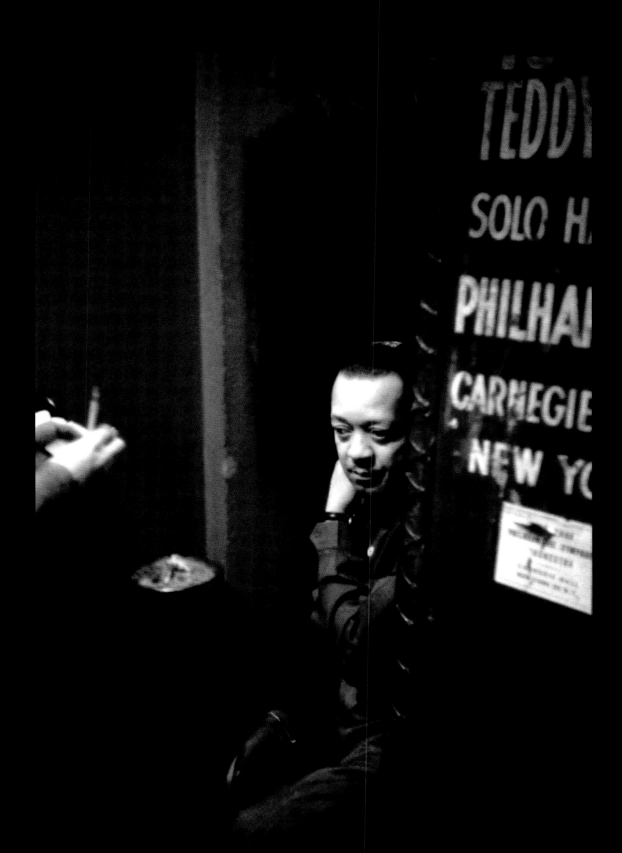

Opposite: Lester Young,
Paris, 1958

Lester Young,
New York, 1950

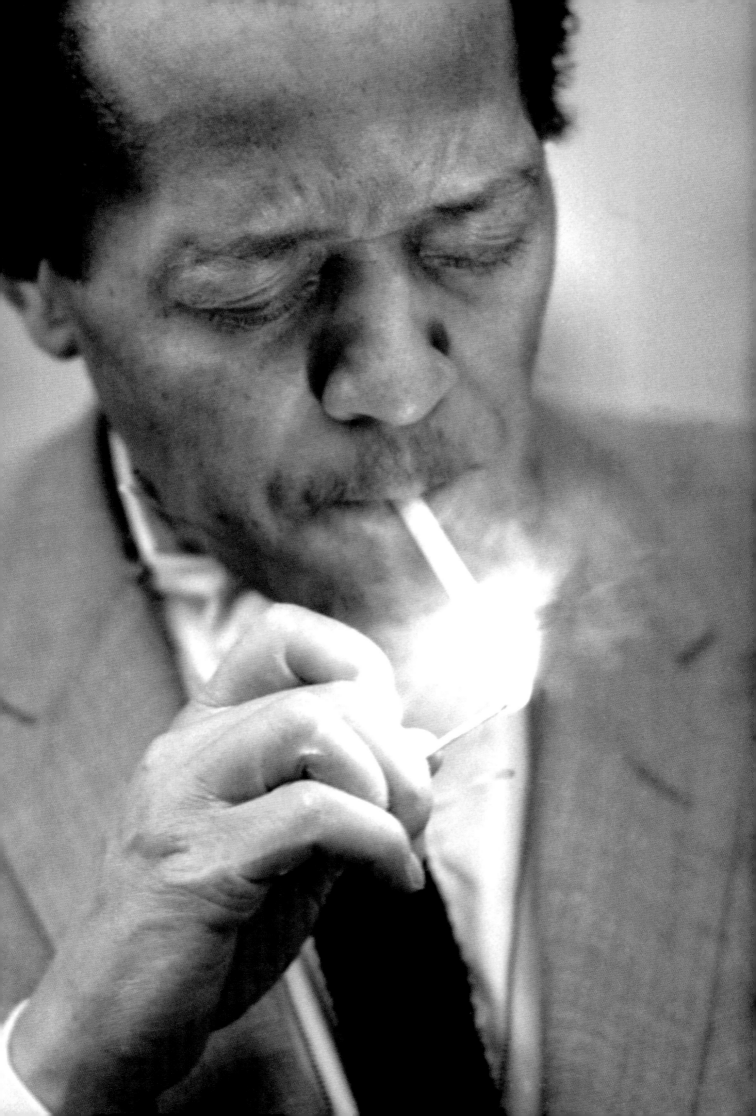

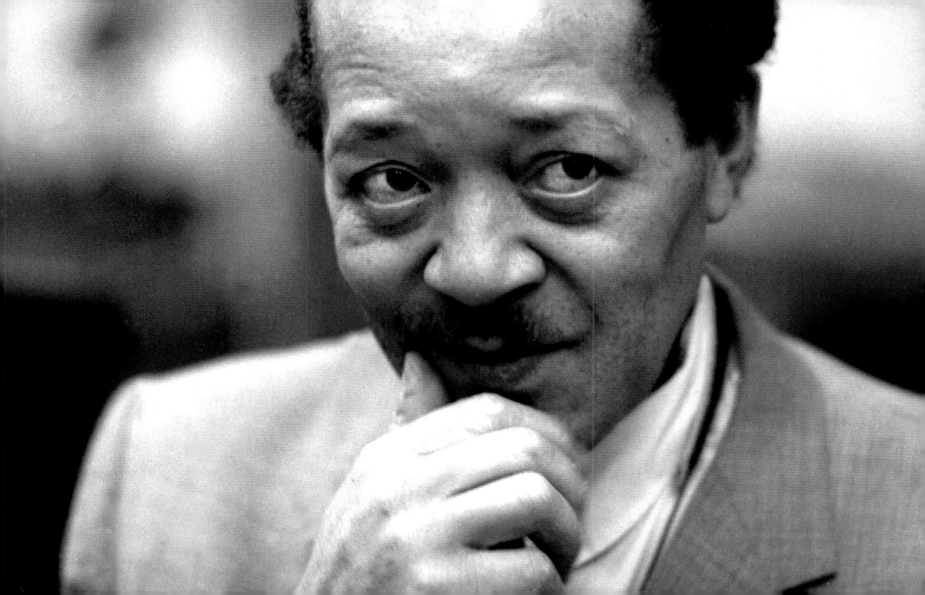

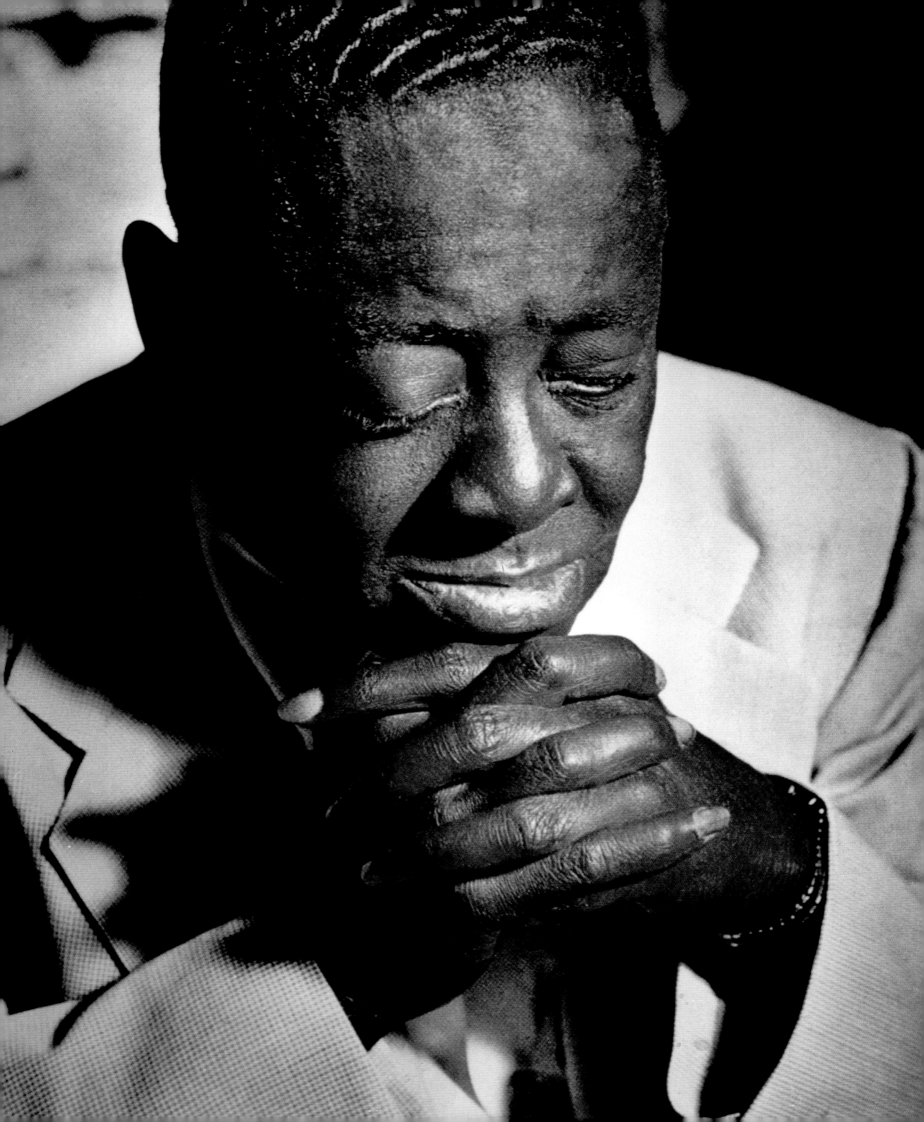

Los Angeles, 1955

Art Tatum, New York, 1953

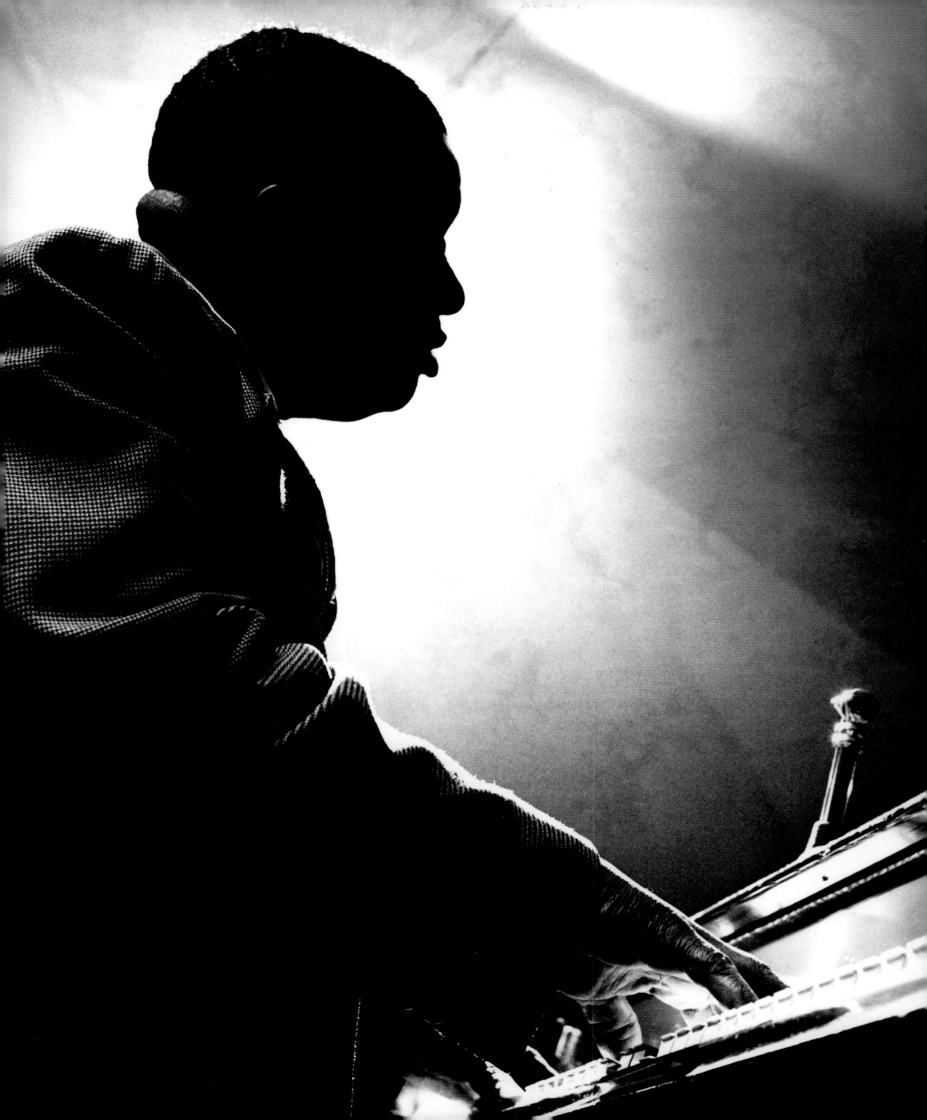

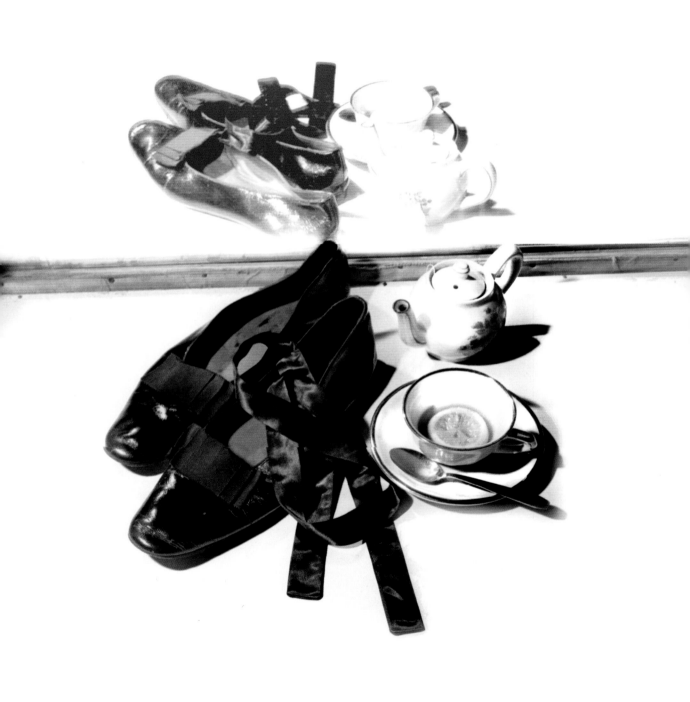

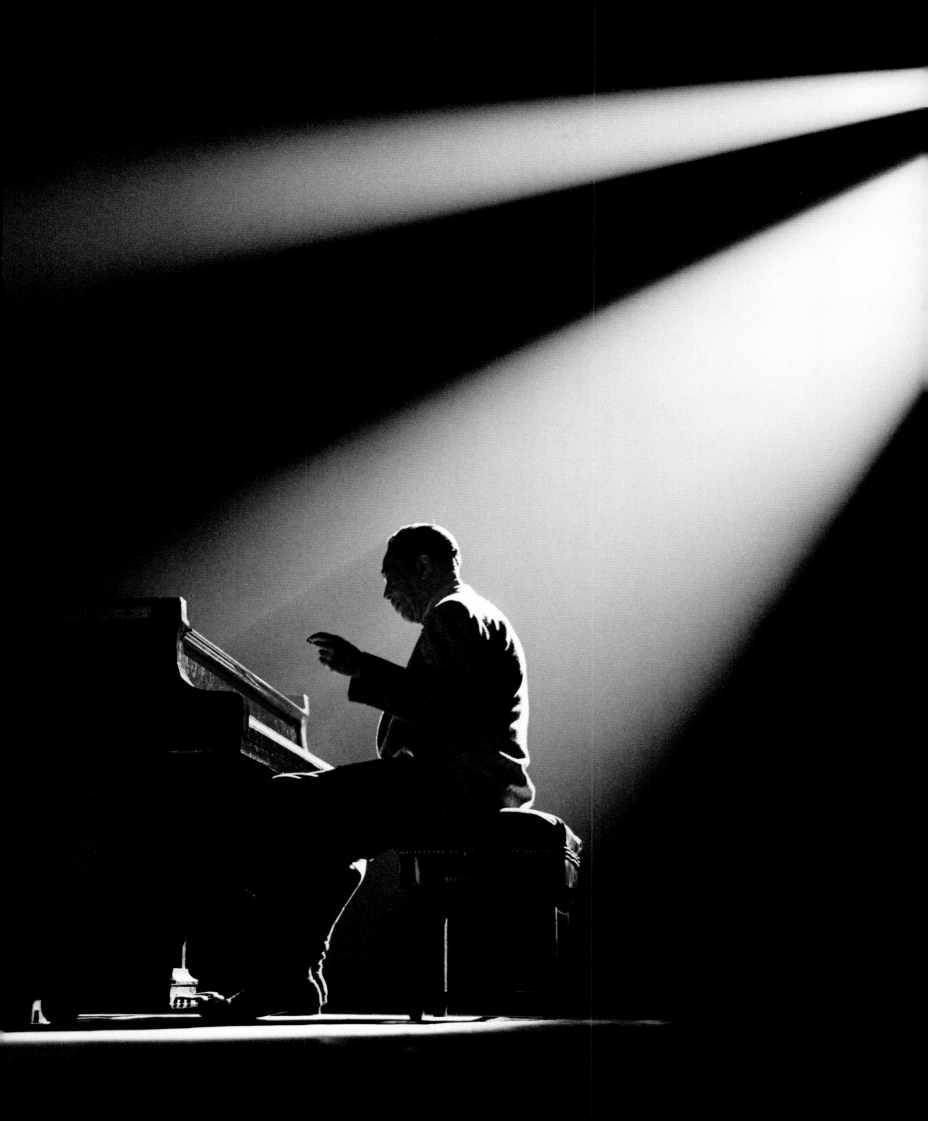

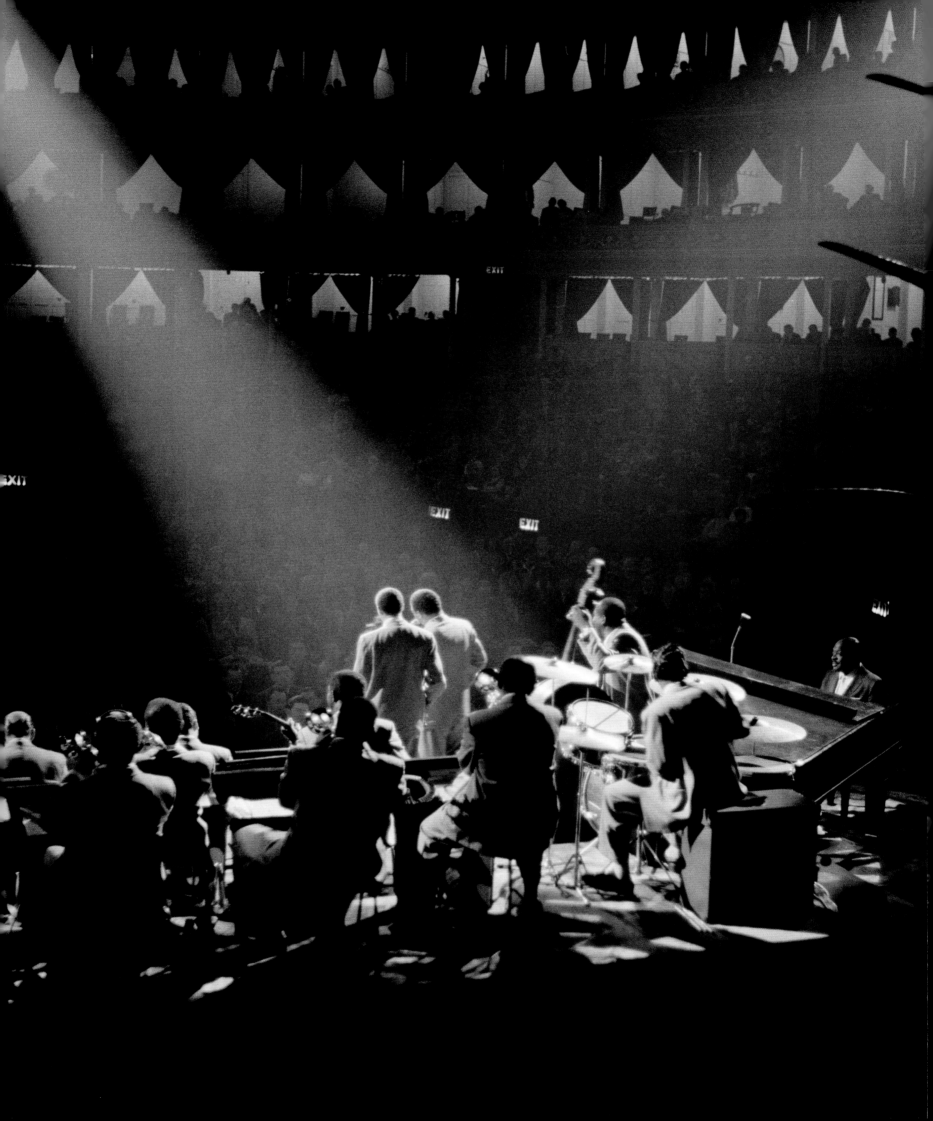

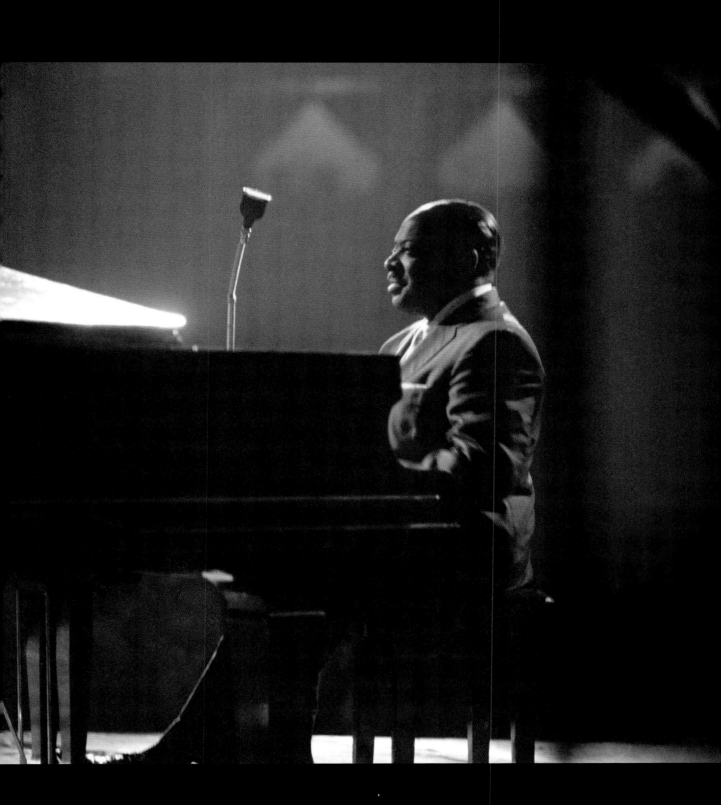

Count Basie, Albert Hall, London, 1958

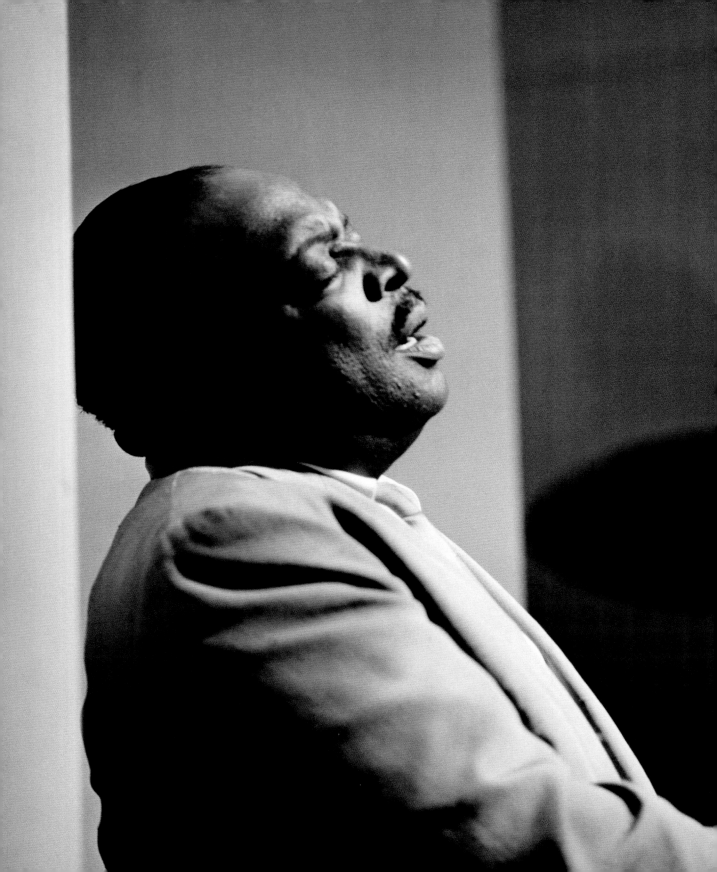

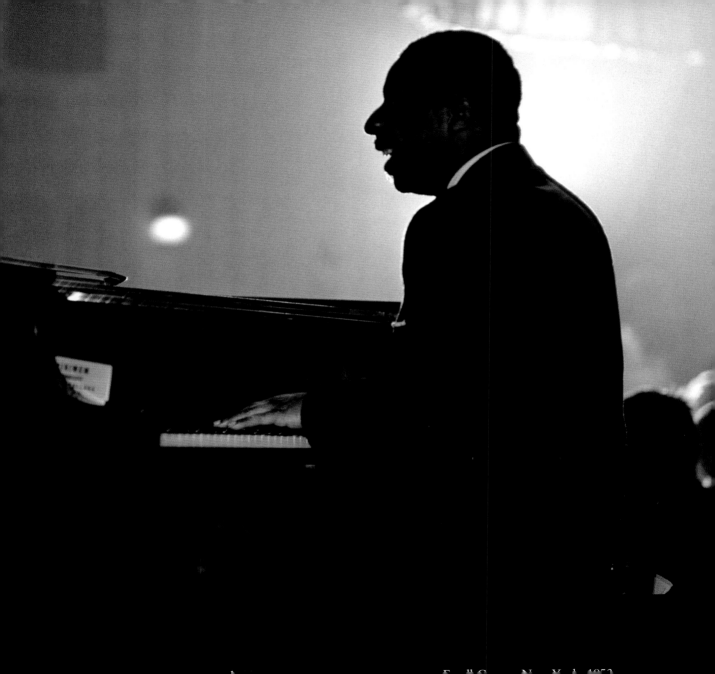

Erroll Garner, Bop City, New York, 1953

Overleaf: Bop City, New York, 1953

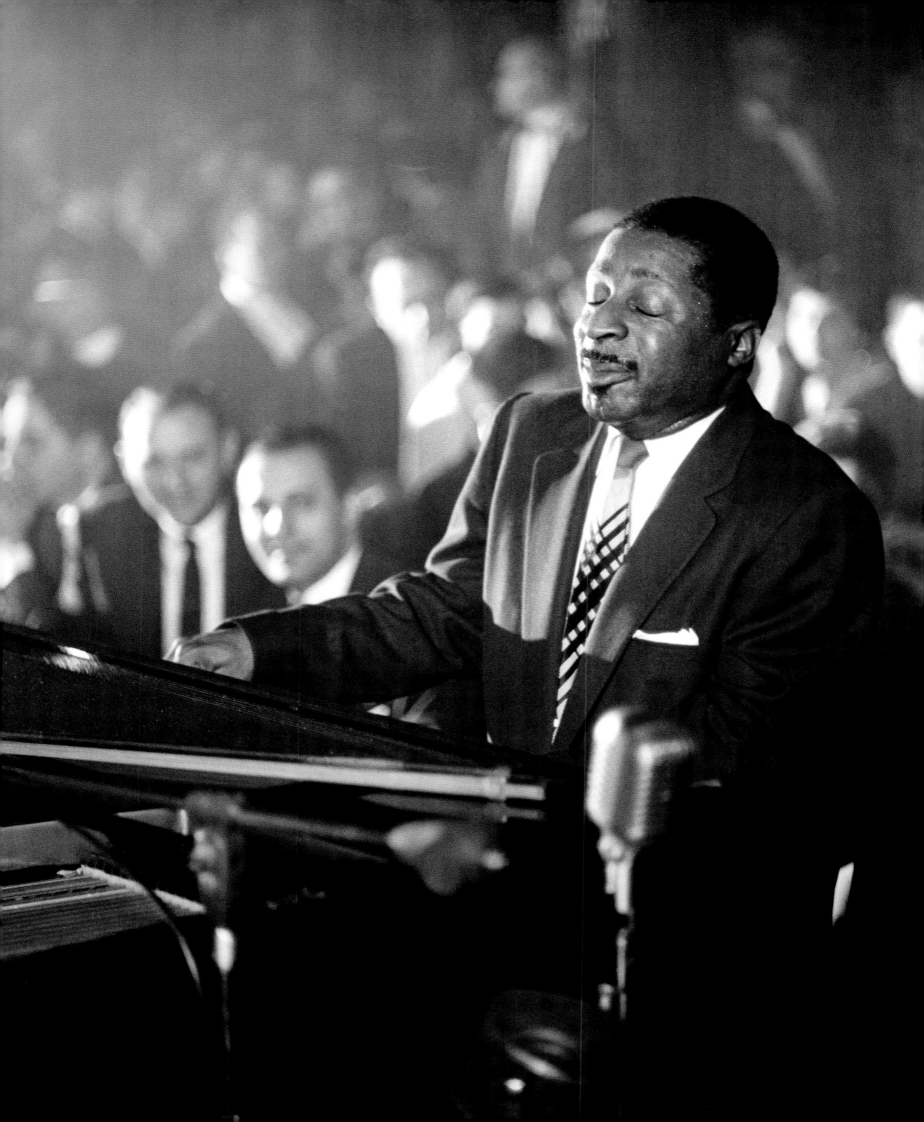

Joe Williams, New York, 1954

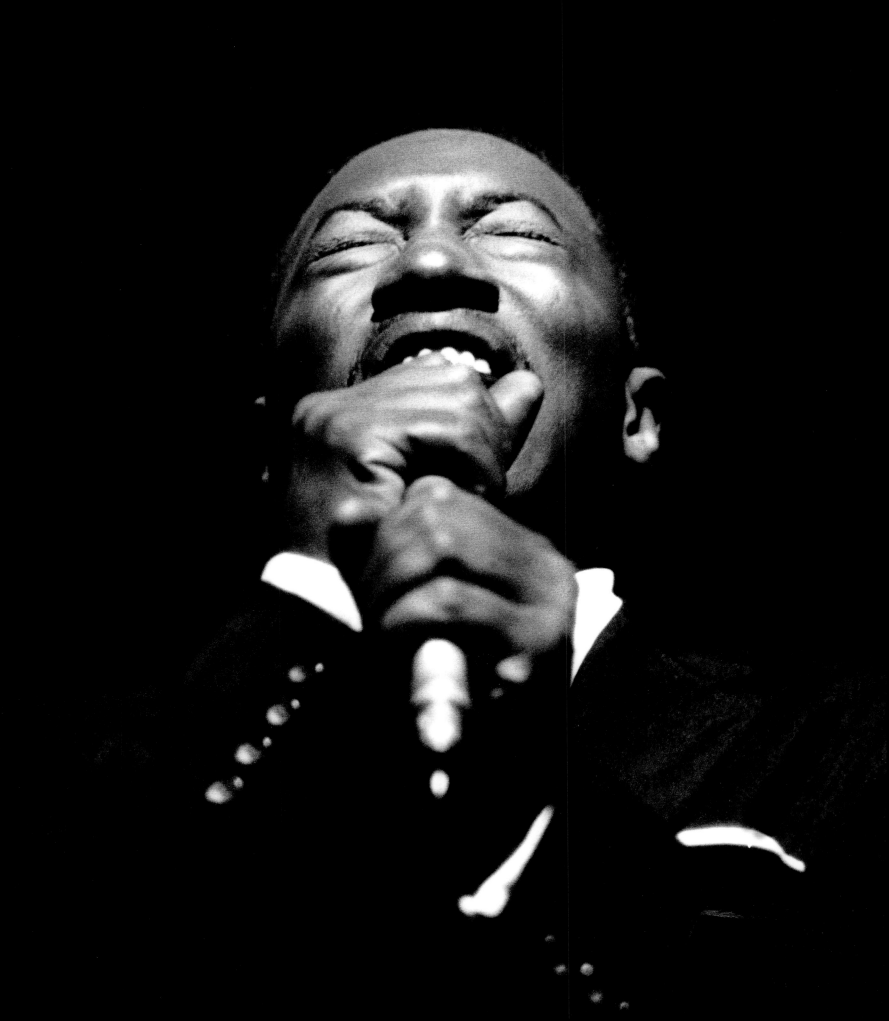

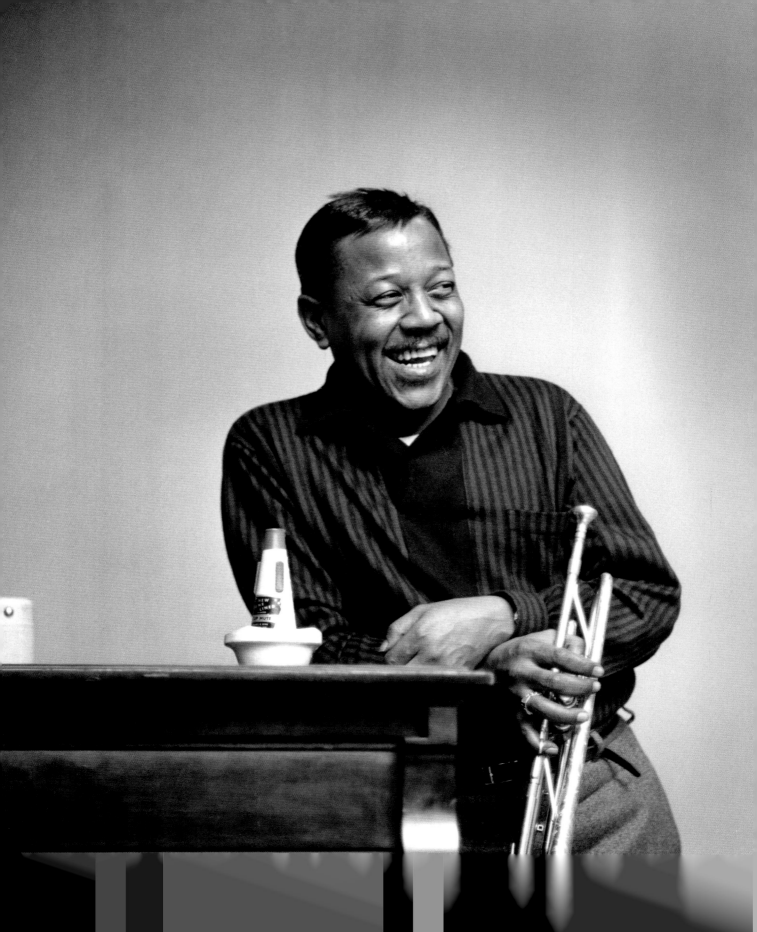

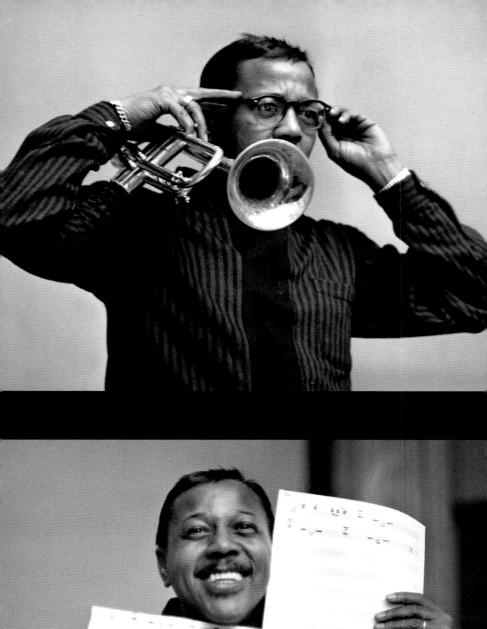
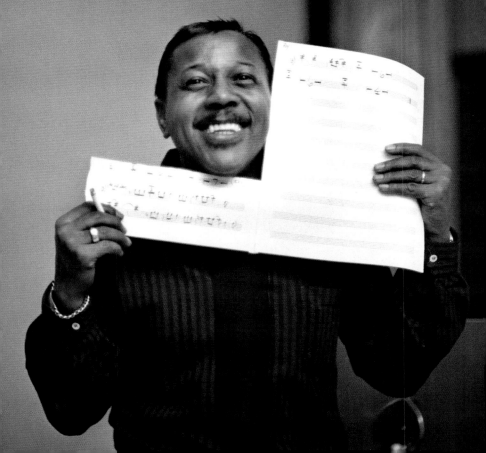

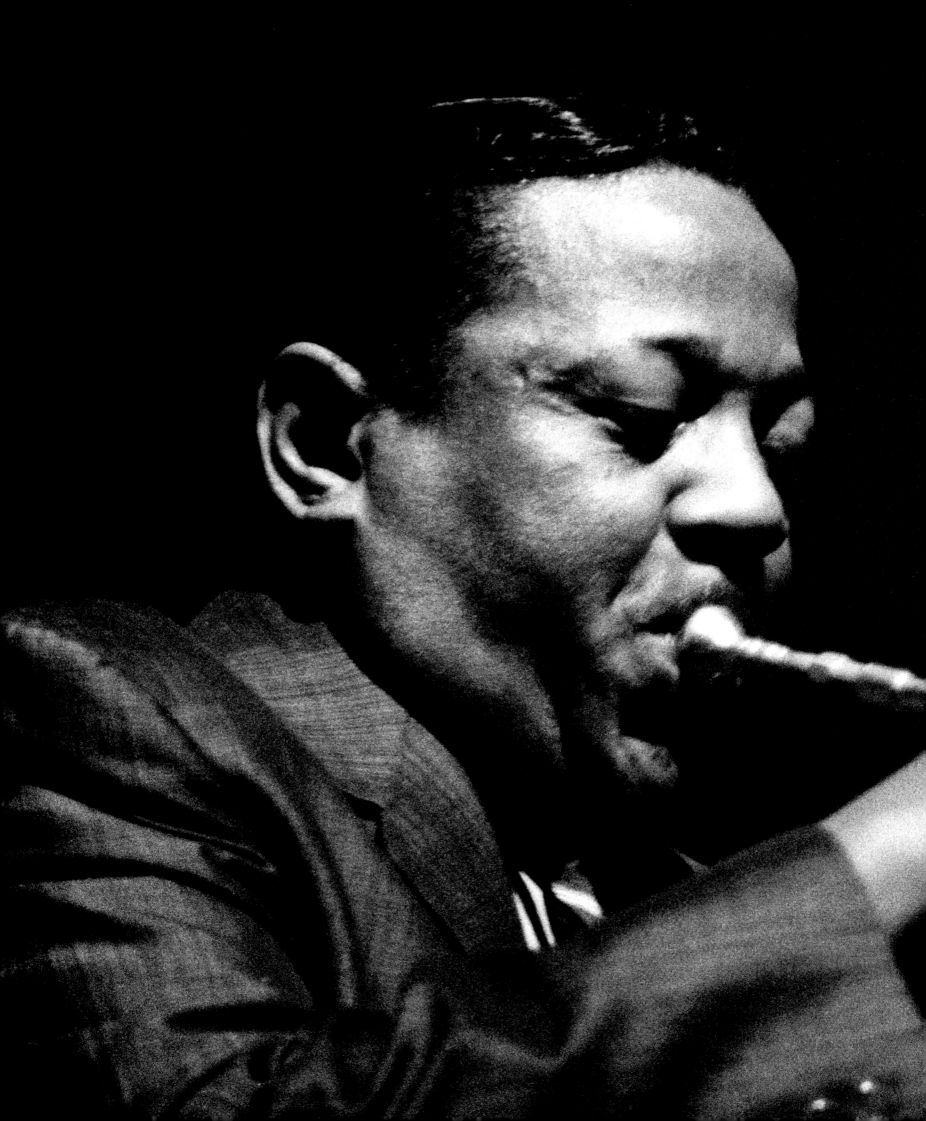

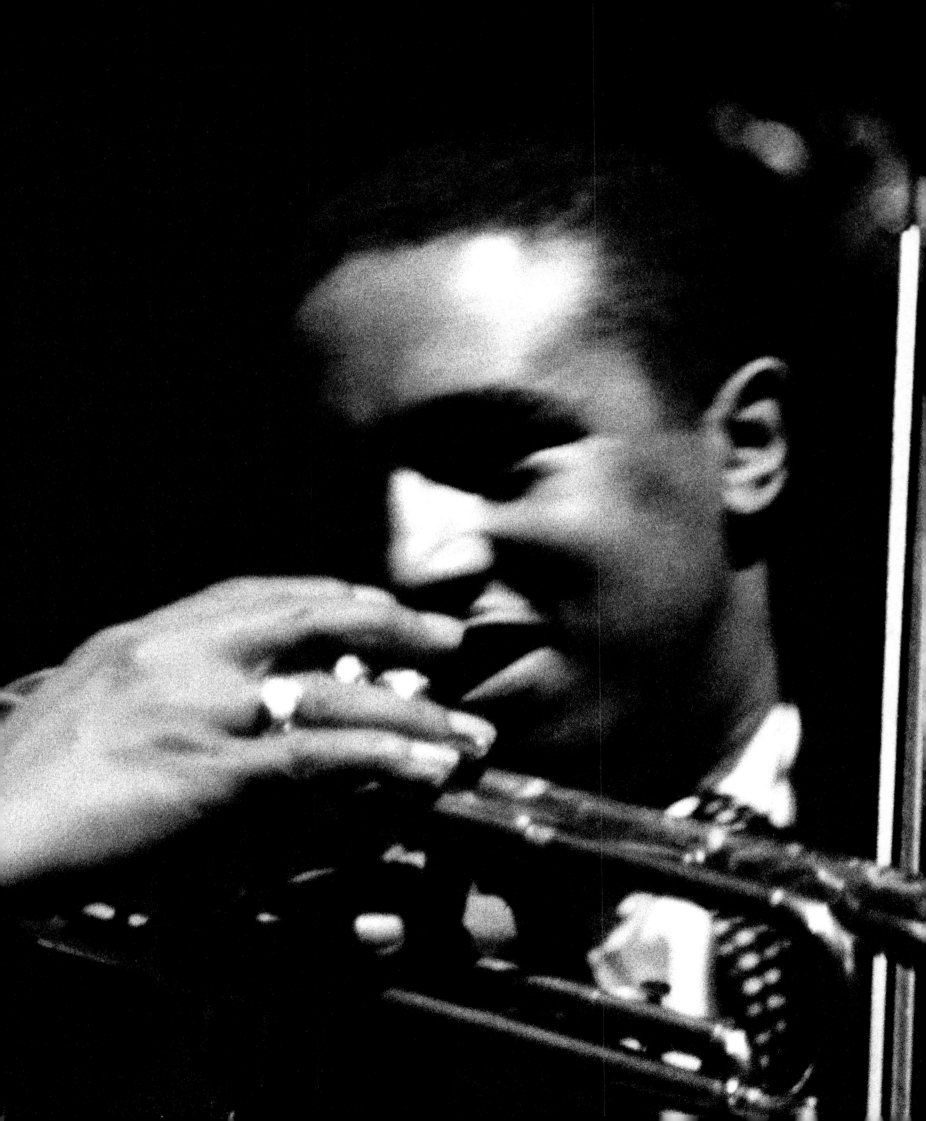

aughan, New York, 1950

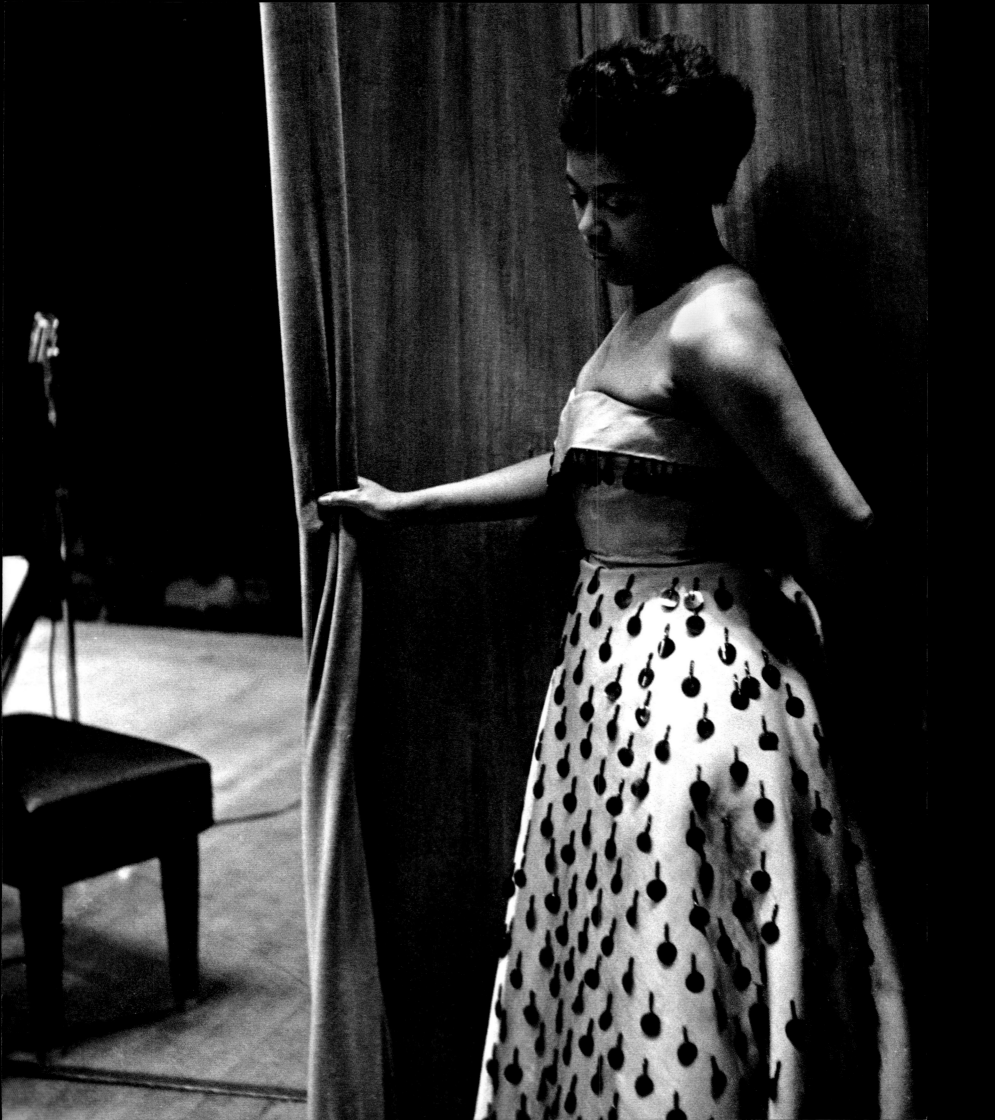

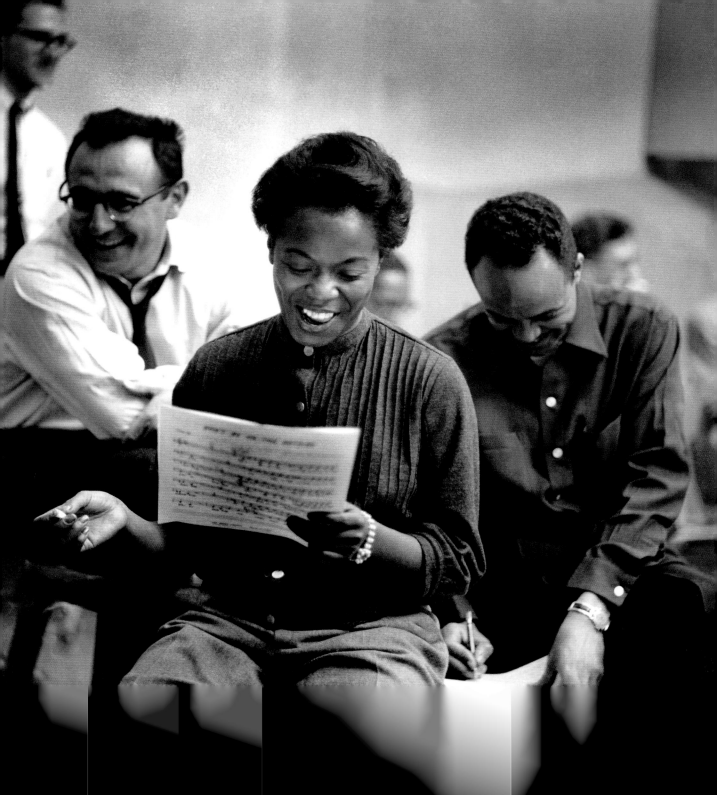

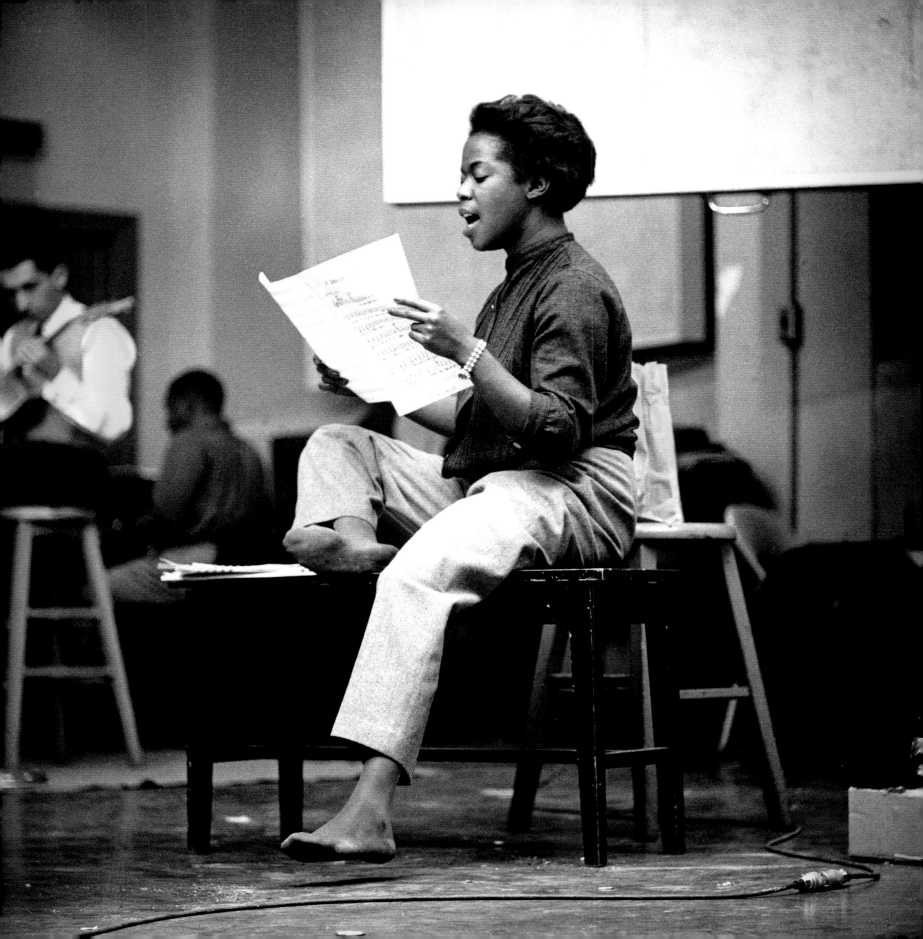

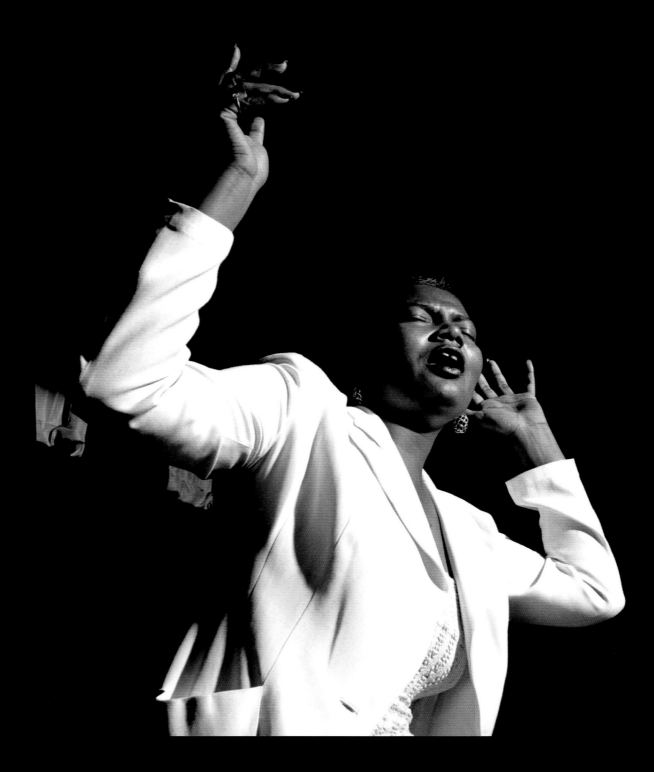

Both: Pearl Bailey, New York, 1950

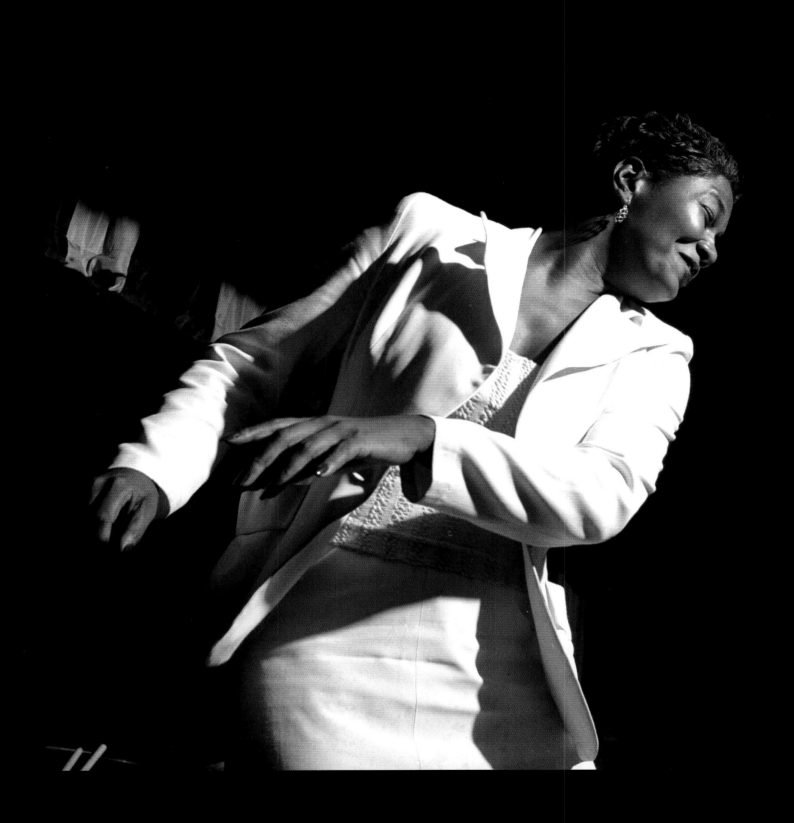

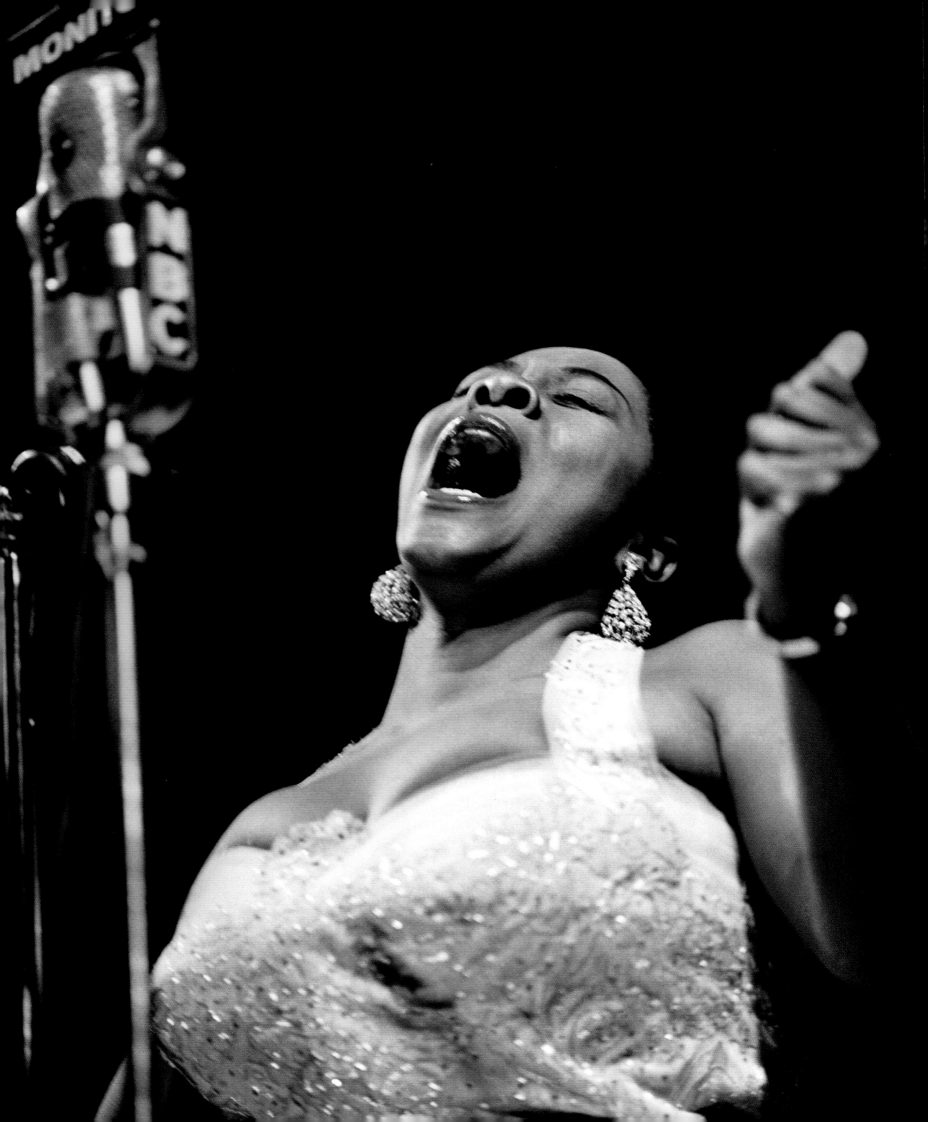

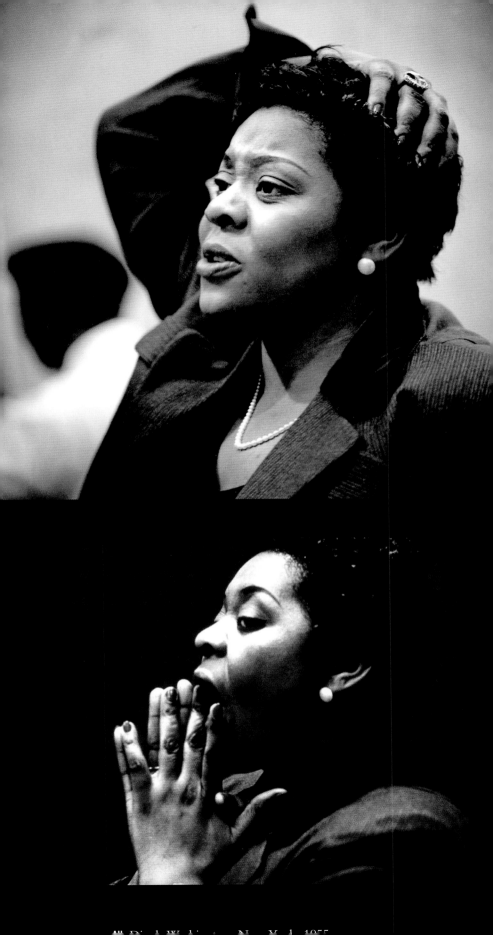

Dinah Washington, New York, 1955

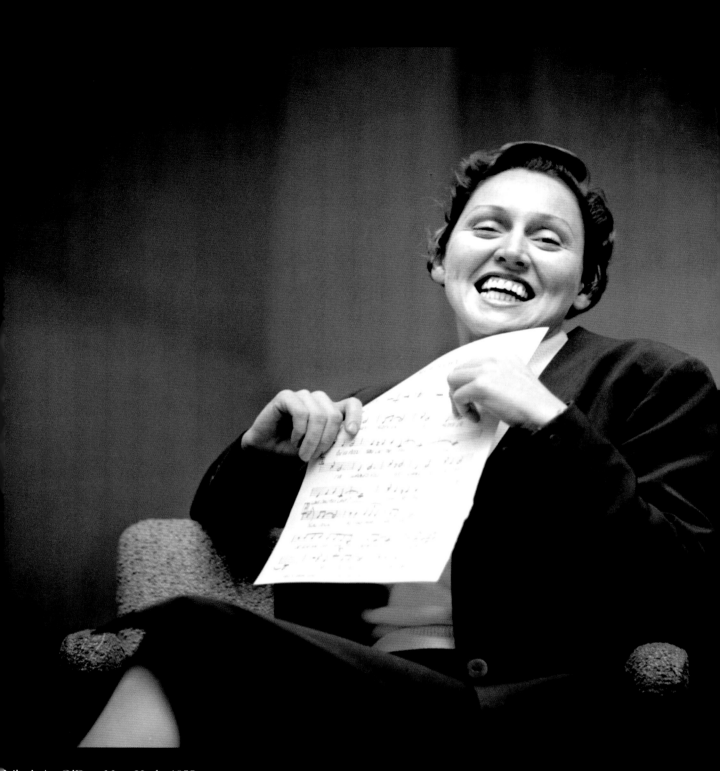

Both: Anita O'Day, New York, 1955

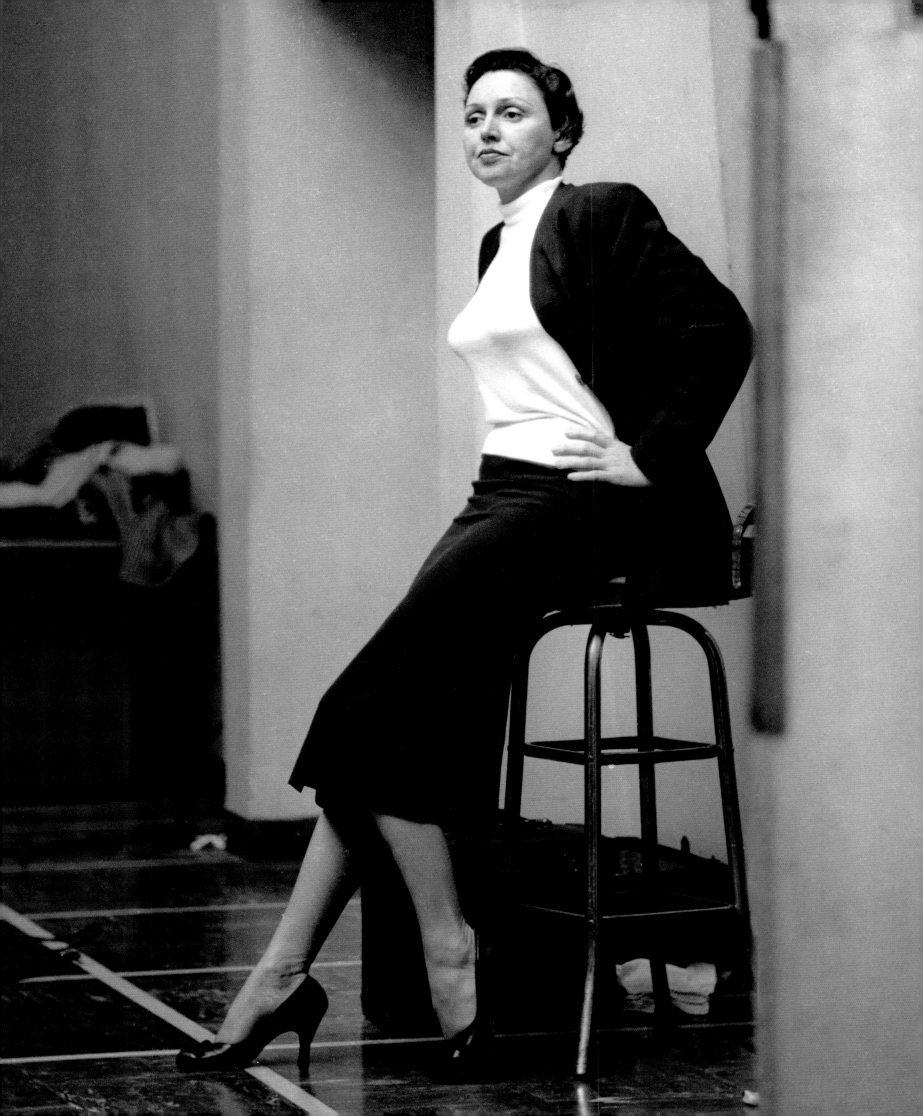

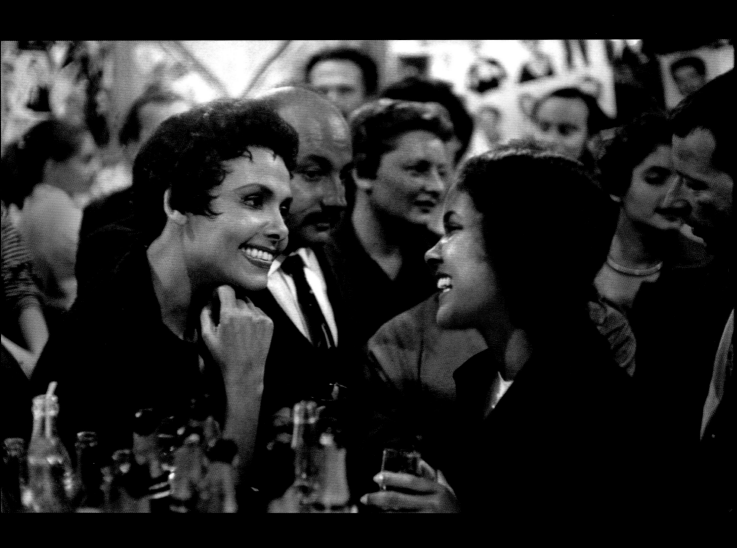

Lena Horne and Marpessa Dawn, Paris, 1958

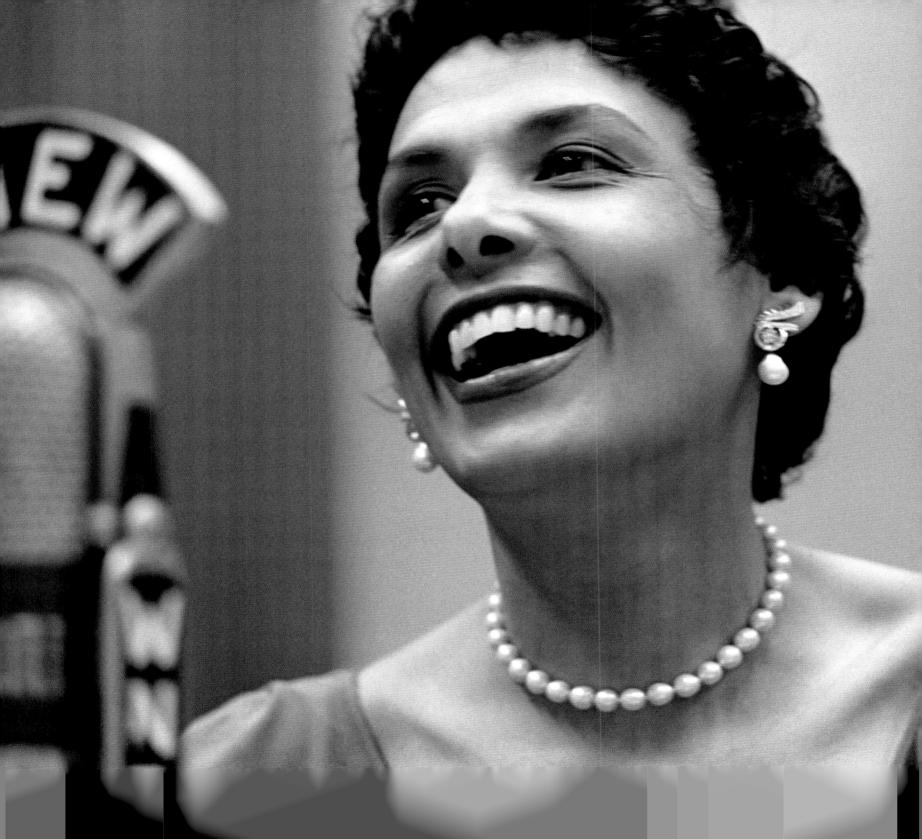

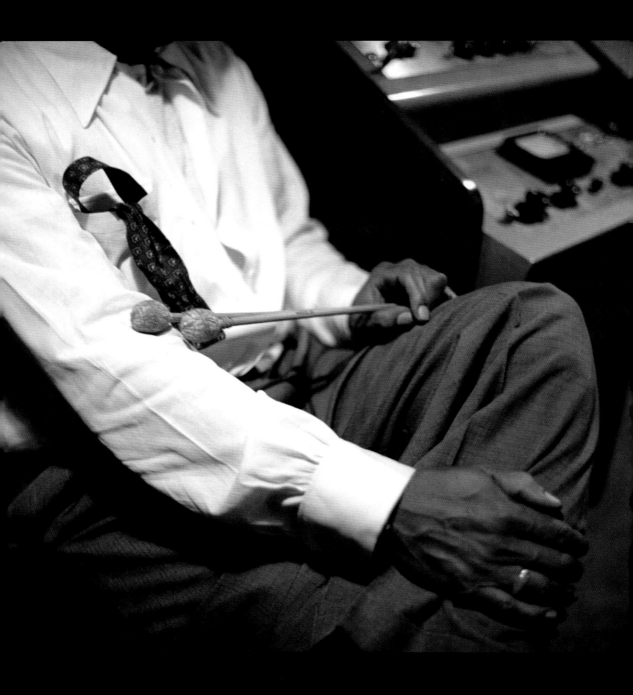

Both: Lionel Hampton, New York, 1954

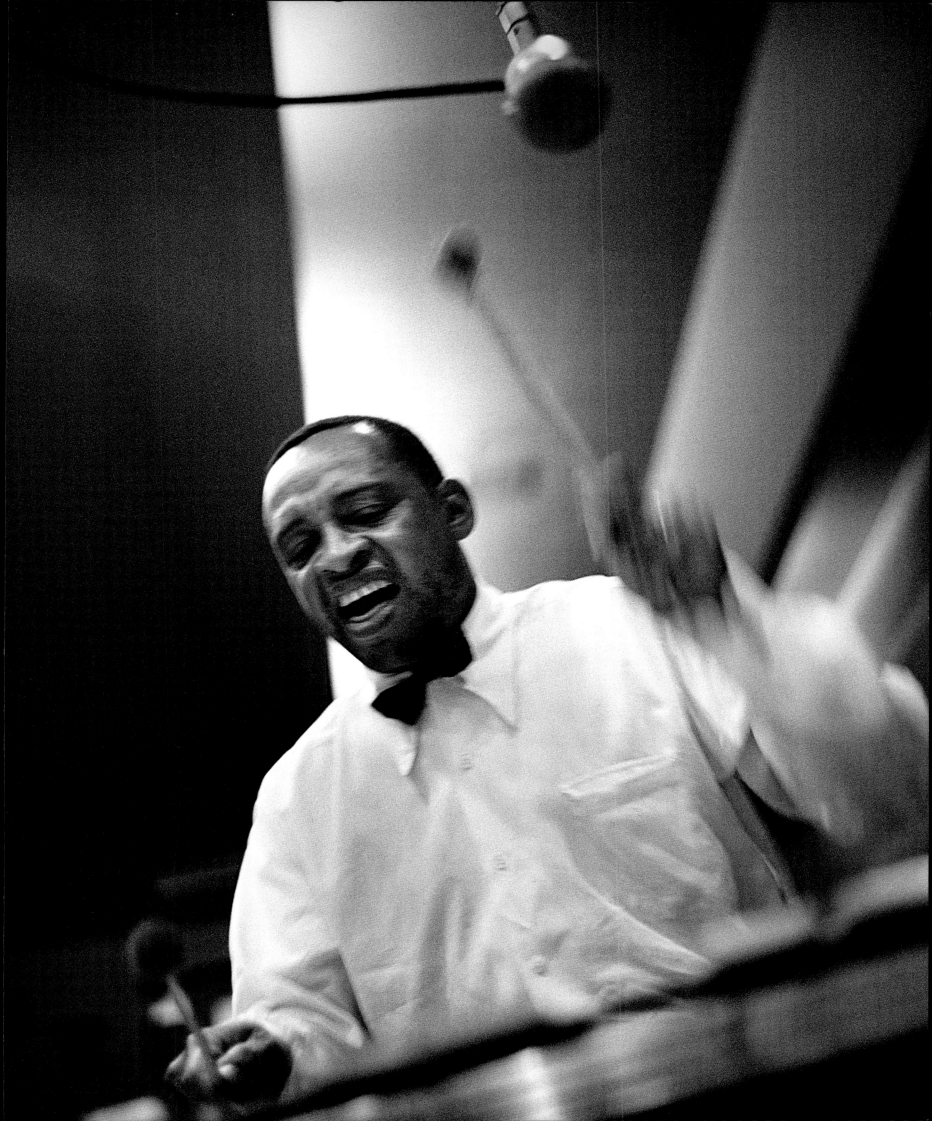

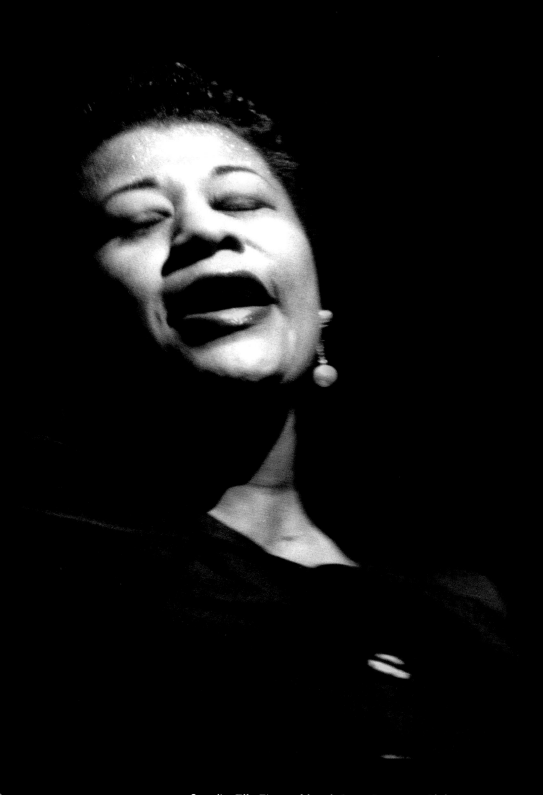

Ella Fitzgerald, Paris, 1958

Opposite: Ella Fitzgerald and Oscar Peterson, Club Saint Germain, Paris, 1958

Overleaf: Roy Eldridge, Herb Ellis, Ray Brown and Ella Fitzgerald, Paris, 1958

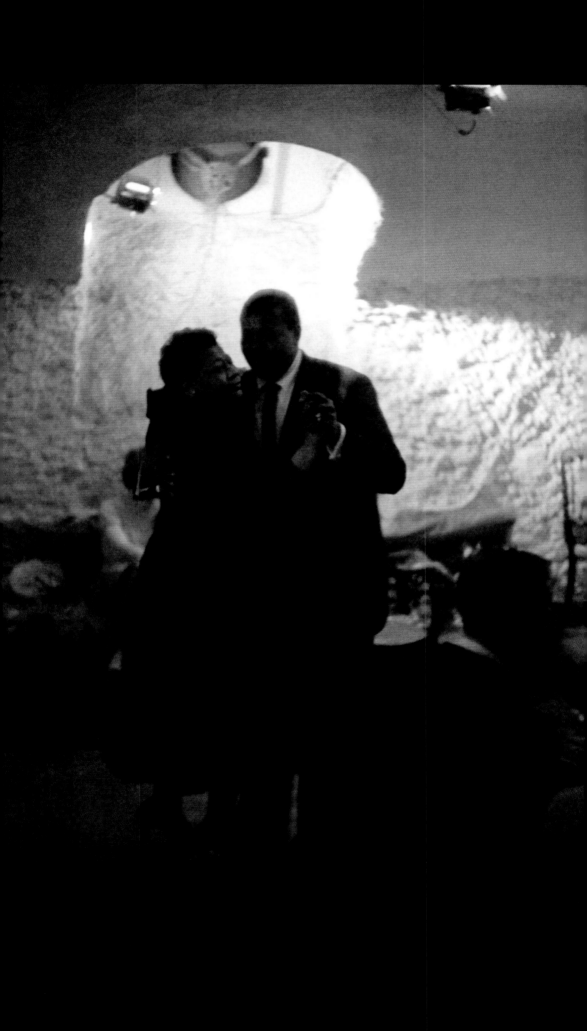

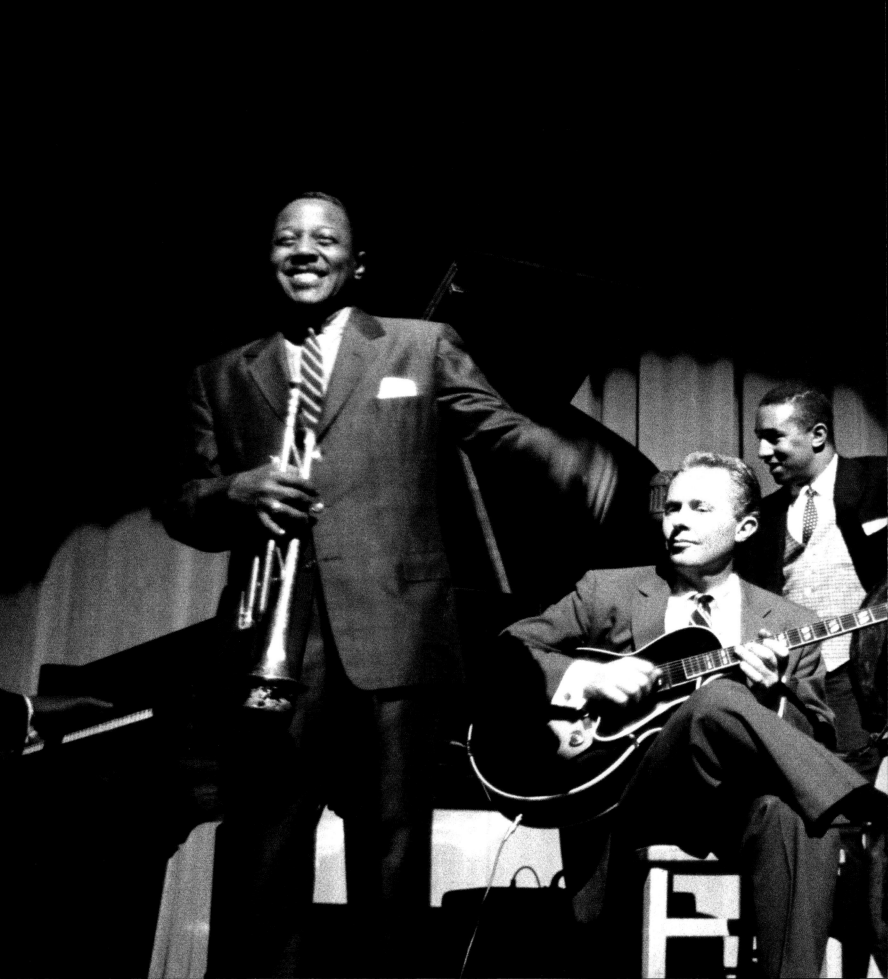

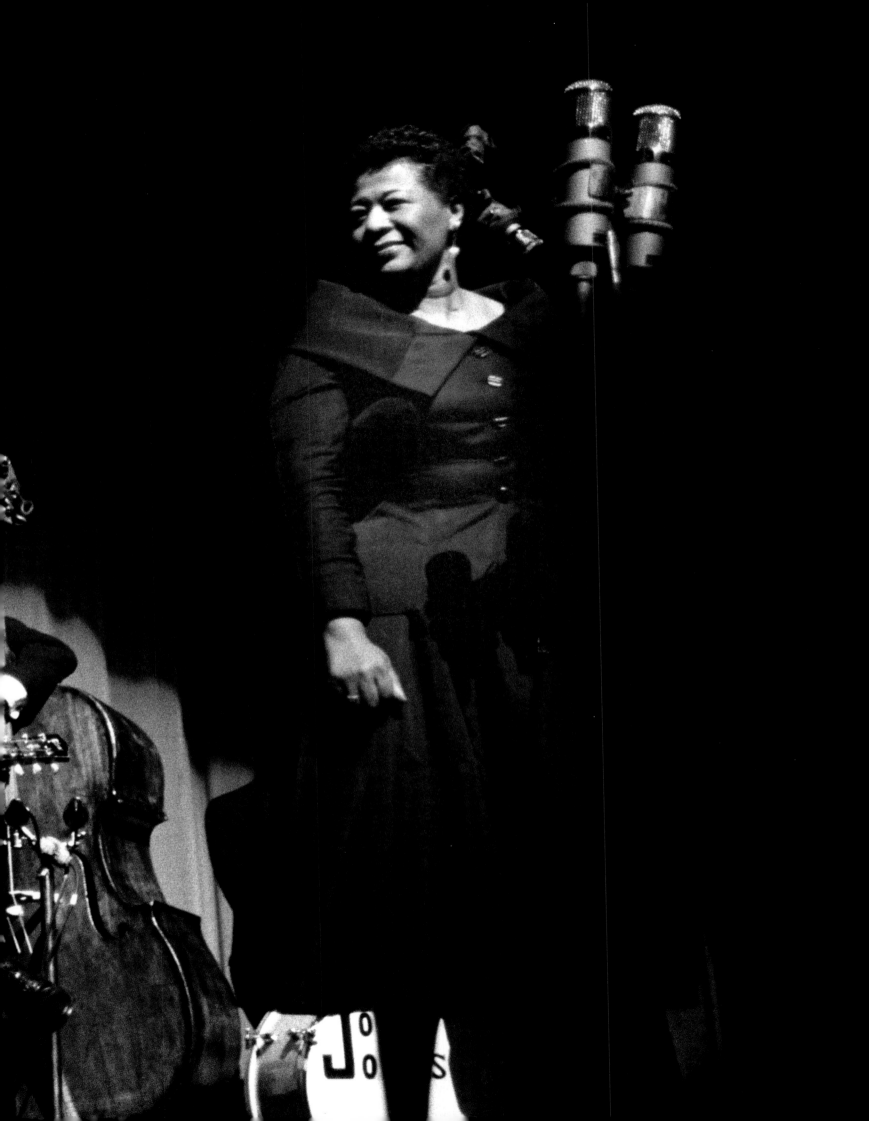

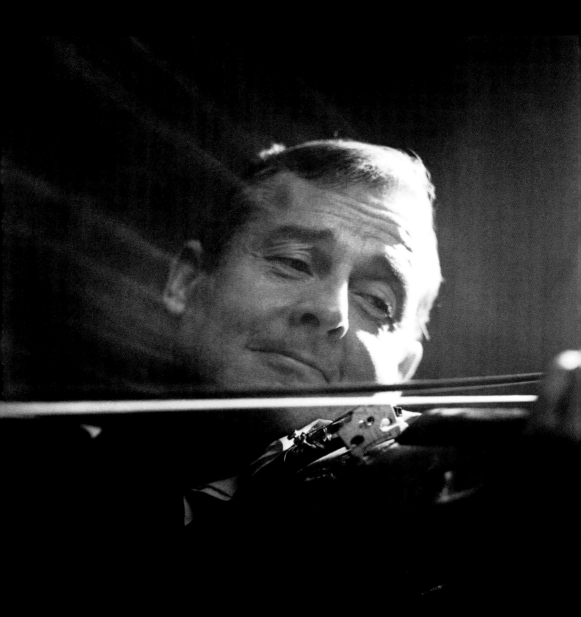

Stéphane Grappelli, Paris, 1958

Opposite: Stéphane Grappelli and Oscar Peterson, Paris, 1958

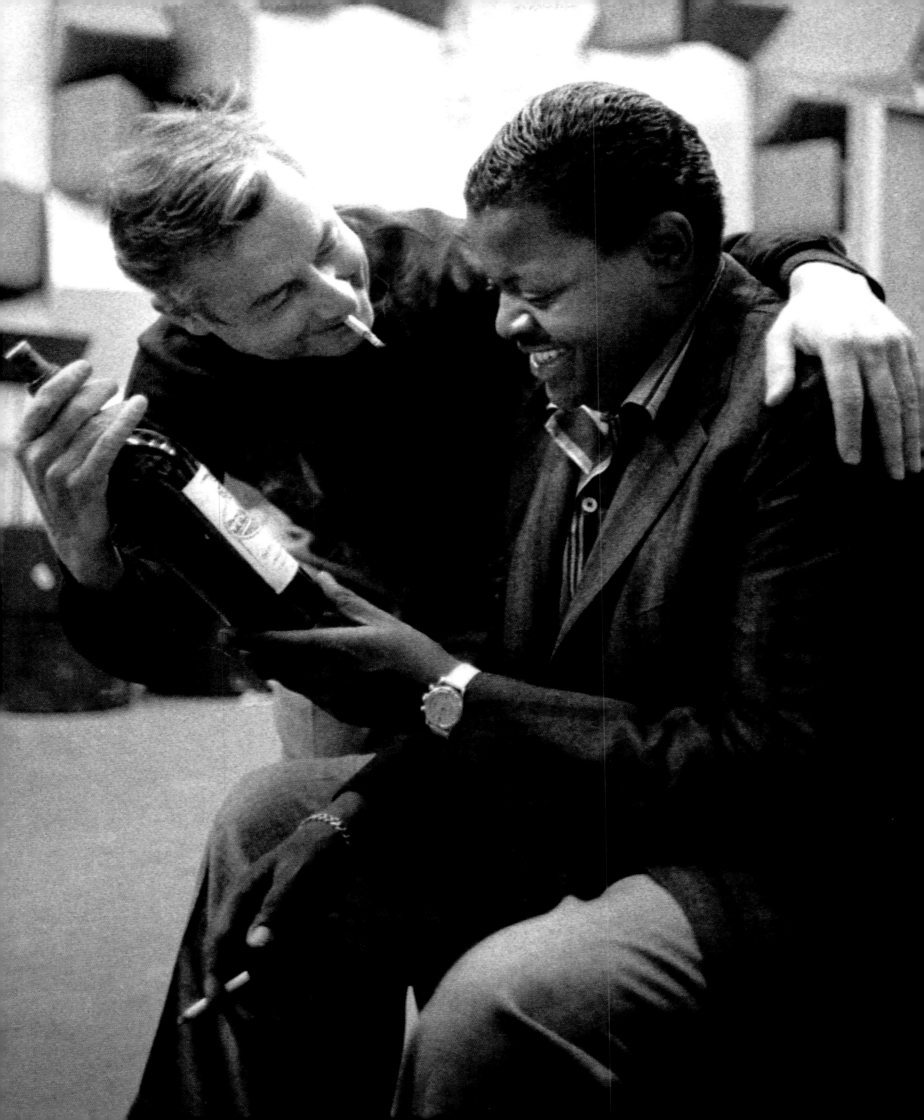

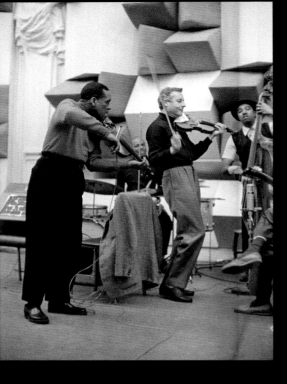

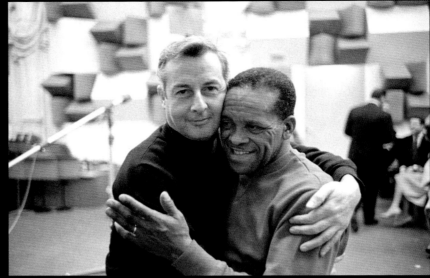

Above: Stéphane Grappelli and Stuff Smith, Paris, 1958

Left: Stuff Smith, Papa Jo Jones, Stéphane Grappelli and Ray Brown, Paris, 1958

Below: Stuff Smith and Stéphane Grappelli, Paris, 1958

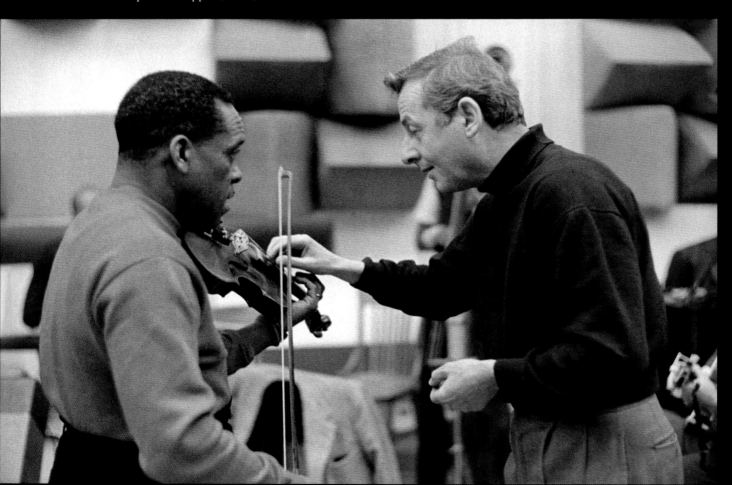

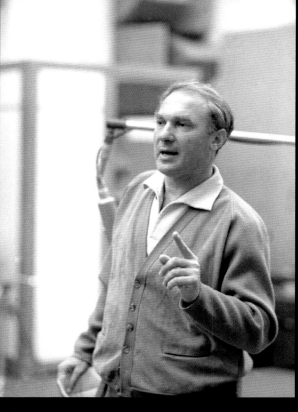

Left: Norman Granz, Paris, 1958

Below: Ray Brown and Oscar Peterson, Paris, 1958

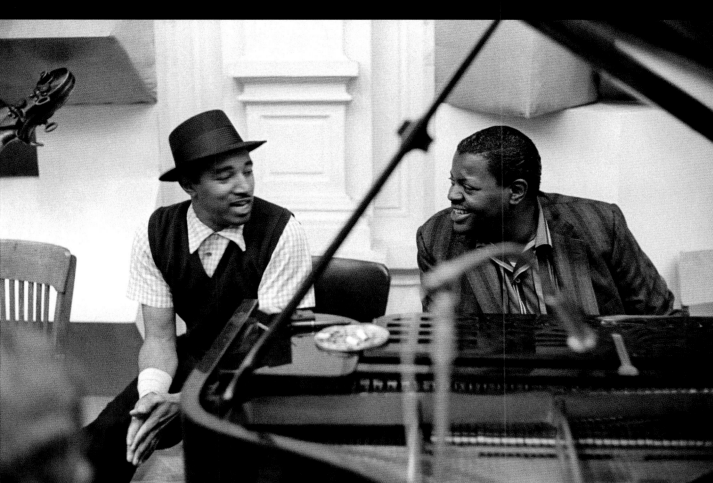

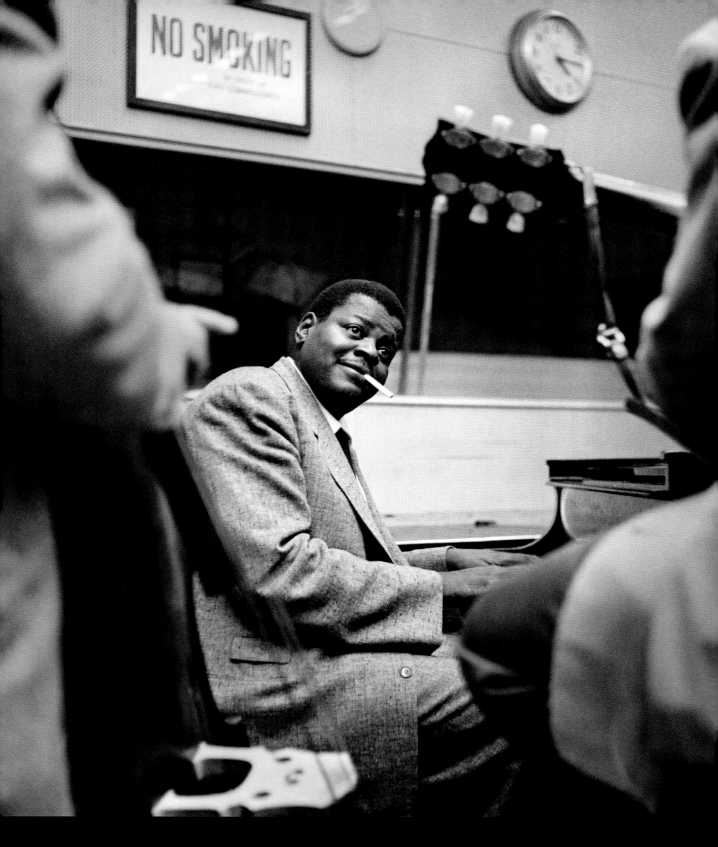

Oscar Peterson, New York, 1954

Opposite: Oscar Peterson, Paris, 1959

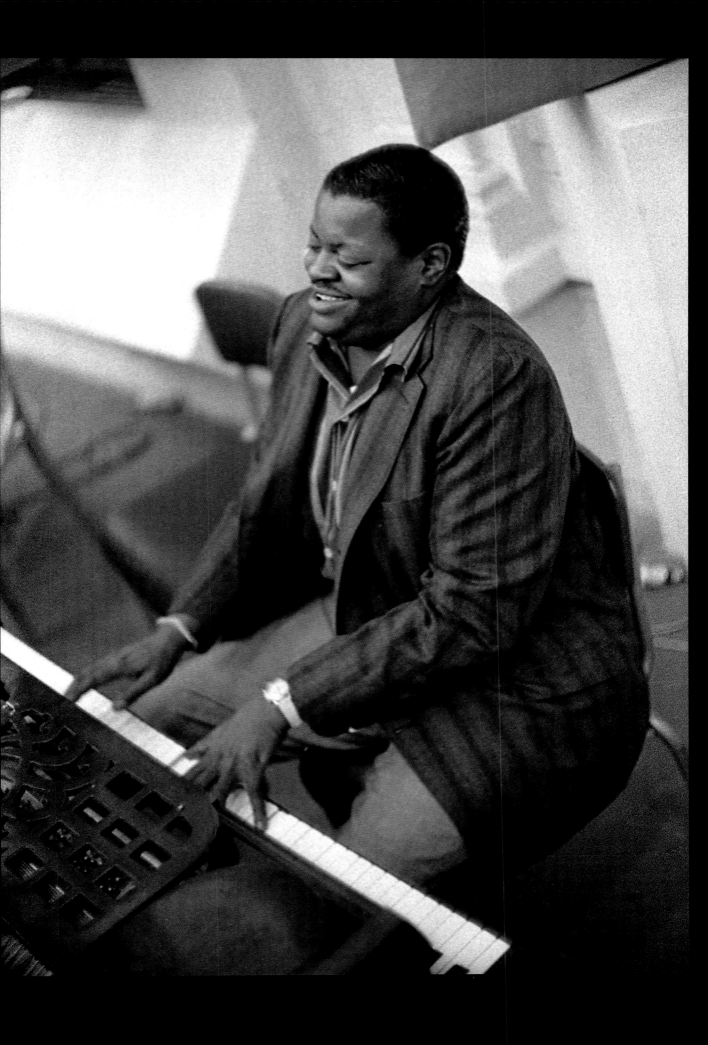

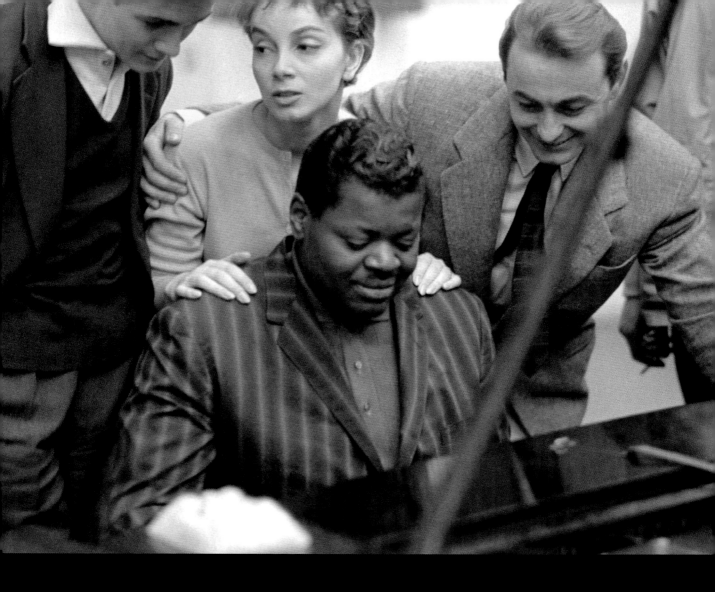

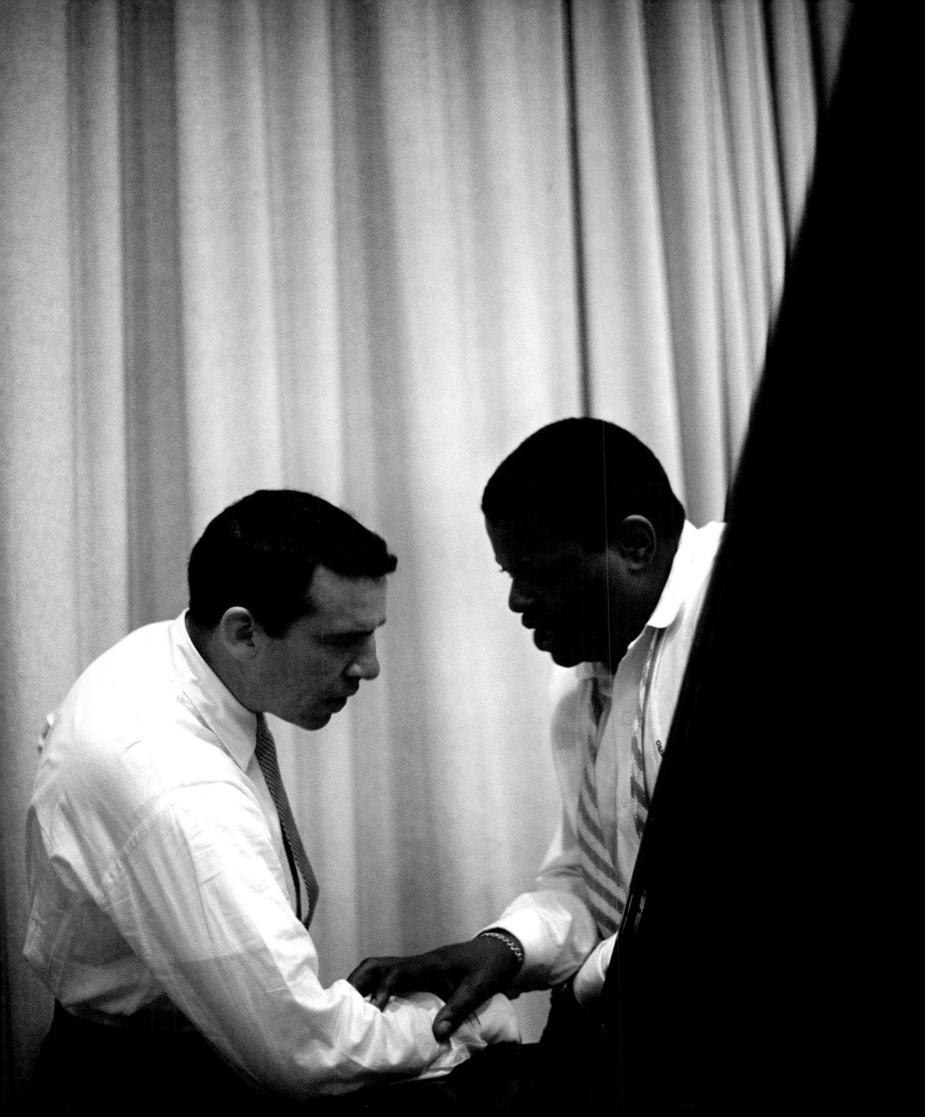

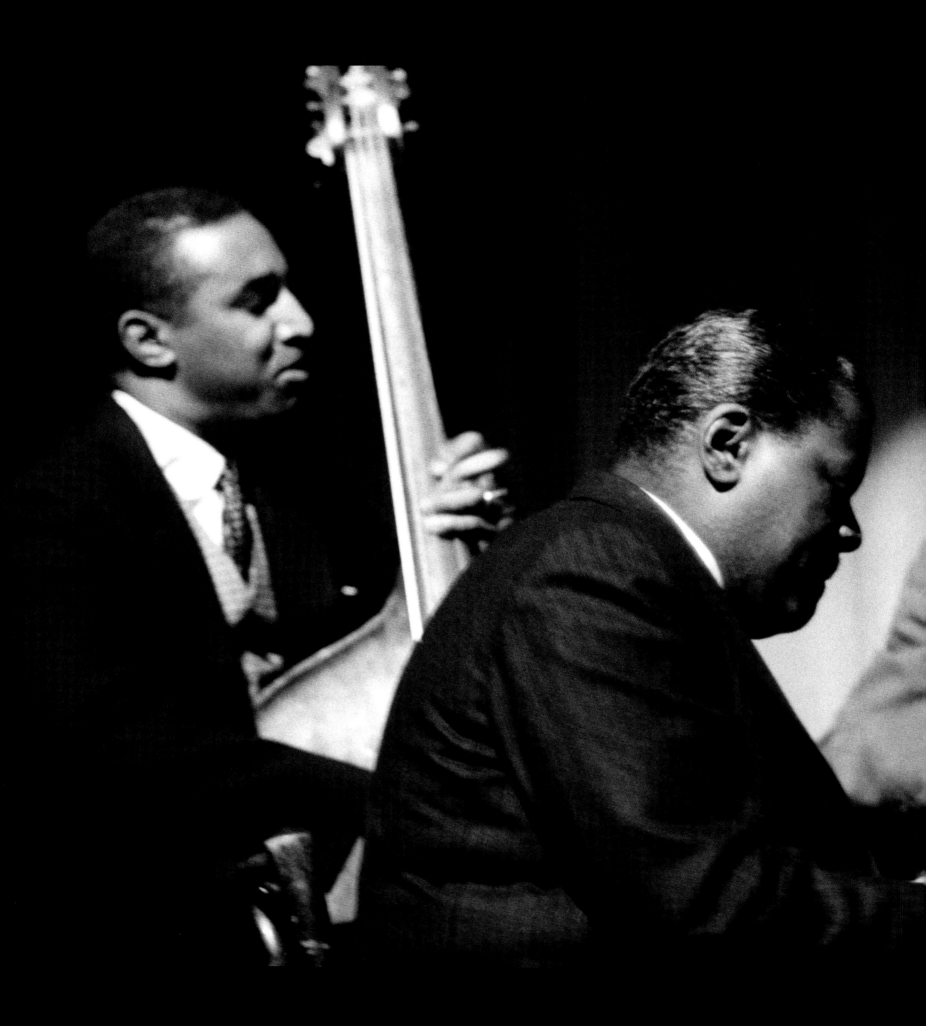

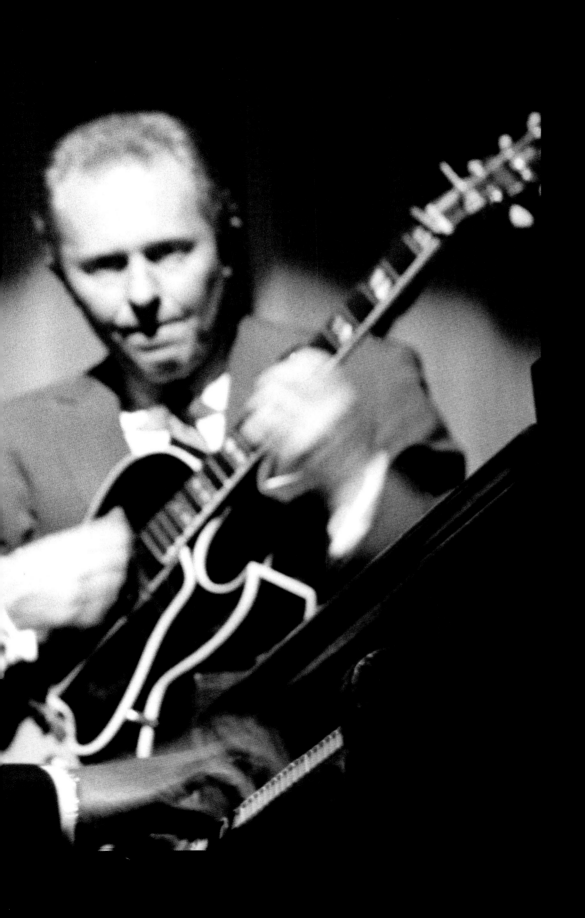

Ray Brown, Oscar Peterson
and Herb Ellis, Paris, 1958

Ben Webster, New York, 1950

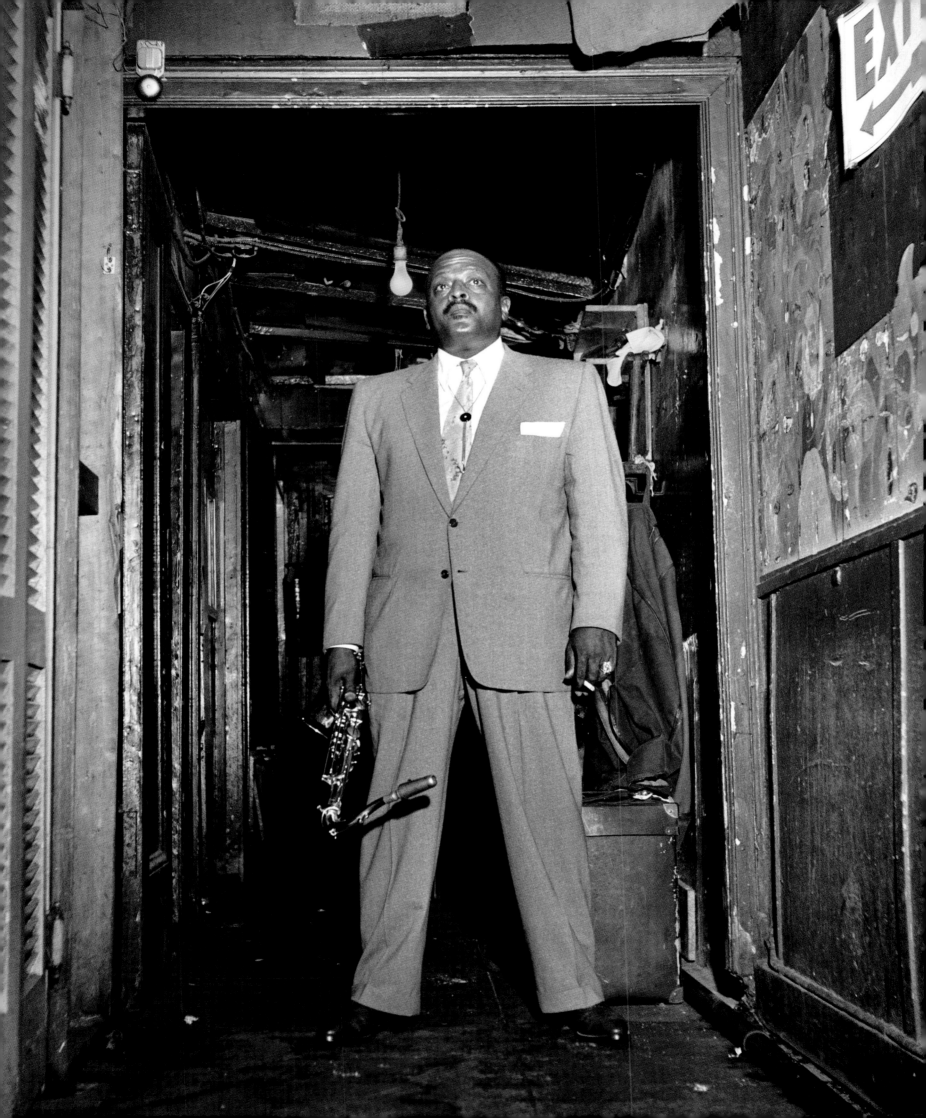

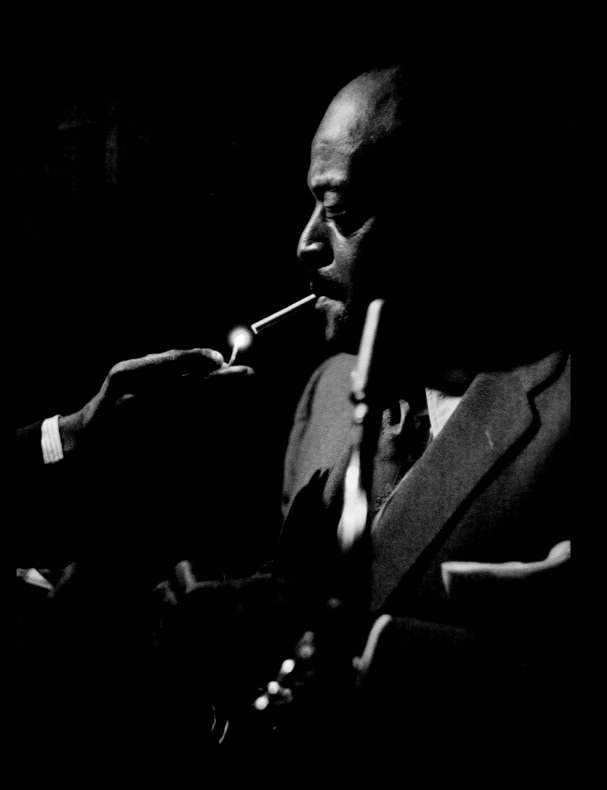

Both: Ben Webster, New York, 1950

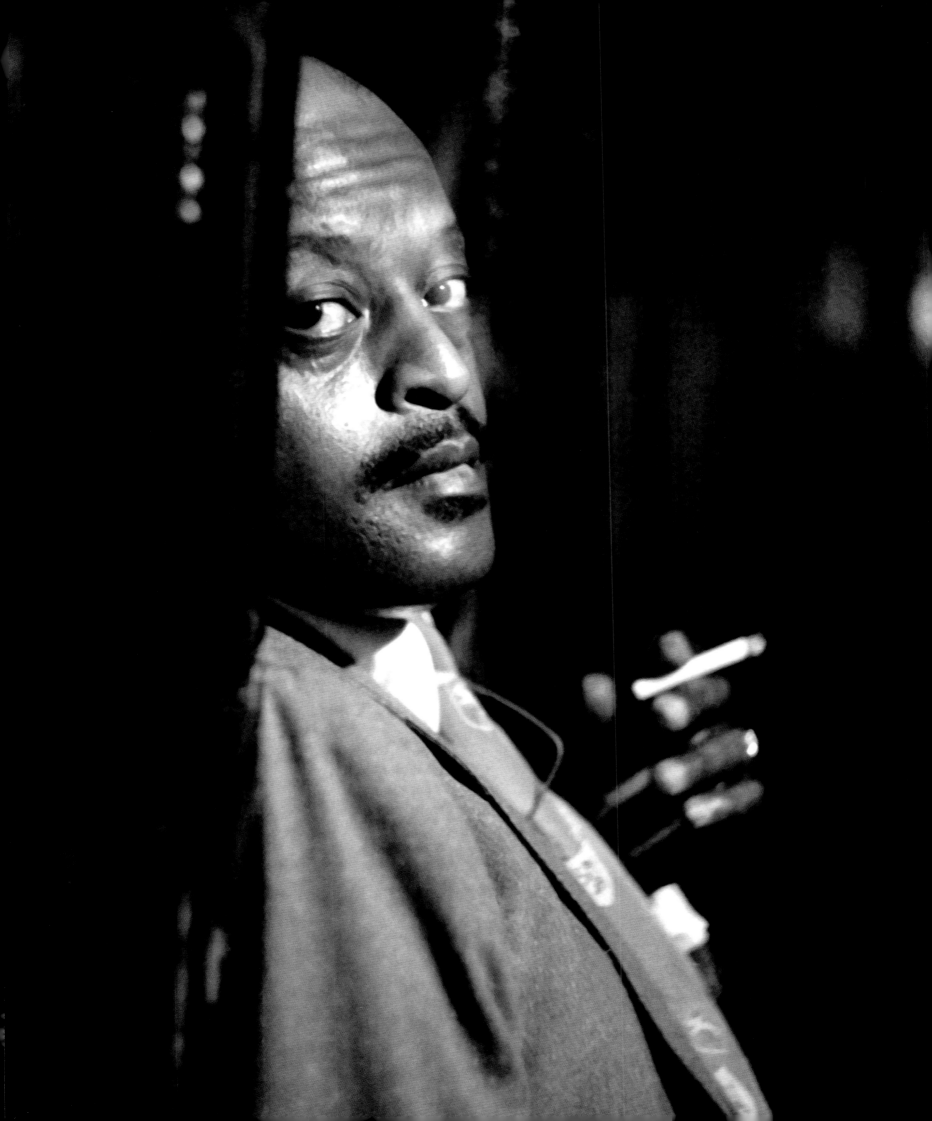

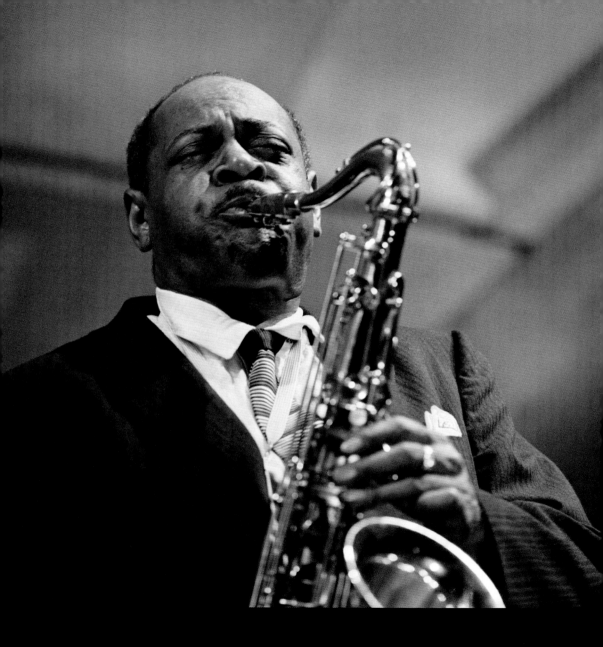

Coleman Hawkins, Newport Jazz Festival, 1955 **Opposite:** Zoot Sims, Paris, 1958

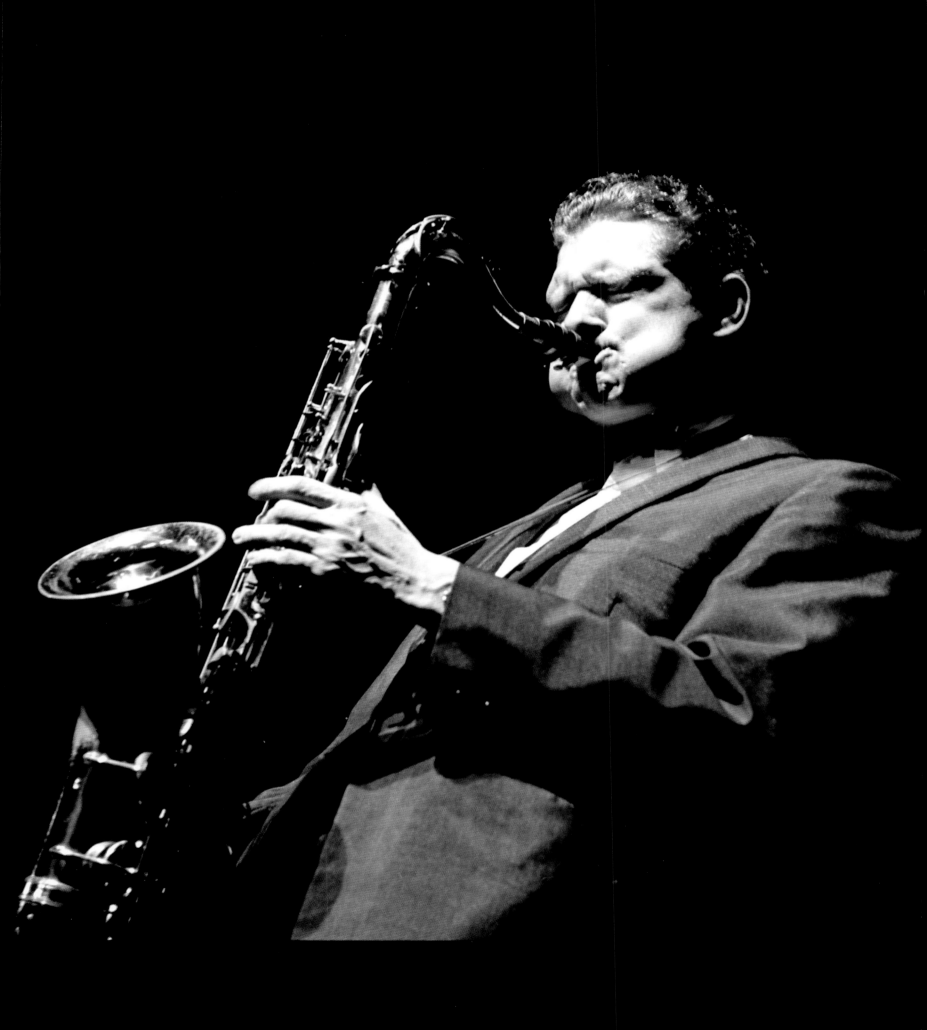

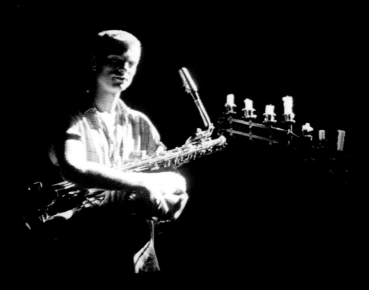

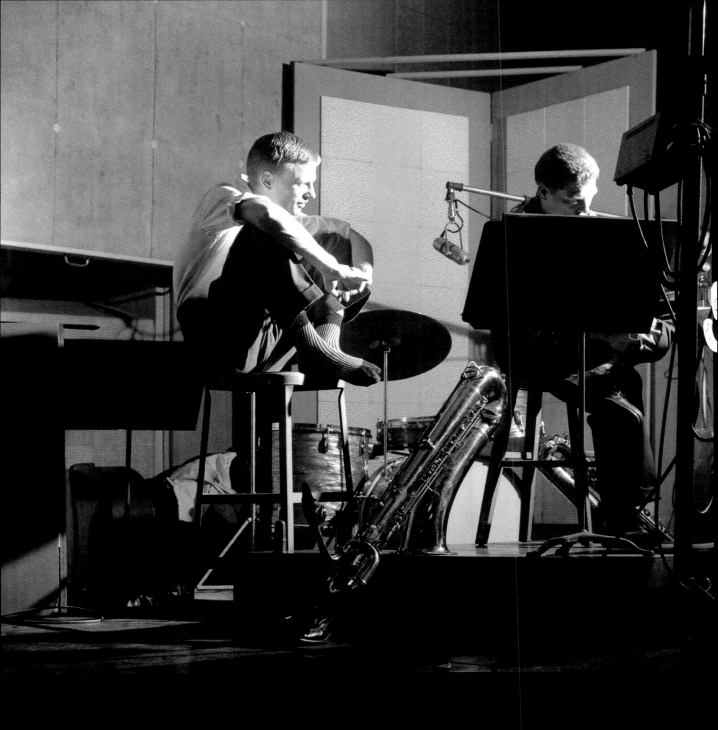

Gerry Mulligan, Newport Jazz Festival, 1955

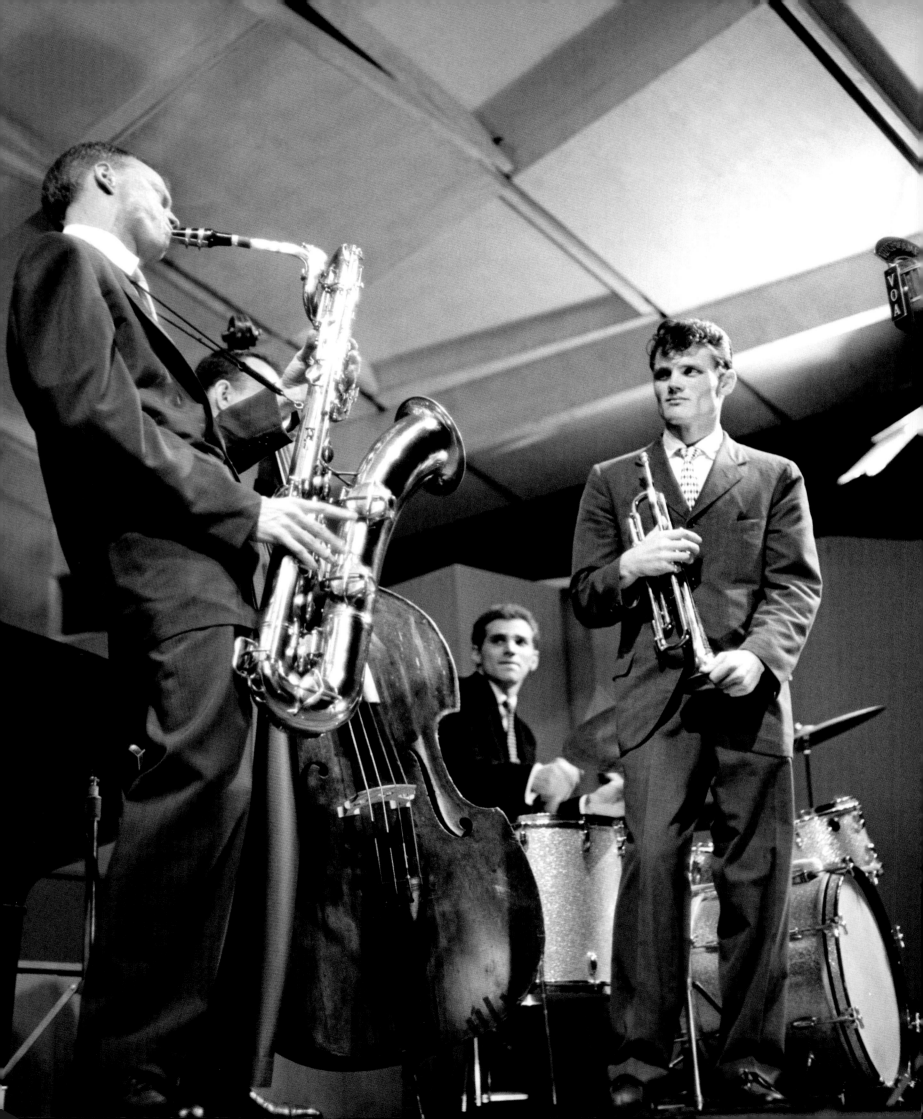

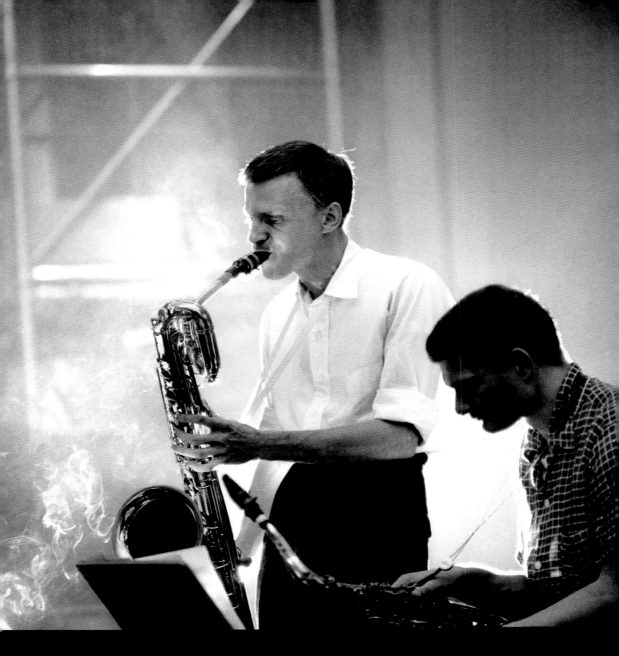

Gerry Mulligan, New York, 1955

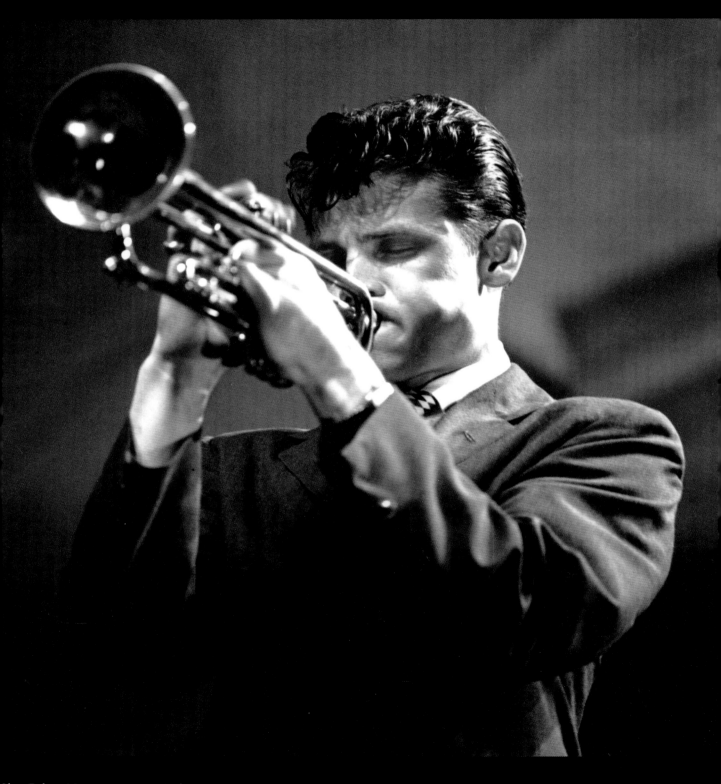

Chet Baker, Newport Jazz Festival, 1955

Opposite: Chet Baker, New York, 1955

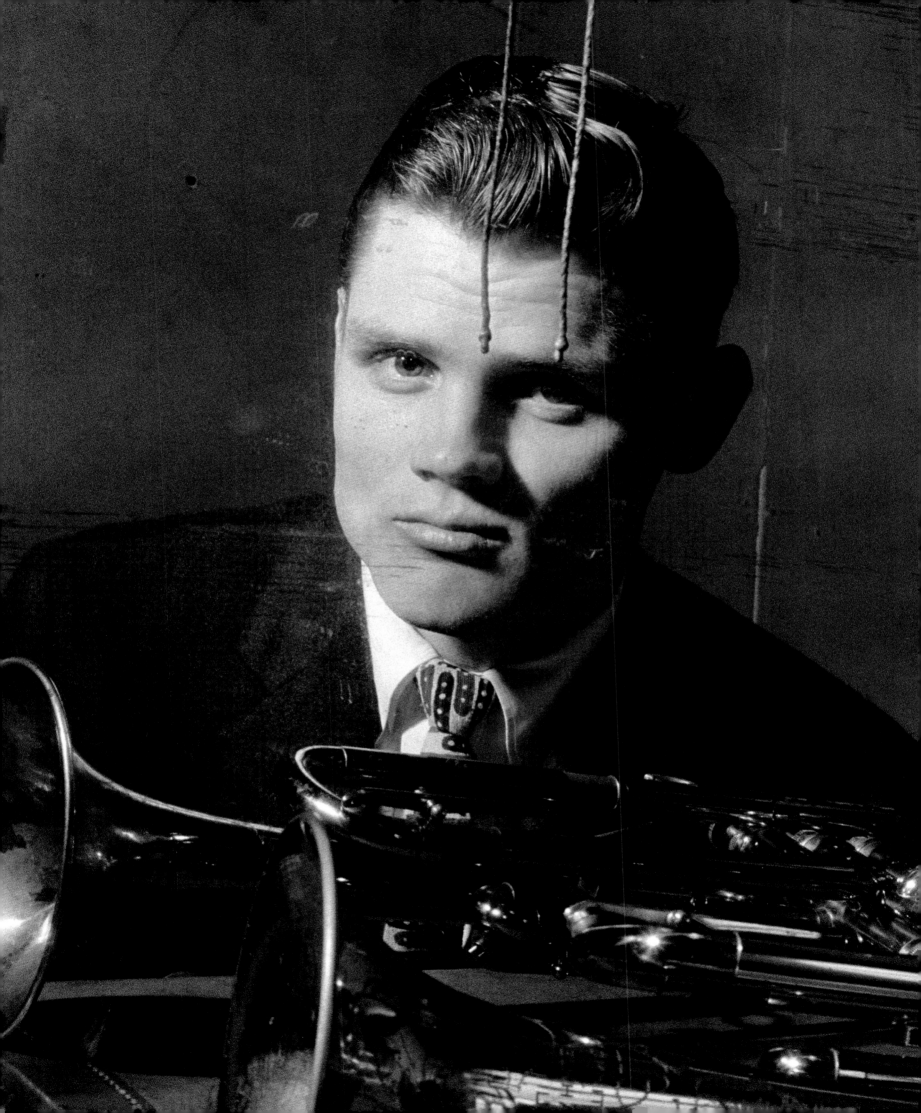

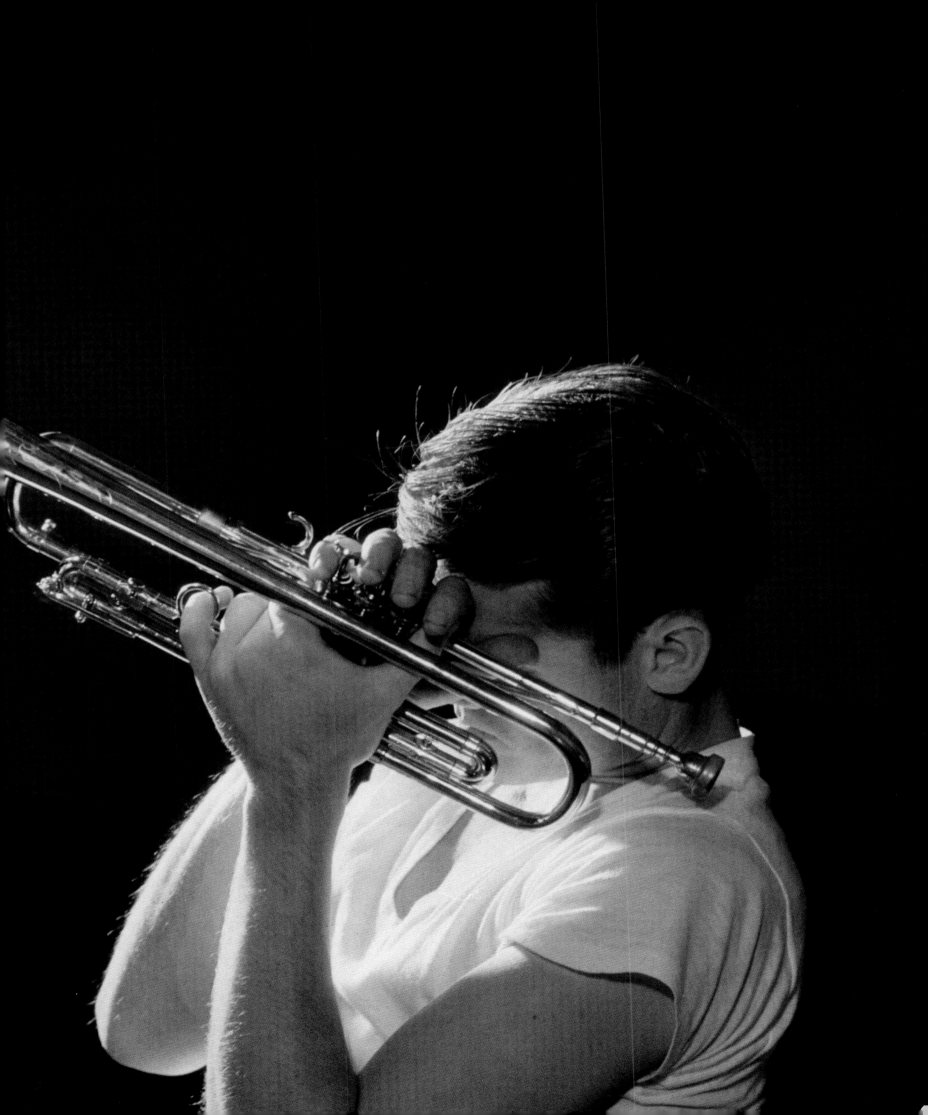

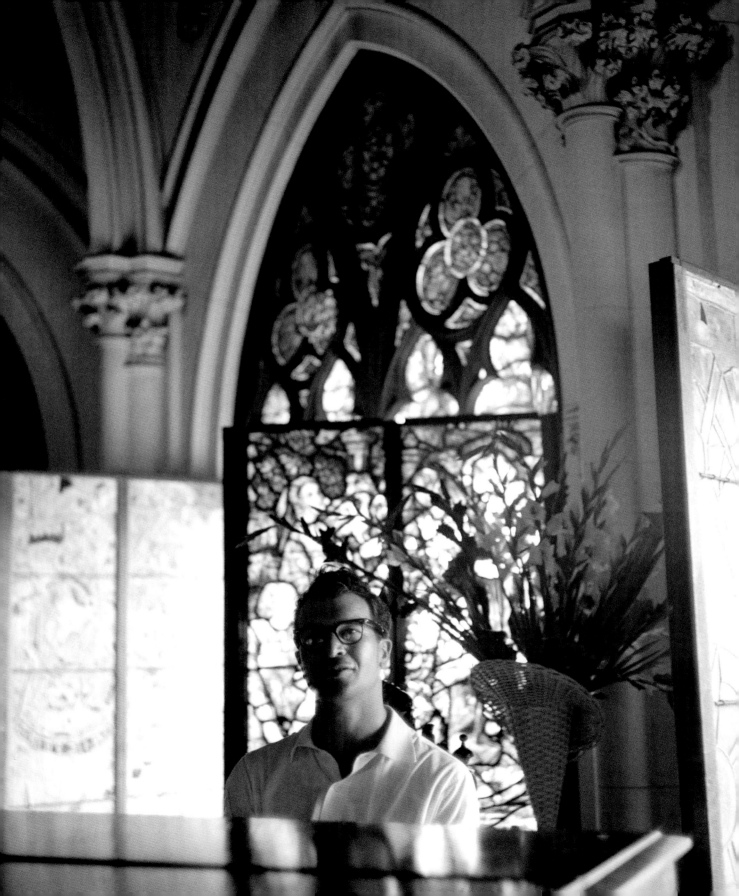

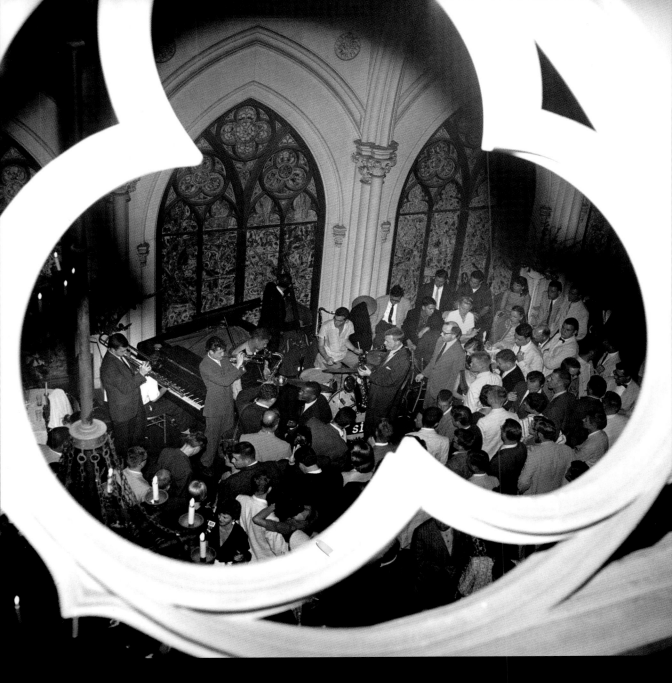

Bob Brookmeyer, Dave Brubeck, Chet Baker and Zoot Sims, Newport Jazz Festival, 1955

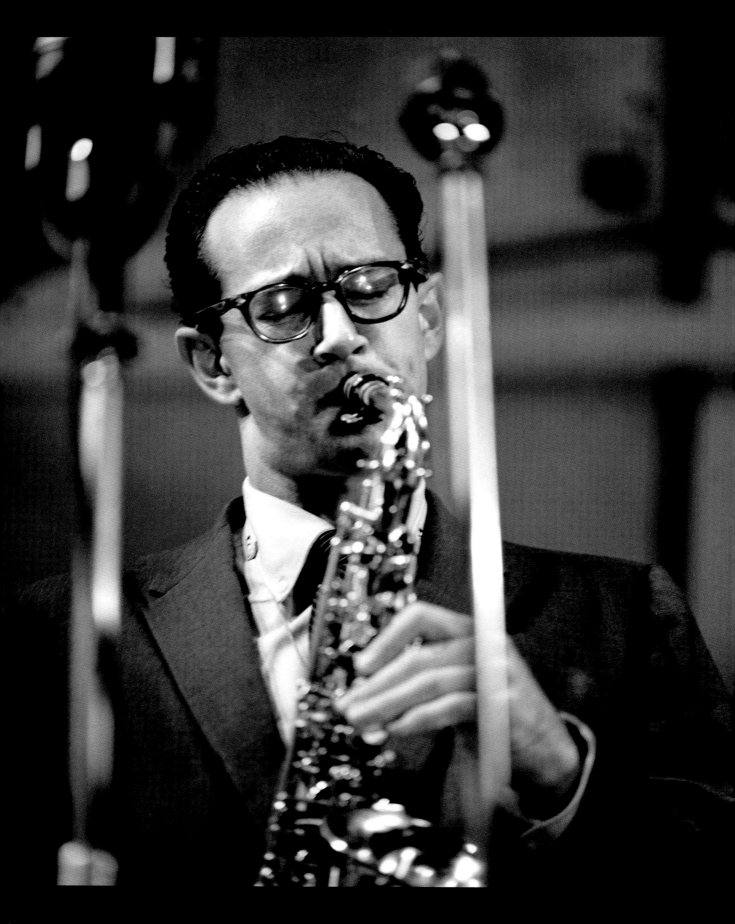

Opposite: Dave Brubeck, Los Angeles, 1953

Paul Desmond, Newport Jazz Festival, 195?

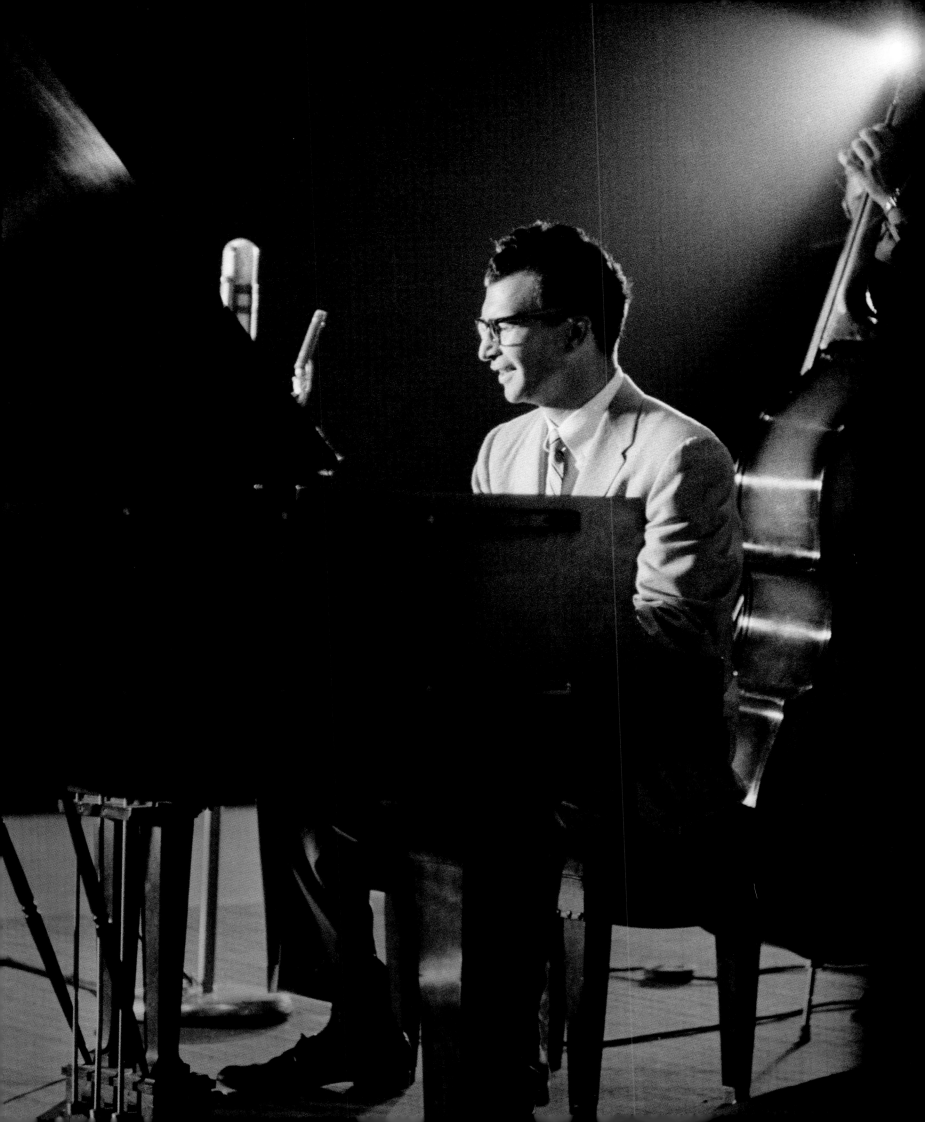

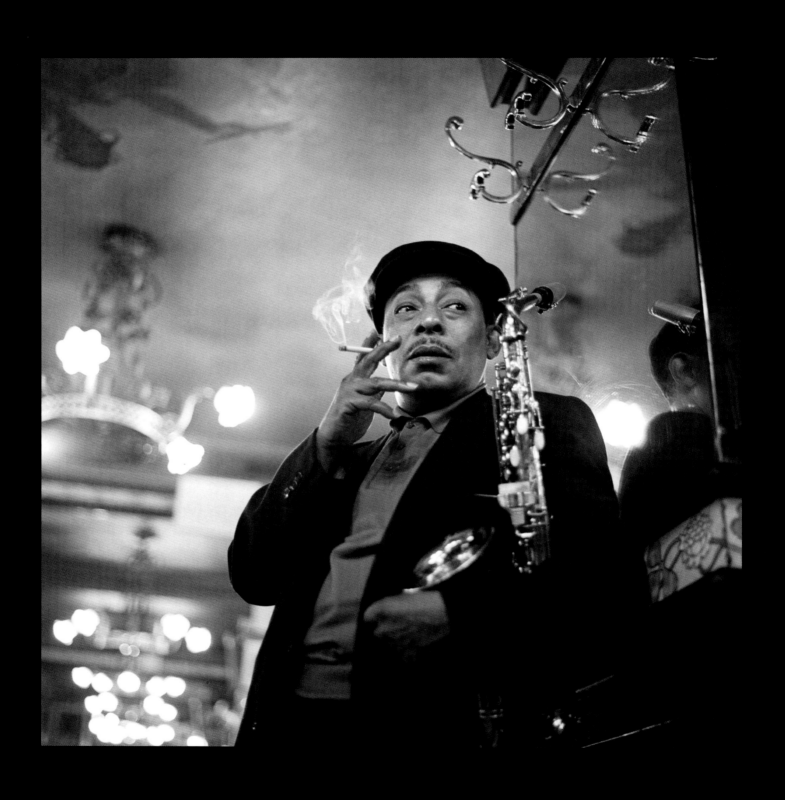

Both: Johnny Hodges, Paris, 1958

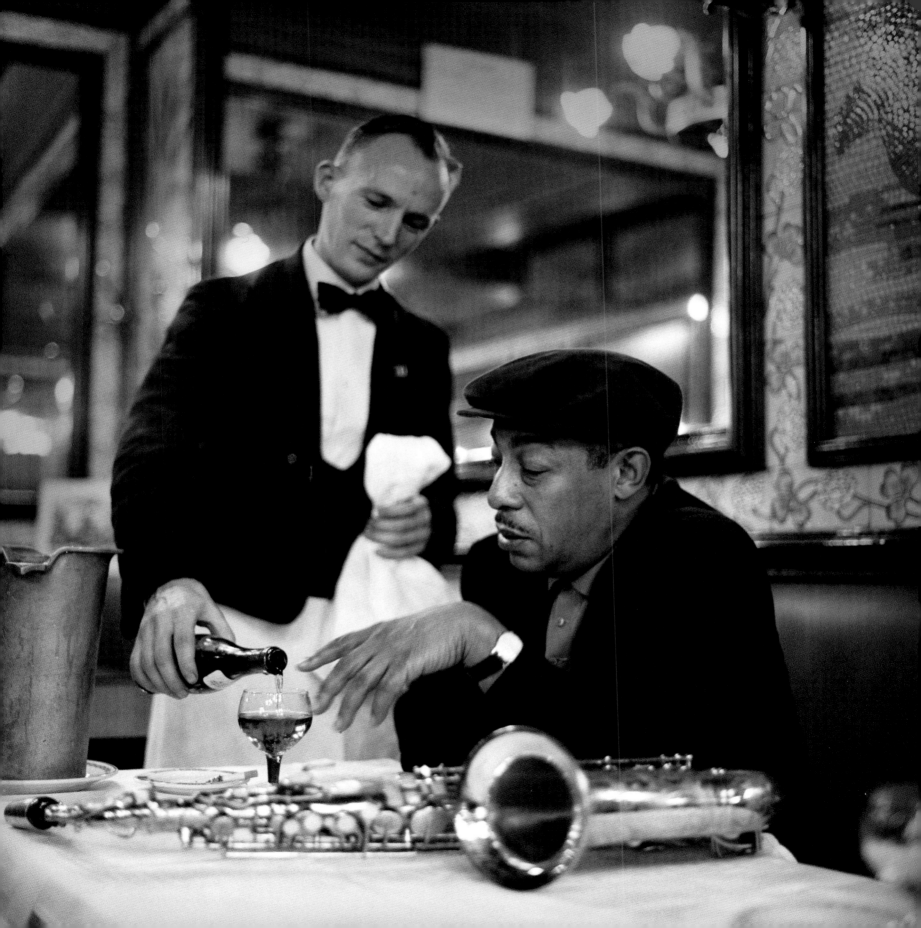

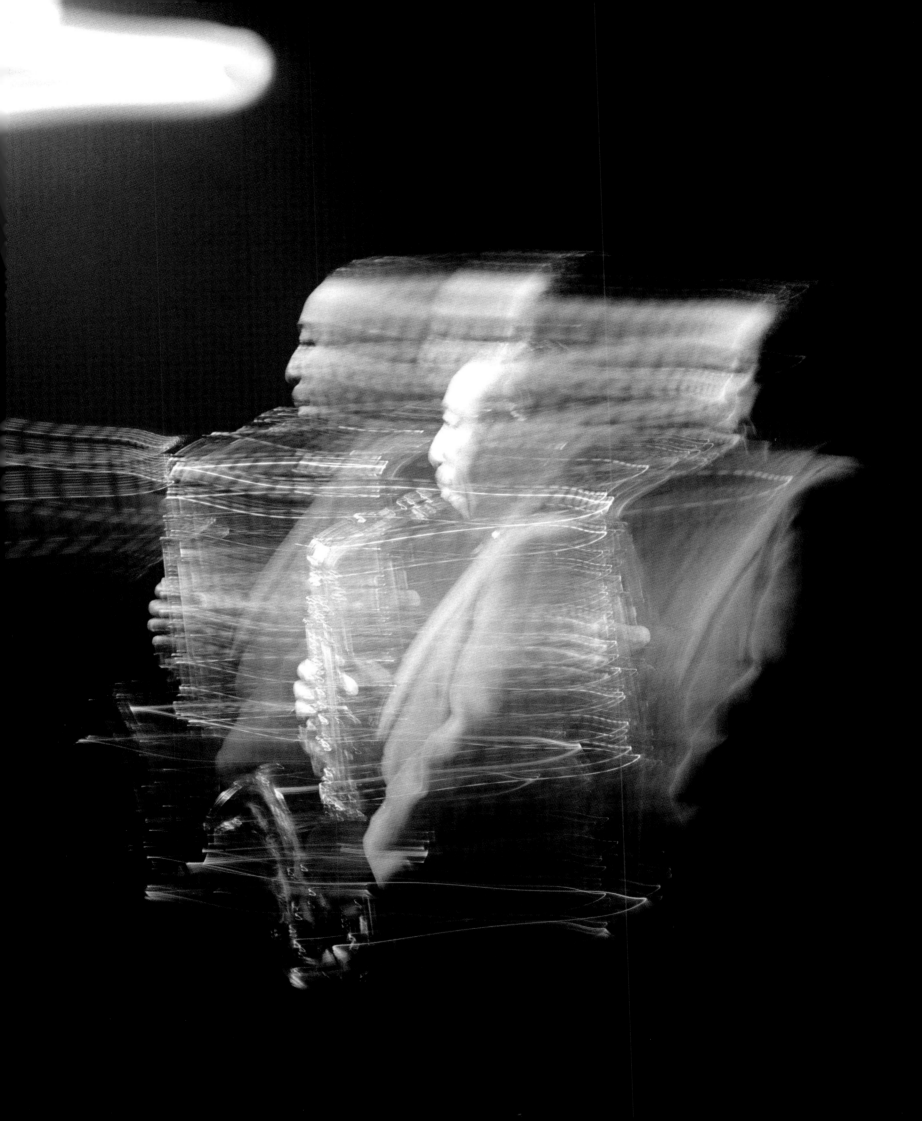

Cannonball Adderley, New York, 1956

WASHINGTON-CENTERVILLE
PUBLIC LIBRARY
05/23/2018

Jazz / Herman Leonard.

Barcode 33508012531706

Due 06-13-18

Total items checked out: 1

You saved approximately $27 by
using your library card instead of
purchasing these items!

Thank you for visiting!

Call 433-8091 or visit wclibrary.info
to renew items.

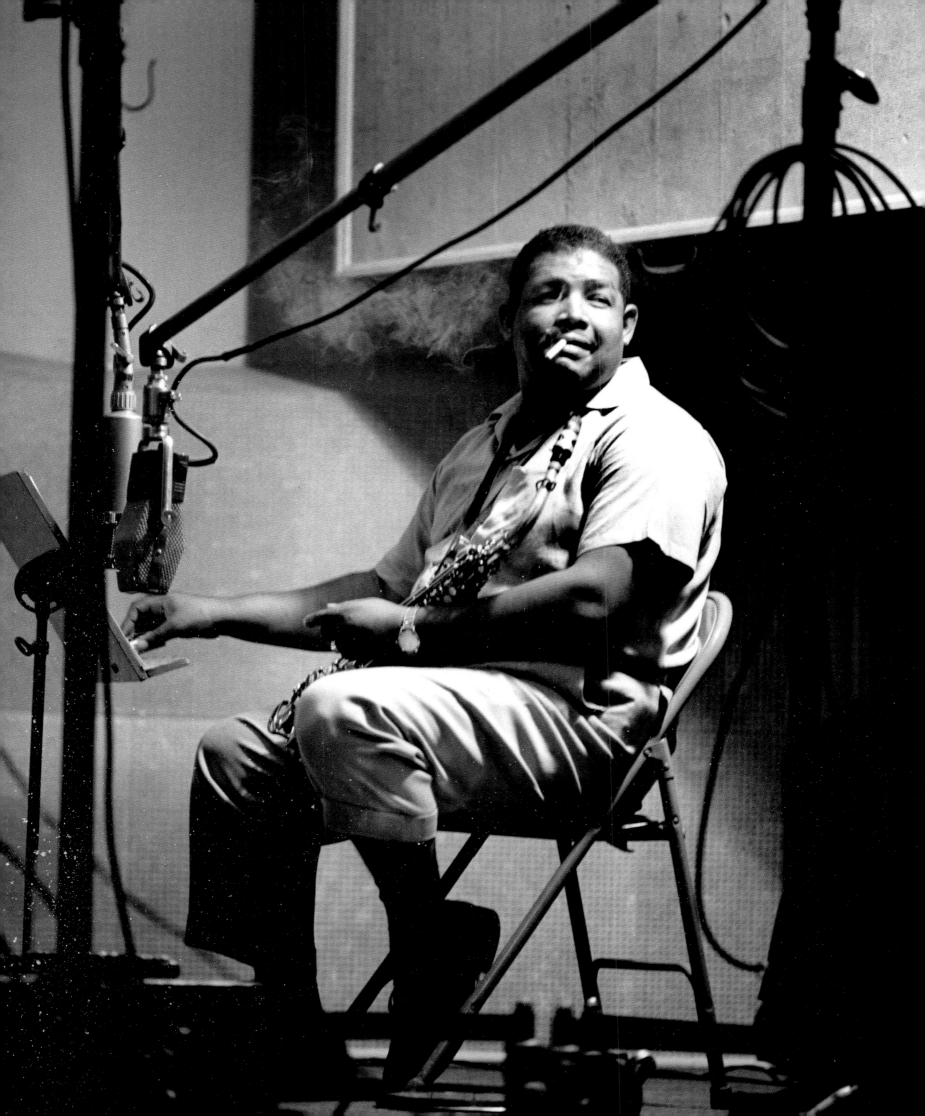

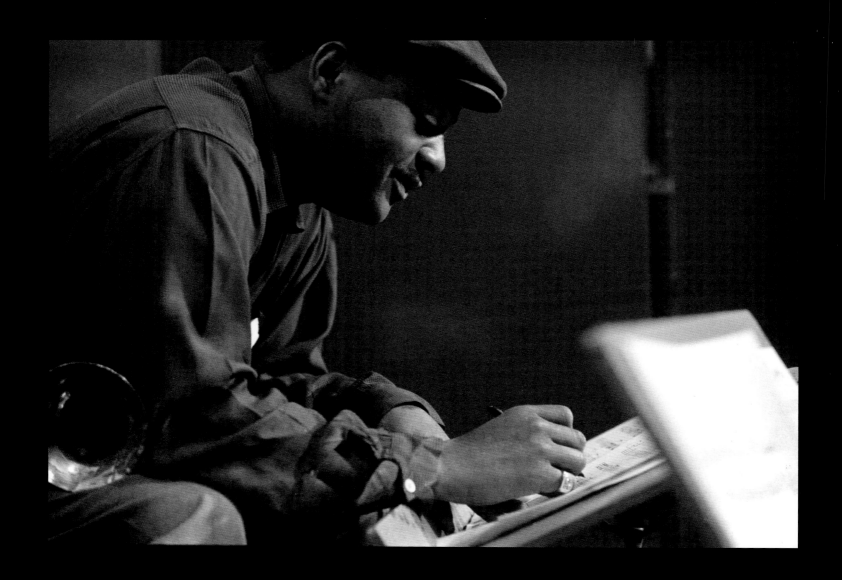

Both: Clark Terry, New York, 1953

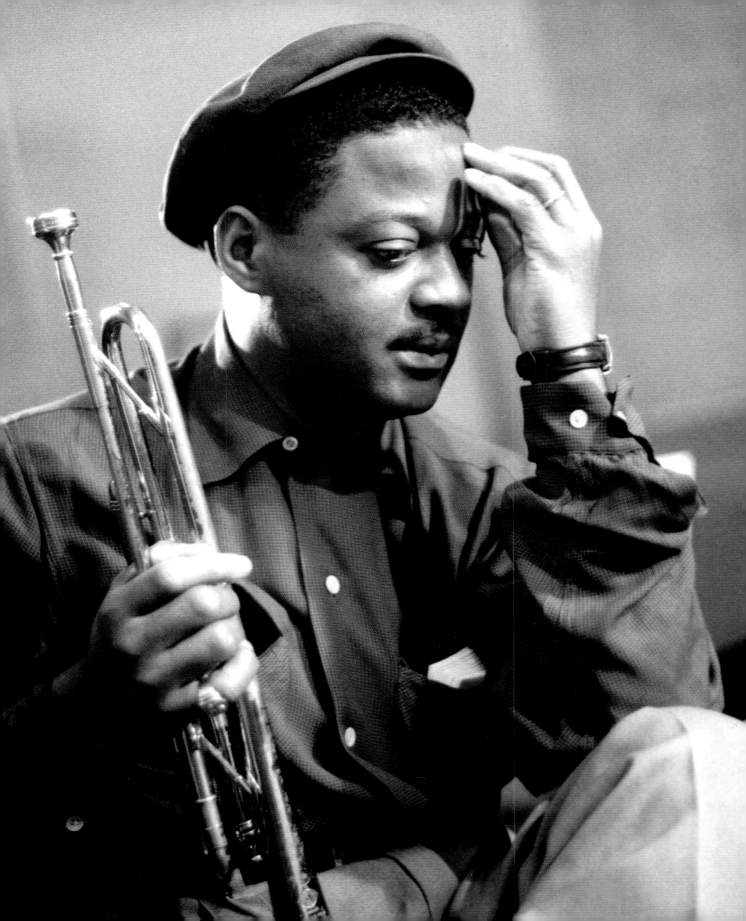

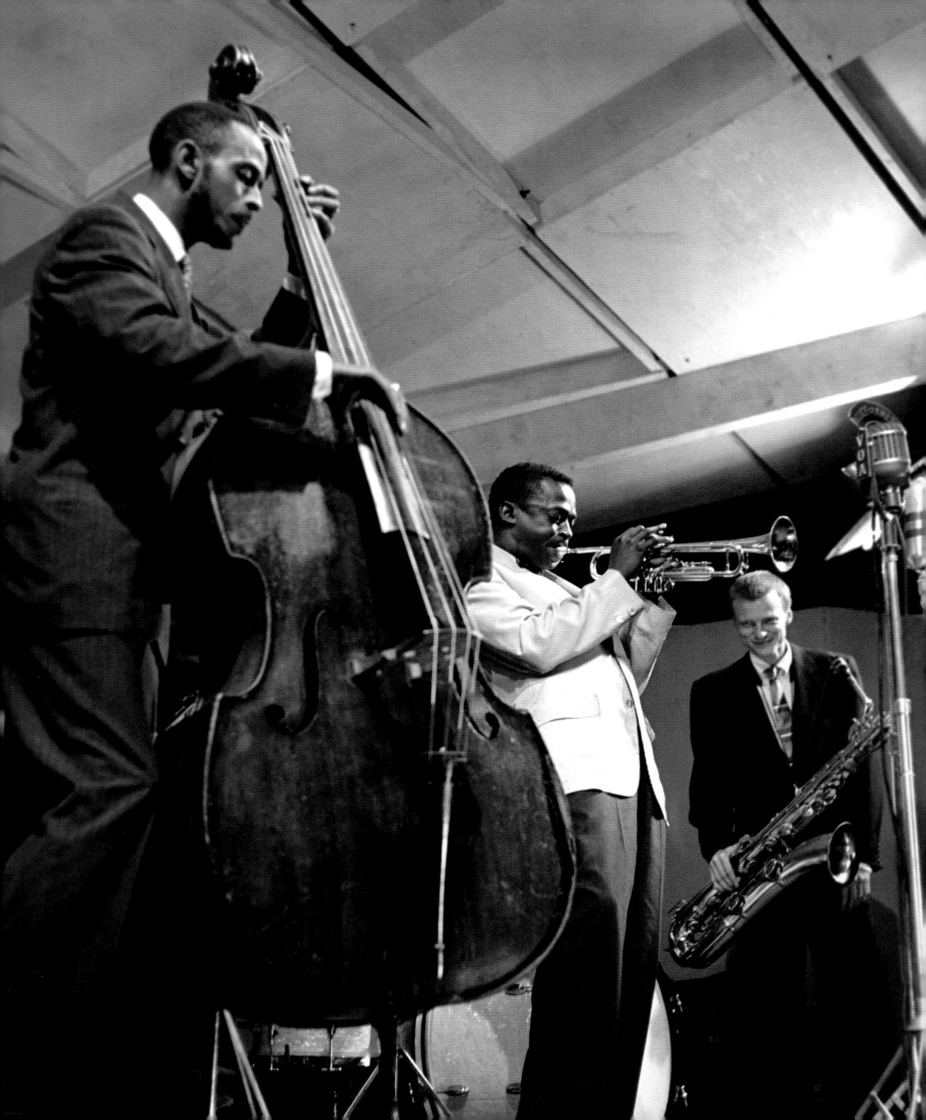

Percy Heath, Miles Davis and Gerry Mulligan,
Newport Jazz Festival, 1955

Overleaf: Miles Davis, New York, 1953

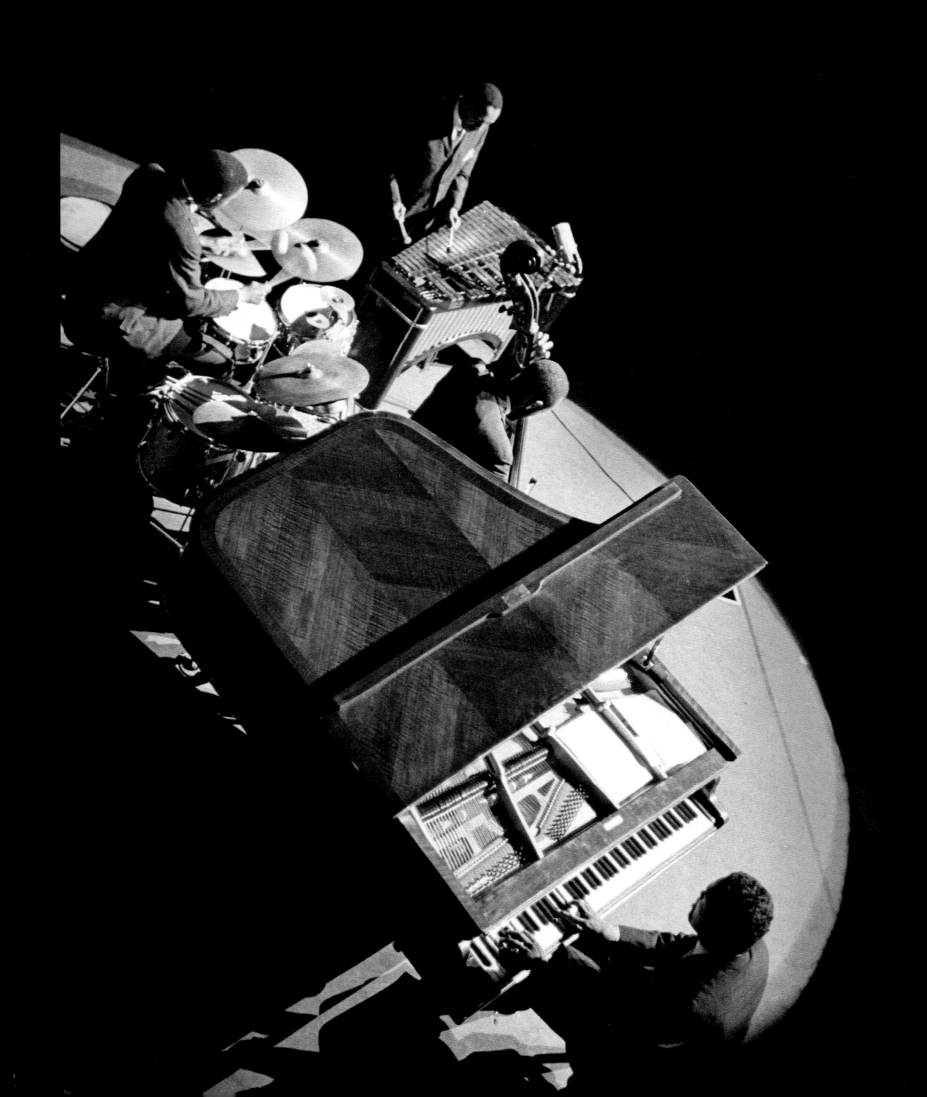

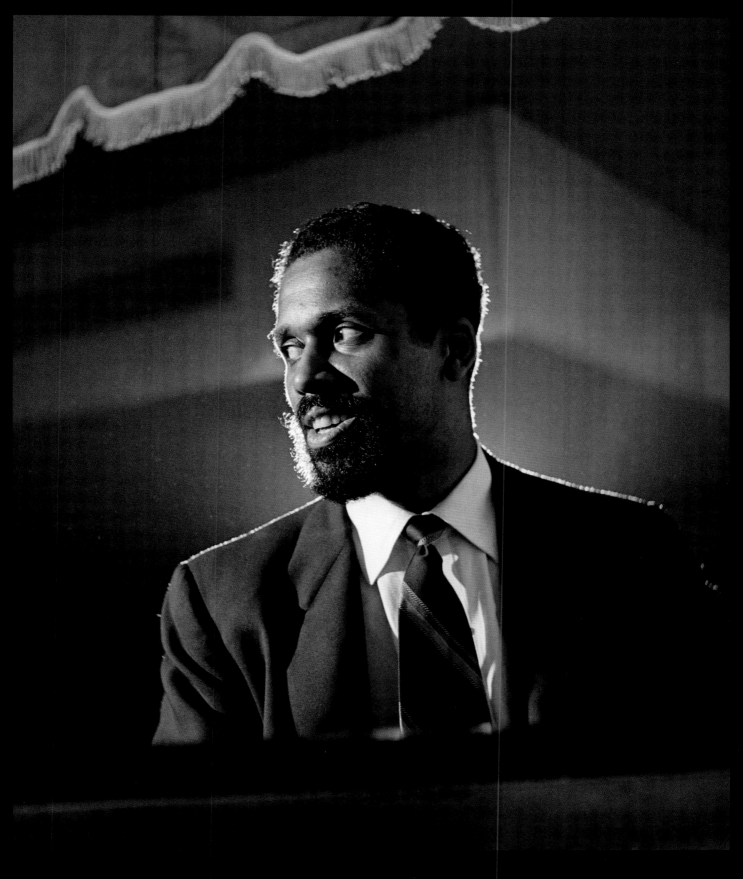

Opposite: The Modern Jazz Quartet, Paris, 1957:
John Lewis on Piano, Connie Kay on Drums,
Milt Jackson on Vibes and Percy Heath on Bass

John Lewis of The Modern Jazz Quartet, Paris, 1957

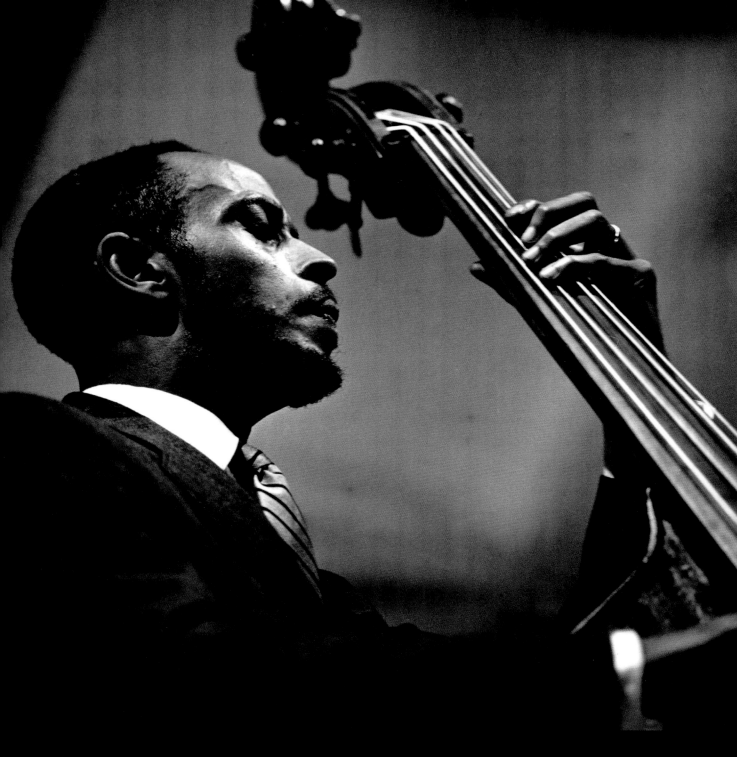

Percy Heath, Newport Jazz Festival, 1955.

Opposite: Percy Heath, New York, 1953.

Milt Jackson, New York, 1953

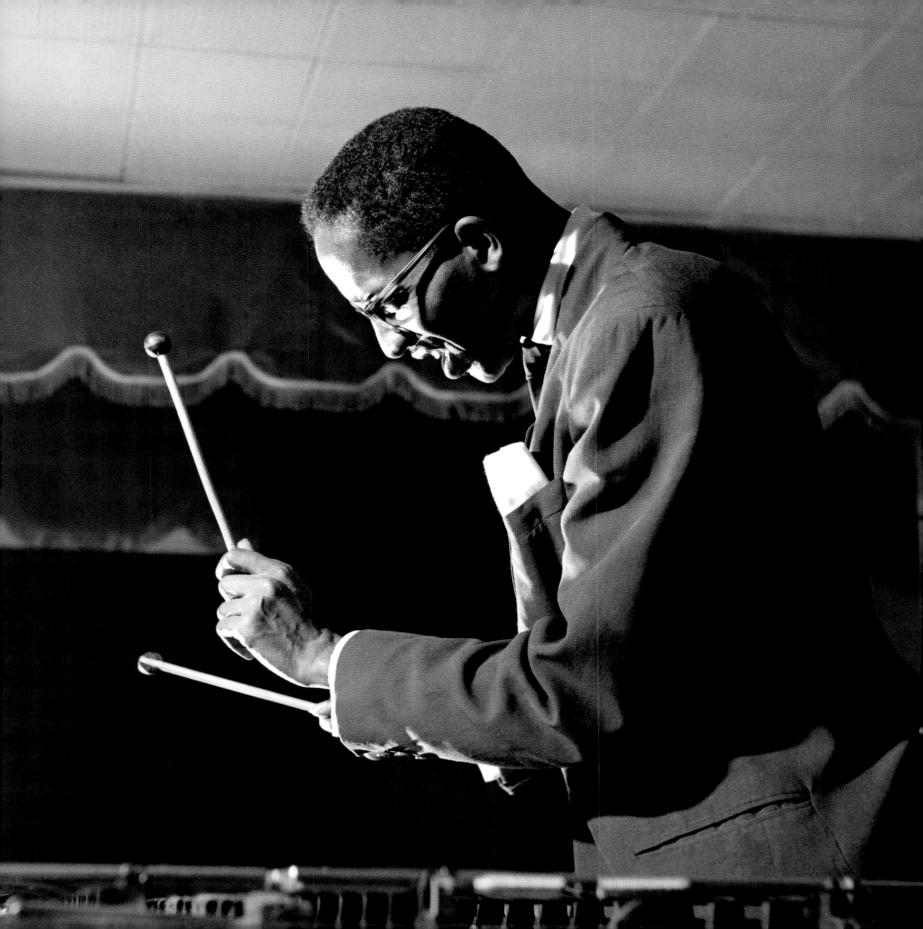

Oscar Pettiford, New York, 1948

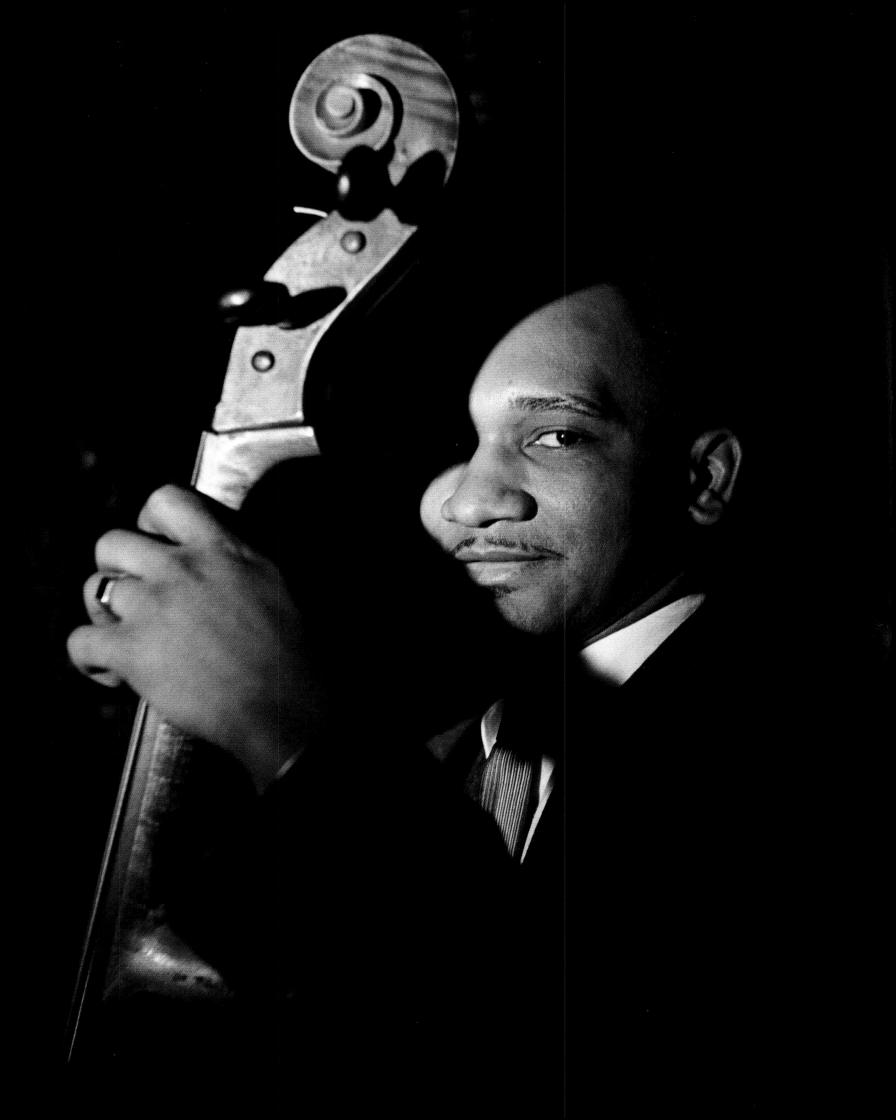

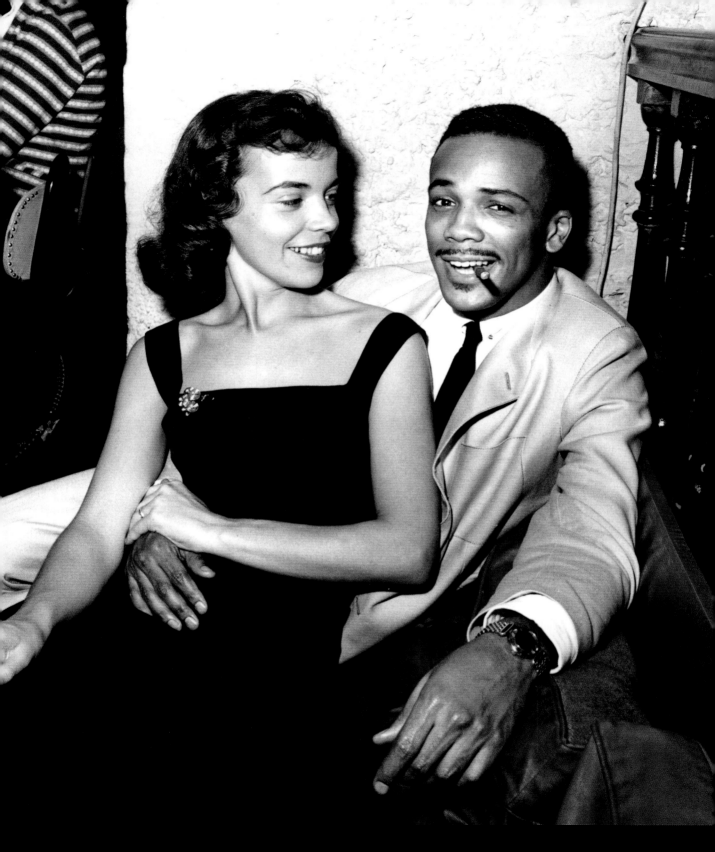

Quincy Jones, Club Saint Germain, Paris, 1958

Opposite: Quincy Jones, New York, 1955

Overleaf: Candido Camero, New York, 1954

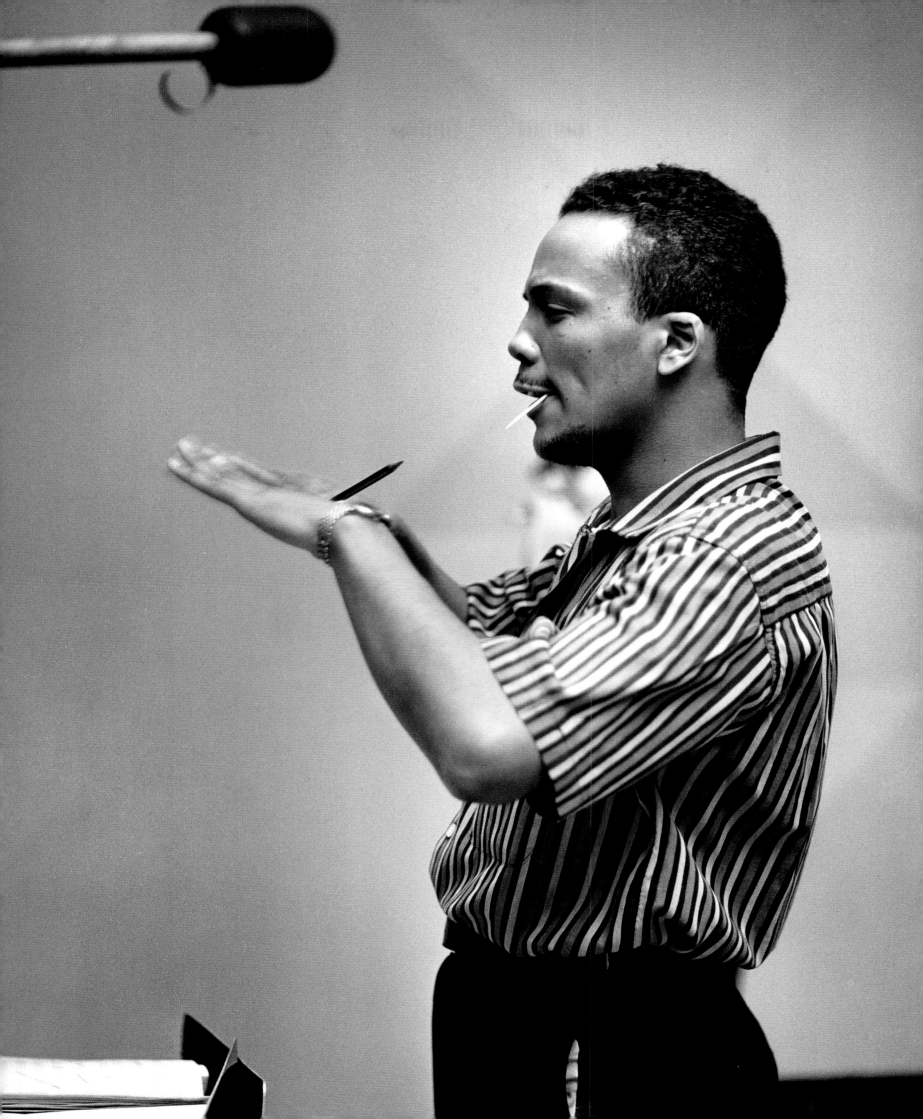

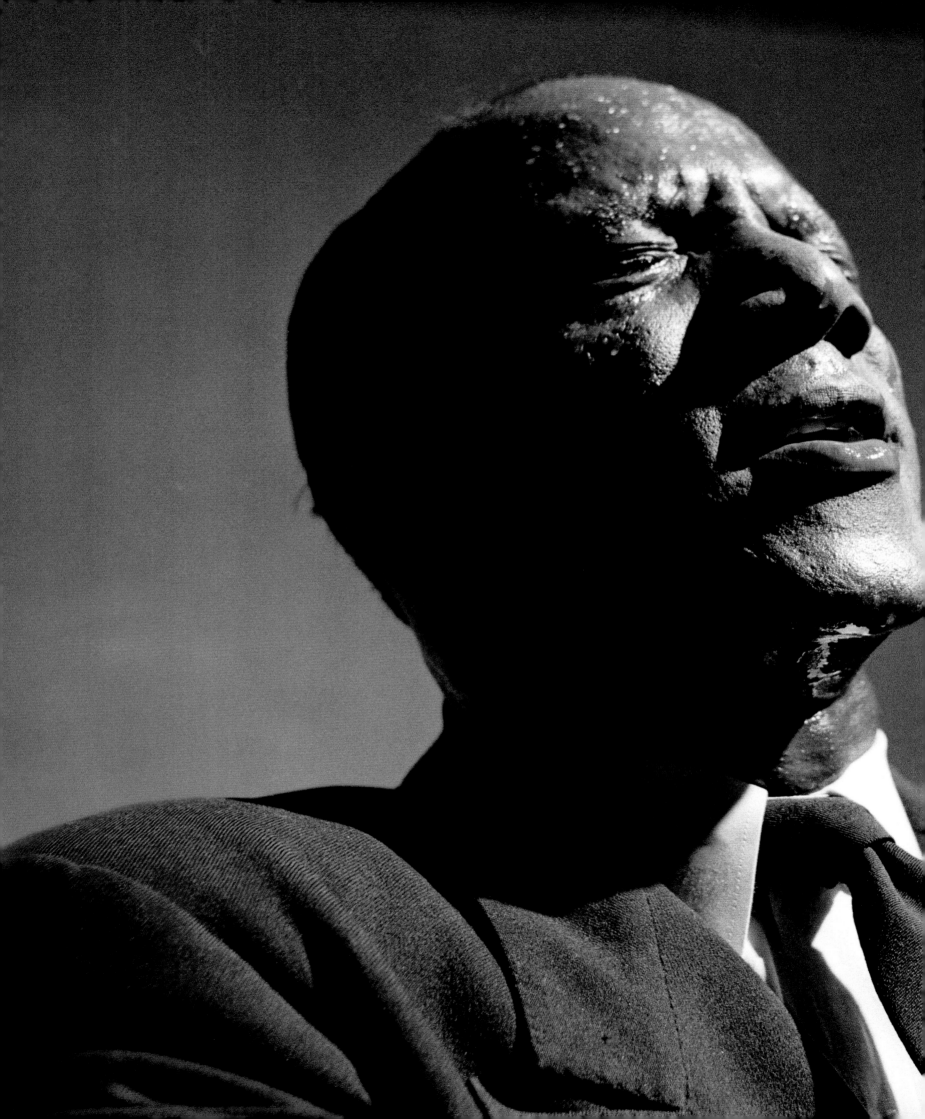

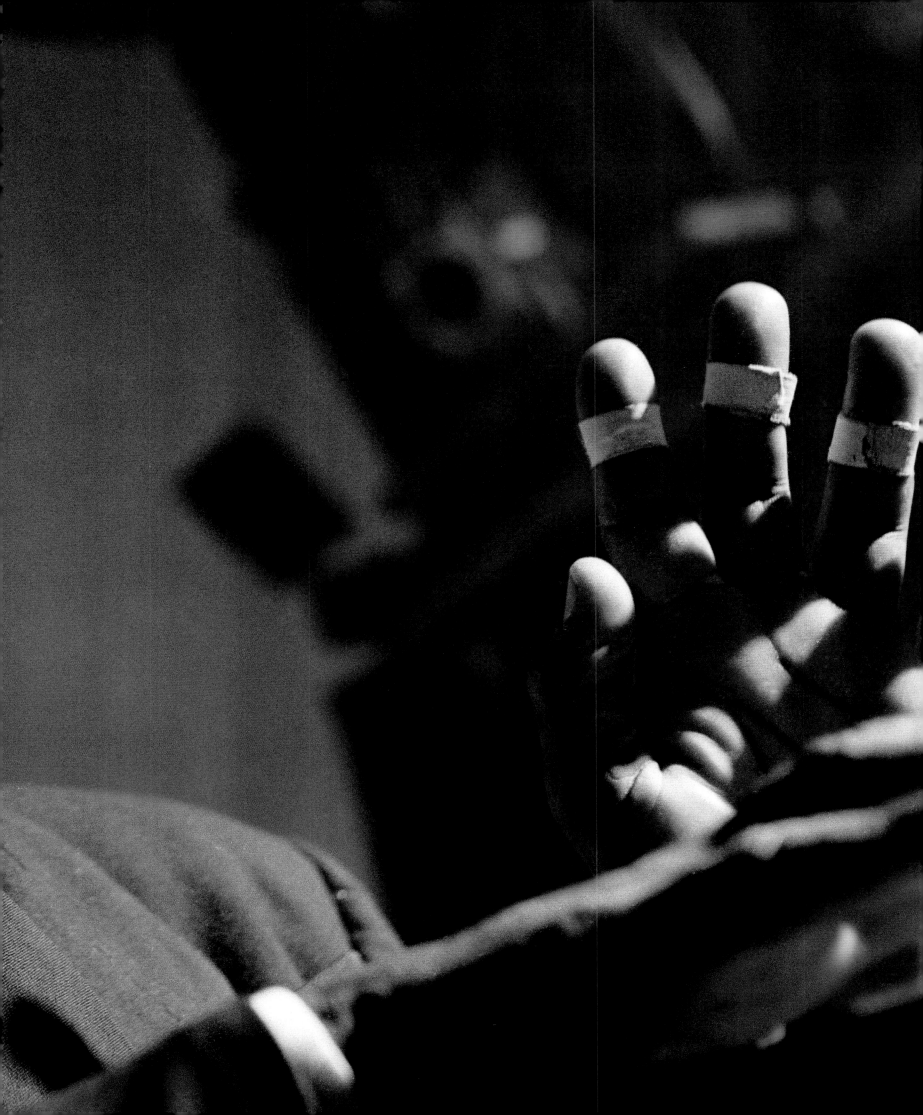

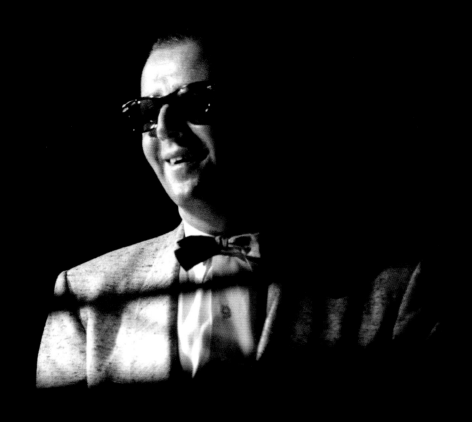

Both: George Shearing, New York, 1950

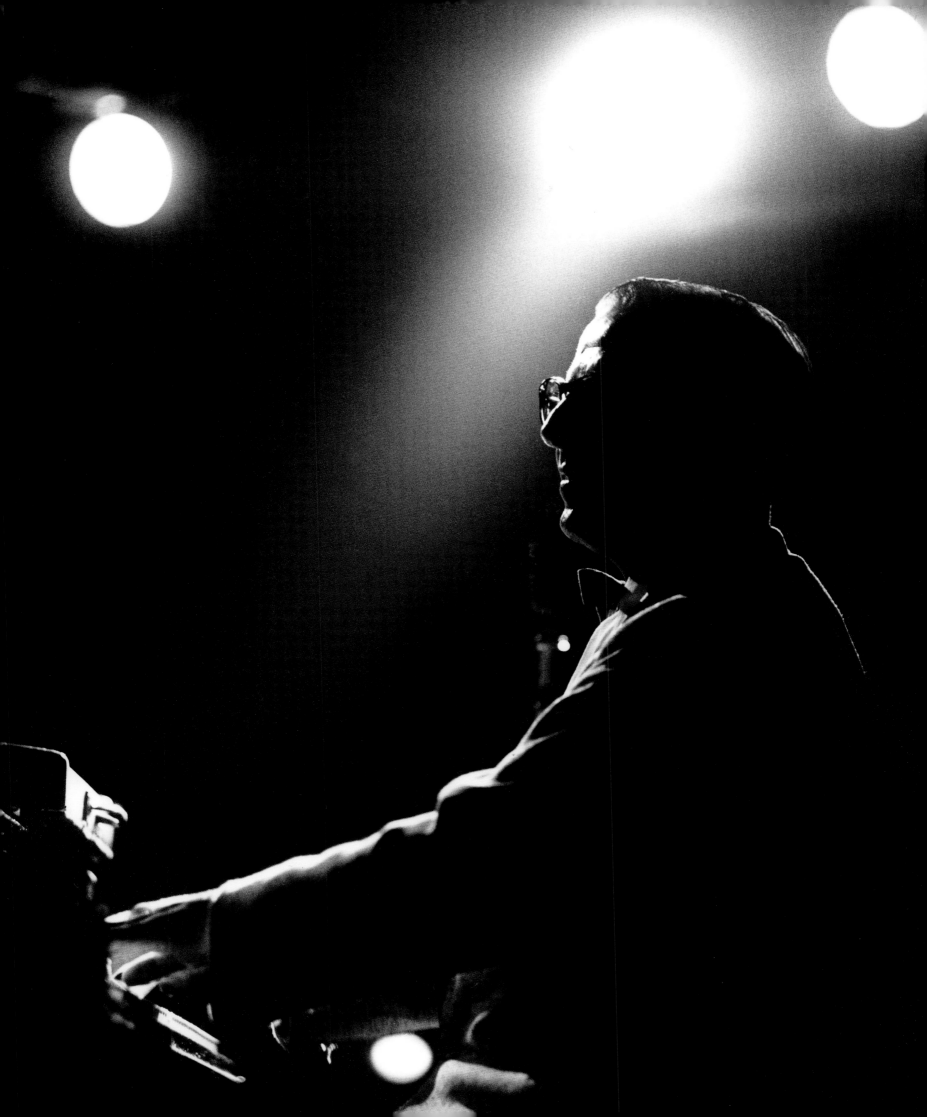

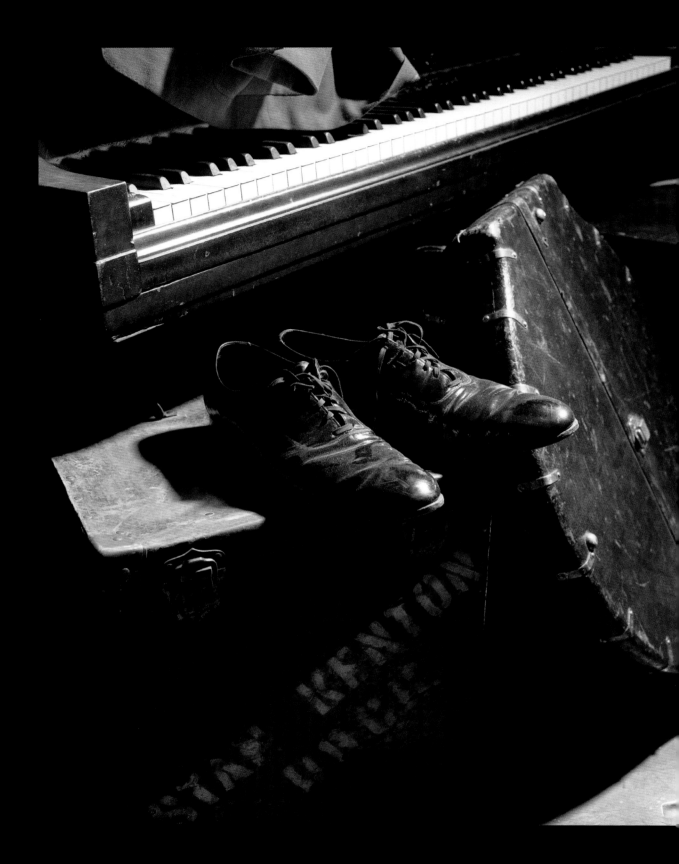

Stan Kenton's shoes, Atlanta, 1950

Opposite: Stan Kenton, Atlanta, 1950

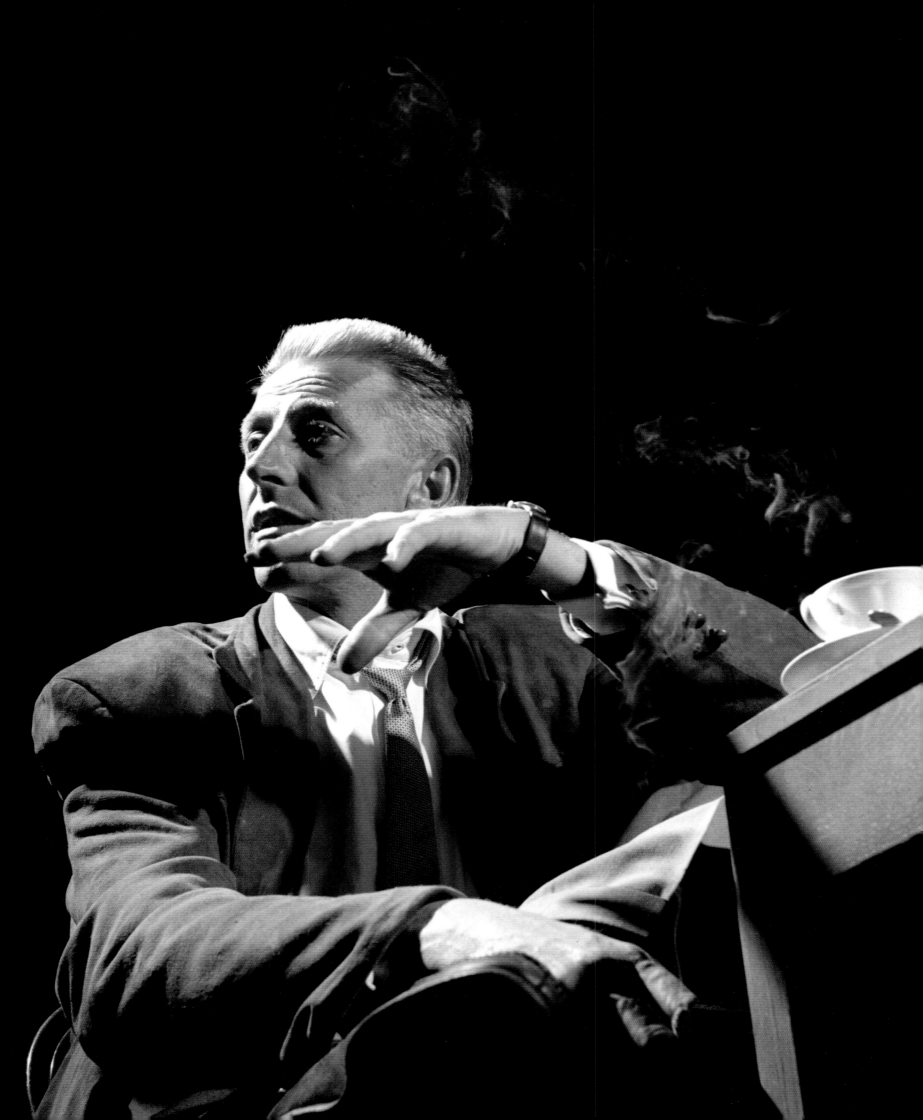

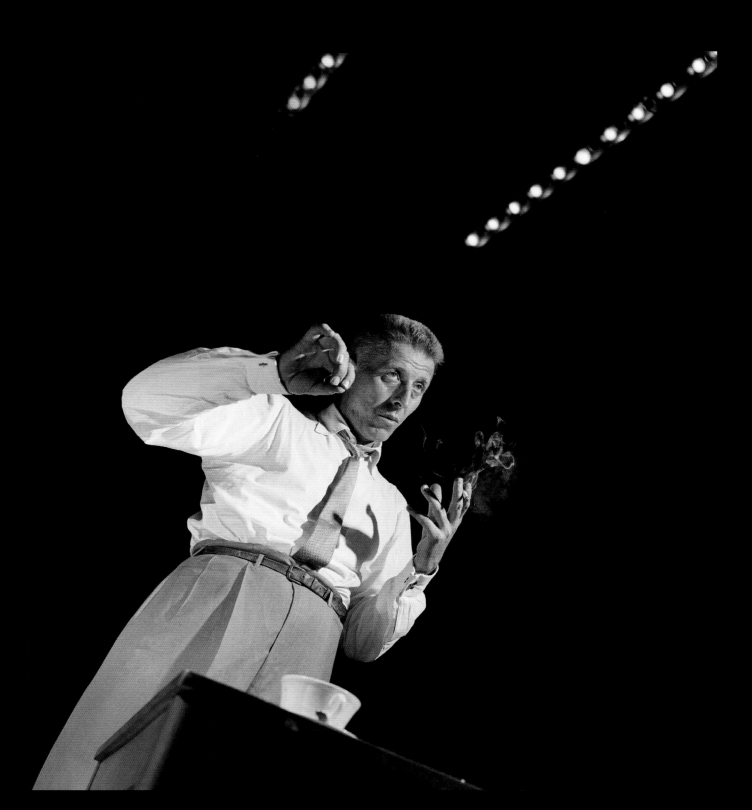

Stan Kenton, Atlanta, 1950

Opposite: Stan Kenton and Shorty Rogers, Atlanta, 1950

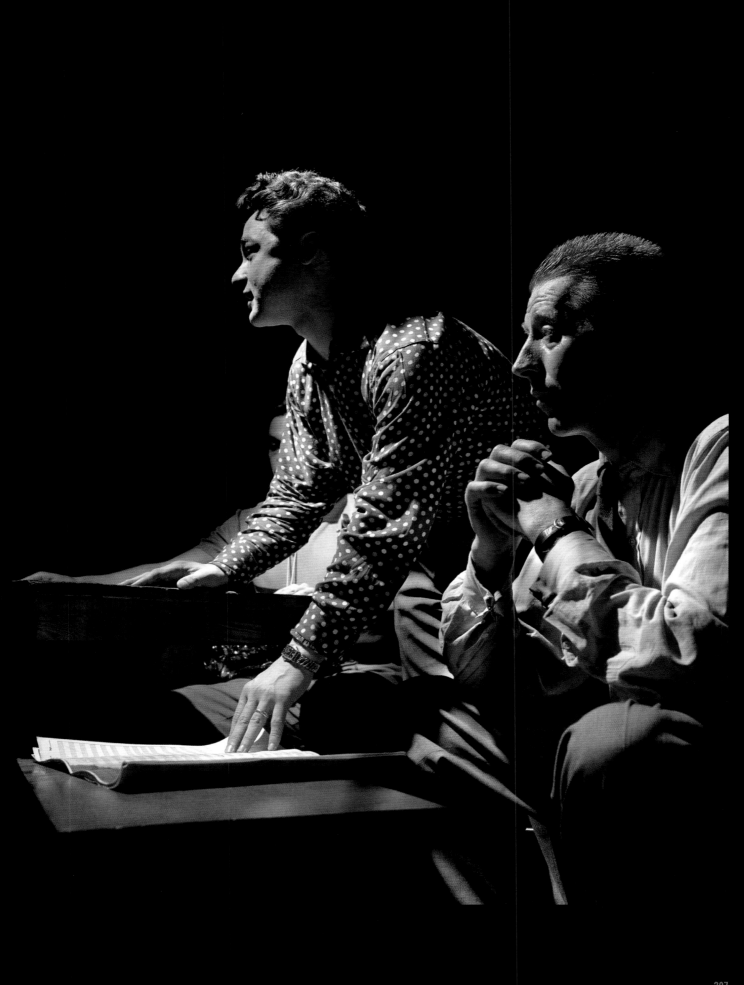

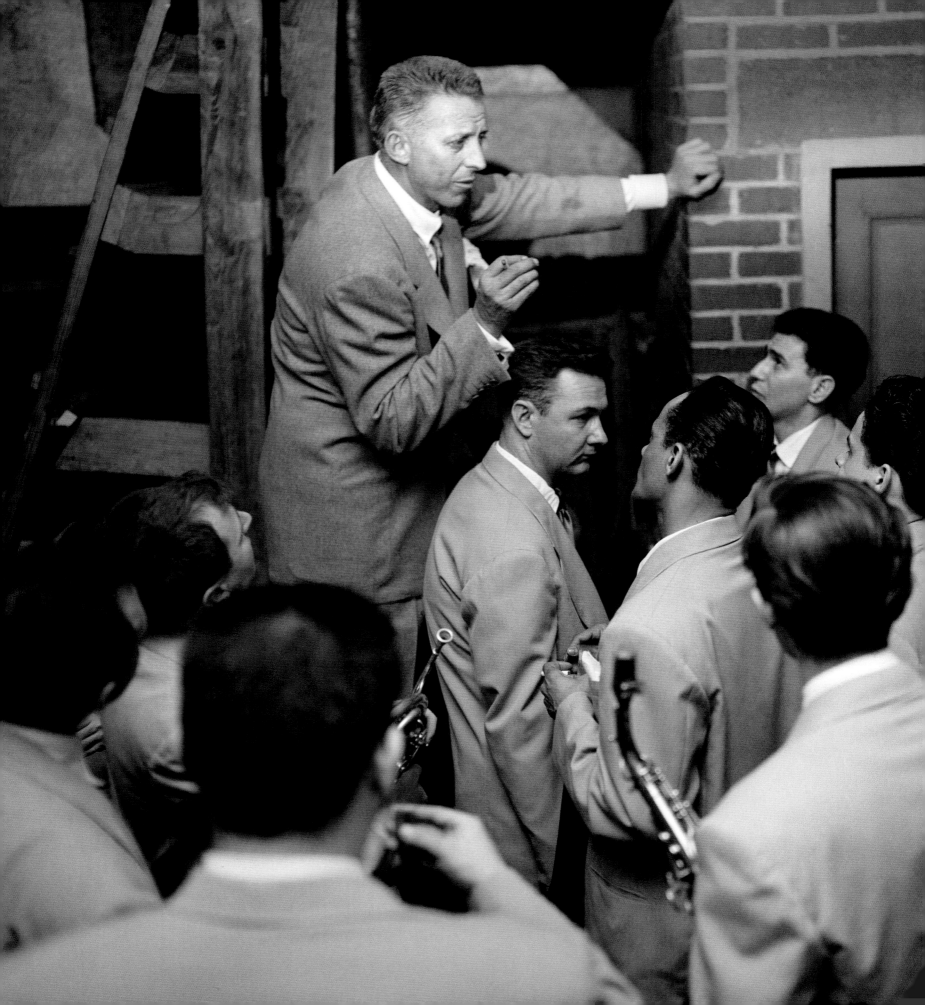

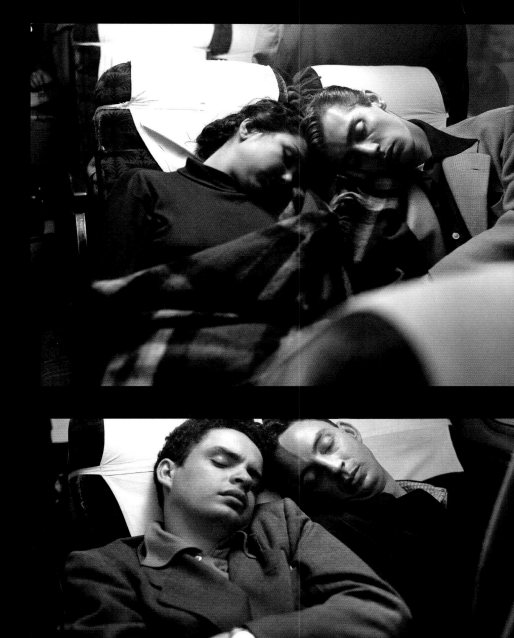

Opposite: Stan Kenton, Atlanta, 1950 **Above:** Stan Kenton Tour Bus, Atlanta, 1950

Overleaf: Tony Bennett, New York, 1950

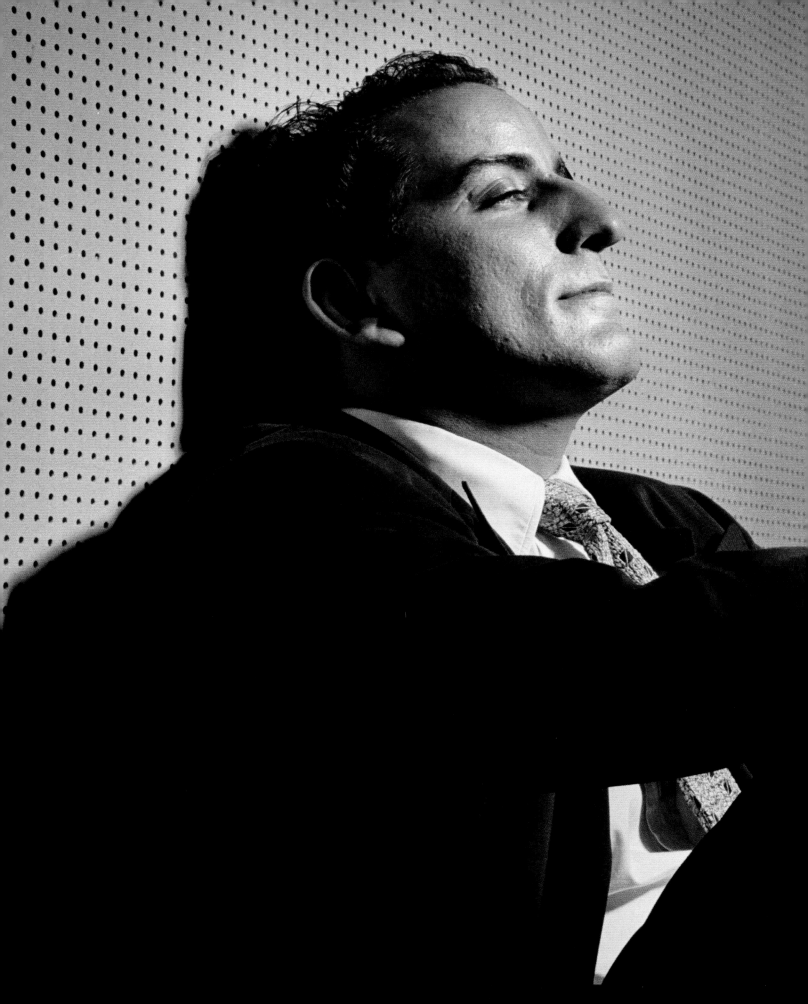

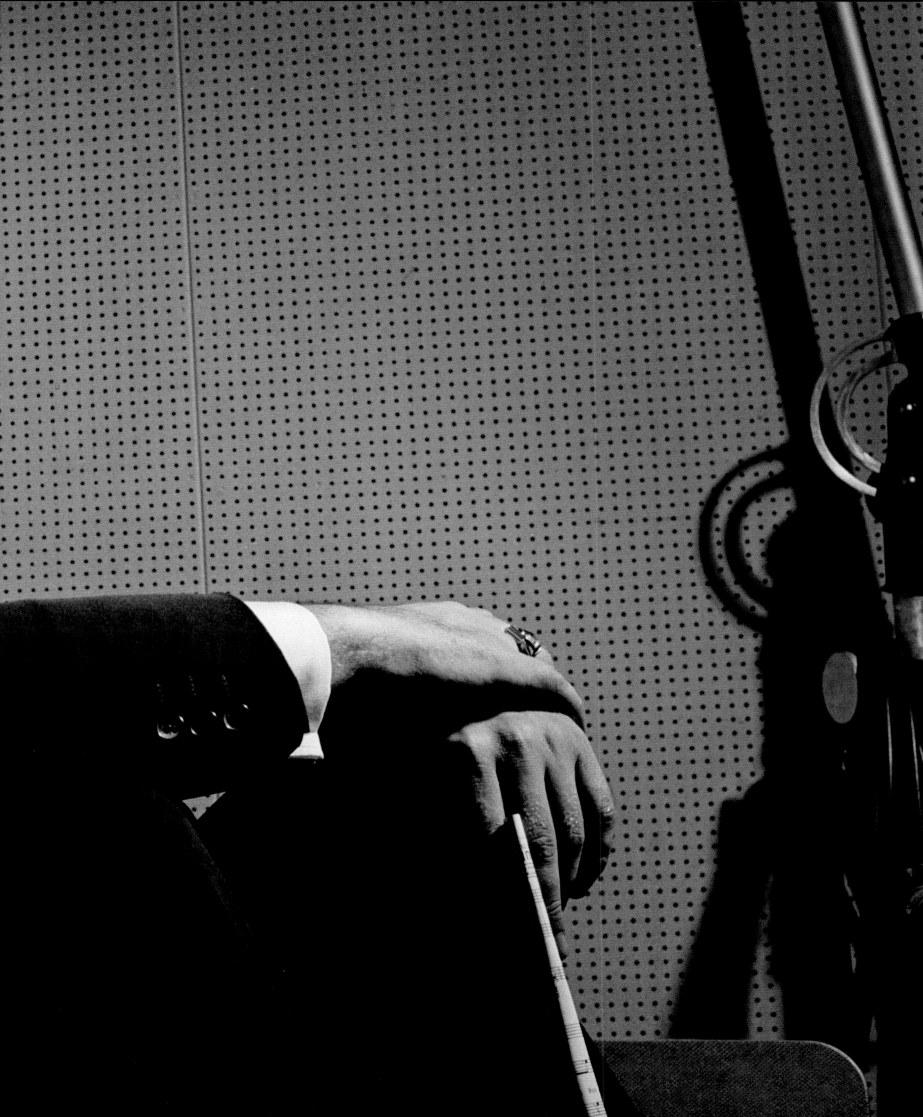

Tony Bennett, New York, 1950

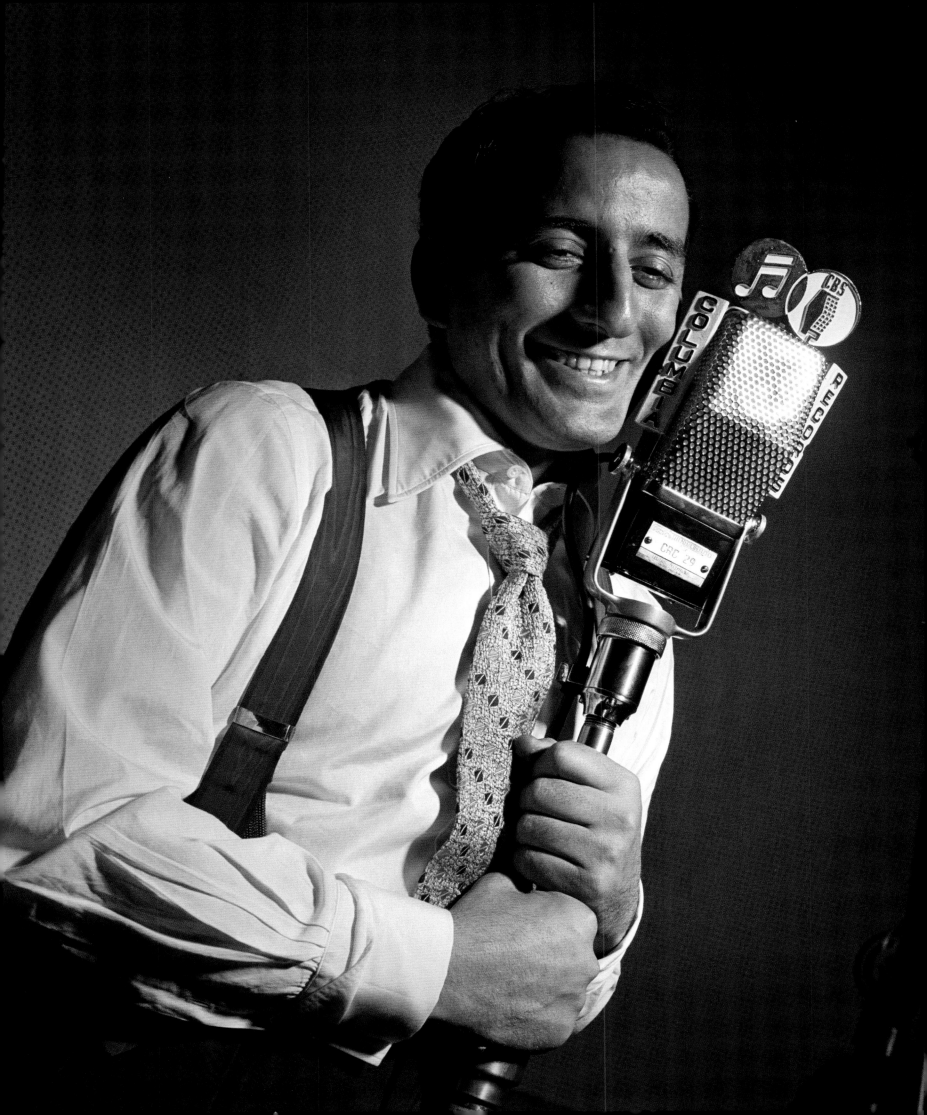

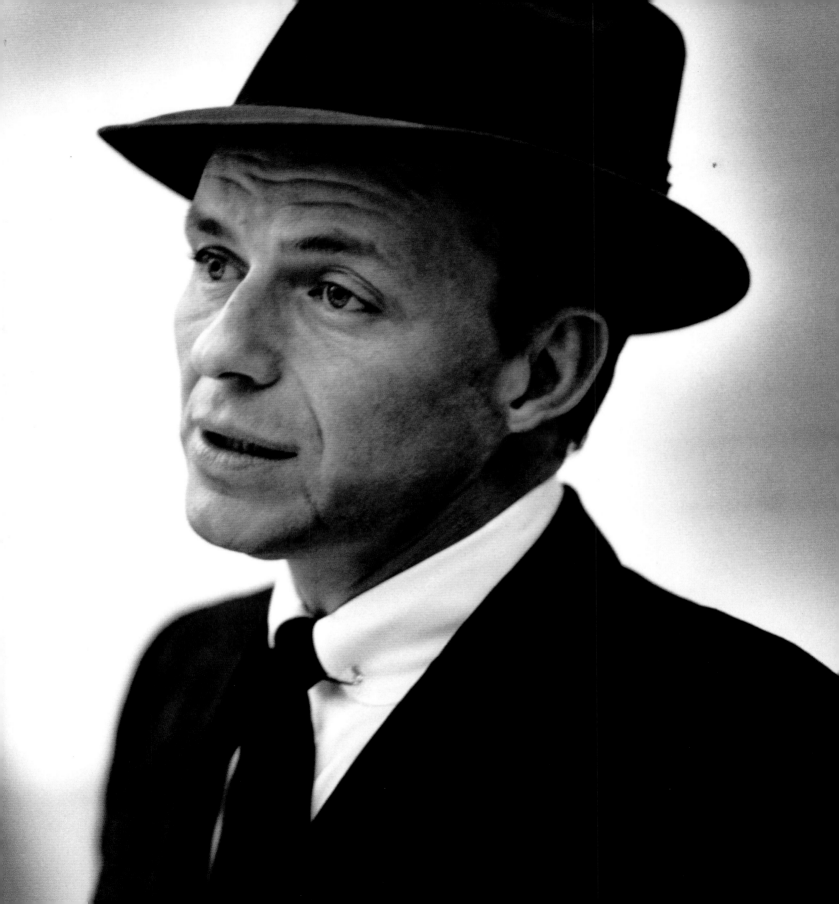

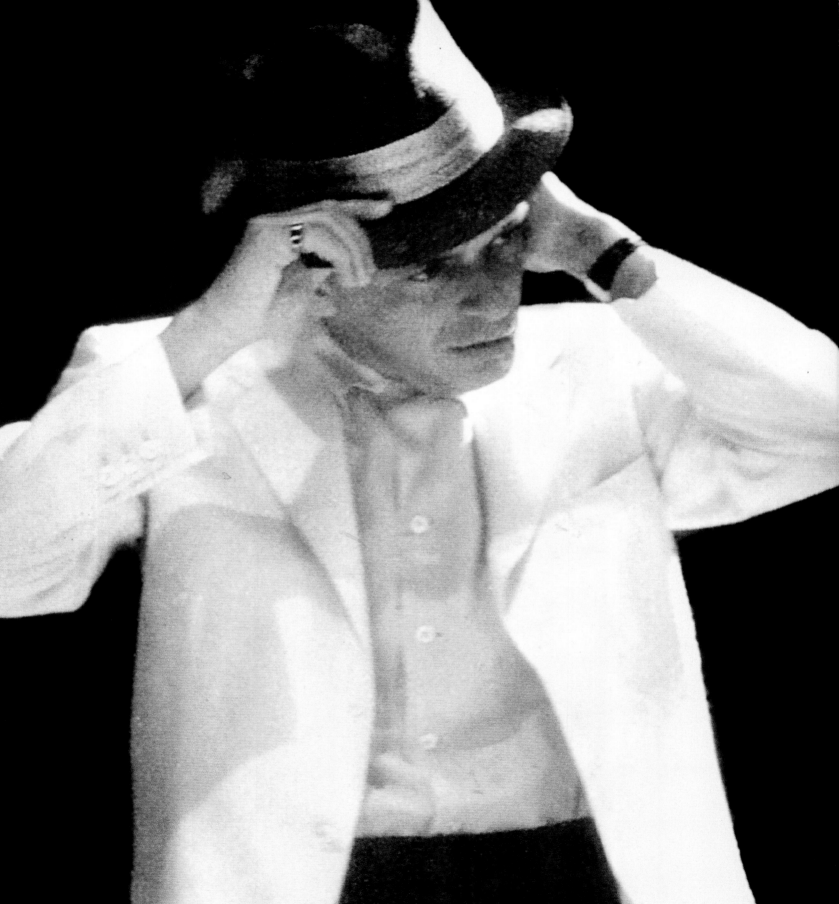

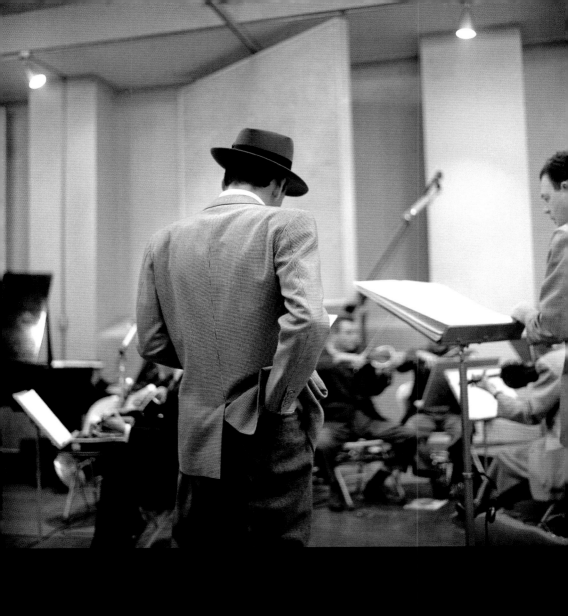

Sinatra, Monte Carlo, 1958

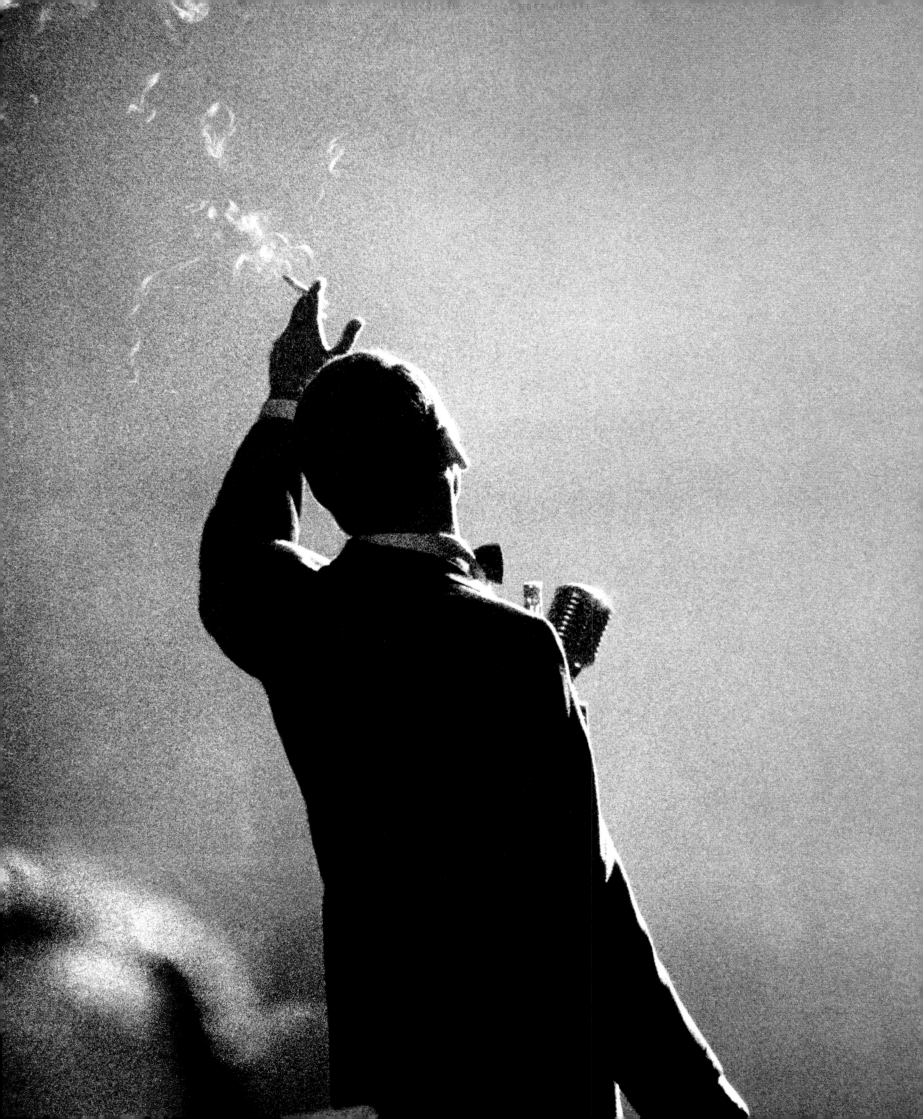

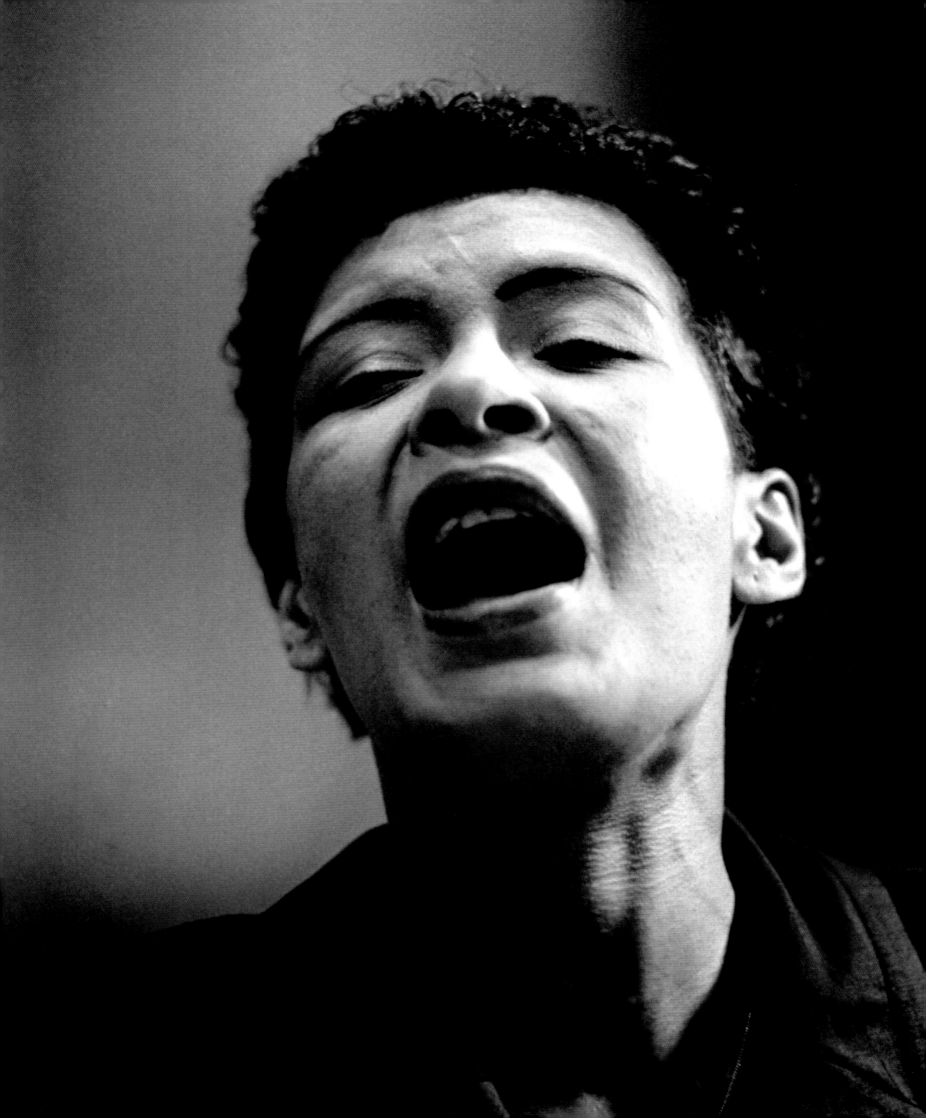

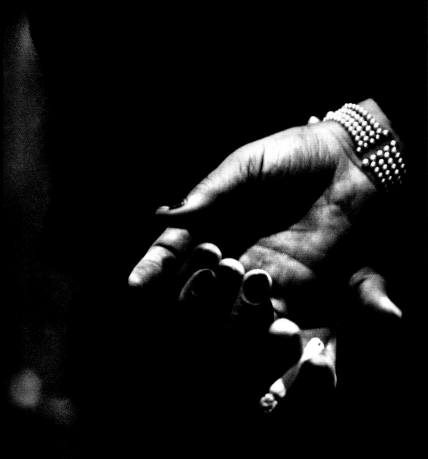

Both: Billie Holiday, New York, 1955

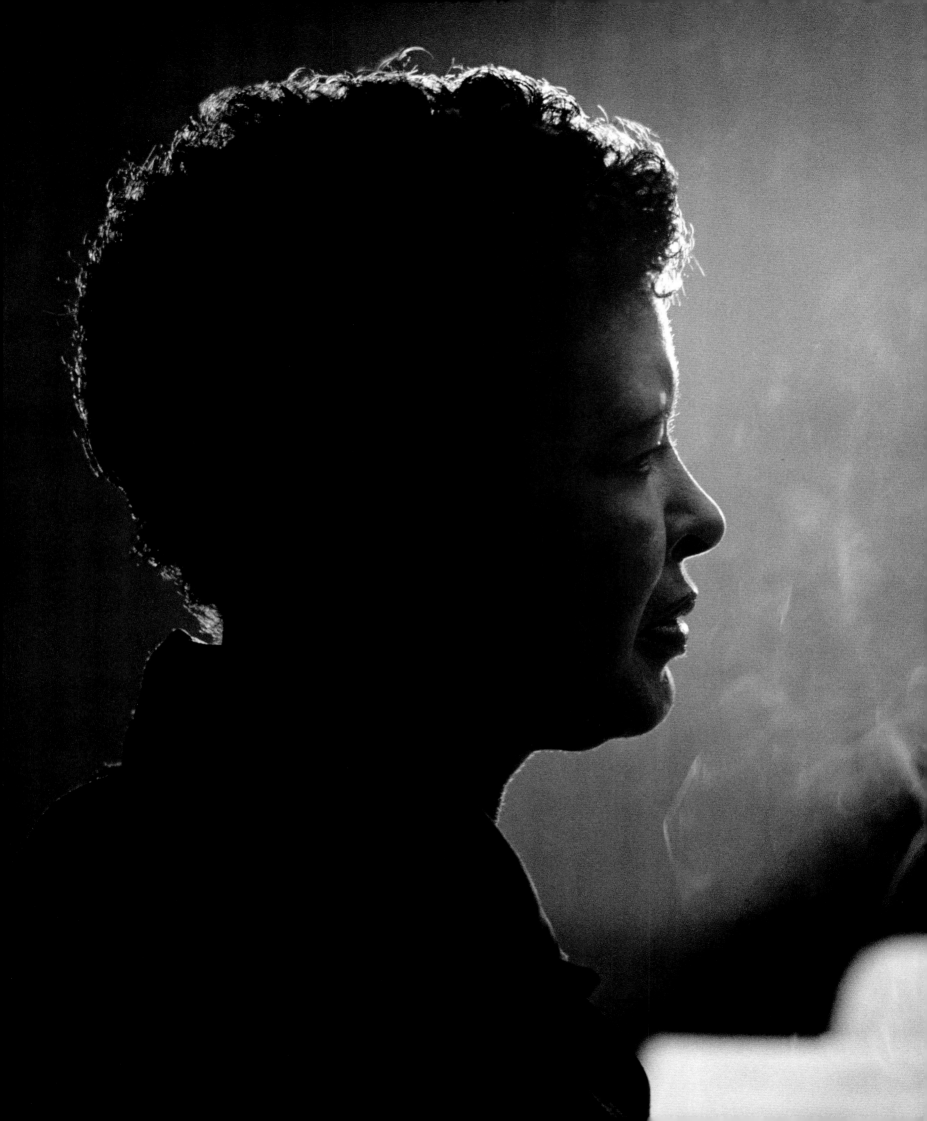

Count Basie, Paris, 1960

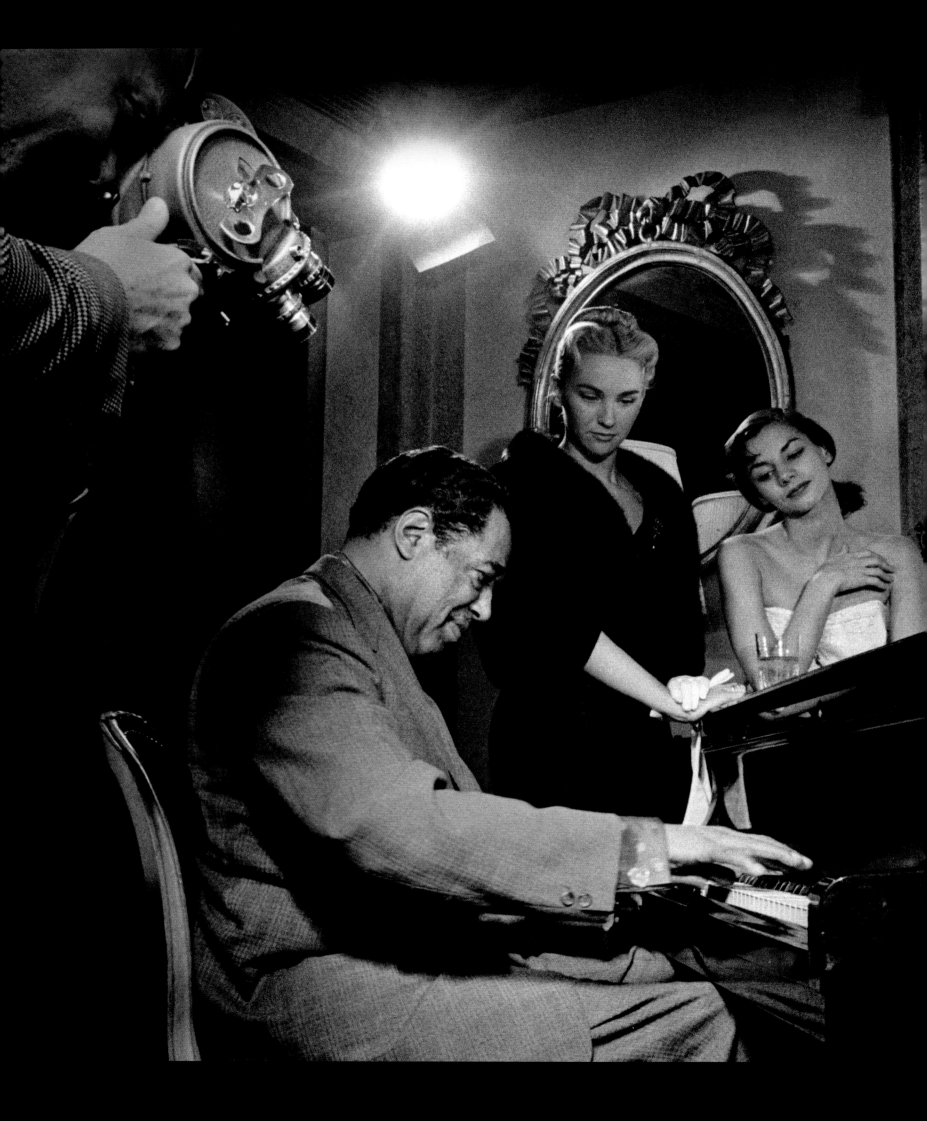

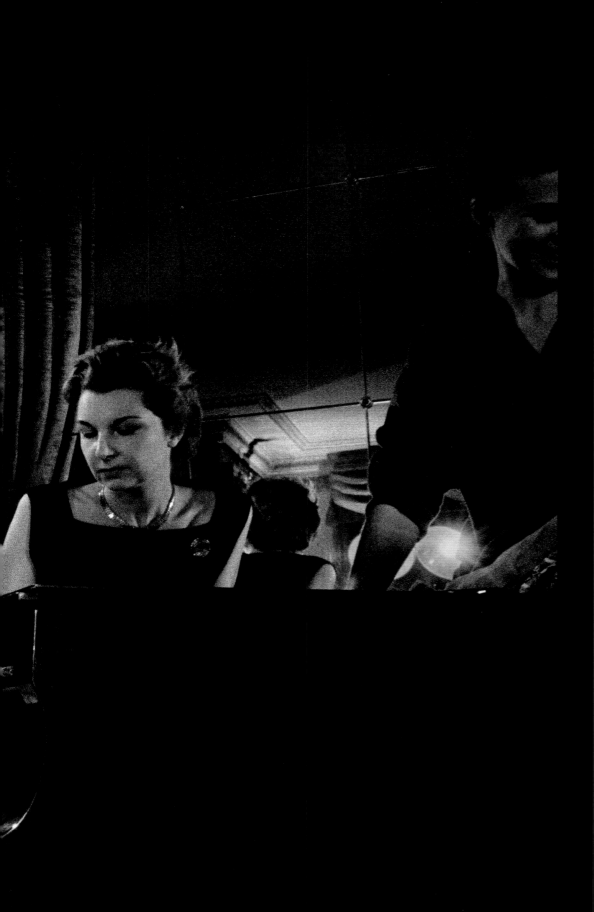

Duke Ellington, Paris, 1960

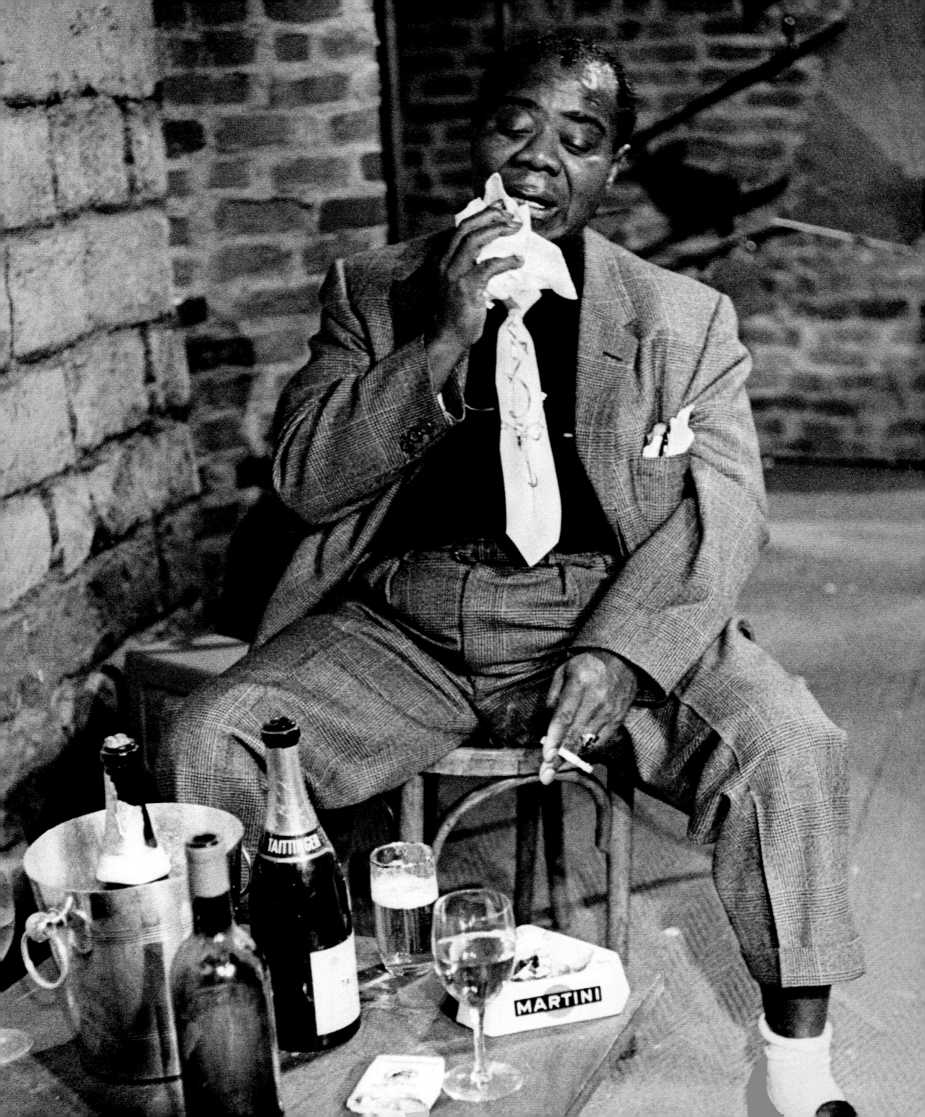

Louis Armstrong, Paris,

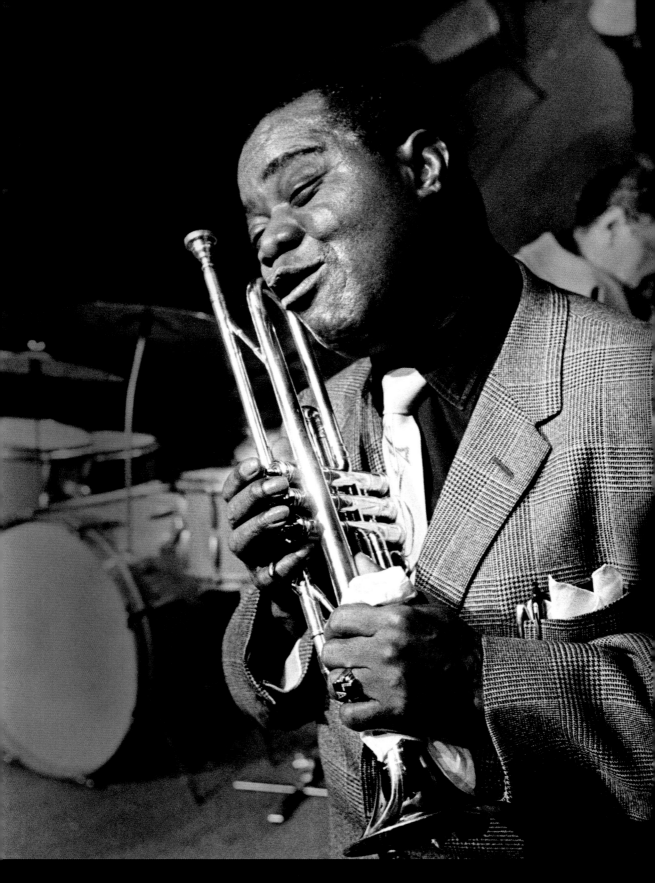

Roth· Louis Armstrong, Paris 1960

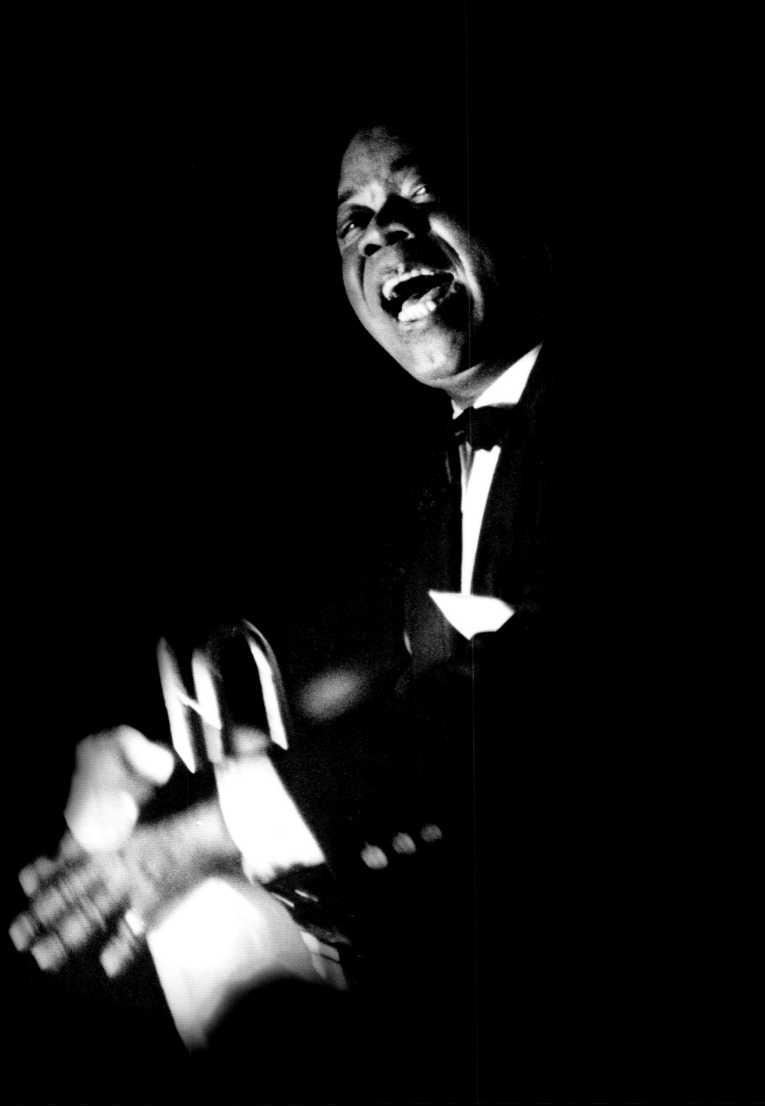

Louis Armstrong,
Paris, 1960

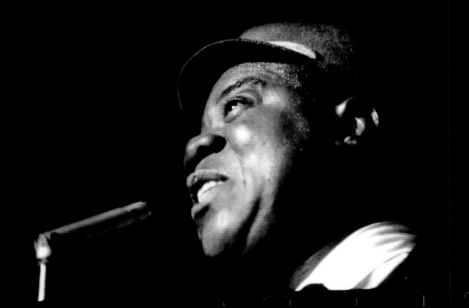

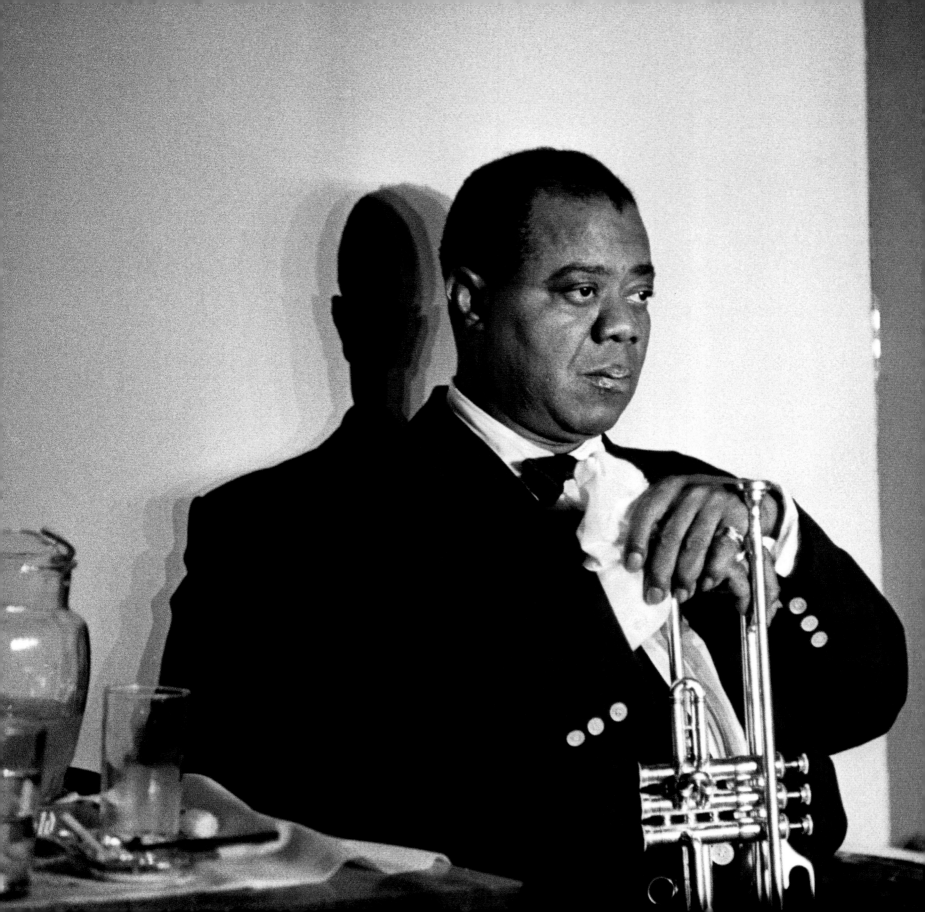

Louis Armstrong, Paris, 1960

Overleaf: Ella Fitzgerald, Olympia Theatre, Paris, 1960

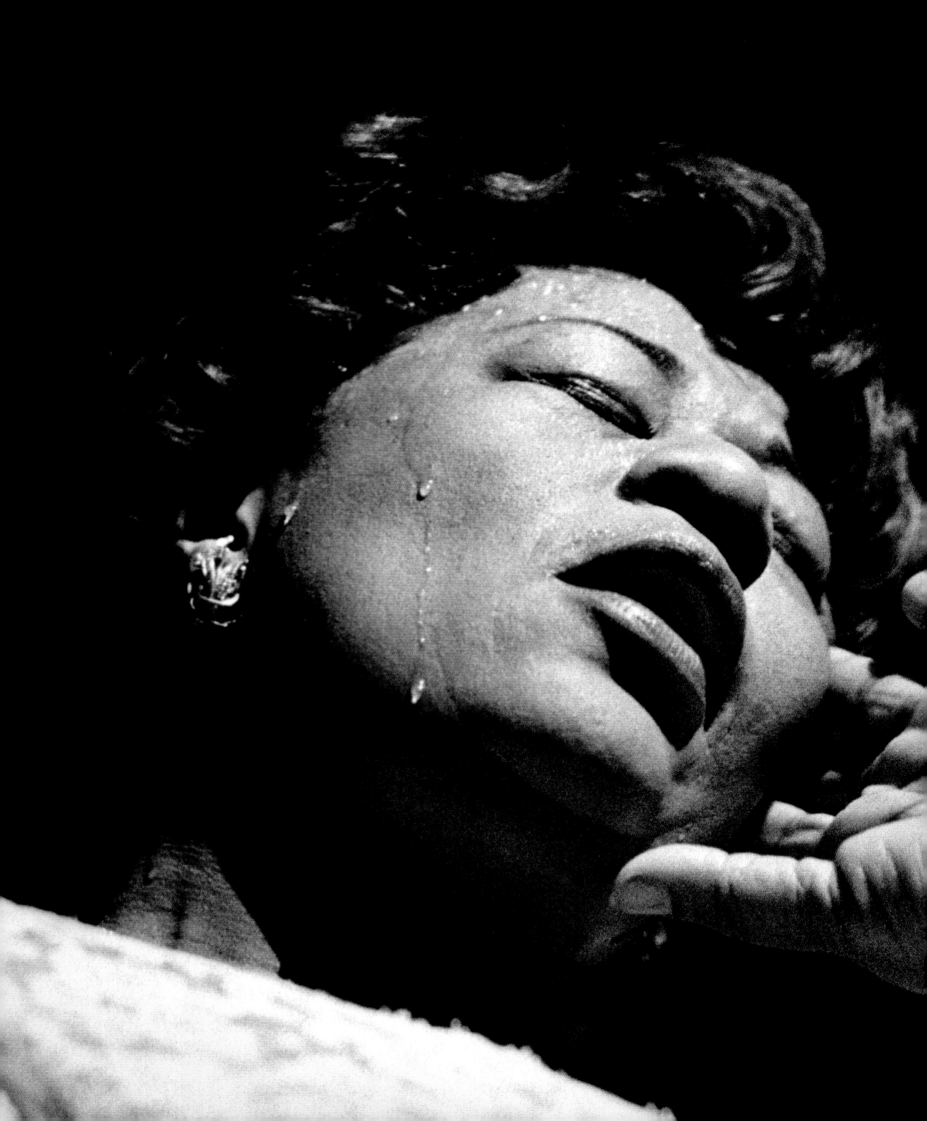

Ella Fitzgerald, Paris, 1960

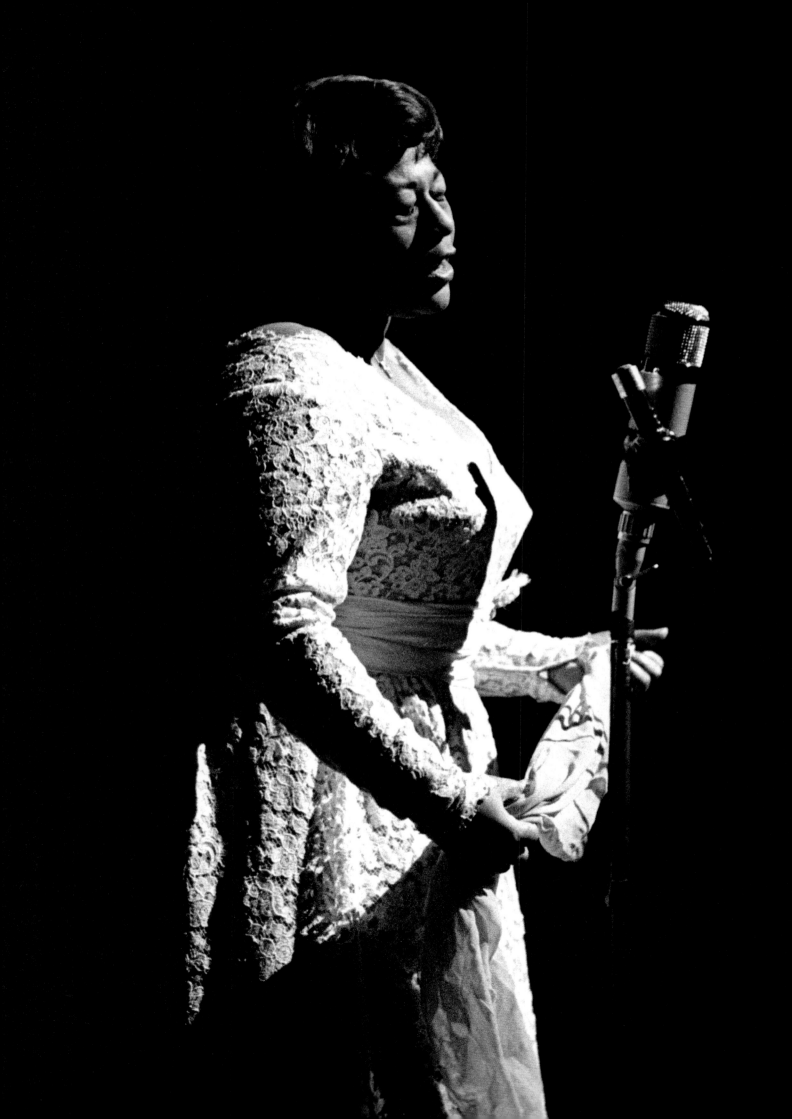

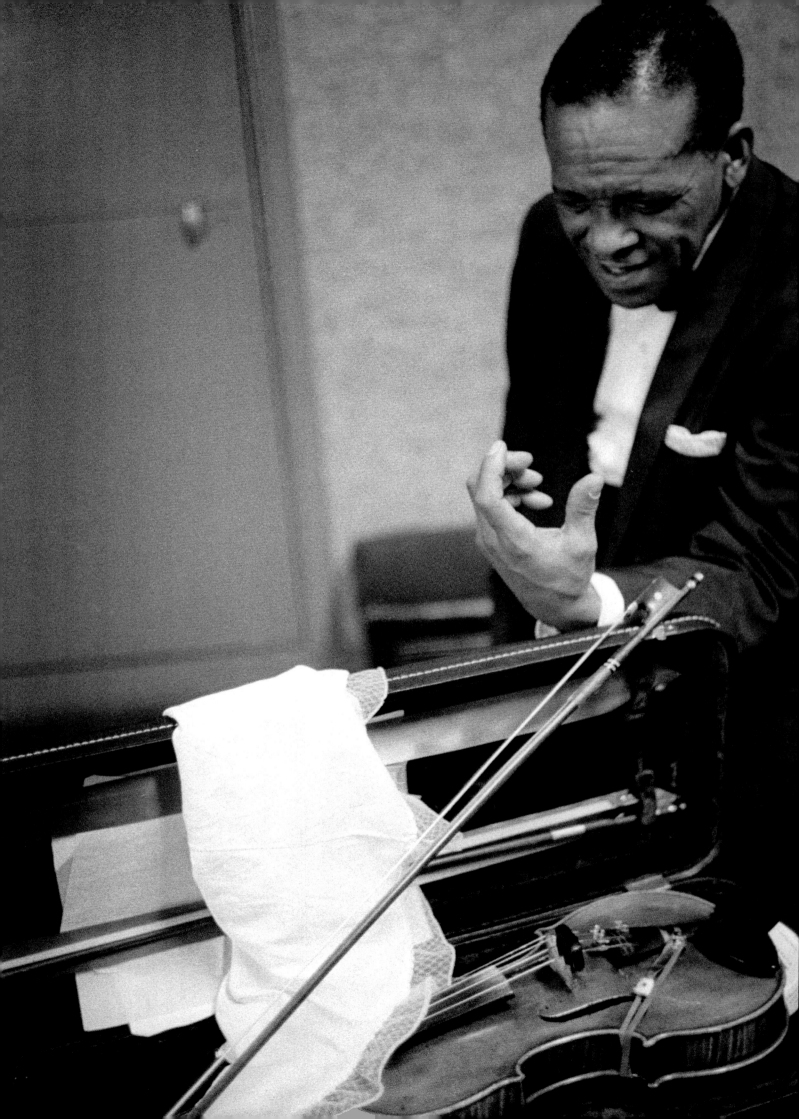

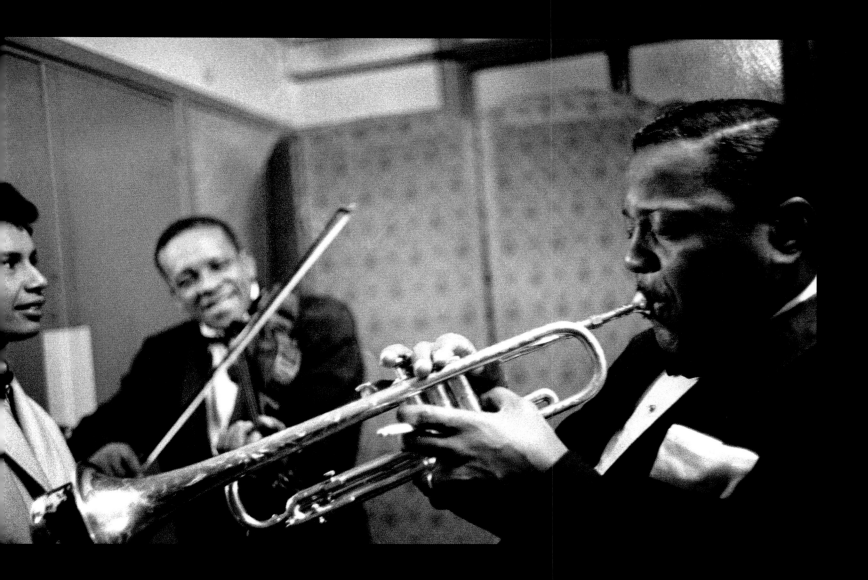

Opposite: Stuff Smith, Paris, 1960

Stuff Smith and Roy Eldridge, Paris, 1960

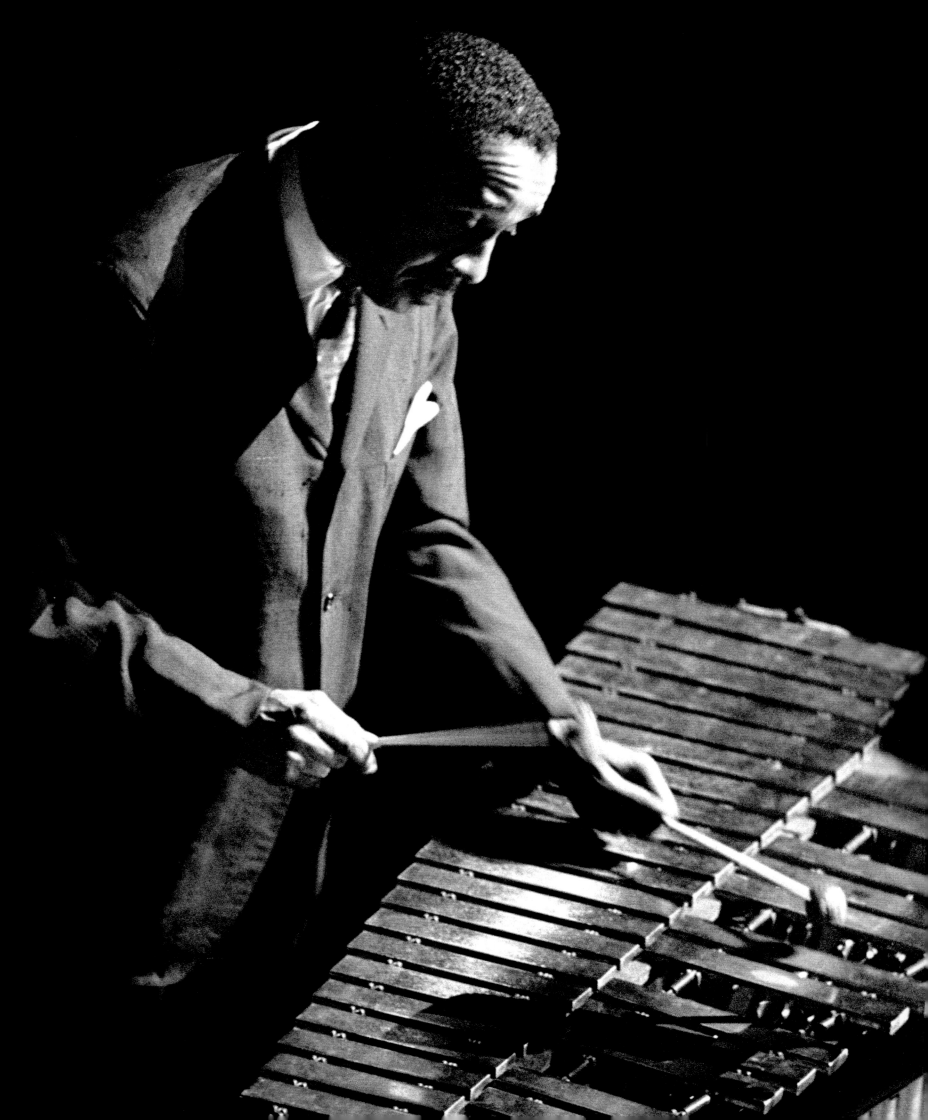

Milt Jackson, Paris, 1960

Hawkins, Paris, 1960

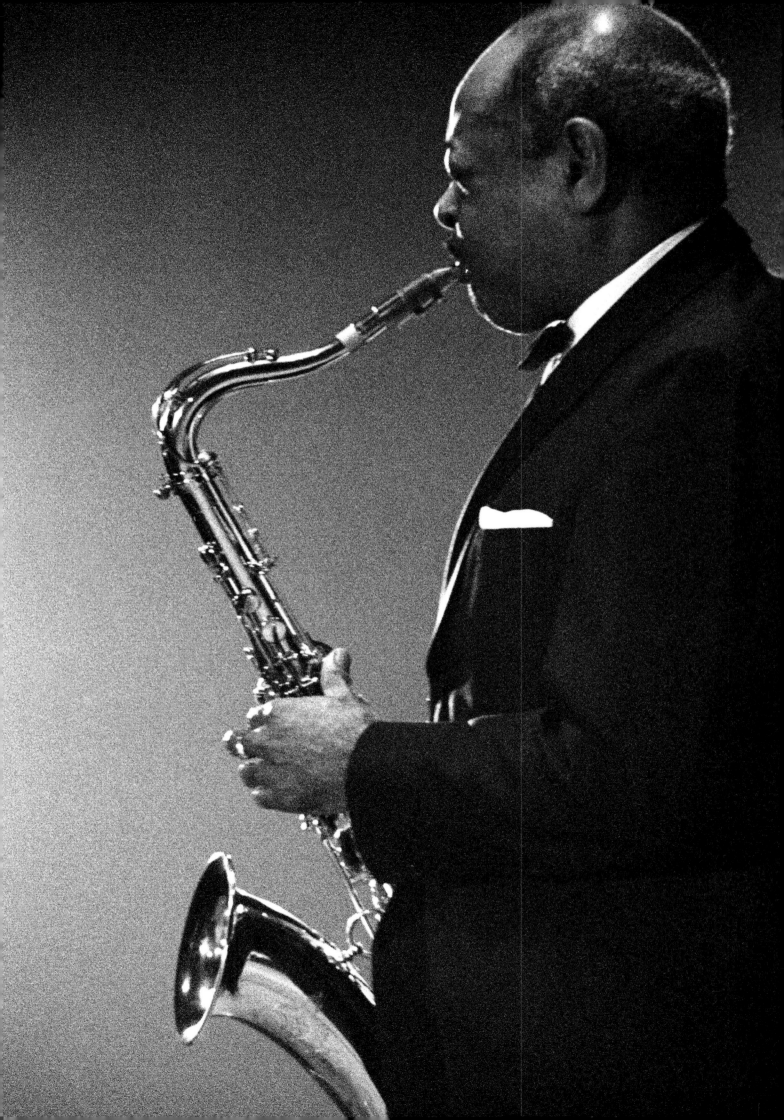

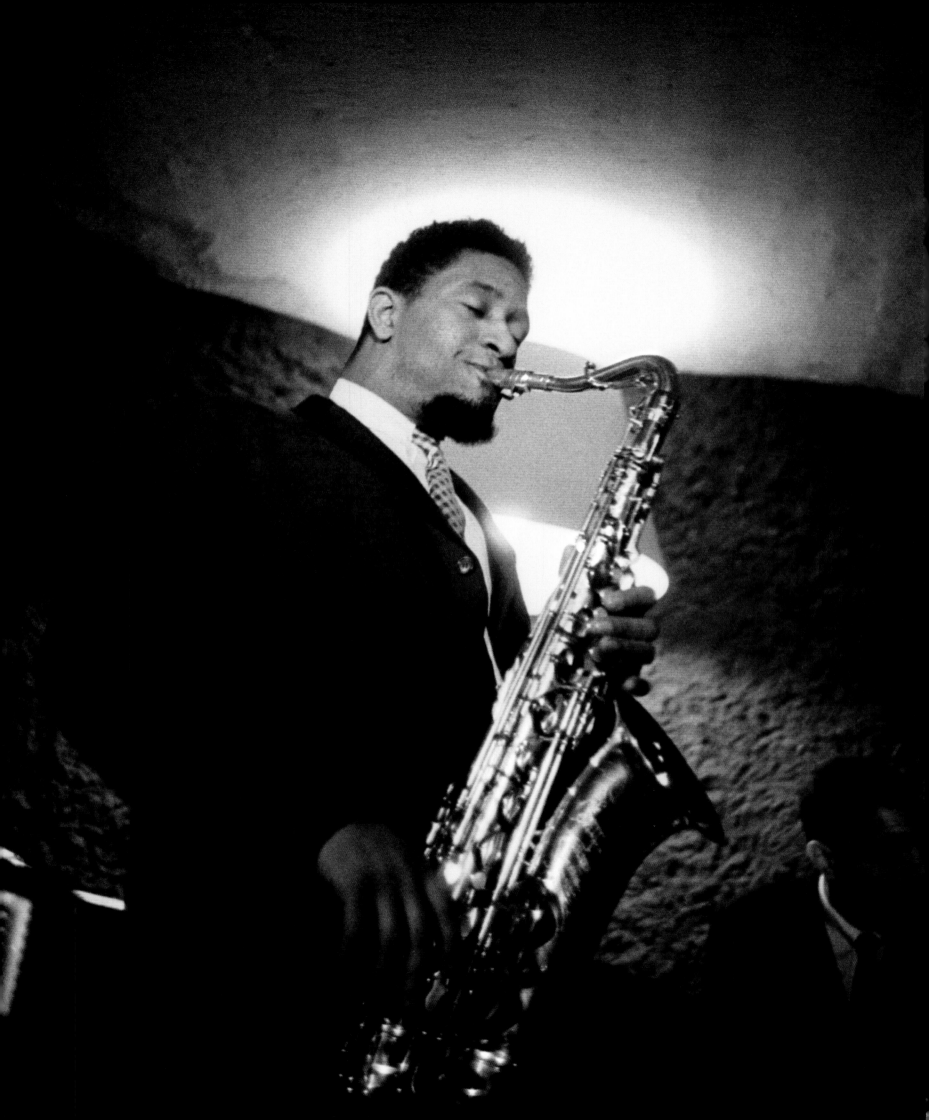

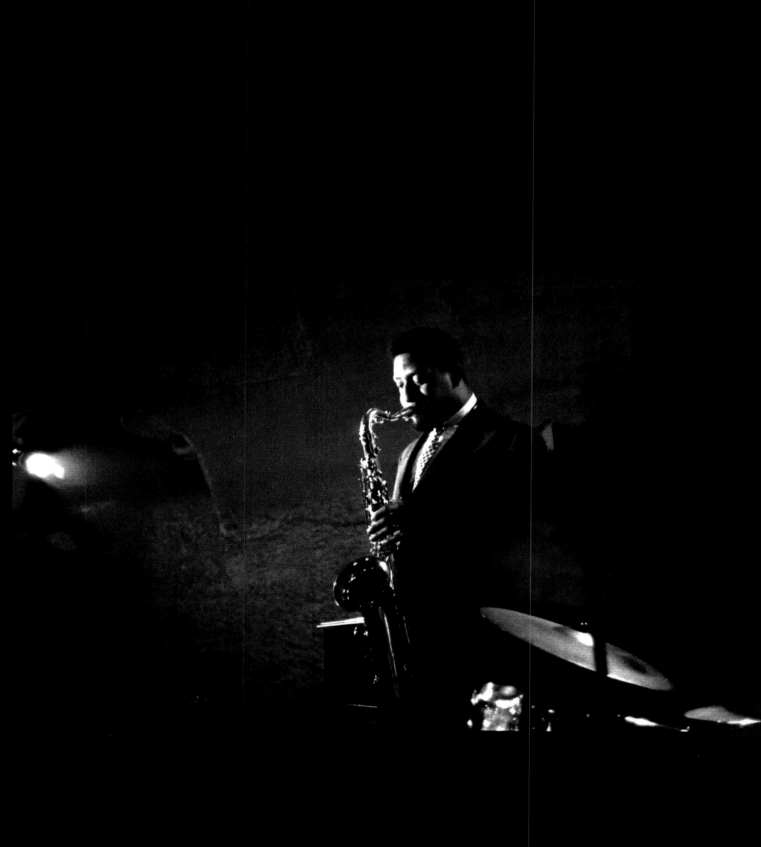

Opposite: Sonny Rollins, Club Saint Germain, Paris, 1960

Sonny Rollins, Club Saint Germain, Paris, 1960

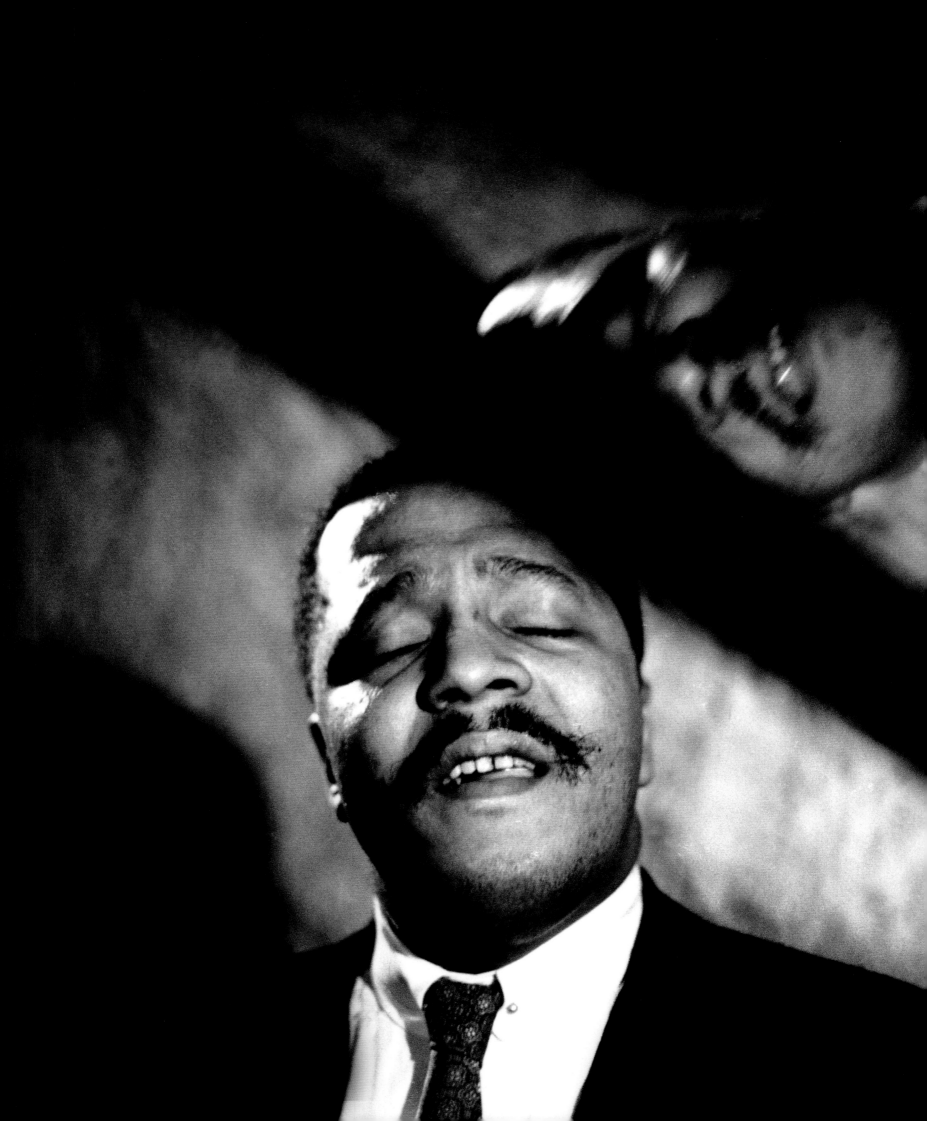

Bud Powell, Paris, 1960

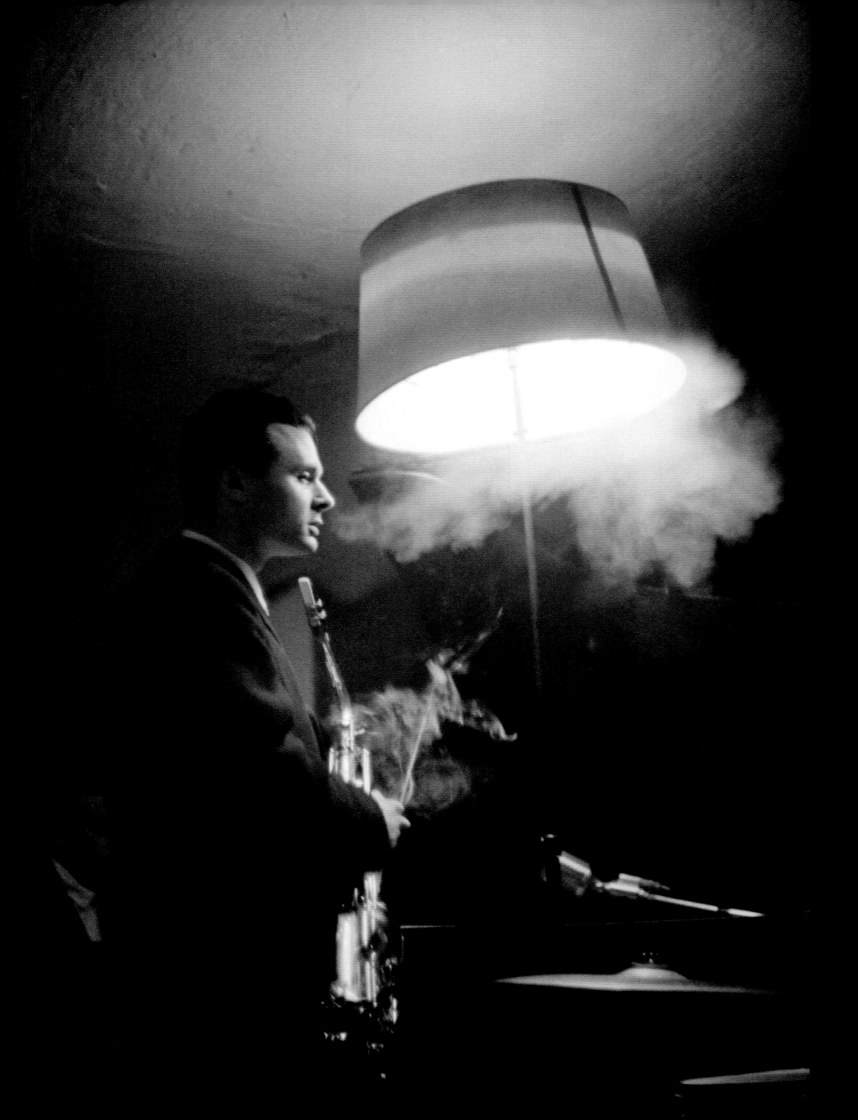

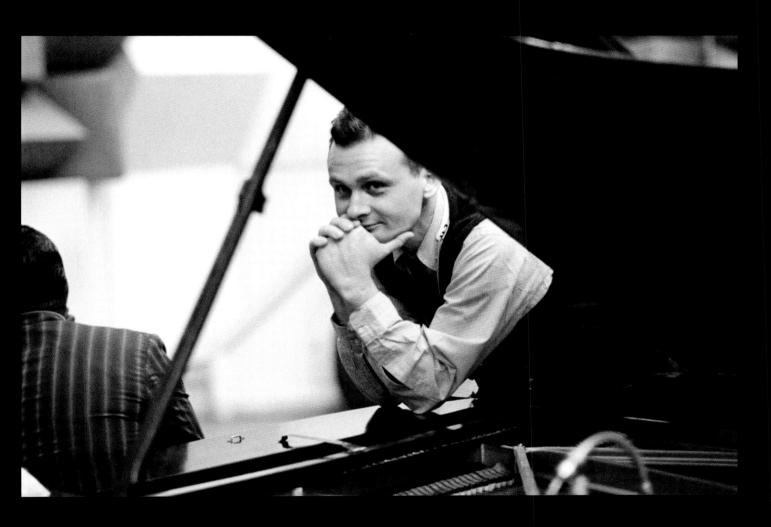

Both: Stan Getz, Paris, 1960

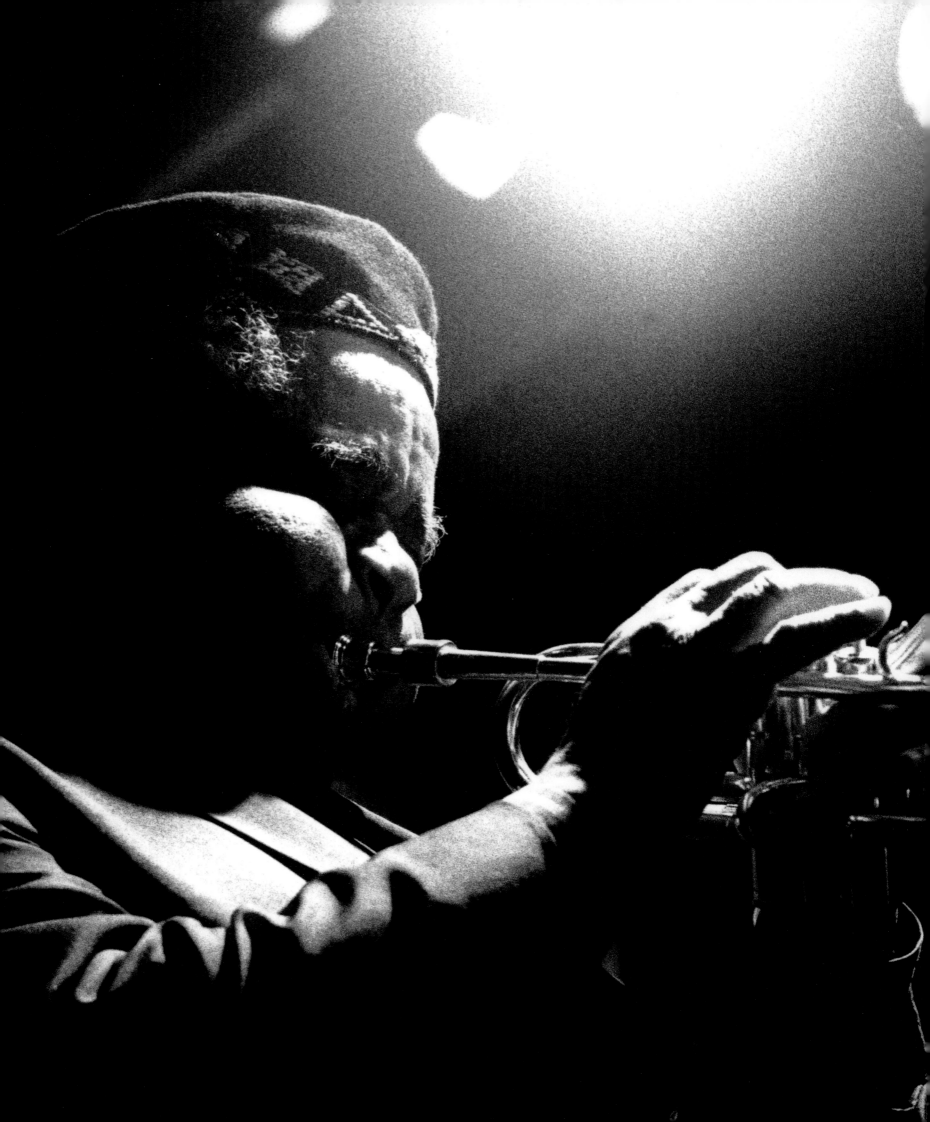

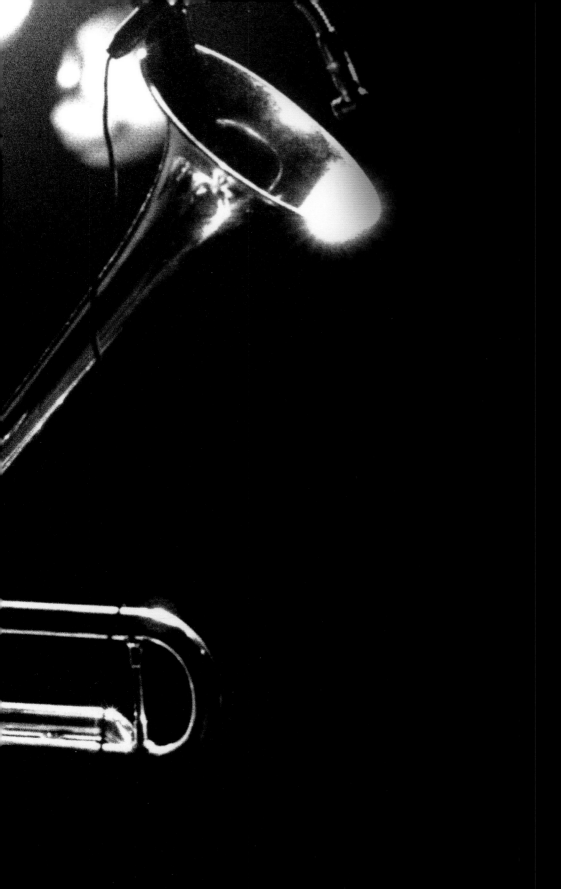

Dizzy Gillespie, San Francisco, 1990

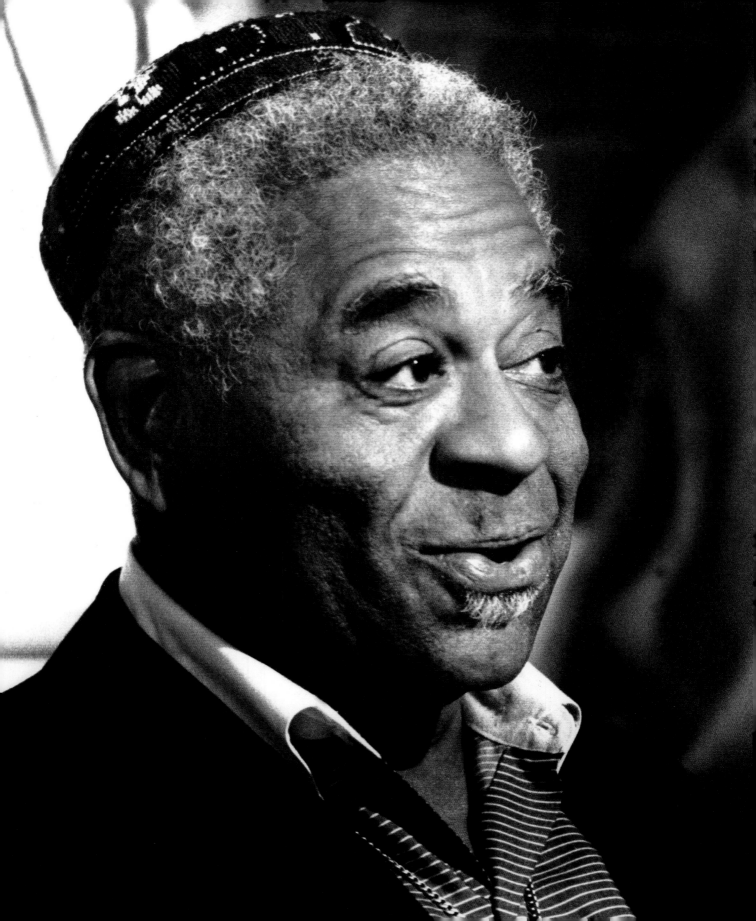

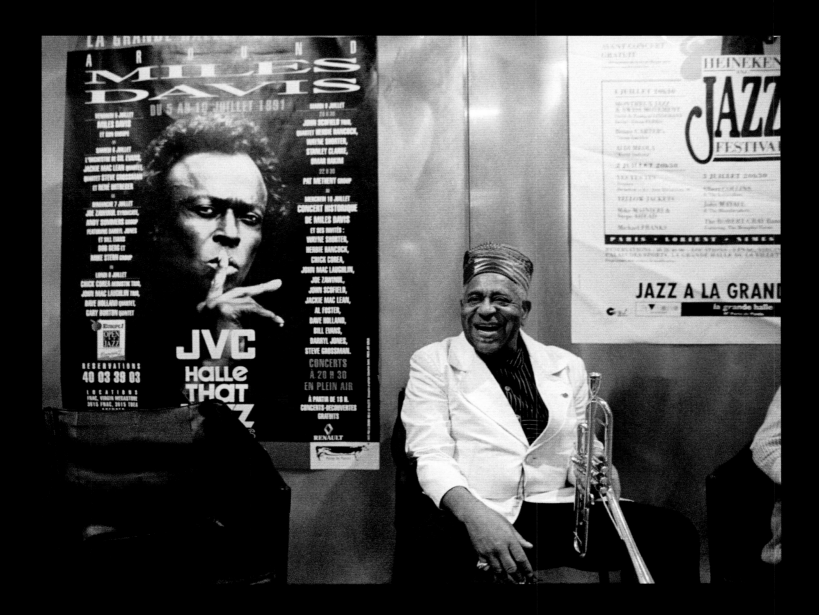

Dizzy Gillespie and Herman Leonard portrait of Miles Davis, Paris, 1991

Opposite: Dizzy Gillespie, London, 1989

Overleaf: Doc Cheatham, New Orleans, 1995

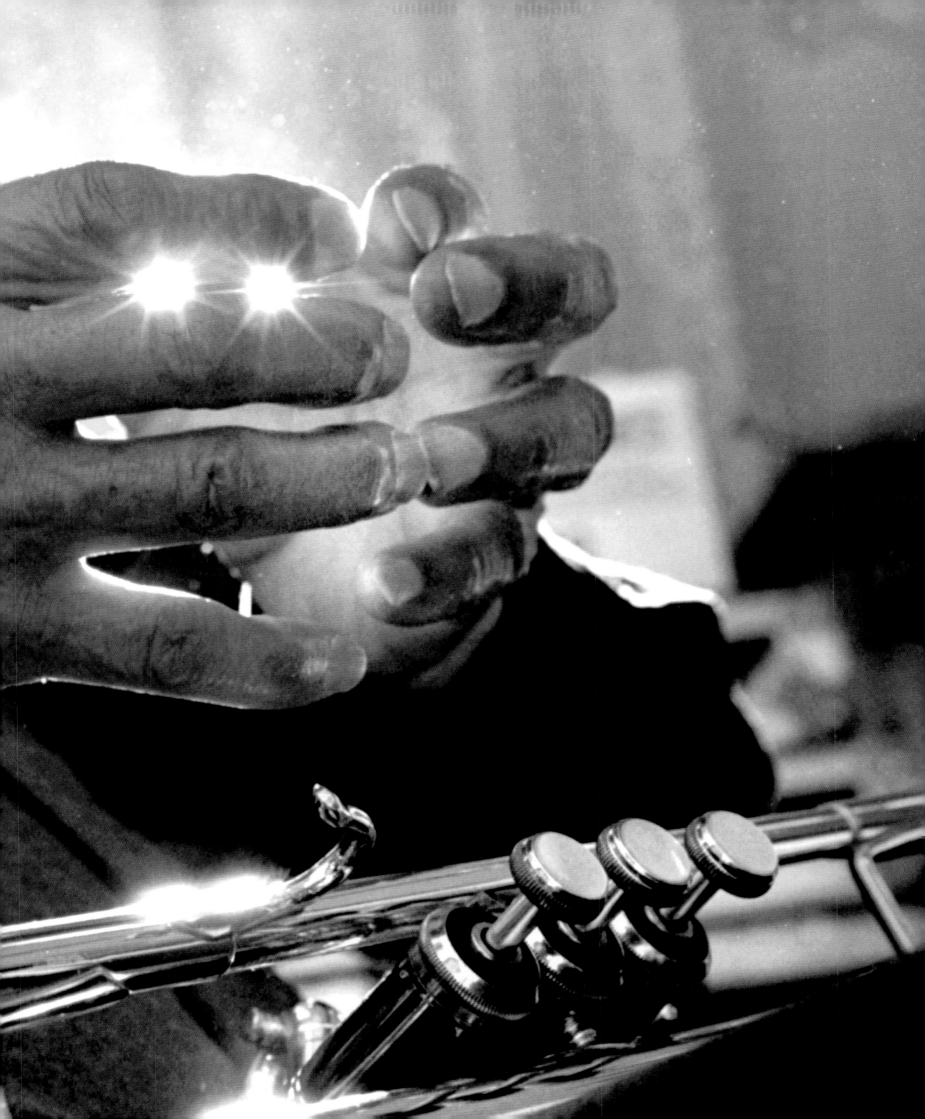

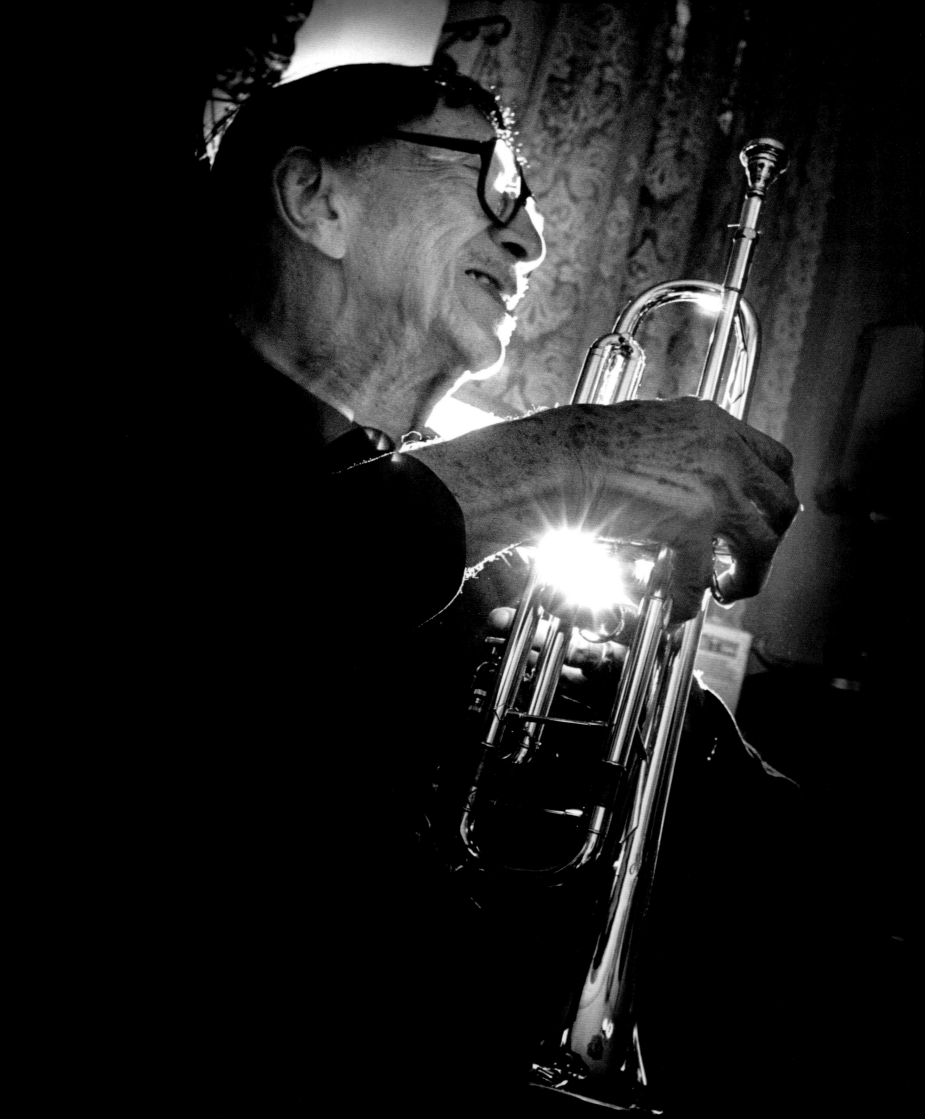

Doc Cheatham, Ne

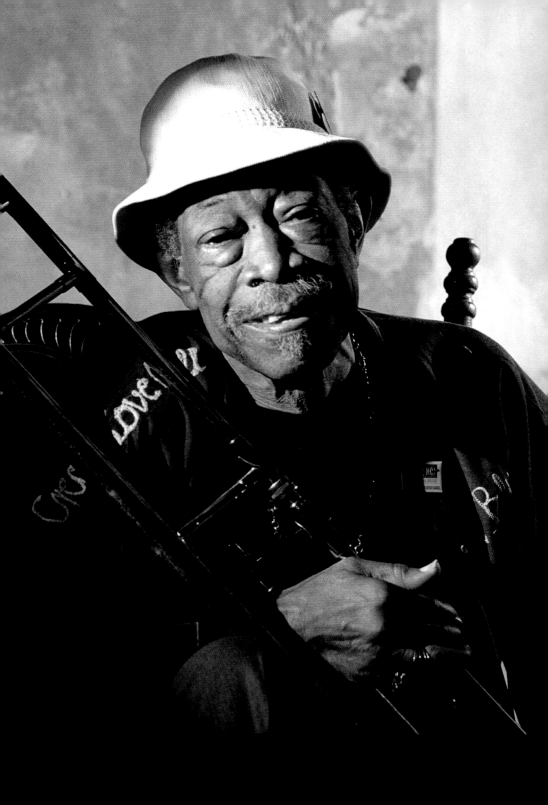

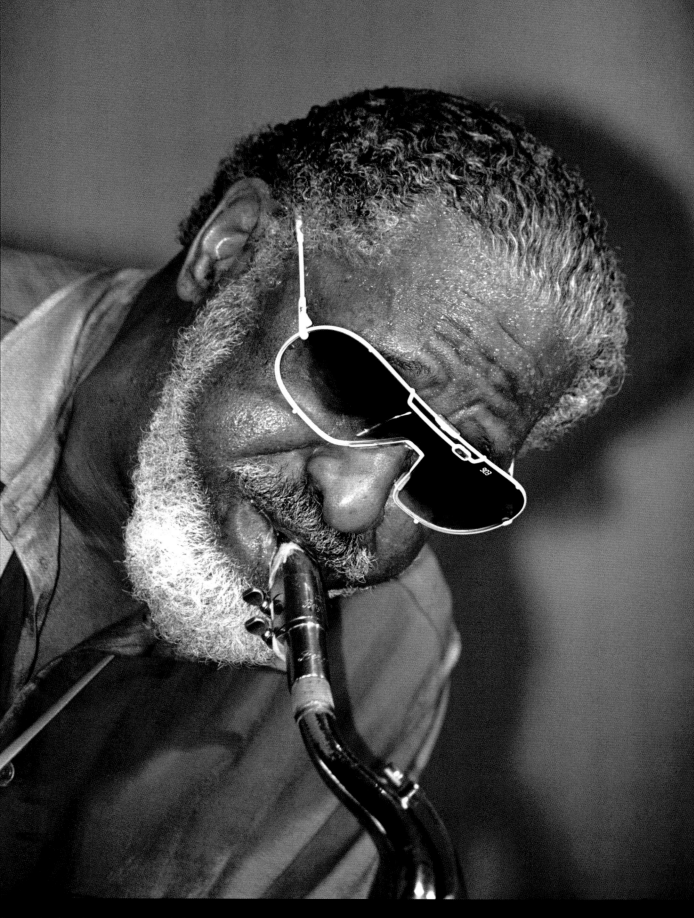

Sonny Rollins, New Orleans, 1995

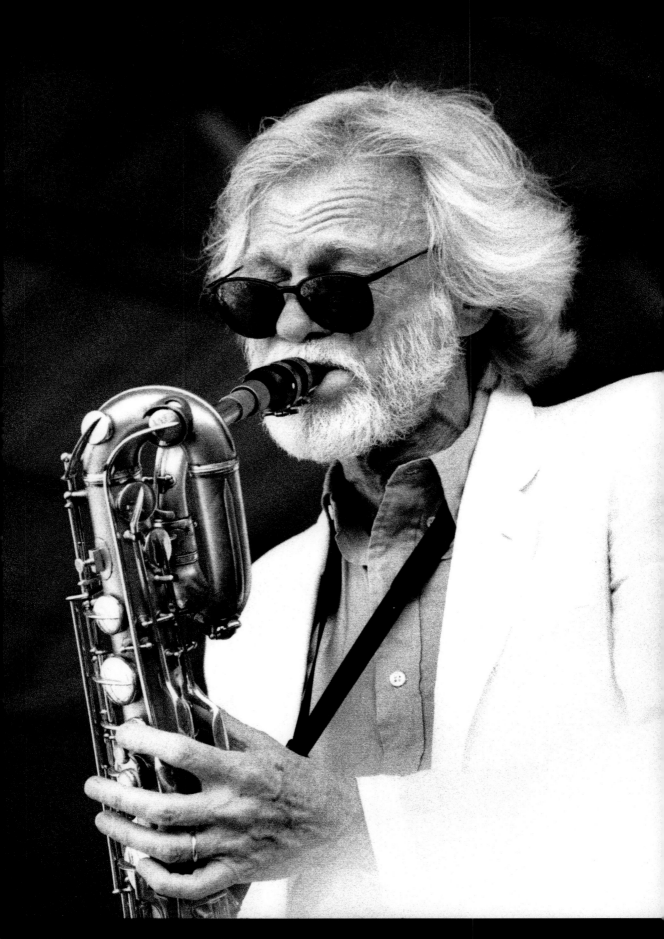

Gerry Mulligan, Newport Jazz Festival, 1990

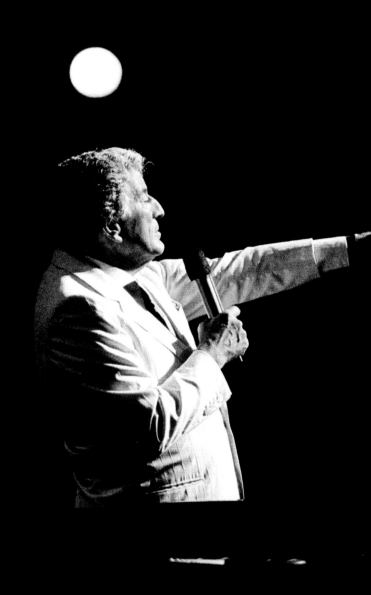

Tony Bennett, North Sea Jazz Festival, 1995

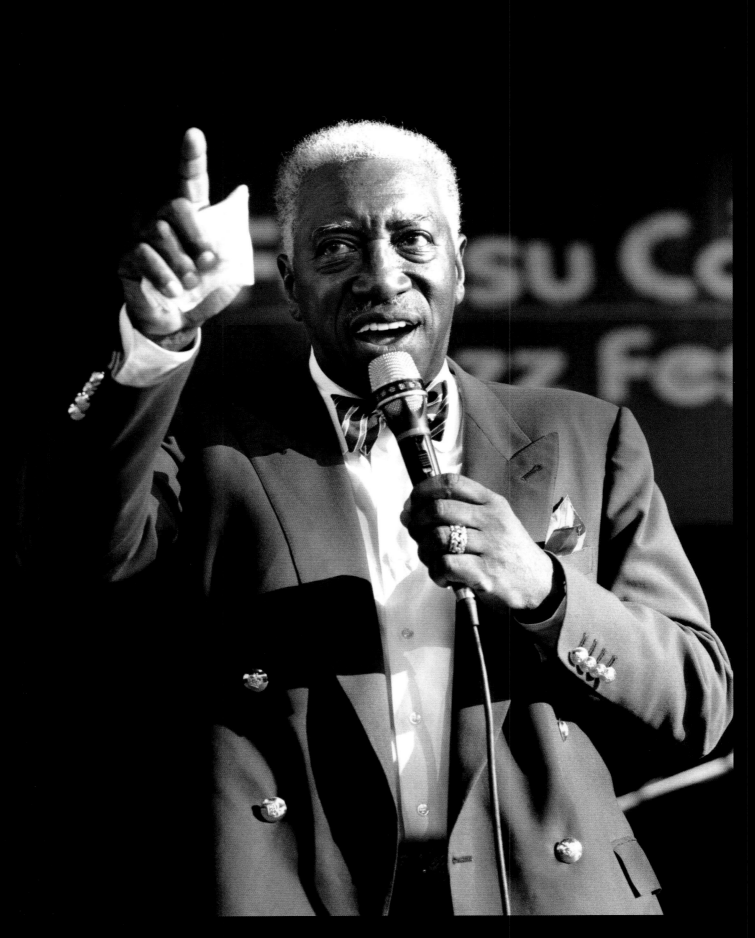

Joe Williams, Concord, CA, 1992

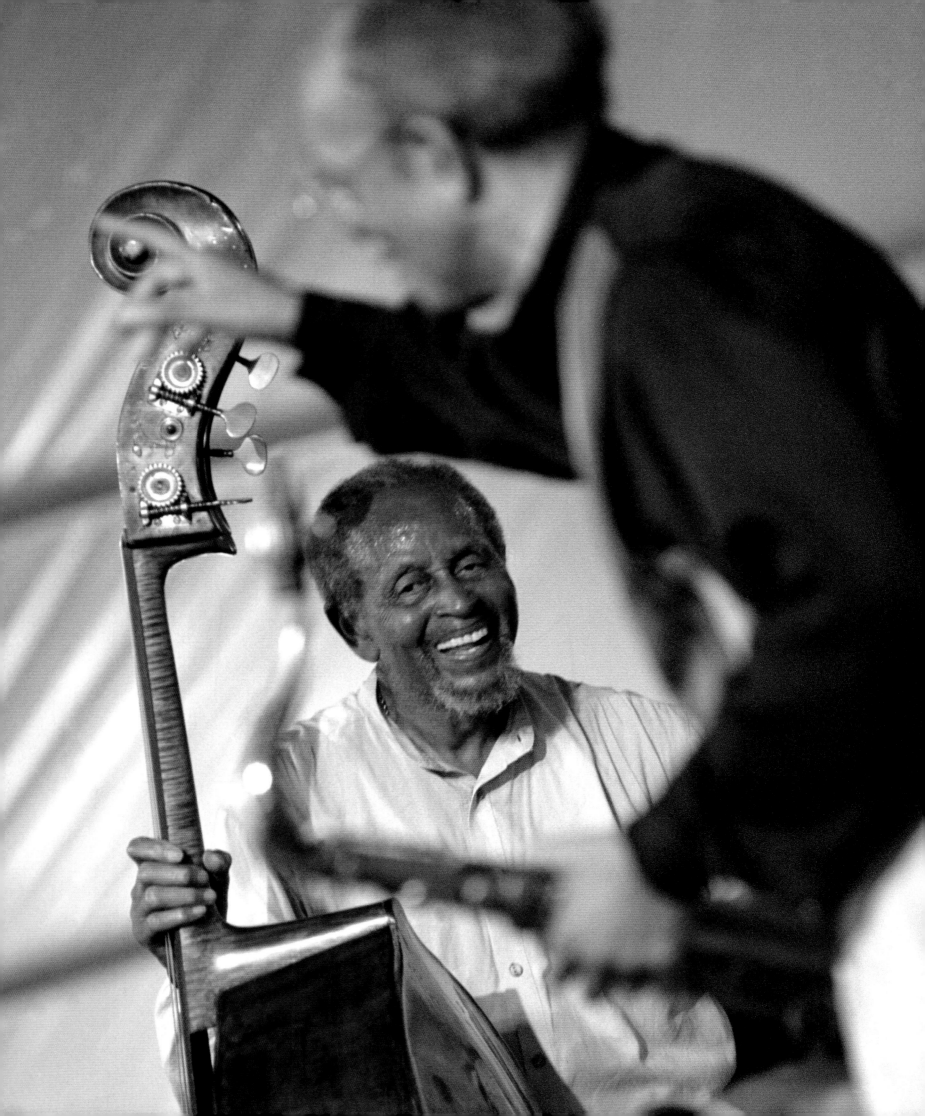

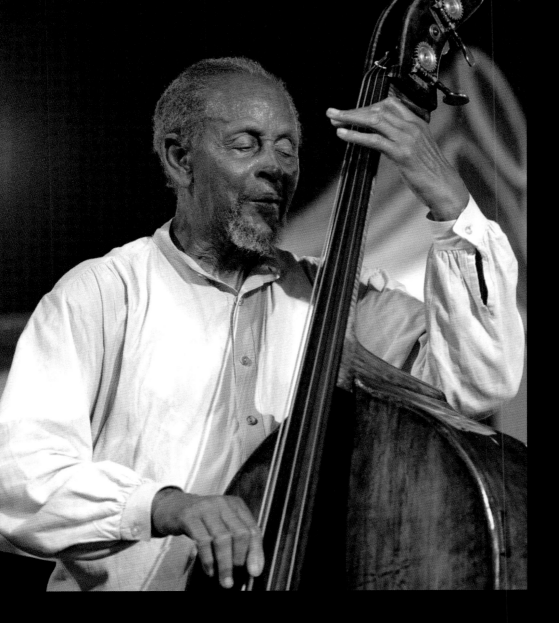

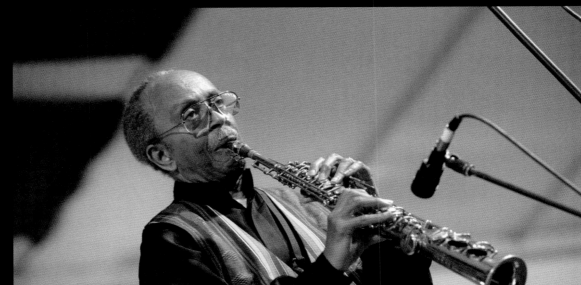

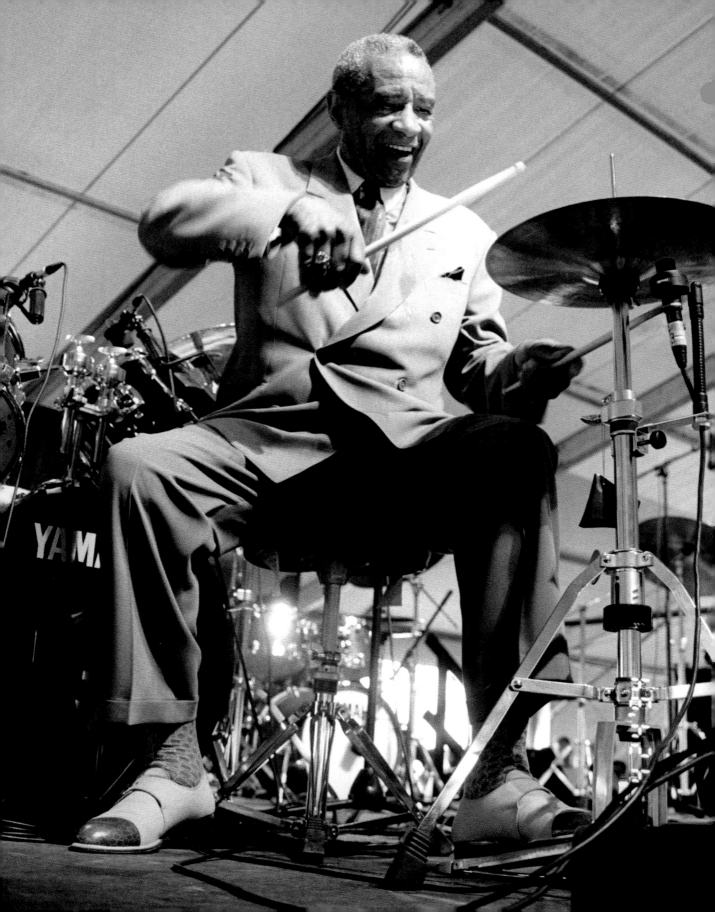

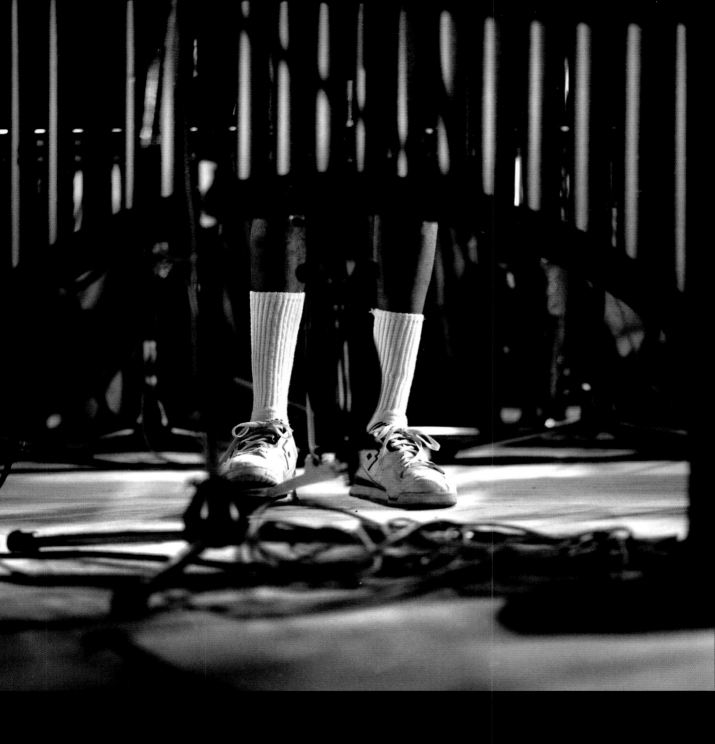

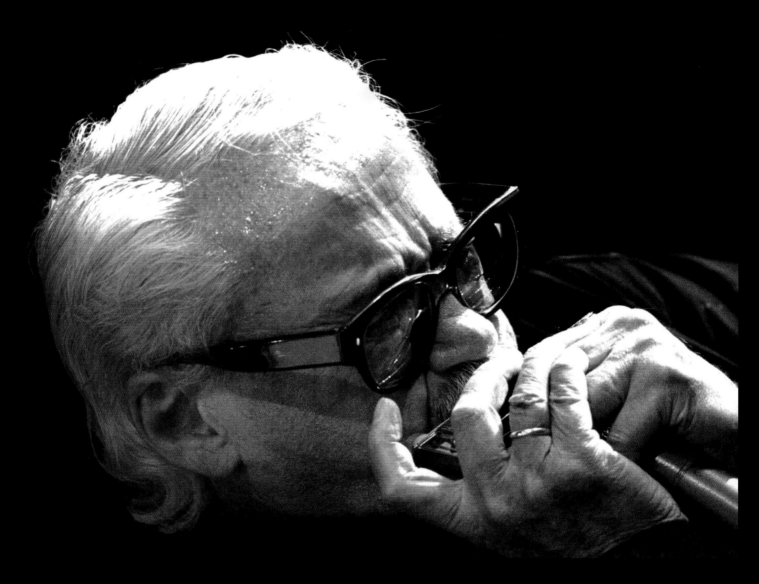

Above: Toots Thielemans, Montreux, 1991

Opposite: Johnny Griffin, North Sea Jazz Festival 1995

Overleaf: Herbie Hancock, Carnegie Hall, 1994

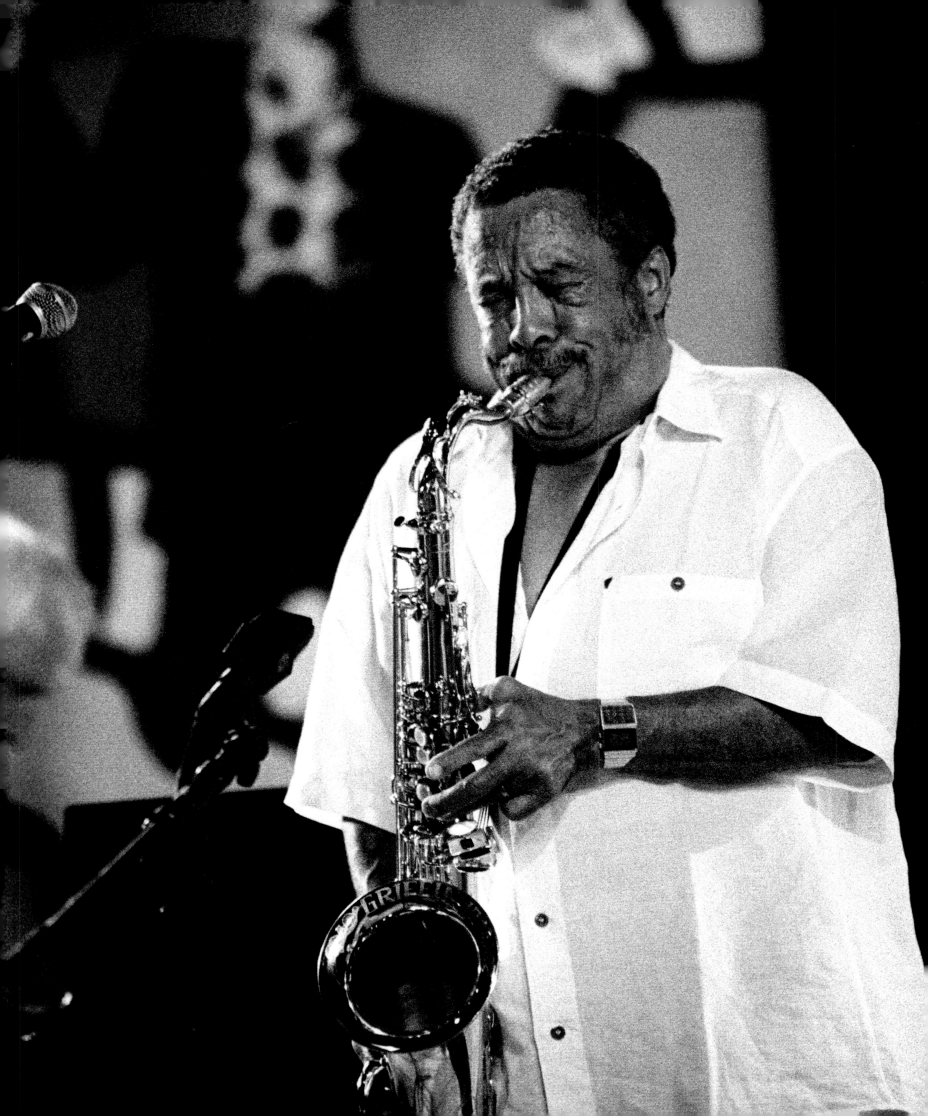

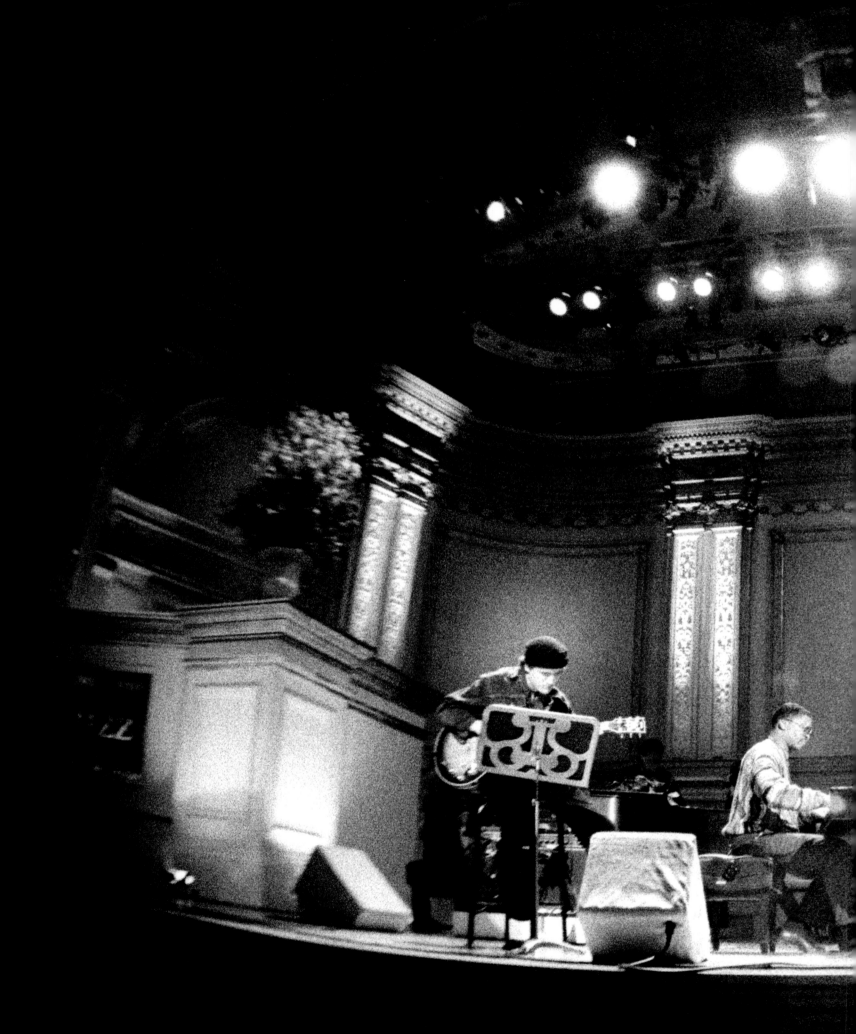

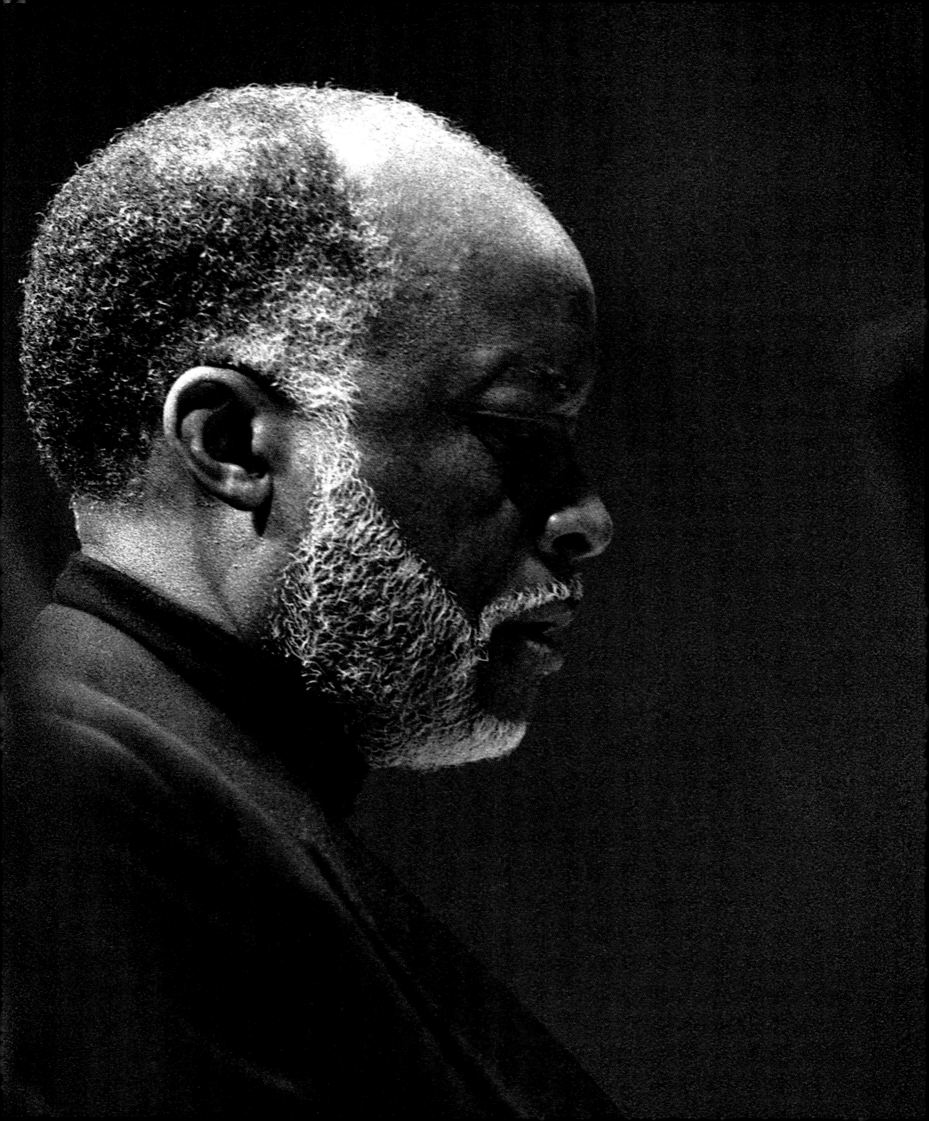

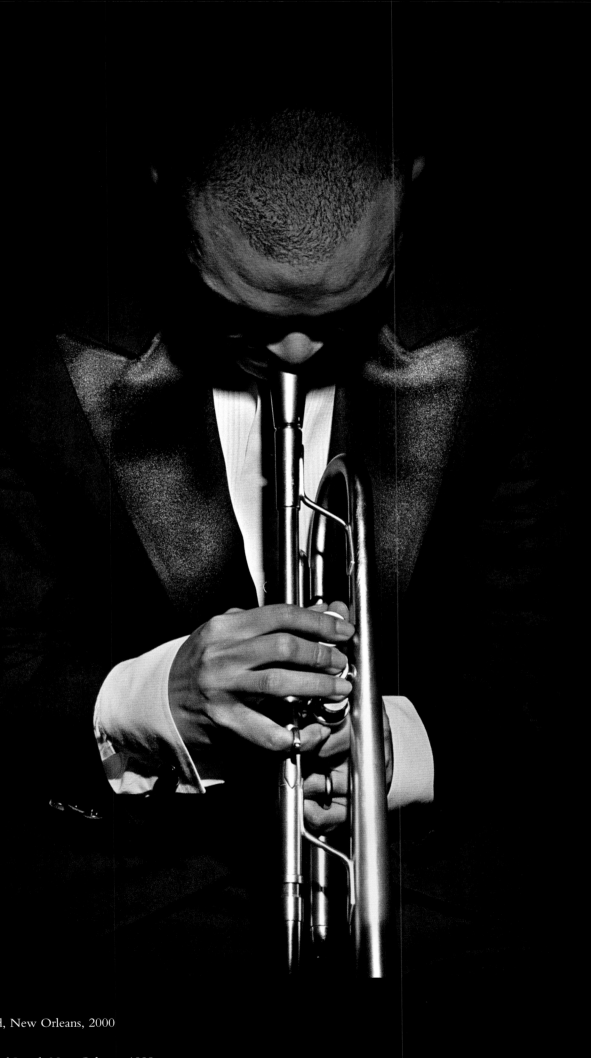

, New Orleans, 2000

nd Jamal, New Orleans, 1998

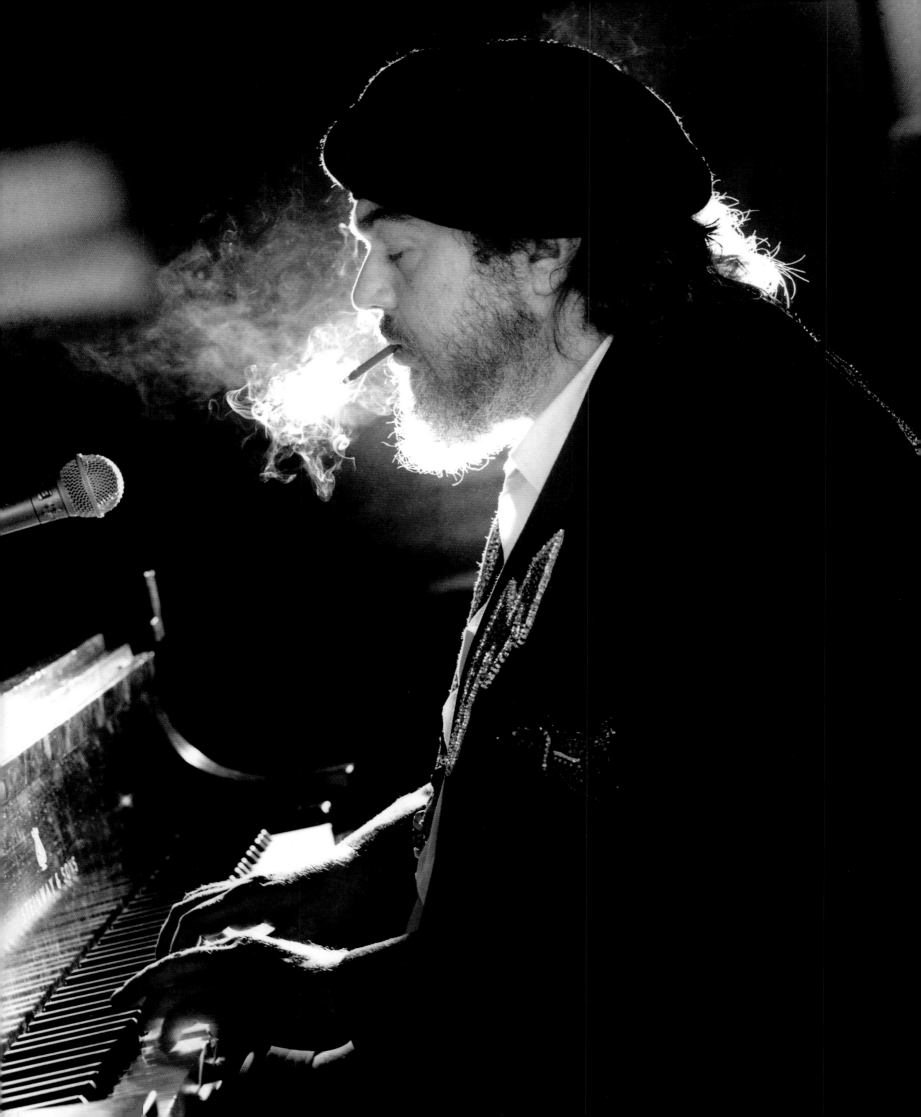

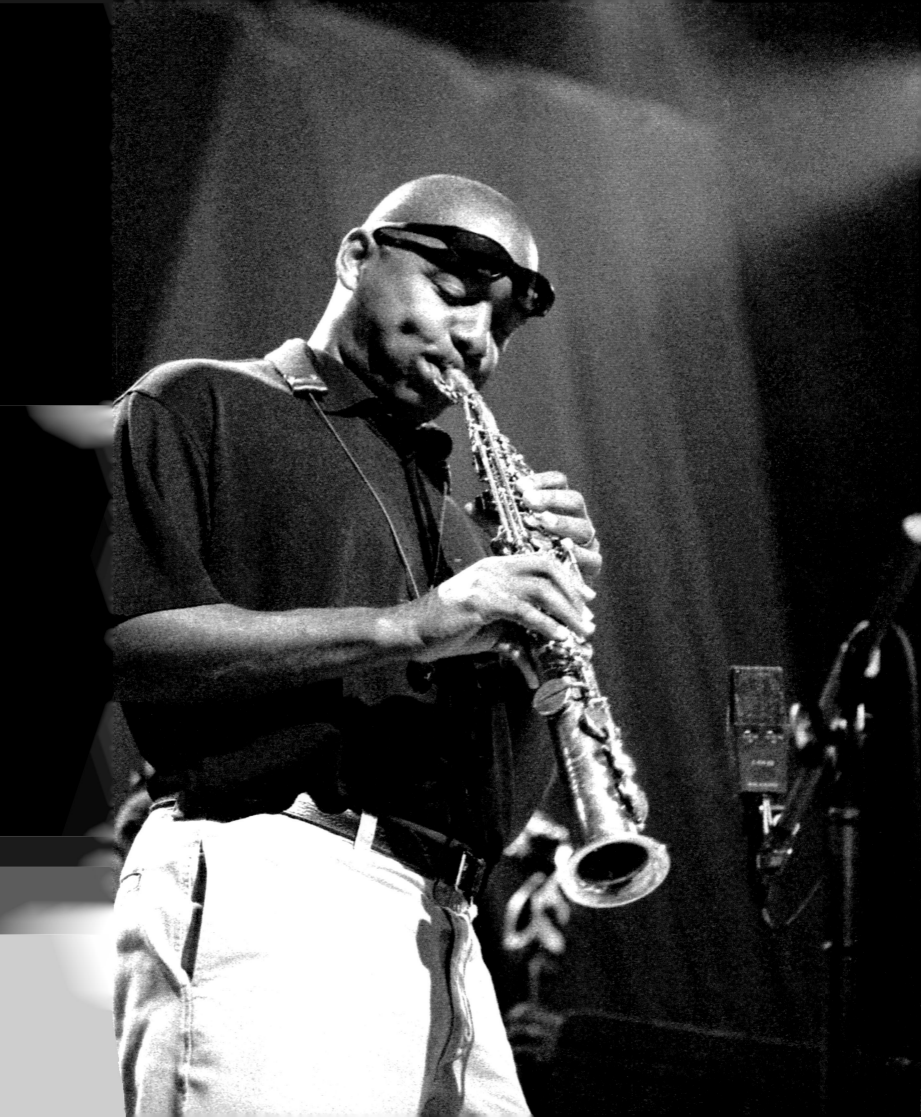

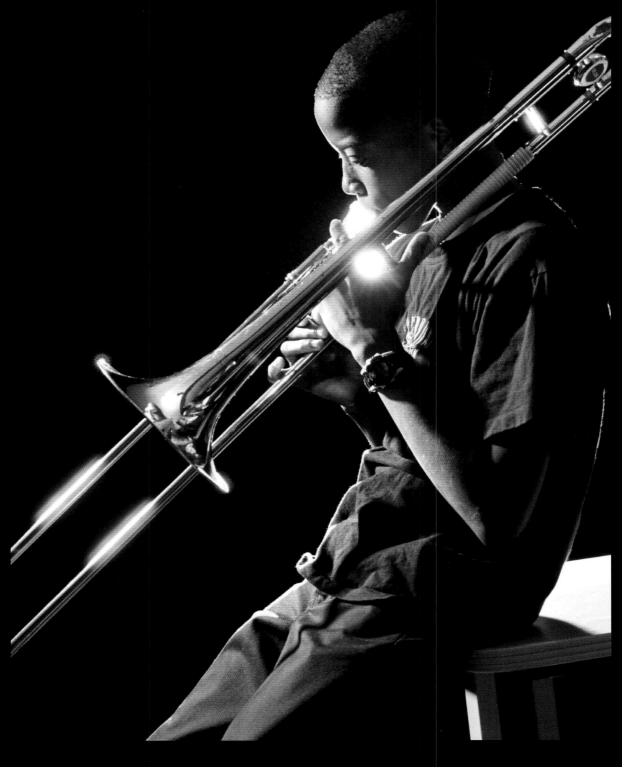

Troy 'Trombone Shorty' Andrews, New Orleans, 1999

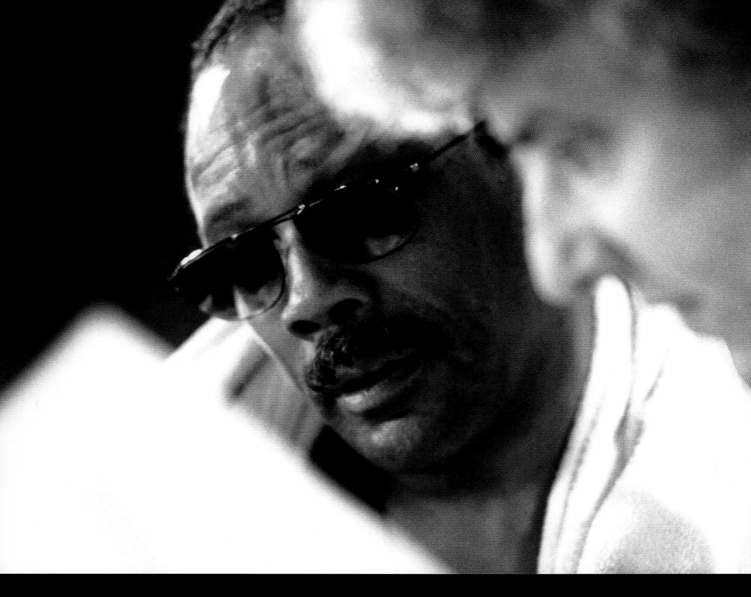

Both: Quincy Jones, Montreux, 1991

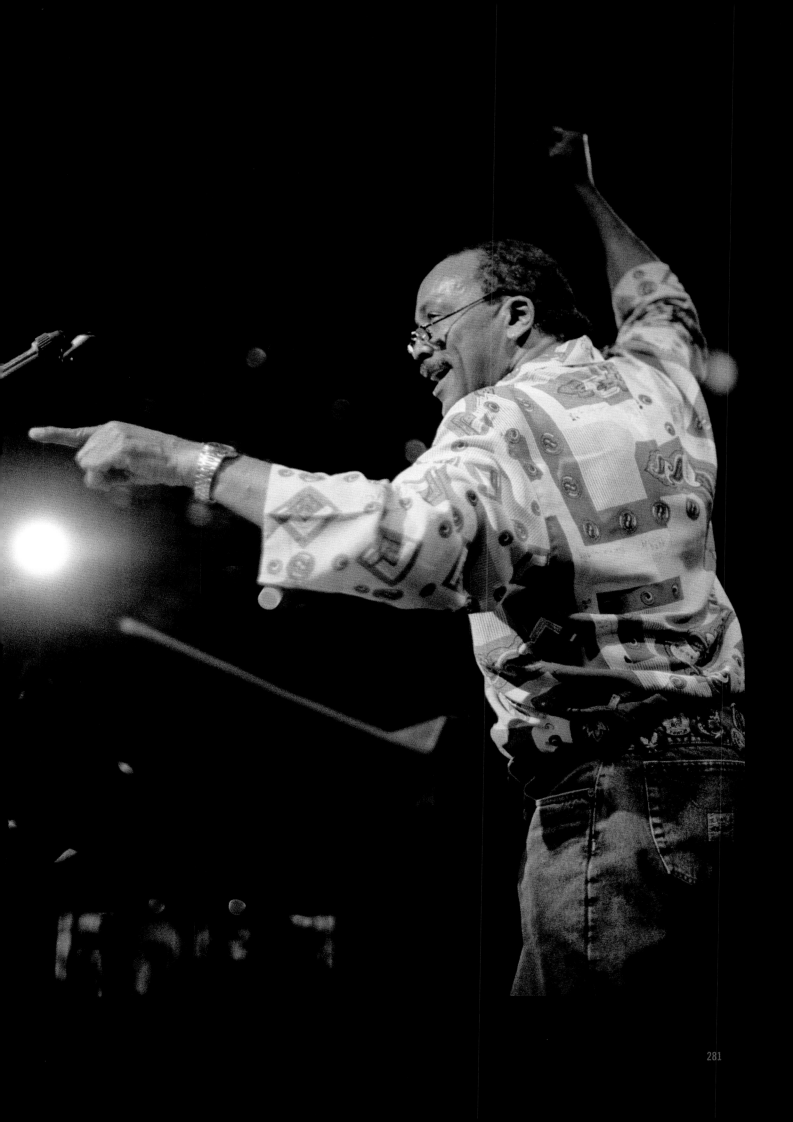

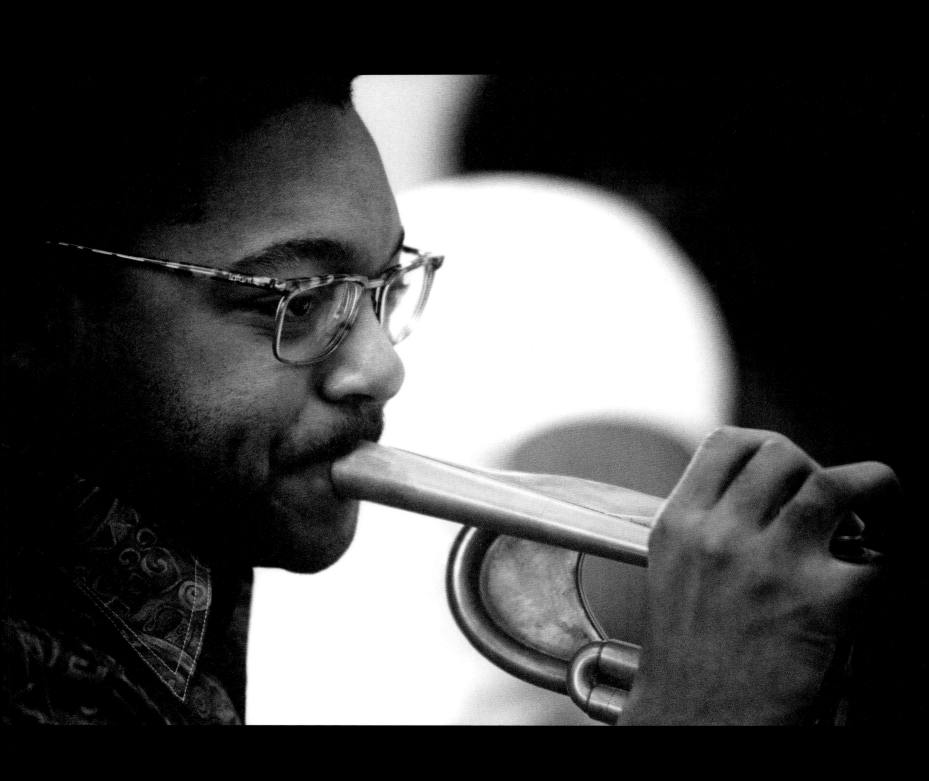

Both: Wynton Marsalis, New Orleans, 1993

Overleaf: Wynton Marsalis, New Orleans, 1993

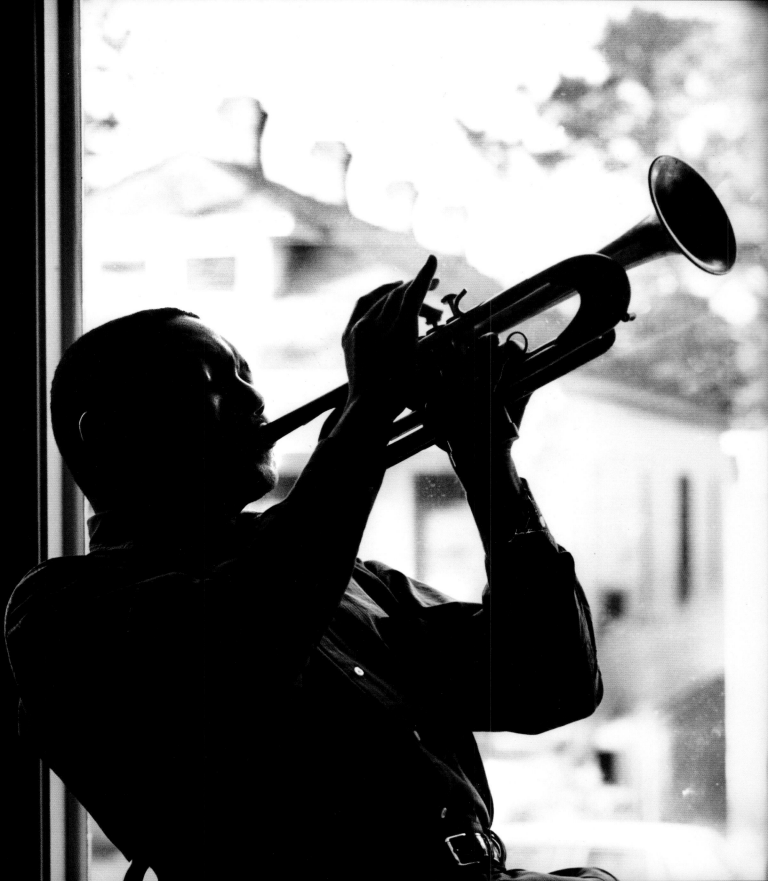

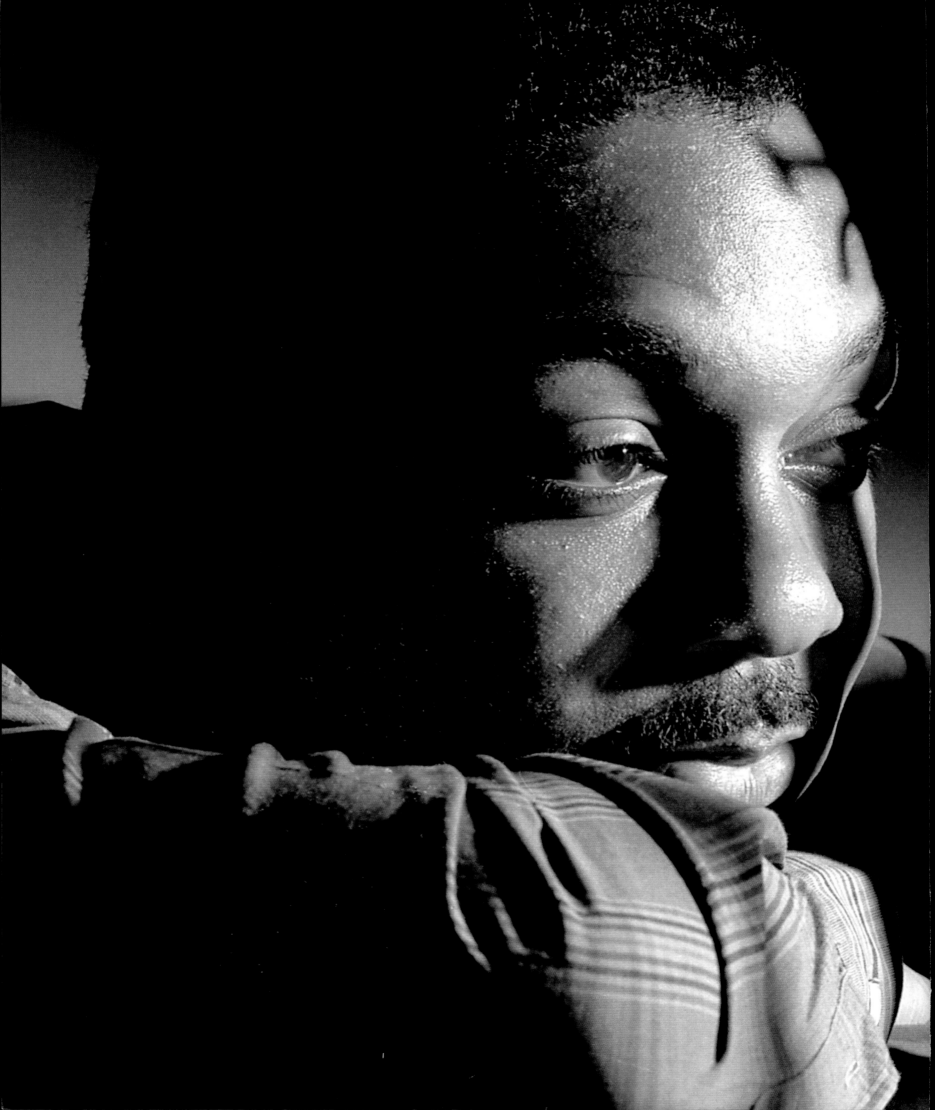

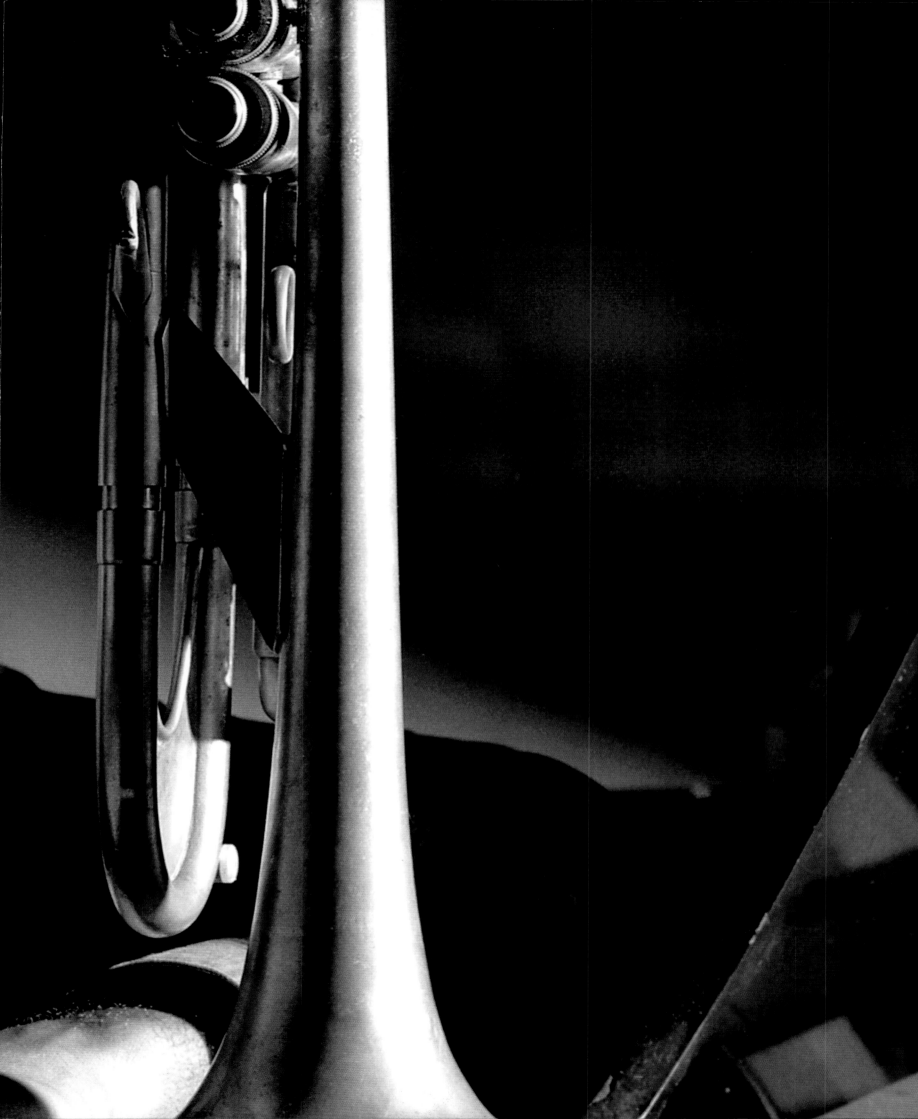

Both: Miles Davis, Malibu, 1989

Miles Davis, London, 1989

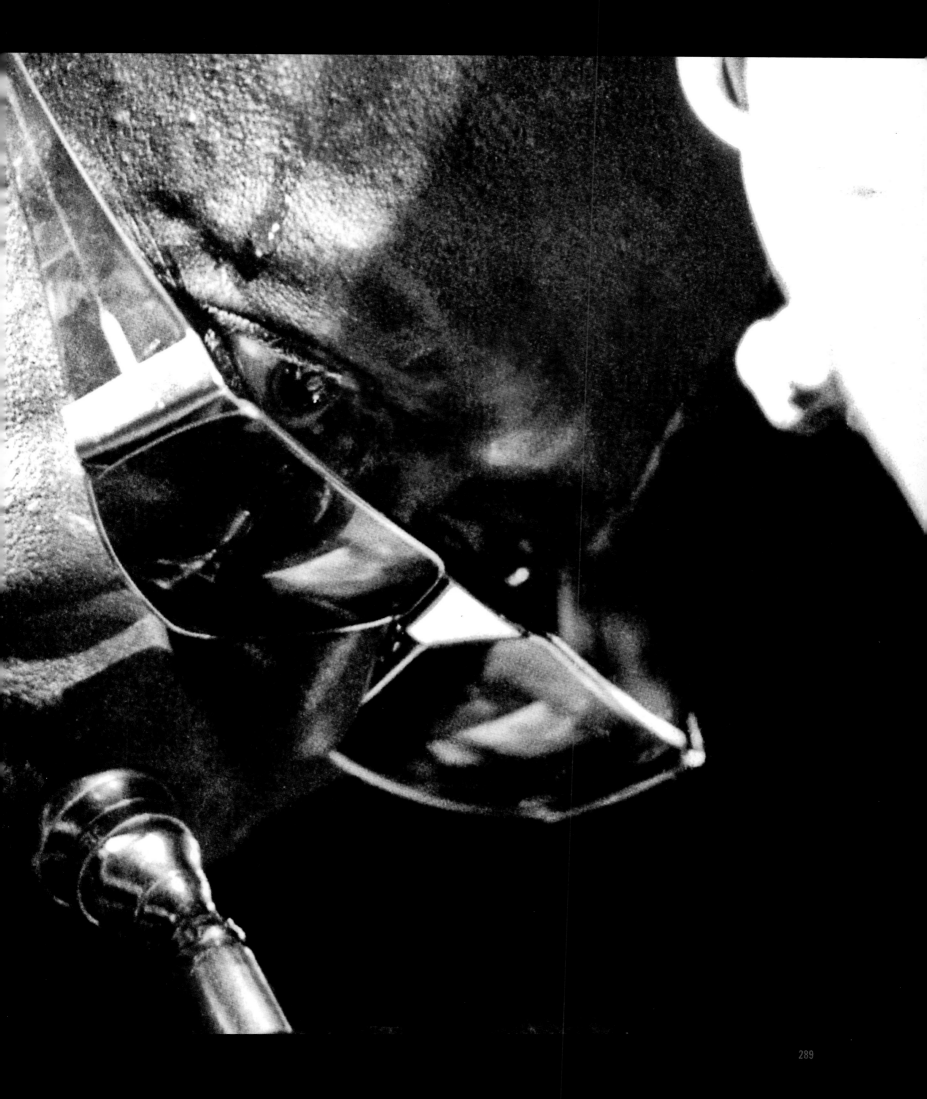

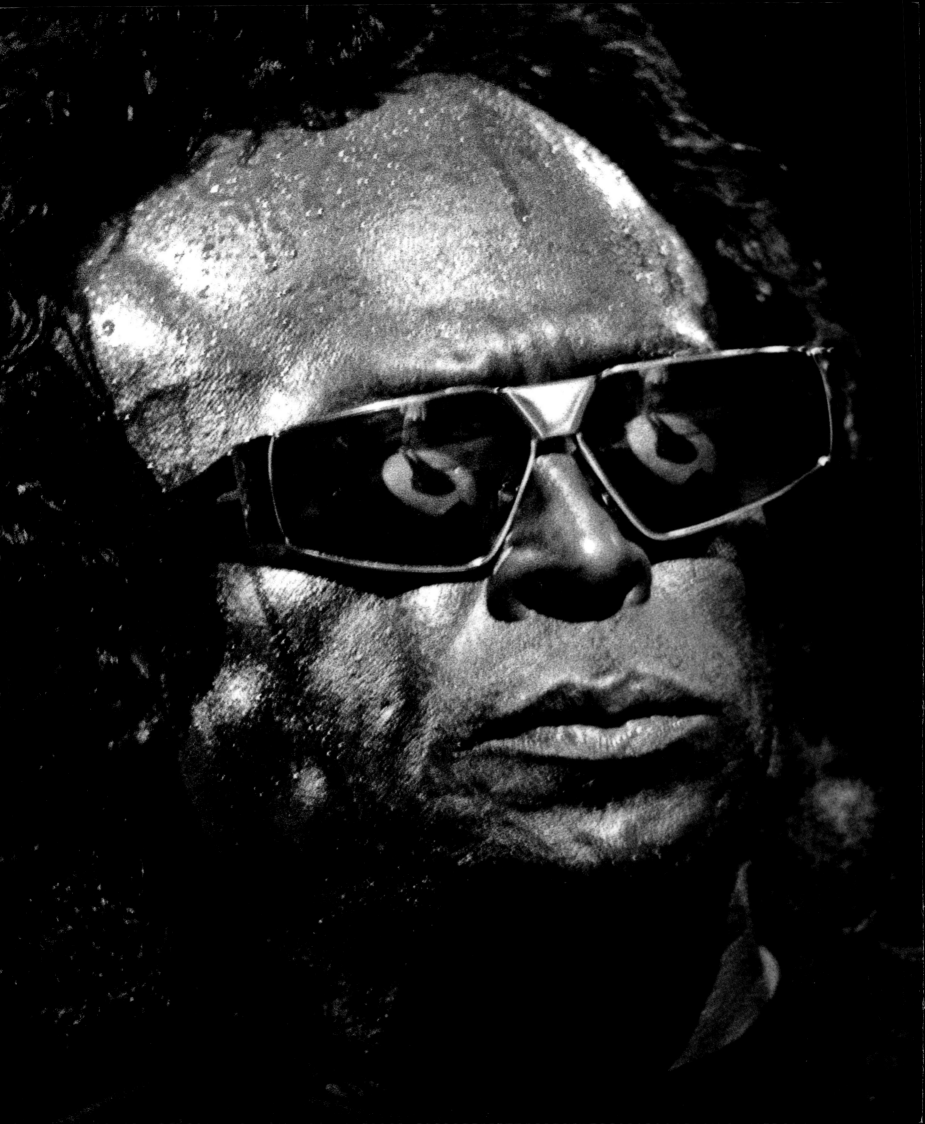

Opposite: Miles Davis, London, 1989

Miles Davis, Montreux, 1991

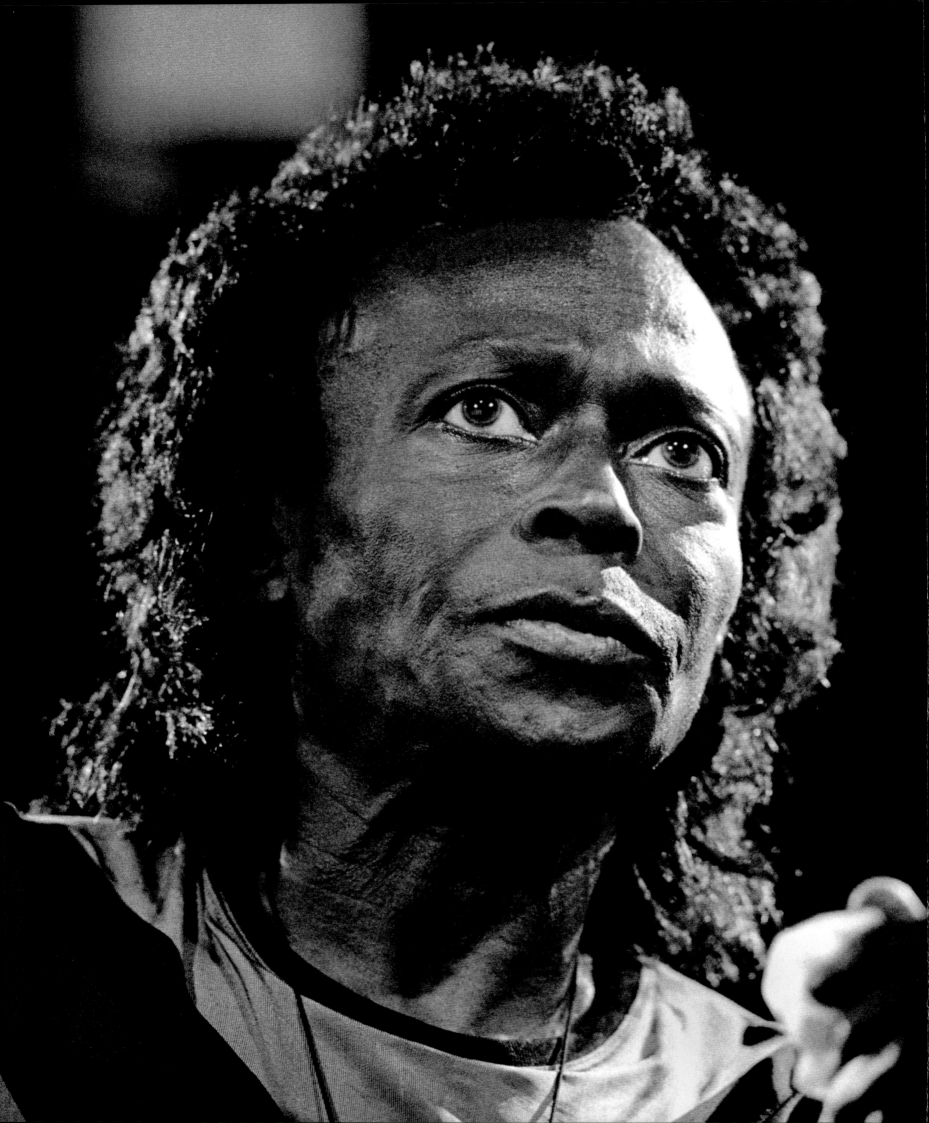

Miles Davis, Montreux, 1991

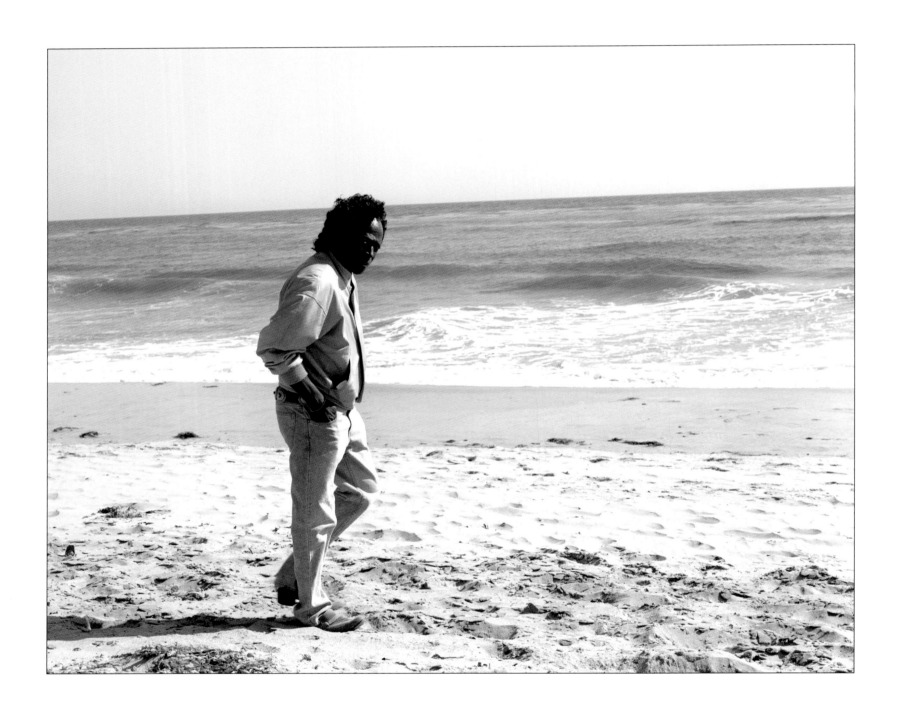

Both: Miles Davis, Malibu, 1989

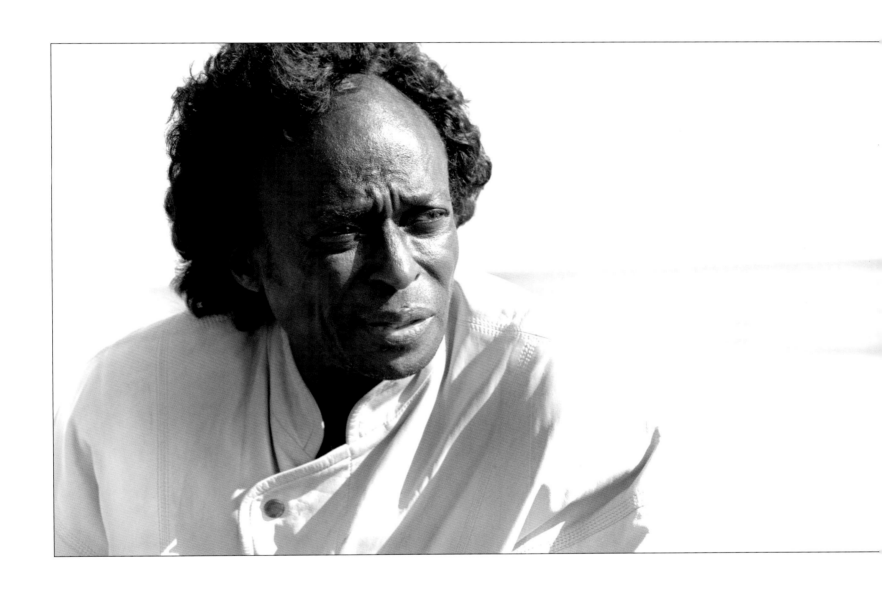

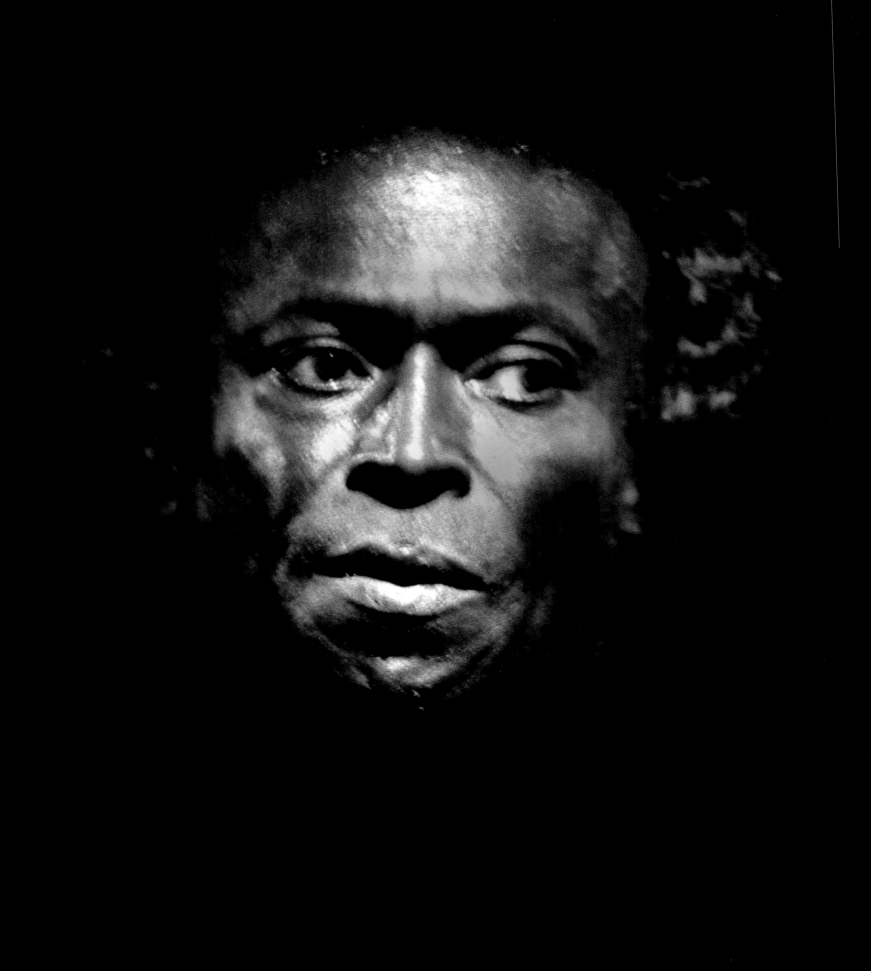

Miles Davis, London, 1989

Smoke and Music:
Herman Leonard at work

LESLIE WOODHEAD

As New Orleans struggled to come to terms with the devastation of Hurricane Katrina, Herman Leonard got to work in the city's only surviving darkroom. I was filming him as he began the huge task of rebuilding his archive of jazz photographs, destroyed when his house was inundated by the floodwaters. In the darkroom, I watched as Leonard slid a negative into the enlarger, a luminous image of the young Miles Davis, taken more than fifty years before. Witnessing the exquisite subtlety with which the master printmaker coaxed textures and nuances from the old negative – teasing out a highlight on Miles's face, accentuating the texture in his shirt collar – I also understood something about Herman Leonard's remarkable resilience. Faced with a loss which would have disabled many photographers – 10,000 prints and all his technical records – at eighty-two, Leonard seemed to relish the challenge of starting again.

As I have come to know Herman, I have been amazed by his constant enthusiasm for renewal, his openness to new possibilities and new ways of working. Talking to him about his decades of photographing jazz, his appetite for change and reinvention put me in mind of a great jazz improviser. As he told me recently, 'I'm still changing every day.'

The ongoing story of Herman Leonard's long photographic journey is signposted in part by developments in cameras and lenses, film stocks and new technologies. But from the beginning, photographing jazz was a passion fuelled by his love of the music and the musicians. 'I was doing my own stuff,' Leonard says. 'It was shot only for me. I wanted to have a visual record of what I was seeing and hearing that night. I wanted a visual memory. I just wanted to get that drama.'

Back in 1948, when Leonard began to photograph jazz, he brought to his labour of love the rare technical skills he had learned during his apprenticeship with the great portrait photographer, Yousuf Karsh. But while the influence of Karsh's masterly control of lighting and texture is evident in many of those early pictures, Herman Leonard's vision is all his own. He found an entirely innovative way to put together the techniques of studio lighting with the restrictions of location photography. As he talked to me about how he worked in the dark, cramped clubs of New York, it became clear how he used the restrictions of his equipment – a bulky camera, lenses with limited sensitivity, and slow-speed film stocks which struggled to register an image in low light levels – to create a visual language which perfectly captured the emotional qualities of the music.

'At the beginning, the club owners felt my photographing would be an interference. You know, there weren't any photographers shooting that subject matter in those days. It wasn't a career thing. You didn't make any money out of it. Nobody cared, but the clubs let me come in. My deal with the owners was to give them prints to put out front in return for the access. I gave the musicians prints too, so they recognized me, 'Hi Herman bla, bla, bla,' like that. And then I would hear them say, "Well we're gonna go and play in somebody's apartment, or going to do a rehearsal at some place," and I'd say, "Well, can I come and take some pictures?" and they'd say, "Yeah." And, you know, one thing lead to another. And after a while I became part of their circle.

'I started with a "Speed Graphic" – one lens, one format – the same camera all the newspaper guys used. You see them in the old movies, the big cameras with the big flashguns – they'd pop away. I started with that because it was the only camera I had when I was in college, and I took it with me to New York. But I'm very happy in retrospect I had that camera, because it obliged me to take a lot of time until I snapped the button – to wait until the subject was either very expressive, or in the right position compositionally.'

As he talks about how he worked, it's apparent that Leonard profited from those limitations and feels now that they had a vital role in focusing and defining the images he was collecting.

'Another advantage was that my camera used a large piece of film – 4 inches by 5, not 35mm or 2¼ inches square – because now I can see a distinct difference in the quality of the picture. And although there were other lenses, either I didn't have the money to buy them or I didn't need them. The lens that came with the camera was a Kodak Ektar f4.5 – rather slow by today's standards. But it didn't limit me at all. I used it in combination with the little flashes that I had. I was probably shooting at about f8, f11. It worked very well.'

Leonard's memories of the laborious procedures involved in taking a few pictures in the clubs sound daunting, but he still feels those time-consuming processes were crucially productive.

'There were 4 x 5 inch film holders that would slip in the back of the camera. Pull out the slide, take the picture, put the slide back in, pull out the entire holder, slip it over to the other side, pull out the slide; see how much time it takes even to talk about it! It took physically that much time. And you knew that when you pressed that button that was the only thing you could shoot for that moment. You couldn't pop it off like today with sequential pictures taken very quickly. So you really had to be very careful and precise as to what you were getting.

'I look now at the old negatives – and I have a picture of Kenny Clarke that I like a lot. And technically it came out absolutely perfectly. My focusing – that's another aspect of the Speed Graphic – was a rangefinder on the side of the camera. You had to look into the little tube of that rangefinder, and join the images as they moved back and forth until they came together. Then you had to move your eye to the viewfinder of the camera – and so on. All of that was very helpful as it made me concentrate on what I was doing. I didn't realize it at the time, but I do now.'

Most challenging of all was lighting, and it was in finding creative solutions to that challenge that Herman Leonard forged the unique look of his jazz photographs.

'Technically, to be reproduced in a newspaper in those days, you had to have a lot of light on your subject otherwise it would be muddy in the reproduction. But I was working for myself, and I wanted to do things that were dark, things that would capture the atmosphere of the club because, for me, my whole project was to make a visual diary of what I was listening to so that later on I could say, yeah, I remember what it felt like because this is what it looked like.

'Had I gone in there with a flash on the camera like a news photographer, easily reproduced, I wouldn't have been happy about that photographically. And I was always impressed by the simplicity of great artists like Picasso who could take a charcoal and do a little line sketch and you'd see the whole character of the person. I thought I could do that with light. So I had two lights, that was all I could afford.'

The highly personal look of Herman Leonard's classic images from the 1940s – Charlie Parker, Dizzy Gillespie, Billie Holiday and many others – is defined by his lighting. He recalls how limited his resources were at this period.

'I had at that time – maybe they were the only portable strobe flashes that had yet been developed – Wabash Strobe units, which were boxes – 12 inches square, 4 or 5 inches thick, and heavy. There were two tubes on the back, and in the tube was liquid. In one tube, little red balls, in the other tube, little blue balls. If the red ball was all the way down, you were out of juice. If the blue balls were up, you had a lot of juice. There was an internal battery that you had to recharge. But out of each unit, I couldn't get more than twenty-five or thirty flashes. And so once again, you had to be very discriminating about when you were going to press that button.'

Leonard had to be aware of the sensitivities of the club owners about upsetting their customers – and about disturbing the musicians.

'I had to go in before the club filled up with people if I was shooting at night. Or, in the afternoon during rehearsal time, was when I managed to get my better pictures, because then I could move around a lot. But during the performance, I couldn't do that. It would be too disturbing.

'You can't use a tripod in those circumstances. You're in a club with tables and chairs. It was just too cumbersome to use a tripod. It was hand held. I'm shooting at 125th of a second, with strobe lights. The strobe is 1,000th of a second. So even if you move your camera, you're going to get a sharp picture. Nobody ever objected to the flashes.

'Once my strobe lights were set up, that was it. And I would set them up so that they wouldn't give me a flat light from my point of view. They would give me an edge light, because that set the subject off from the backlight more distinctly. It also accentuated the gradations of the musician's face and the instrument. And luckily, though I didn't realize it at that moment, it would bounce off the instrument and give me a flare. I like that in some of the pictures, but I wasn't aware of it when I was shooting. Because you couldn't see the effect until the strobe fired off, and it was so fast that you weren't fully aware that it had accentuated the smoke.'

In the late 1940s and early 1950s, rigging his lights in the clubs was a challenging business for Herman, requiring elaborate preparation.

'Generally I would try to light the subject as it was lit by the club lights. There was always a spotlight on the microphone, so the artist would be lit up as he performed. And I would clamp one of my strobe units up in the ceiling right next to their spotlight and point it towards the microphone. Then I trailed the wire that came from that unit – a long, long darn wire, through the ceiling camouflage, down in the back wall and across the floor to wherever I would position myself. It was a whole damn installation. But that was the only way I could do it. Nobody else was doing that with the strobes at that time in that way.

'The other light I usually put behind the subject, blocked by him from my camera so it gave sort of a glow in the background and it would pick up the smoke back there. That's why a lot of my pictures have a lot of smoke, because everybody smoked.'

The smoke in Herman Leonard's jazz pictures is a signature feature, a critical ingredient which defines his images, and

which he has made part of jazz iconography. It's as though the smoke is in fact the music made visible.

> 'In the case of the well-known picture of Dexter Gordon with all the smoke, there was one strobe that was up high to the left, and I had another one behind me – but not as strong as the one in the ceiling. I didn't want to overpower that light – I wanted that to be the principal source. And the one behind me was to fill in the shadows a little bit. And I would put a handkerchief or tissue over the unit to soften it. There were no controls, and no Polaroids to check what I was getting.'

Leonard's obsessive campaign to make a visual record of the jazz and the jazzmen he loved had to be squeezed in alongside his need to make a living as a portrait photographer. And the commitment to photographing jazz did not end with the long nights in the clubs.

> 'I tried to make prints as quickly as I could. I processed them at my apartment and washed them, and then blow-dried them with a hair drier to get them dry so I could print faster. Sometimes I was in there until five or six in the morning. Then I'd do whatever I did in the day, and go to the club again at night.
>
> 'Being able to go in there and work freely, and then come back the very next night with prints and giving them to the musicians, got me into that world a little more and I became very close friends with people like Dizzie Gillespie and Miles Davis.'

At the end of the 1940s, Herman Leonard began to explore a different kind of jazz photography. He started to experiment with a new camera which would free him from the constraints of his fixed lighting rigs.

> 'It was only in the late 1940s when I graduated to a twin lens Rolleiflex camera with a sensitive f2.8 lens that I was able to shoot under dark conditions. I had made a little more money, so I was able to buy a Rollei. And I wanted to shoot without flash whenever

I could. Sometimes the ambient light was not as dramatic as the strobes I was using. But I was able to shoot more frames with the Rollei. I could put a dozen rolls in my pocket which gave me over 100 pictures.

> 'I could shoot more pictures, and get more moments. I would not have the quality of the old 4 x 5 Speed Graphic – that was the equivalent of five million megapixels. We have blown up those 4 x 5 pictures to wall size, and they're still pin-sharp. But I was looking for something different now.'

From the beginning of the 1950s, Herman Leonard's jazz photographs evolved a different feel, the images becoming less formal, more observational. The locations moved beyond the bandstand and into the backstage areas, looking in on after-hours get togethers in musicians' homes. And he was exploring techniques which would extend the possibility of shooting jazz in difficult locations.

> 'I picked up an old photo book from the early 1900s, and I found a little chapter about how to increase the speed of your film by subjecting it to mercury vapours for twenty-four hours. The only way I could do that was by getting some mercury that was in thermometers in those days. So I'd go to the pharmacy and buy a dozen thermometers. The guy says, "Are you a doctor?" "No, I'm a photographer." "So what are you...?" And I would break them and collect the mercury, and put it in the bottom of a plastic developing tank. Then in the darkroom, I would roll the film on to the spool and put it in the tank, suspended above the mercury, close the lid and leave it overnight. And it increased the sensitivity of the film by at least two factors. So that permitted me to shoot under more extreme lighting conditions. I had no idea then that it was toxic.'

At the same time, Leonard was also relishing the liberating potential of new cameras.

> 'Around the early 1950s, when I had a bit of money, I bought a Hasselblad camera. It was glorious,

because the quality of the lenses is so wonderful. For a while, the Hassleblad became my main camera, and I got a lot of good pictures with that camera. Then I started to fool around with 35mm.

'I was able to buy an older Nikon Rangefinder. And I began to experiment with a lot of ultra-fine grain developers. Because when you blow up a 35mm negative to 11 x 14 you start to get grain and so on. Today I don't mind the grain. The priority then was sharp clean images.'

The freedoms offered by the new cameras and new techniques had a profound impact on Leonard's jazz images. His low key pictures of musicians such as Stan Getz and Sonny Rollins, and his documentary shots captured backstage in London with Count Basie, reveal a more relaxed and informal approach.

'My changes of camera inevitably affected my pictures, because when I was restricted to the 4 x 5 Speed Graphic, I paid a lot of attention to the lighting and the composition of my image. When I graduated to the Rollei, the Hasselblad and the 35mm, I was concentrating more on the moment – more documentary. And I could record a lot more images.'

From the mid 1950s, Herman Leonard lived and worked in Paris. Alongside his commercial work, he extended his personal archive of jazz images by photographing a number of great American musicians – Miles Davis, Duke Ellington, Louis Armstrong – as they passed through the city. He also encountered a great French photographer.

'I met Henri Cartier-Bresson in Paris because he and I used same lab for processing film, and we would cross paths. And I had occasion to go into that lab and see his contact prints when he wasn't there. Now, he shot a lot of film. But what we see today is only what he approved of. He had a whole sheet of thirty-six images of which he wouldn't print anything – because he didn't get what he wanted to get.

'And it's the same with any photographer who is conscious of his work. You can only judge him by what he wants to show you – not by what he's shot outside of that. It's the same with me. I have a lot of reject stuff that I'll never show you or anybody else, 'cos I don't like them. You can only judge me by what I consider to be a worthwhile image. You're not necessarily judging me on my photography as much as my taste.'

Today, six decades after he began photographing jazz in the little clubs where a new music was being forged, fusing classic portraiture with a fan's passion, Herman's taste has shifted and changed.

'It's the final image that I want you to judge me by – not how I got it. I can piss on the Goddamn print to give it colour if that's the effect I want. So you judge me on what I'm showing you – not how I got it.'

Being with Herman Leonard in a New Orleans jazz club, you feel his intense connection to the music – and to the musicians. As Ellis Marsalis, the sprightly seventy-five year-old pianist and patriarch of an extraordinary jazz dynasty, bounds on to the stage to join his trio, Herman shouts to him: 'Where do you get your energy, baby?' 'From you baby!' Marsalis yells back, before sailing into an exhilarating set.

The exchange dramatizes Leonard's visceral feeling for jazz and for the people who make it. It underlines how jazz musicians regard him – as one of their own. The Marsalis trio rolls out a succession of witty and original readings of jazz classics, and Leonard circles the bandstand with his digital camera, moving and swaying with the music so that he seems almost to be a fourth member of the band. Back in his seat, he is utterly absorbed in the music, head bowed, eyes shut, smiling and nodding with the beat. Herman Leonard is in his element.

'Right now I'm in the process of scanning every single thing that I've shot – even the rejects. We're coming across pictures that in the old days I completely rejected; either because they were out of focus or [the

subject] moved. And I look at the image and I say, "Wait a minute, that has some atmosphere!" It isn't photographically perfect, but it doesn't matter. I have a tendency to like silhouettes, because the image is strong and graphic, and not too highly detailed.

'One of my preferred Sinatra pictures in Monte Carlo – I do not have the original negative; I don't have anything I shot in Monte Carlo – it was lost somewhere along the way. All I have are the contact prints. Now when I make an enlargement of the Sinatra, it's extremely grainy. And I love it that way. It adds to the feeling of the picture – foggy. You don't even see his face. It's a back shot, very grainy, heavily underexposed, over-developed: perfect. I didn't intend it that way but that's the way it came out, and I'm very pleased with it, with that gesture and the little cigarette. It's only Sinatra.

'And he comes out, and you hear just a little bit of the bass fiddle in the background just going – and a spotlight starts, and he lights a cigarette. You don't see him but the spotlight with its pin-spot just on his hands and the cigarette, and he lights the cigarette, and the glow illuminates his face and he takes a puff and then the spot light broadens and picks up the smoke and then picks up him, and it was 'One For My Baby (and One More For the Road)'. You know even now as I tell you, the thrill of that whole entrance was so incredible.'

Now, in his mid-eighties, Herman Leonard welcomes and embraces the new digital technologies which have transformed photography.

'People say, "Do you shoot digital?" And I say, "Yeah." And they say "That's not quite..." And I say, "Come on!" It doesn't matter what tools you use. What matters is the image you end up with. Not what you used to get it or how you produced it.

'I'm very grateful for Photoshop, because I can print things I could never print before, and get effects I could never get before. The other day we were going through some recently scanned images, and there was a picture of Cannonball Adderley that I shot that I could never print because it was so badly under exposed. But there's just a little thin edge of light on his profile. In Photoshop I can accentuate those highlights, and bring out that image. And I have no hesitation in doing that. Computers, Photoshop – what a Godsend! I'm enchanted by new technology. I'm criticized for it by some of the young purists. Whether I use the Leica or a Box Brownie, it doesn't matter.

'I've had some people send me hand-coloured prints of my pictures, and they look awful. The colouring was OK, but they look wrong. I shot some jazz in colour, but I don't find those pictures effective. When you're looking at a black and white picture, your brain doesn't have to work as much. You're looking at a graphic shape rather than the colour value – and in that sense, the image becomes stronger.'

In his six decades of photographing jazz, Herman has come to know, and become part of, a community of musicians which is a roll-call of the most iconic names in the music's history. Leonard's pictures put us in touch with all of them, preserving their legacy with a freshness which goes way beyond mere documentation.

That special quality in Herman Leonard's jazz images is surely to do with the fact that you feel he knew these people; they were his friends as well as his subjects. Bird and Diz sharing a joke backstage; Count Basie chatting in his T-shirt; Duke Ellington flirting at the piano with a group of pretty girls; and Louis Armstrong relaxing with a bottle of champagne – pictures that reveal an intimacy and trust which illuminates so many of Leonard's photographs.

A conversation with Herman Leonard puts you vividly in touch with the remarkable men and women who made modern jazz, as well as with the greatest popular singers of the twentieth century. Hearing his stories and seeing his pictures, you have the frisson of being there.

'I'm still changing every day. I want to get something different, and with a more documentary feel – so that I can look at the image and say: "Wow – what a moment that was!"'

I would like to thank: Geraldine Baum, Katie Rosinsky, Cynthia Sesso, Ravi Mirchandani, George Gibson, Toby Mundy, Caroline Knight, Margaret Stead, Orlando Whitfield, Sachna Hanspal, Alan Craig, Lauren Fulbright, Richard Carr, Leslie Woodhead, Reggie Nadelson, Eric LoVecchio, Shana Leonard, David Leonard, Stephen Elvis Smith, Melinda Sanders, Daniel Weidlein, Hilary Johnson, Jeffrey Stein, Bowhaus Inc., and The Grammy Foundation.

Herman Leonard, California, 2010.